D1106739

Lighting for Location Motion Pictures

Alan J. Ritsko

VNR VAN NOSTRAND REINHOLD COMPANY
New York Cincinnati Toronto London Melbourne

FOR JANET

Printed in the United States of America

Line drawings by Janet Dupont and Michael Hernandez.
Editorial assistance by Cliff Solomon
Photographs by Alan Ritsko unless otherwise credited
Designed by Loudan Enterprises

Published in 1979 by Van Nostrand Reinhold Company
A division of Litton Educational Publishing, Inc.
135 West 50th Street, New York, N.Y. 10020, U.S.A.

Van Nostrand Reinhold Limited
1410 Birchmount Road, Scarborough, Ontario M1P 2E7,
Canada

Van Nostrand Reinhold Australia Pty. Limited
17 Queen Street, Mitcham, Victoria 3132, Australia

Van Nostrand Reinhold Company Limited
Molly Millars Land, Wokingham, Berkshire, England

16 15 14 13 12 11 10 9 8 7 6 5 4 3 2 1

Library of Congress Cataloging in Publication Data
Ritsko, Alan J.
Lighting for location motion pictures.

Includes index.
1. Cinematography—Lighting. I. Title.
TR891.R57 778.5'34 77-28366
ISBN 0-442-26956-0

ACKNOWLEDGMENTS

I would especially like to acknowledge and thank Wendy
Lochner, for her help in editing this book; Cliff Solomon,
who first worked on the manuscript when it was about
two steps above being deciphered; Janet Dupont, for her
fine illustrations; Paul Snow, for his assistance with the
chapter on electricity; Jeff Gurkoff, for his numerous
contributions to the text; Jean Koefoed, Roger Manvell,
and Evan Cameron, for their help when this book was in
an embryonic stage; and Janet Ritsko, without whose help
this book would not have become a reality.

Contents

Introduction

There is always more than one effective way to solve a particular lighting problem or to design a lighting and rigging plan for a specific interior location. If you were to ask five different filmmakers to develop a lighting plan for the same set, you'd probably come up with five or even more different methods and approaches. The criteria for selecting one approach over another cover a wide range of possibilities, and the professional, after a review of aesthetic, mechanical, and technical considerations, settles on a creative plan that is practical, efficient, and adapted to the situation at hand—keeping in line with the time, money, and equipment needed to achieve the desired effect. Since every location is different and the variables are always changing, it is very difficult to devise a rule book for troubleshooting and selecting the most efficient and aesthetic means for lighting a complicated location of an advanced nature. Basic lighting, on the other hand, can be outlined and passed on as information. But it can prove to be invaluable to the filmmaker only if he or she is able to adapt the theory to the practical situations encountered, since "ideal" conditions seldom exist in everyday locations. For this reason, along with the text I've included many photographs of lighting setups from actual films and matched them to lighting diagrams. I hope that this particular blend of theory and practice will provide you with a substantial background from which to develop your own methods, techniques, and characteristic style for lighting future location motion pictures.

Key to symbols used in this book

filter material

camera

lighting grid

500-watt practical

250-watt practical

1K focusing spot on stand

2K focusing spot on stand

softlight

broad light

half scrim on side of light beam

diffusion material

half scrim on bottom of light beam

camera movement

subject

subject movement

tie-in

bounce light

1. Lights, Color, Intensity, and Quality

Through the mechanics of vision shapes, forms, and colors are interpreted. Much of our environment is defined by what we see; the sense of sight is made possible by the visual sensation of *light*. More specifically, visible light can be defined as a particular range of electromagnetic radiation that stimulates receptors in the eye, causing the qualities of an object that make up its appearance to be perceived and evaluated.

Although light is not seen as radiation itself, its effects are everywhere. The sun, a natural source of light, produces heat and colors. Anyone who has looked at the refraction of light through a prism, rainbow, or oil on water knows that light can be broken up into *colors*. Just as important to the cinematographer is the change of the color of light throughout the day. The white light of midday becomes red or yellow at night and, reflected from the moon, almost blue.

More characteristics of light can be defined through observation of common light sources and analysis of their effect on everyday surroundings. In addition to color light varies in intensity and in quality. *Intensity* is a quantitative measurement of an "amount" of light, while *quality* is a subjective evaluation of the ability of light to emphasize or deemphasize contrast in a subject.

The terms "intensity" and "quality" can be readily applied to the characteristics of everyday natural illumination. The differences in the intensity of light on a bright, sunny day and on an overcast one are quite obvious, but the different quality of the illumination present on each occasion is of great consequence to the filmmaker. On a bright day, the light is characterized by sharply defined areas of sun and shade. Shadows are visibly sharp and deep; contrast is very noticeable. On an overcast day, however, the illumination has a much softer appearance: shadows are minimized and contrasts are deemphasized.

The human eye adapts well to differences of color, intensity, and quality, usually unconsciously. Film, on the other hand, does not have the capability to adjust to these changes. For example, on a sunny day we can easily see objects in bright sunshine as well as in deep shadow, provided that we focus our attention on each area separately, but film is more objective and cannot focus on or adjust to the varying intensities of lights and darks in sun and shade. Because light is *actinic*—it effects chemical changes—a particular film responds to the actual intensities reflecting from each area and records them within its own limits. Unfortunately, the range of intensities that the eye adapts to is far greater than those that the film records. The eye's ability to identify these differences of intensity thus becomes a hindrance to a proper estimation of the poorer response of the film.

In controlling and directing light cinematographers must train themselves to interpret, from what they see, the manner in which the film will actually reproduce the image. What you see is not what you get. The filmmaker must consequently understand the limitations of vision, the properties of light and light sources, the characteristics of film emulsions, and the subject qualities that are affected and limited by lighting.

VISUAL ADAPTATION
LOCAL ADAPTATION

The eyes respond to illumination differently as lighting conditions differ. These changes are called *adaptations*. As far as the filmmaker is concerned, there are two major disadvantages of the eye's automatic adaptability: local adaptation and color adaptation. *Local adaptation* occurs when the eye scans a contrasty scene and adjusts to the intensities of illumination in each area. It does not evaluate the lightness or darkness of each area as compared to that of another area. The scene therefore appears to have a smaller range of intensity differences among light and dark sections than it actually does, giving us the *impression* that the scene is of lower contrast.

The local adaptation of the human eye *prevents* an objective evaluation of contrast and is a constant hindrance to a correct evaluation of the scene's tonal reproduction on film. Consequently, contrasts must be measured with a light meter, which is free from local adaptation and responds to varying intensities in the same manner as the film. In this way the filmmaker can accurately interpret the contrast of the scene and adjust it by controlling the lighting to fall within the recording capabilities of the film.

To get an idea of how local adaptation may affect the filmmaker's perception of contrasts, consider the following series of photographs. The first is an extremely wide shot of a lighting setup used to illuminate a scene from a location film. The lit area corresponds to the center of the frame in the still photo. Since the outlying areas were not to be included in the frame while filming, they were not lit and appear very dark. The photo is a good representation of the actual contrasts in all the portions of the still frame as they would have appeared on the screen if the wide shot had included all the areas. On film this shot would reproduce with much contrast, because there is a vast difference in illumination levels between the lightest and the darkest areas. To the eye this scene would appear quite different: the variance

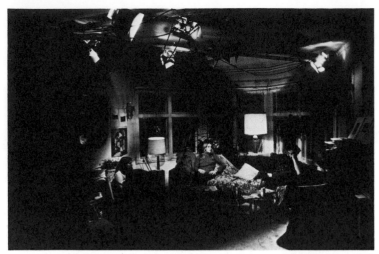

1-1

between the levels of brightness would appear to be much less.

The eye does not see the scene as the film does. It would rather have scanned the scene, focused on the subjects in the center, and locally adapted to the intensity of the light falling there (1-2). Likewise, in considering any of the objects in the outlying areas of the frame it would have adapted to the darkness of these unlit areas (1-3), and the contrast of the entire scene would predictably have appeared to be much less than it actually was. The impression of these contrasts, influenced by the local adaptation of the eye, may lead the filmmaker to interpret the overall scene as more "normal" in contrast (1-4).

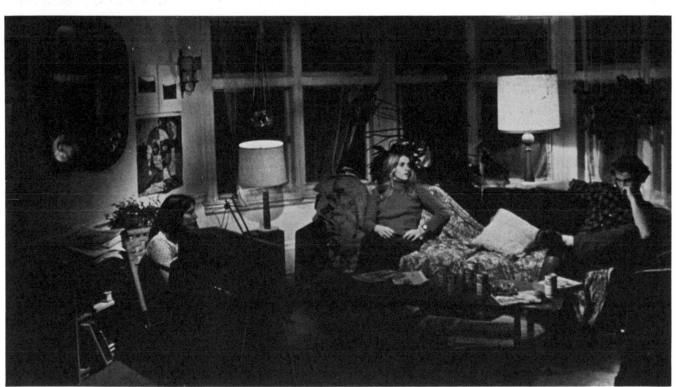

1-2

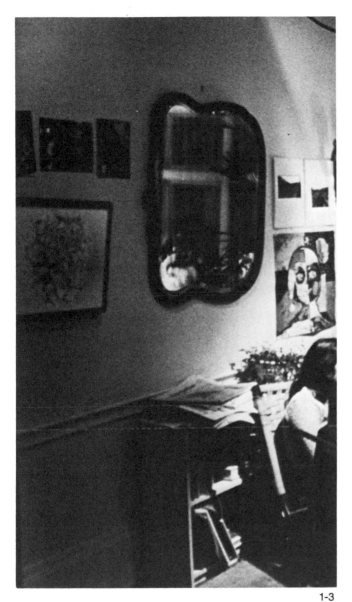

1-3

1-4

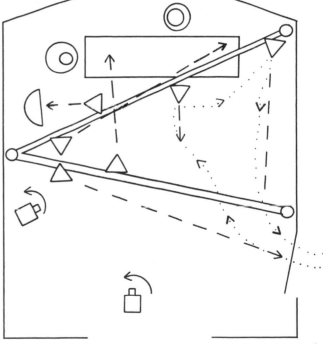

1-5

Long shot/living room/low key. 1-1. Contrast as it would appear on the screen. 1-2. Blowup of the light area as seen by the locally adapting eye. 1-3. Blowup of the dark outlying area to which the eye has locally adapted, making it appear much lighter than it would actually film. 1-4. Contrast appears "normal": the locally adapting eye adjusts to the varying intensities of light, making the scene appear lower in contrast than it would on film. 1-5. Lighting diagram.

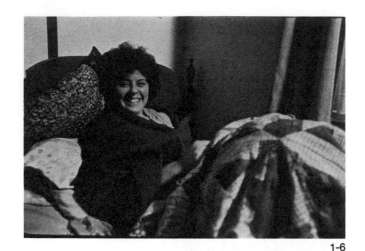

1-6

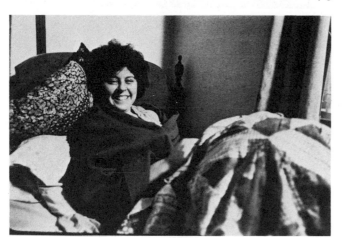

1-7

Variances in contrasts are usually dealt with by the film-maker by controlling and balancing the set lighting. It is important to remember, however, that, barring unusual circumstances, the shot will generally reproduce on film with greater contrast than that observed at the time of filming. For example, because of the local adaptation of the eye a closeup or two-shot that appears at the time of filming to be of "normal" contrast (1-6, 1-10) may exhibit a great deal more contrast on film (1-7, 1-11). Likewise, a long shot that appears to be high in contrast at the time of filming may reproduce with such extremes in contrast that all detail may be lost in the darker portions of the frame.

Closeup/morning bedroom/daylight interior. 1-6. Contrast appears "normal" at time of filming. 1-7. Contrast as it might appear on film. 1-8. Lighting setup: one 2K softlight illuminates the shot, lighting the face with a narrow-lighting design. 1-9. Lighting diagram.

1-9

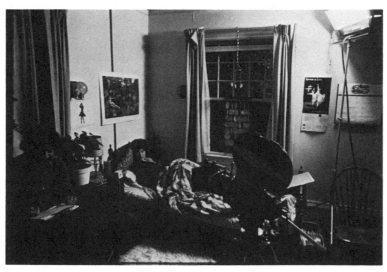

1-8

10

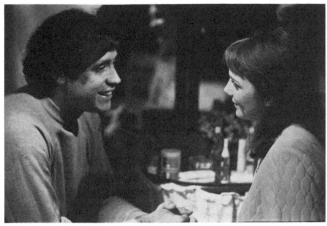

1-10

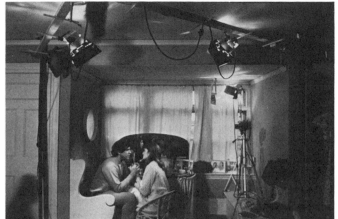

1-12

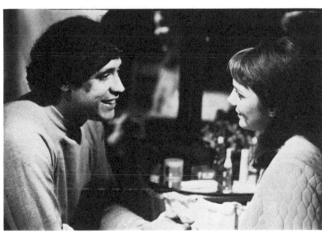

1-11

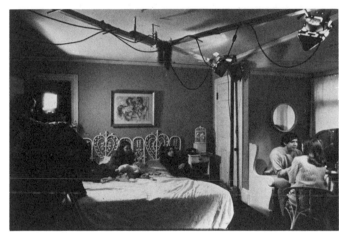

1-13

Medium shot/goodbye sequence/daylight interior. 1-10. Two-shot appears "normal" in contrast at the time of filming. 1-11. Contrast as it might appear on film. 1-12. Woman lit by a broad-lighting setup. 1-13. Softlight fill lowered the lighting ratio of the faces to 3:1. 1-14. Lighting diagram: the background, seen as a reflection in the mirror, is lit to one f/stop less than the exposure of the subjects.

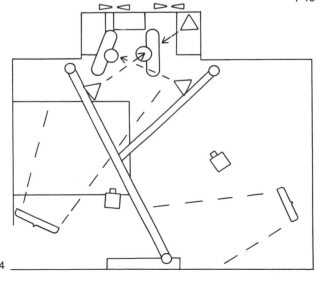

1-14

COLOR ADAPTATION

Color adaptation is responsible for the impression that all light appears to be colorless or white. Although each type of light has its own distinct color, the eye, when subjected to a particular type of light for any length of time, automatically adjusts. Given the chance to compare the color of two identical objects lit by sources of dissimilar color, however, slight variances of hue will be perceived. This is due to the differences in the colors of the light sources that reflect from the object seen. Film cannot easily adapt to varying colors of lights: adjustments must be made so that the emulsion can realistically reproduce all the colors and tones of the subject.

A film emulsion designed to produce an accurate color rendition of subjects illuminated with a particular color of light is said to be *balanced* to that color of light. Because the film does not have the eye's color-adaptive capabilities, subject-color reproduction will be influenced by the color of the light source if a film is exposed under illumination other than that for which it is balanced. For example, film balanced for indoor illumination (which is actually heavily yellow), if shot outdoors in daylight (which is actually blue in color), will reproduce all subjects with a bluish cast. Film balanced for outdoor illumination, if exposed indoors under fluorescent illumination (which is blue-green), will reproduce scenes with a greenish cast.

Another problem inherent in the eye's color adaptability involves more subtle variations in the color of the lighting that may occur during the course of interior filming. Since the eye constantly adapts to the color of the illumination used to light the set, other methods must be employed to monitor the color of the light. No specific set of corrective techniques can be suggested, for the degree of change may be negligible to the eye but have a great effect on the color reproduction of the scene. Choosing corrective techniques to compensate for color-balance problems is an important concern of the filmmaker: see chapter 7 for a complete discussion of this topic.

CHARACTERISTICS OF LIGHT

Light as energy is made up of electromagnetic waves of varying lengths. These waves emit light in all directions and are *transmitted* through the atmosphere. One way to create light is to heat up an object. An iron left in a fire, for example, will give off light. A light bulb works in much the same way: electricity passing through a thin tungsten filament causes it to glow, radiating light in all directions. Light is transmitted until it is blocked by an opaque object, which

reflects the waves: the object becomes visible. A single ray of light is thought to travel in a straight line; waves or bundles of rays, however, travel out from the source in a pattern that resembles the spokes of a wheel (1-15). This type of source is best thought of as a point from which the light emanates. Light from point sources has interesting qualities. It is sharp and well defined: none of the rays transmitted from such sources interferes with the others by doubling up or crisscrossing. Provided that nothing else interferes with transmission, light reaching a subject will cast crisp shadows, as in the case of sunlight on a clear day.

Most artificial sources emit light from multiple points along a filament, but, if each point could be singled out, you would see that most light is interfered with or altered before it can reach a subject. The drawing, for example, shows the transmission of several rays from only one point of a common multiple-point source—a light bulb. The rays from the filament are transmitted clearly through the vacuum inside the bulb, but those coming through the glass envelope are *refracted* (bent). This illustrates one important quality of light: whenever it passes from one medium to another of a different density, it will be refracted.

1-15. A radiating point source.

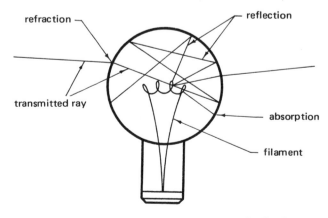

1-16. Transmission, refraction, absorption, and reflection.

The glass envelope of the bulb interferes with light transmission in another way. Not all the light, for example, passes through the glass: some of it is *absorbed* by the envelope. Still other rays are reflected and bounced off the inside of the envelope. Light that is absorbed may be dispersed through the glass as heat; light that is reflected may bounce around until it is refracted or absorbed by the bulb. Before light from this simple source is transmitted to illuminate a subject, it has been altered by reflection, absorption, and refraction. And this effect, of course, is compounded when you consider that this source emits light from an infinite number of points along the surface of the filament.

TYPES OF ILLUMINATION
SPECULAR ILLUMINATION
When light strikes a subject from a single angle or from a few very similar angles, it is said to be specularly transmitted. When specularly transmitted light (which is hard, sharp, and well directed) hits a subject, it provides a particular quality of lighting called *specular illumination*. Shadows cast by specular light are distinct and dense (1-17). Specularly transmitted light continues in a straight line until interference and varying degrees of diffusion occur.

DIFFUSE ILLUMINATION
When intercepted light hits a subject from a wide number of different angles, it produces *diffuse illumination*, light that is soft, flat, and scattered. Shadows cast by diffuse light are less dense and defined. The contrast of diffusely illuminated subjects is potentially less pronounced and noticeable than that of subjects lit with specular illumination (1-18).

It is important to remember that diffuse transmission is typically the result of the interception of and interference with transmitted light rays *after* they leave the source and *before* they reach the subject. When specular light is diffused, other properties—i.e., absorption, refraction, and reflection—may also be affected. For instance, the sun produces and transmits specular illumination. On a clear day it casts sharp, hard, contrasty shadows, all traits of specular illumination. On an overcast day, however, the clouds act as a diffusing medium. By refracting and reflecting the sun's rays within the translucent medium of cloud cover the light is scattered and diffuse illumination reaches the subject (the earth). The fact that cloudy days are less bright (less intensity reaches the earth) and usually cooler illustrates the fact that diffusion media absorb light and heat from their sources. Light reaching the earth on an overcast day produces a soft, flat

quality of illumination.

In location lighting objects that scatter specular light in order to produce diffuse transmission are called (conveniently enough) *diffusers* or *diffusion material*. Although there are many types of diffusers available for motion-picture lighting, each type affects the properties of light in much the same way as cloud cover affects the quality of the illumination produced by the sun.

Although altered transmission of a fixture's illumination can be readily observed by the filmmaker, two characteristics of diffusers should be kept in mind while viewing the subject: diffusion material absorbs heat and intensity. The filmmaker must be careful to measure the intensity of the light on the subject after the diffusion materials are in place. Because diffusers absorb heat, they must be carefully watched: if they are placed too close to the light source, they will eventually discolor or burn due to overheating.

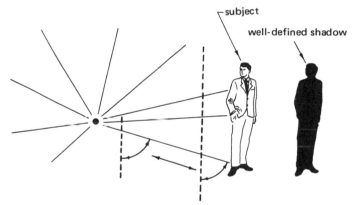

1-17. Specular transmission from a point source, with the resulting shadow cast by a subject lit by such illumination.

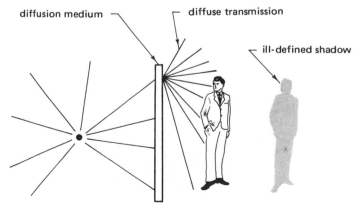

1-18. Diffuse transmission from a point source, with the resulting shadow cast by a subject lit by such illumination.

13

LIGHT-BULB TYPES

Light bulbs used in location lighting are designed to be practical, efficient sources made to be matched up with fixtures that control and direct their intensity. Bulbs are rated by the luminous intensity they produce, called *candle-power*, and by the amount of electricity they draw, measured in units called *watts*. Wattage is commonly used as a factor to refer to the light output of various bulbs that are used in the same fixtures—e.g., a 1000-watt bulb has the potential to produce twice the intensity of a 500-watt bulb in the same fixture.

THE QUARTZ-HALOGEN BULB

The majority of interior-location-lighting fixtures use *quartz-halogen* bulbs. These bulbs contain a tungsten filament and are encased in a tiny glass envelope made of quartz, which is filled with halogen gas. The quartz envelope can withstand extremely high temperatures, so the filament can burn "hotter" without cracking the surrounding glass. Quartz-halogen bulbs cast off a very high intensity of light for their tiny size, allowing them to be used in small, lightweight, portable fixtures that provide wide possibilities for location use. These bulbs maintain a stable color output of light throughout their lives and actually regenerate themselves as they are used. This ability is best illustrated by comparing the way in which quartz bulbs burn to the way in which ordinary tungsten-filament household bulbs burn.

Inside every common light bulb is a burning element, the filament. As the filament of a household bulb burns, particles of tungsten evaporate and are deposited on the inside of the glass envelope in the form of a dark powder. This evaporation eventually inhibits production of the optimum color of light that the bulb was designed to produce. The bulb continues to burn, but the color change makes it unsuitable for color cinematography. The quartz-halogen bulb is able to maintain a stable color output throughout its life because, though the filament evaporates as the household bulb does, it is constantly being regenerated: the evaporated tungsten is never deposited on the inside of the envelope but is instead redeposited onto the filament. Since the filament does not disintegrate rapidly in use, the color output remains constant throughout the bulb's life.

As they are designed to produce specular light when fitted into specific fixtures, quartz-halogen bulbs are always made of clear glass with relatively small filament areas (1-19). Bulbs made for fixtures that spread out the light or provide soft, diffuse illumination are usually tubular in shape (1-20). Coated-, frosted-, and textured-glass bulbs produce an even softer, more diffuse light.

1-19. Quartz bulb for a directable focusing fixture.

1-20. Quartz bulb for a softlight.

How to change a quartz bulb and test it safely. 1-21. Make sure that the fixture is unplugged. Never touch the surface of the bulb with your bare hand: wrap the bulb in paper to prevent contact with the skin. Grease from the hand can cause the bulb to burst when it is first lit. 1-22. When first turning on the bulb, always point the fixture away from people and the set to protect from flying glass in case the bulb bursts.

THE CARBON-ARC BULB

Although the quartz bulb is by far the most commonly used source for illumination on interior-location sets, other types of artificial sources are at times very useful. The *carbon arc* is an intensely bright source of illumination produced by a discharge of electricity between two carbon electrodes, which are either encased in a gas-filled envelope or, for large light sources, enclosed in a metal housing. The carbon-arc lamp is a true point source of light: with the help of condensing lenses and reflectors it transmits a sharp, well-directed illumination that approximates the color balance of daylight. Carbon arcs, however, are generally inconvenient sources of illumination for the location filmmaker. The arc operates best on DC current (not standard household AC current), and the fixtures that they are designed to function within are often heavy and expensive and require frequent attention or servicing while in use.

THE HMI LIGHTING SYSTEM

The *HMI* (*halogen-metal-iodide*) lighting system operates like a tiny arc encased in a quartz envelope. It produces a daylight-colored balanced light and is an extremely efficient source; it puts out at least three times the intensity of illumination that a similarly rated (by wattage) tungsten bulb can produce while generating approximately half the amount of heat. HMI sources operate on standard household current but require special ballast units to help "start" the lamp and maintain steady voltage. At this stage in the development of the HMI source it appears that flickering problems, which were common when these sources were first introduced, have been eliminated. Inconveniences of the HMI light include heavy and expensive ballasts, unstable color temperature as the lights are used, relatively short life spans as compared to tungsten-halogen sources, and long warmup times.

THE TUNGSTEN-FILAMENT BULB

Although ordinary household bulbs with tungsten filaments are inefficient sources of illumination for filmmaking, two special types of tungsten-filament bulbs are useful for location lighting: photo bulbs and photofloods. They are similar in weight and have the same screw-in edison base as ordinary light bulbs but are available in higher wattages and are designed to produce light matched to the color sensitivity of the film.

Photo bulbs closely resemble the shape of ordinary light bulbs and are available inexpensively from photo retailers. There are two types, 250-watt ECA and 500-watt ECT,

both of which produce indoor color-balanced illumination. They often replace household light bulbs in table, overhead, and floor lamps to produce specialized lighting effects. (See the sections on motivated lighting in chapters 3 and 5.)

Photofloods have built-in reflectors, so their illumination is much more directable than that of photo bulbs. In the past photofloods were referred to as movie lights: they were common sources of illumination for the amateur movie-maker of the 60s. Specially designed accessories manufactured for use with these sources now make them attractive for location conditions that call for an extremely light-weight, low-level illumination. The Lowell light system, for example, transforms photofloods into highly efficient, directable, and inexpensive professional lighting fixtures that can be taped to walls or ceilings to light locations impossible to illuminate with conventional fixtures.

REFLECTION AND REFLECTORS

While the bulb is the heart of the location-lighting fixture, reflectors influence the quality of illumination reaching the subject. Before the construction and use of reflectors can be explained, the characteristics of reflection should be clarified.

REFLECTION

Reflection is defined as the redirection of light rays from a surface. Like transmission, reflection can be specular or diffuse. If the angle of a light ray striking an object is exactly equal to the angle from which it is returned from the object, *specular reflection* takes place (1-23). Specular reflections are entirely dependent on their surface reflectors. Mirrors, plate glass, high-gloss paint, still water, polished metal, and perspiring faces are all specular reflectors. These reflectors are specular because their surfaces do not scatter or break up the light rays' parallel emission: they bounce back the reflected light rays at an angle equal to the light incident upon the surface. The shinier and smoother the surface of the subject, the more the chance of specular reflections.

Specularly reflected light has the same qualities as specularly transmitted light. Light reflecting from smooth surfaces is intense, sharp, and well directed. If it strikes a subject, it will cast hard, well-defined, dense shadows. Specular reflections usually make up the highlights or most brightly lit areas of a scene. Specular highlights are generally the same color as the light source incident upon the subject. If the camera happens to be at the angle of reflectance from the subject, it may record a very bright highlight called

glare. Unwanted glare often appears in eyeglasses or interior window reflections that mirror the image of the light source back into the camera.

If light is scattered or broken up by the surface that it strikes, *diffuse reflection* takes place (1-24). Dull, textured, bumpy, or mat surfaces are diffuse reflectors, and they alter the quality of light incident upon them by multiplying the angles of reflection of each of the rays. Diffusely reflected light exhibits a quality of illumination similar to that of diffusely transmitted illumination.

To illustrate the different types of reflection, consider a situation in which a subject is lit by a single bare bulb placed in a socket. If the bulb is placed near a flat, shiny, smooth metal reflector, a person standing a few feet away from the bulb will be illuminated primarily by its direct rays (1-25). The light will be hard and contrasty; the shadows cast will be dark and well defined. Some of the sharp and equally specular reflections from the reflector may strike the subject.

A smooth reflector does not alter the quality of the illumination but does influence the light's direction. Unfortunately, most of the light misses the subject completely, except for rays reflected directly back from the reflector through the bulb itself. The subject in the illustration is very bright; the outlying background region is much darker. He is positioned in what is called the lamp's *hot spot*.

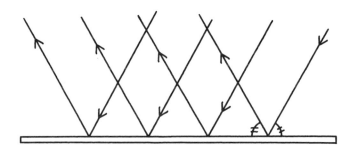

1-23. Specular reflection.

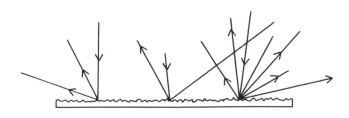

1-24. Diffuse reflection.

If the same clear bulb is used but a textured, dull metal surface is substituted for the shiny reflector (1-26), the specular rays emitted directly from the bulb will still strike the subject but will be combined with softer, scattered light directed toward the subject from the reflector. The surface of a textured reflector alters the quality or character of the light by breaking up and redirecting the rays incident upon it. The light bouncing off the reflector is softer and more diffuse, as it is made up of combinations of rays diffusely transmitted toward the subject from varying angles. The shadows cast by the more diffuse reflector are softer, less dense, and less noticeable than those cast from a subject lit with specular reflection. The surrounding background is also brighter, due to the greater scattering of light by the textured reflector.

All reflectors alter the direction of light incident upon them, but the quality of the light transmitted from the reflector is dependent upon the quality of the illumination that strikes its surface. A specular source directed toward a specular reflector creates a specular reflection. A diffuse source directed toward a specular reflector is still specularly reflected, but, since the light incident upon the reflector is diffuse to start with, the reflection reaching the subject will be much more diffuse than if a more specular source were used with the reflector. It is important, when selecting bulb types, to consider the type of both light source and reflector in terms of the type of reflection desired.

To illustrate this point, consider the illumination that would strike the subject if the "clear" bulb used above were changed to a frosted, more diffuse source (1-27). With this combination few specular rays will reach the subject, and a hot spot created by any direct rays will be virtually eliminated. The more diffuse bulb coupled with the diffuse, textured reflector will produce the softest, flattest light possible. The light will spread over a wide area, and there will be a lack of definite shadows and hot spots.

1-26. A subject lit by both direct illumination and diffuse reflection.

1-25. A subject lit by both direct illumination and specular reflection.

1-27. A subject lit by both diffuse illumination and very diffuse reflection.

REFLECTORS

Reflectors in location-lighting fixtures have several functions. They gather, concentrate, and direct the light from the bulb and modulate its quality and characteristics. Reflectors also influence the spread of light or the narrowness of its focus and have a great effect on the fixture's efficiency in illuminating the subject at any given distance with the greatest possible intensity. Following are some generalizations regarding the characteristics of reflectors used in lightweight location-motion-picture lighting fixtures.

1. The *size* of the reflector determines the *quality* of light. In terms of the size of the light source, the larger the reflector, the more diffuse the light; the smaller the reflector, the sharper and more specular the light.

2. The *shape* of the reflector influences the projection of the light beam and the efficiency of the fixture. The *projection* of the beam concerns the control that the reflector has on the direction of the light and the distance that it can be thrown. (This is called the *throw* of the lamp or fixture.) The *efficiency* concerns the reflector's ability to redirect the maximum amount of light possible from the source toward the subject. In general, *flat* reflectors spread light over a very wide area. Because of their shape they are unable to direct the light and are considered to be inefficient projectors. *Angled* reflectors produce reflections that can be directed to include large areas. They are more efficient in their control of light but do not match the directional or focusing ability of curved reflectors. *Regular-curve* or *spherical* reflectors have good focusing ability, giving off light in a narrow spread. These reflectors are efficient in directing and concentrating the light. *Parabolic* reflectors are extremely efficient and throw a very directable, hard, and concentrated light. They are noted for their long throw.

3. The *texture* of the reflector's surface influences the quality of the light as well as the throw or distance of the beam to be projected. There are four major varieties of textured surfaces. The *smooth-and-polished* reflector is capable of projecting a specular beam in a narrow light spread. It is frequently used for long-throw applications in a spherical-shaped reflector, and it can project high-intensity light great distances. *Dull-and-textured* reflectors produce a softer, more diffuse light. They are often used in angularly shaped reflectors for short-throw applications in which directable light is needed. *Shiny-and-textured* surfaces produce a medium-hard quality of light. They are often placed in a curved reflector, which enables reflection from its surface to be well directed, an ideal combination of qualities if the light is used as a primary source of illumination (the *key light*). When a soft, almost shadowless light is needed, *white-mat* reflector surfaces are invaluable. Their extremely widespread, directionless light produces a flat, diffuse illumination.

LAMP-REFLECTOR POSITION

The position of a bulb used as a source of light in relation to the reflector position is a factor that affects the projection and efficiency of the illumination produced. The reflector is sometimes fixed within the lamp housing; in other fixtures either the reflector or the lamp is moved (*focused*) between the apex of the reflector and the open end so that the projection and efficiency of the light can be changed. For instance, consider a light with an adjustable lamp and an open face. Placing the bulb close to the reflector causes specular illumination; the fixture is now a *spotlight*. Placing it further away from the reflector creates more diffuse light: the fixture is now acting as a *floodlight*.

ARTIFICIAL-LIGHT FIXTURES

The types of lighting fixtures used by location filmmakers can best be divided into categories indicative of the size of the area that the fixtures cover. There are traditionally two categories, spot and flood, but a third type, the focusing spot, a fixture that can serve as both a flood and a spot, has been developed.

VARIABLE SPOT-FLOOD OR FOCUSING SPOT

One of the most commonly used and versatile lighting units is the *variable spot-flood* or *focusing spot*. It is often selected to function as the primary source of illumination for a location set (1-28). This fixture is capable of changing its area of illumination from a narrow, concentrated spot to a wider, less intense spread. As mentioned before, this is achieved by moving either the bulb or the reflector within the lighting fixture.

The angle of coverage is altered by a focusing knob on the fixture, usually marked with the words "spot" and "flood" at its focusing limits. Turning the knob to the spot position concentrates the intensity of the beam to light a limited area, producing a medium-hard quality of illumination capable of being projected over a large distance. In this position the fixture is said to be *focused in* and is working at its maximum efficiency. The quality of the shadows cast from a subject lit by a focused beam are sharply defined and very dark in appearance; specular illumination capable

1-28

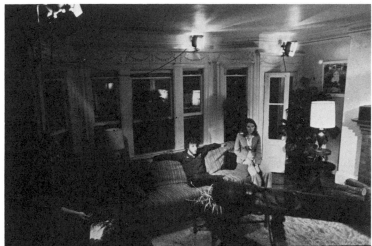

1-30

1-29

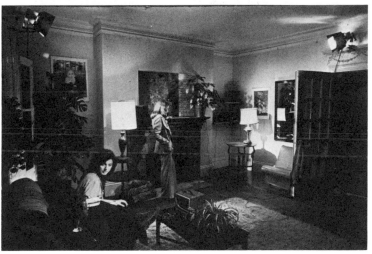

1-31

Long shot/mechanic sequence/low key. 1-28. Focusing spots used as key lights for an interior long-shot sequence. 1-29. Focusing spots clamped to ceiling-height moldings light the subject to 250 foot-candles. 1-30. Barndoors on the lights are narrowed in a vertical position to limit the spread of illumination. The white walls are lit to 64 footcandles. 1-31. Cross keys striking the standing subject produce a motivating effect from the practicals. 1-32. Lighting diagram: no traditional fill-light fixtures are used. The fill illumination is produced by bouncing the practical's light off the white ceiling and walls.

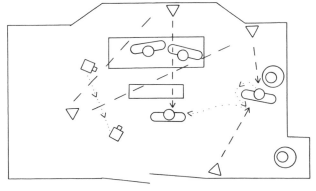

1-32

of creating great lighting contrast is produced. When the focusing knob is turned to the flood position, the fixture is *focused out*: the light is broken up and redirected to spread evenly over an expanded area. In this position the illumination reaching the subject is less intense and softer in quality than that produced by the focused-in fixture. A flooded focusing spot produces less lighting contrast and

1-34

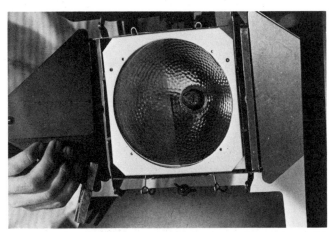

1-35

1-33

Versatile features of focusing spots. 1-33. Four-leaf barndoors on a focusing spot. 1-34. Bulb sizes. 1-35. A half scrim and a soft reflector installed in a fixture. 1-36. Mirror reflectors being installed.

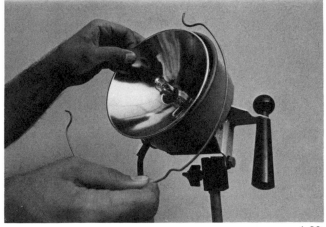

1-36

less distinct shadows on and behind the subject being lit.

Besides the convenience of being able to change the area of coverage the variable-focus potential has other uses. Focusing to the spot position, when setting lights on a large interior, aids the filmmaker in directing the light: the fixture can be spotted to see what the center of illumination is, then flooded back to the desired level of illumination. It can also be used to give a certain level of intensity: focusing in or out raises or lowers the intensity of the light, allowing the filmmaker, within limits, to reach a certain footcandle level.

The manufacturers of variable spots have added many features that increase their versatility. The spread of the beam can be controlled with large, opaque light shields called *barndoors.* Usually used in two- or four-door attachments, they can be rotated fully around the front of the lamp, allowing great flexibility in limiting the throw of illumination. Bulbs used in this fixture are available in different wattages (intensities) and can be adapted to varying conditions and electrical requirements. The units are lightweight, easily mountable, and portable. Most units accept *full* and *half scrims,* accessories used for intensity control of the beam of light. Some fixtures have replaceable reflectors for even more diversity of lighting quality. For instance, a smooth, mirrored reflector, which gives a long, hard throw of light, can be replaced with a pebbled reflector, which gives a more diffuse illumination.

When using focusable spots, the filmmaker must keep several facts in mind. The spread of the beam is usually most even and efficient at *one* bulb or reflector position. Moreover, some fixtures are constructed so that the light that they produce is not even over their entire throw. Care must be taken not to place the light so that the subject is positioned in a dead spot of light. Again, fixtures with movable bulbs are less efficient in prolonging bulb life than those that require movement of the reflector. Finally, the comments above concerning the relative positions of lamp and reflector and their relationship to the type of illumination produced apply only to fixtures with open faces and not to those with Fresnel lenses.

SPOTS

Although the versatility of the focusing spot enables it to produce a somewhat narrow spread of light, there are numerous lighting situations in which a longer-throw, intensely bright specular light is needed. *Spotlights,* more commonly called *spots,* are used for this purpose. They cover a relatively narrow angle, which cannot be changed, as with the focusing spot. The sources of light for most lightweight location spots are specifically designed *sealed-beam* lamps, usually coded as *PAR* or *FAY* globes.

Sealed-beam globes are similar in style and appearance to automobile headlights. They are an extremely efficient tungsten-halogen source and are usually built with a combination of reflector and condensing lens. The globes are available in both long- and medium-throw types. The lamps are fitted into lightweight metal fixtures so that they may be supported and directed. The globes are fixed-focus, but *intensifiers* (smooth reflector-cone attachments) are available that, when mounted onto the fixtures, produce an even, more specular beam. These fixtures may not be used as often as a focusing spot but are invaluable for special lighting situations.

For example, lightweight sealed-beam PAR lamps fitted into metal location fixtures are commonly used as punch lights for interiors. A *punch light* is a fixture with an extremely long throw that is used to add specular highlights to a scene. A PAR spot may be used to light a back wall of a set from the camera position or to add a special highlight effect to an interior scene. The spots may also be used at night if a harsh, specular illumination is needed for the key light, giving the scene a feeling of reality. Because of their long throw and high-intensity capabilities sealed-beam spots are also used as a supplemental source in daylight filming.

Certain types of FAY lamps have special dichroic filters built into the envelope of the reflector bulbs. They produce daylight-colored illumination that may be used to lighten deep shadows created by harsh and contrasty sunlight (1-37). Daylight-balanced FAYs are often mounted in groups of four or six on a large, square metal fixture, with variable-intensity control available by switching each globe on or off independently as needed.

When FAY lights are used indoors as key-light sources, their intense, specular illumination closely resembles the character and quality of natural sunlight. They can thus be positioned to light large areas directly with great intensity. If the intensity and color of the illumination produced by the FAYs is correct but the specular and directional characteristics of their illumination is not needed, the quality of the illumination may be altered by bouncing the light onto the set. This is done by pointing the fixture toward a diffuse, neutrally colored surface that scatters and breaks up the specular light falling upon it and returns a softer, more diffuse illumination to the set. White ceilings, walls, or cards are great surfaces to use for bouncing light.

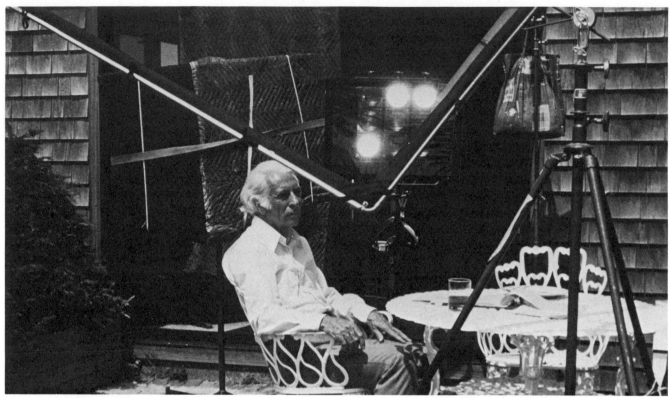

1-37

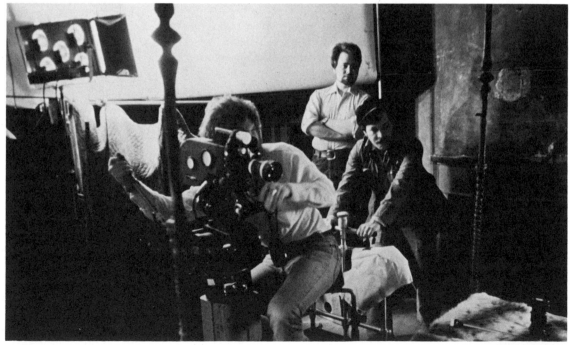

1-38

Some studio and heavy location-lighting equipment designed as a spot or focusing spot has condensing lenses built into the housing to concentrate and control the lighting even further. These lenses are called *Fresnel lenses* (1-40). Fitted into a location-lighting fixture, this condensing lens provides an amazingly even field of illumination over the entire spread of the spot. By making the light rays passing through the lens more or less parallel the Fresnel lens helps minimize light falloff. Unfortunately, this lens drastically increases the bulk and weight of location-light fixtures, so the evenness of illumination created by the lens is usually sacrificed to the portability and compactness of fixtures without it.

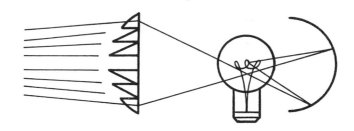

1-40. Parallel beam created by a fresnel lens.

Spotlights. 1-37. Spotlight PAR lamp fixture used outdoors. (Photo courtesy of B. J. Nelson.) 1-38. Spotlight bounced off a white surface is used to light the scene. (Photo courtesy of Francesca Morgante.) 1-39. Spotlight through a window produces a specular sunlit-interior effect. (Photo courtesy of Francesca Morgante.)

1-39

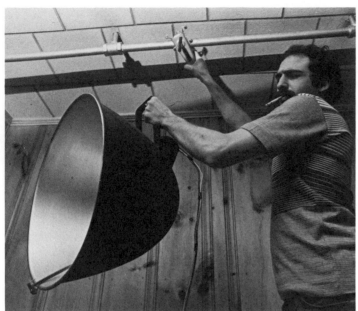

1-41

FLOODS

Floodlights, traditionally defined, are fixtures capable of producing diffuse light that spreads evenly over a large area. Floodlight fixtures offer varying degrees of illumination quality, light directability, size of area over which the light is spread, and effective distance over which the fixture can project the light. Floods may be used either as key lights, the primary source of illumination, or as secondary sources of illumination, called *fill lights*. There are three types of floodlights that need to be considered: scoops, softlights, and broad lights.

Scoops

Very large reflector floods are often used in the studio but seldom on tight locations. Called *scoops*, these fixtures consist of a single-bulb source positioned within a large,

Floodlights. 1-41. Scoop being rigged on a set. 1-42. Softlight in use on a set. 1-43. Broad-light detail with clear bulb. 1-44. Broad light with adjustable reflectors and a frosted bulb: Tota-lite detail.

1-42

usually regularly but sometimes irregularly curved, textured metal reflector that ends in a circular opening in the front. They produce an excellent softlight that functions well as a general fill, but they can cause problems on the location set because their diffuse, widespread illumination is difficult to control and because of their large size and weight. If large interiors are involved, however, scoops are valuable lighting fixtures, for they have a longer throw than most other types of floodlights.

Softlights

The *softlight* is by far the most versatile and popular floodlight used for location filming. It is a self-contained bounce-light source with a rectangular front opening, a large, curved reflector, and a single or multiple light source. The unit is designed to direct the illumination from the light source into the large reflector, whose mat or textured

1-43

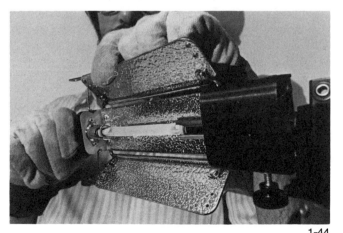

1-44

surface scatters the rays, diffuses the illumination and projects the soft spread of indirect light toward the subject.

The quality of the illumination emitted from a softlight is considerably more diffuse than that produced by a scoop and spreads over a much wider area. Since the bounce light is scattered by the fixture, the illumination from the softlight often wraps around a subject, cancelling out any noticeable shadows either on or directly behind the subject. This effect has led to the popular misconception that a softlight's illumination is "shadowless." It is true that softlights generally produce much less defined and less dense shadows than do scoops, but the shadow production of a light source is dependent upon the proximity of the source to the subject as well as upon the quality of the illumination produced by the fixture. If the subject is close enough to the softlight, no shadow will be noticed. (See the section on lamp and subject distance below for a more complete discussion of this topic.)

The degree of diffusion of the light produced by the softlight is influenced by the reflector that breaks up the light and by the quality of the illumination produced by the source. Reflectors are commonly available in both a mat-white and a dull-textured metal finish. The mat-white surface diffuses light more than the metal reflector, but the textured-metal finish projects the illumination further into the set. Two kinds of bulbs are available for most softlights: *clear* and *frosted*. The frosting on the envelope of the bulb acts as a diffuser of the illumination before it reaches the reflector, and a frosted bulb used in combination with a mat reflector emits the most diffuse light possible.

The versatility of the softlight is emphasized by the fact that it can be used for location filming as either a key (1-8) or a fill (1-13). As a fill light it is often placed on a stand or hung above the set to provide an almost shadowless source of base illumination. Used as a key light, the softlight can give a wonderful soft illumination to a subject, a look that has become especially popular recently.

Broad Lights

The *broad light* is a portable flood fixture consisting of a tubular quartz bulb and a shallow metal reflector in a small, rectangular housing (1-43, 1-44). The illumination produced is spread evenly over the subject, as with a flood, but is not very diffuse: the shadows cast are often as contrasty and as well defined as those produced by a spot. Properly used, however, the broad light can perform well as either a key or a fill.

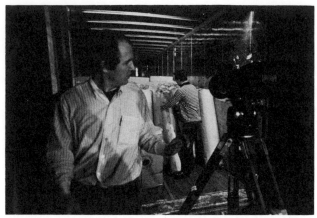

1-45

1-46

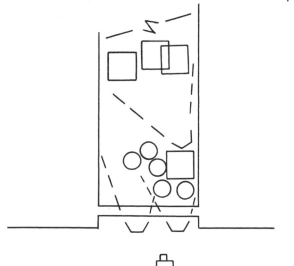

1-47

In order to provide an efficient source of illumination, a broad light used as a key generally must be located close to the subject or set being lit (1-45). In this way it can be used to light an entire wall or background of an interior. When key lighting large areas with broad light, the filmmaker should be careful to watch the shadows produced and should realize that, because of its short throw, wide spread, and lack of beam control due to the rigid barndoors usually attached to many broad lights, problems may sometimes result. As a key this fixture is often improperly used instead of a good focusing spot. The tendency to direct several broad lights to light a large area evenly can result in multiple shadows cast by the light's overlapping areas of coverage. When fill lighting with broad light, the fixture may have to be diffused heavily before an effectively soft spread of light can be achieved. It is often better to bounce the broad light onto the set to break up and diffuse its quality in order to produce an ambient, soft base of illumination.

One excellent use of broad lights is to recreate diffuse sunlight coming through windows. By placing several fixtures behind heavy diffusion material mounted on the location's windows and throwing the light onto the set, the broad throw, combined with the intensity of the illumination (the lights can be placed very close to the diffusion material), gives a bright yet diffuse light that looks much like diffuse sunlight.

All floodlights, whether scoops, softlights, or broad lights, must exhibit different characteristics when used as fills rather than as keys. Although all floods produce diffuse illumination, fill-light floods should illuminate the subject with more diffuse light than should keys. This is important if the fill is to lighten shadows created by the other lights, to control the lighting contrast of the scene, and to raise the general level of illumination of the set *without* creating significantly noticeable shadows on or behind the subject.

Long shot/truck interior/high key. 1-45. Broad lights used as keys illuminate a truck interior. The lights are rigged from a position above the camera. 1-46. One broad-light key is clamped to the rear of the open truck doors, while another, hidden by boxes, is attached to a stand inside the truck. 1-47. Lighting diagram: multiple shadows are unavoidable but are not distracting, because they fall onto textured packaging material.

OTHER ILLUMINATION CONSIDERATIONS
SHADOW PRODUCTION

In addition to the standard considerations of light spread, intensity, quality, and control the quality and the density of the shadows produced both on and behind a subject by the lighting fixture need to be considered when choosing a specific type of lighting unit to illuminate an interior. The shadow production of a light is of particular interest to the location filmmaker: he must often minimize noticeable or multiple shadows that can be distracting and unrealistic.

It has already been pointed out that each of the various types of lighting units generally produces particular qualities of shadows, depending upon the quality of the illumination projected by the fixture. It is true that shadows of subjects lit by specular sources are contrastier, more defined, and denser than those produced by more diffuse illumination, for example. It is important to realize, however, that shadow production is not a result of the quality of the illumination alone but is also influenced by the proximity of the subject to the source and by the distance between the subject and the background.

Although the effects vary among specific fixtures within different categories, some generalizations can be made regarding the shadow-production differences between a typical focusing spot and a softlight. As a subject moves toward a focusing spot, it is likely that he will be illuminated by the more parallel rays of light coming from the center of the fixture. This tends to increase the contrast of the shadows cast on the subject (a nose shadow, for example) compared to that created when the subject is located at a distance from the source and is lit by a mixture of both specular and diffuse rays. The opposite is true of a subject moving closer to a softlight: he or she will be illuminated by the more diffuse rays bounced off the large reflector. This tends to further decrease the contrast and density of the shadows cast on the subject.

As a subject moves in toward *any* light source, the shadows cast behind the subject will be more diffuse than those cast by a subject further away from a source (1-48). With a specular fixture this is caused by the diffraction of the light rays bending around the sharp outline of the subject (1-49). With a diffused source of light this also occurs because of the illumination's tendency to decrease in intensity as it moves further away from the source.

1-48. Shadow production on the back wall of the set as a subject moves closer to a light source.

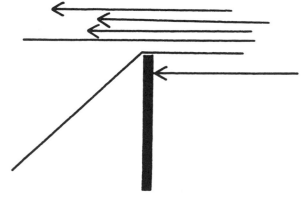

1-49. Diffraction of light.

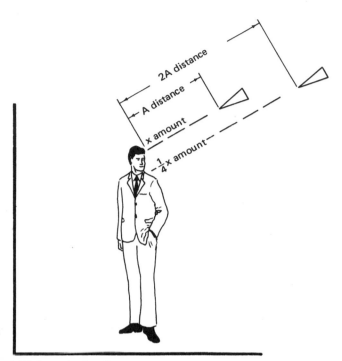

1-50. Intensity falloff as the light is moved twice as far from the subject.

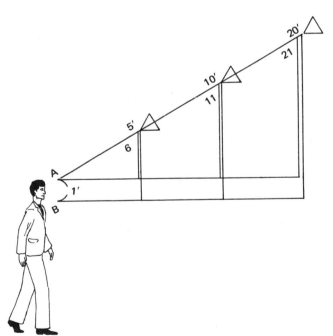

1-51. Intensity falloff between two points 1' away from each other on a subject at various lamp distances.

LIGHT-INTENSITY FALLOFF

Besides affecting the quality of light and the shadow-casting ability of the source, close lighting of a subject creates an excessive light-intensity *falloff* inversely proportional to the square of its distance ($lif = 1/d^2$). This means that moving a lighting fixture twice a distance away from the subject will cause the illumination to decrease not to one-half but actually to one-fourth (1-50). This problem is further increased by the fact that a fixture may, because of its construction, cause even more light to be "lost." It is important, when lighting a small set, to keep the lights as far away as possible from the actors.

The drawing illustrates a subject lit by similar sources placed at varying distances from the subject. Take two points on a subject 1' apart—e.g., the top of the head and the shoulders. Using the formula for light falloff, compute lamp distances of 5' and 6', 10' and 11', and 20' and 21'. When the key light is placed 5' away from the subject's head (6' away from his shoulders), the light reaching the shoulders is only 69% as intense as the light reaching the top of the head. This difference may not be seen when setting the lights but will be quite noticeable on film.

When the key is moved 10' away from the subject, the falloff between the two points is decreased by 13%. When the key is moved 20' away, 90% of the light reaching the head of the subject will reach the shoulders. The greater the distance between the key and the subject, the more even the illumination across the length of the subject. This is one reason why studios keep all their lights high overhead the set.

Intensity falloff varies from fixture to fixture as well. Falloff from floods and softlights is much greater than from spots, for spotlights are controlled and focused to radiate a narrow beam consisting of parallel rays of specular light. Floods and softlights, on the other hand, spread diffuse rays over a much larger area and have a greater tendency toward intensity falloff. The classic example of light falloff (or lack of it) from a specular source is the sun. Because of its great distance from the earth almost all its light rays are parallel. Because of the fact that falloff is minimized by a specular source with parallel rays and by great distances between subject and illumination, the sun exhibits almost no intensity falloff. This can be shown by taking a light reading from the top of a tall building and again at the street level. The light-intensity readings should be very close.

SURFACE TEXTURE

Texture is normally associated with touch or feeling, but its visual appearance is greatly influenced by the direction from which a light strikes an object as well as by the type or quality of illumination itself.

Spotlight is contrasty light; it creates sharp, crisp shadows and bright highlights that can accentuate the visual appearance of an object's texture. The degree to which it is noticeable, however, depends upon the angle of incidence of the light rays. For example, spotlight skimming across an object at a tangent produces a textured appearance in a rough-surfaced object (1-52). The raised sections are highlighted by the light's specular rays, while the indented portions remain dark and in shadow. This contrast within the surface of the object created by a well-directed light is responsible for the textured appearance. As the angle of incidence is changed to strike the object more obliquely, the appearance of the surface is altered. Light striking the surface from a perpendicular angle will produce no shadows. The raised and indented portions of the object will be equally lit: there will be no lighting contrast, no dense areas and bright highlights (1-53). The flatly lit object will have little texture, depth, or perspective.

Some light sources, especially large softlights and some floods, are unable to bring out the texture of objects regardless of the angle from which they light the surfaces. Light from these diffuse illuminators produces no bright highlights and tends to fill in shadows when directed toward a roughly textured object. This flat, directionless light will never produce the appearance of surface texture. Even when placed at a tangent to a surface, the scattered nature of the light will fill in indentations and produce a flat-looking, shadowless object (1-54).

COLOR-RENDERING CHARACTERISTICS

Most surfaces selectively reflect and absorb different wavelengths of light (colors), the exact wavelengths absorbed and reflected determining the color of the object. If an object reflects equal amounts of all wavelengths, its color will most likely appear to be white, for white light is made up of all the visible colors. If an object absorbs almost all visible light, it will look black or dark. A red object reflects red light and absorbs the other colors. Likewise, a blue object reflects blue and absorbs the others.

Most objects have what might be thought of as two types of reflections: one on the surface, which defines the texture of the object, and one from within the "body" of the object itself, which represents the color that the object appears to be. The appearance of color is influenced by the quality of light illuminating the object: spots and floods, for example, render colors differently.

1-53. Specular light deemphasizing surface texture.

1-52. Specular light emphasizing surface texture.

1-54. The inability of diffuse light to emphasize surface texture.

In the drawing the spot illuminating the red vinyl wall is a white light made up of three primary colors: red, green, and blue. The green and blue wavelengths of the illumination are absorbed by the body of the object, and the color red is reflected from multiple angles in *all directions*, regardless of the direction of the incident light.

Since the spot's illumination is made up of fairly parallel rays, only one specular reflection is produced at an angle equal to the angle of incidence of the light. From this position (marked B in the drawing) the viewer sees only the white glare from the spotlight, as the intense reflection overpowers the weaker "red-colored" reflections also

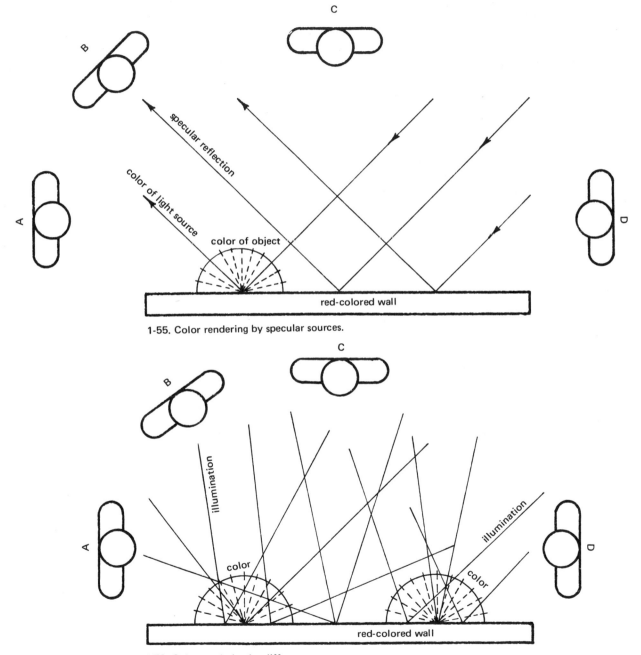

1-55. Color rendering by specular sources.

1-56. Color rendering by diffuse sources.

emanating from the surface. But by moving to positions A, C, or D or to any position other than the angle of reflection of the specular source, the viewer will see the red color reflecting from the surface without the interference of glare. The color will be bright, vivid, and undiluted by the white light of the source: the full color of the object will come through. These undiluted colors are said to be *saturated*.

When the source of illumination is switched to a soft floodlight (1-56), the same reflection that produces the "color" of the object will be produced. The blue and green are absorbed, and the red is reflected in all directions. But the scattered, diffuse white light striking the object from many angles is also reflected back in *all directions*. This creates a mixture of white and red light when viewed from *any* angle. The white light from the flood does not overpower the "colored" reflections, but it does dilute the red, making it appear pale and washed out. The color mixed with the white light from the source is *desaturated*.

It is easy to see why softlights tend to desaturate colors and to flatten the color contrasts of a scene as well as the perspective of the subject. Reflections from a surface illuminated by a softlight contain a mixture of the color of the object plus the color of the light source. This desaturated mixture is reflected equally in all directions, reducing the contrasts of all the colors on a set. Spots, on the other hand, create strong color contrast and produce vivid, sharp, undiluted, saturated colors. The color of the spot mixes and is reflected from the object from only one angle. This specular reflection appears to be the same color as the light source but is only visible from an angle equal to the angle of incidence. Light reflecting from the object, viewed from any other angle, will not be diluted with the color of the light source, and these reflections will contain only the vivid, saturated colors of the object itself. But, of course, the filmmaker must be careful of the glare that may appear when using a spotlight, especially when the surface texture of the subject is smooth, flat, and shiny.

ACCESSORIES

Accessories that are commonly used in lighting a location set can be divided into two groups: devices that are placed on the lighting fixture to control the illumination and devices designed to control the quality, color, or spread of the light after it leaves the fixture and before it reaches the set. (This latter group is sometimes referred to as *grip equipment* and also includes stands and other devices needed to attach, hold, or otherwise position a fixture or piece of lighting equipment.) A description of selected accessories is outlined below. It is a basic listing of the items most useful to location filmmakers who light the majority of their locations from stand-mounted fixtures. (For a description of items used for attaching and placing fixtures on a location, see chapter 6. For a more precise description of specific accessories available, consult equipment manufacturers' catalogs and brochures.)

1. Attached directly to a lighting unit, *lightshields* or *barndoors* restrict the area of coverage of the light beam. The most valuable accessory used in location lighting, barndoors are commonly produced in either two- or four-door configurations. The most versatile barndoors are not rigidly affixed to the light unit but are able to rotate a full 360° around the opening of the light fixture.

2. *Flags* are rectangularly shaped metal frames on which are stretched various types of light-control materials; they are positioned between the source and the subject to influence or control the lighting on a set. Frames stretched with diffusion material are called *silks*; frames covered with thinly knit fabric and used as scrims are called *nets* or *screens*. They are available commercially in sizes ranging from 12" X 18" to 24" X 72". Frames smaller in size but similar in function to flags are called *cutters*. The flag, covered with a black opaque cloth, acts as an off-the-fixture barndoor when placed between the fixture and the subject: it controls, with a rather sharp line of delineation, the final spread of the illumination.

3. *Snoots* are used to confine and narrow the light produced by spots and focusing spots even further. They are cylindrically shaped, and they secure directly to a fixture or its filter frame. With a variety of shapes and sizes available for producing a number of effects, snoots most often produce round-shaped areas of lighting coverage.

4. Sometimes called *gauze*, *diffusion material* is used to soften and scatter the light from any source, altering the quality of any light passing through it by producing a less intense, flatter light with weaker, less noticeable shadows. Many types of diffusion material are available for varying qualities of diffusion. Most are purchased in rolls or sheets.

5. *Scrims* are used to lessen the intensity of a fixture's output without changing the wattage of the bulb, moving the fixture, or altering the focus of the lamp. They are constructed of wire-mesh screens and attached to the

barndoors surrounding the light or to the fixture itself. There are two types of scrims: *full* scrims, which cover the entire opening of the lamp, and *half* scrims, which cover only half the lamp opening. Full scrims are available in various *densities*, the two most common of which are single and double. *Single* scrims decrease the light output by a factor of two, while *double* scrims reduce the illumination by a factor of four. The half scrim is especially useful in balancing the luminous intensity in different areas of a set and in controlling intensity falloff, topics discussed in chapters 3, 4, and 5.

6. *Dots* are small, round wire circles stretched with either opaque material, diffusion material, wire scrims, or nets. They serve a similar function to flags, but their small, circular size also makes them useful in filtering or diffusing small areas of illumination reaching the subject—hot spots, for example.

7. *Butterflies* or *overheads* are large aluminum frames over which a variety of lighting-control materials may be stretched. Commonly 5' to 12' in size, they are stretched with diffusion material and are used on exteriors to soften existing sunlight falling on a set to be shot in medium or closeup range.

8. A *cookie* is an object with a cutout pattern that is used to produce a patterned shadow when placed between a light and the subject. Positioned and rigged like a flag, cookies are used in conjunction with the background light to add interest or depth to a plain back wall.

9. The purpose of a *stand* is to hold fixtures and lighting accessories. Available in many sizes, weights, and styles of construction, a good location stand should extend to at least 10', have a $\frac{5}{8}$" stud on its tip to hold fixtures safely, and be easily portable. The sturdiest stands are made of a heavy metal, such as steel. Unfortunately, these are also the most troublesome to transport and often the most expensive. Convenience, expense, and portability are all factors that should be considered and matched to the specific needs of the filmmaker. Stands with wheels or casters are a useful convenience for readjusting the lighting on a large location. Often, though, the added expense and weight plus the increased need for sandbags are disadvantages.

10. *Risers* are vertical extensions for floor stands, used to increase their working height.

11. *Double* and *triple heads* are metal yokes that attach to a floor stand, enabling more than one light to be rigged to the stand.

12. *Gobo heads* and *arms* are adjustable horizontals that attach to the tip of a vertical floor stand. Gobos are generally used to hold and position light-control equipment but may also be used to support unstretched diffusion or filter material hung in front of a light.

13. *Sandbags* are nothing more than bags filled with 15 to 25 pounds of sand. Used for weighting down light stands and props, saddle-type bags have handles for ease in carrying and positioning. Sandbags for use around motion-picture equipment must not leak: getting sand in expensive and delicate motion-picture equipment is disastrous.

14. *Photographic umbrellas* are large, lightweight umbrellas made of textured silver fabric. They are used to provide illumination similar in appearance to that produced by a softlight. When mounted on a stand with two or three focusing spots pointed toward the fabric, the light bounced onto the set is soft and shadowless. It is also fairly uncontrollable and inefficient, however, and the umbrella, when unfolded to working position, takes up a lot of space. When folded, it is quite small and portable; it is inexpensive, simple to store, and easy to transport; and it expands the usefulness of a focusing spot or broad-light fixture.

15. *Bounce cards* are white mat-surfaced reflectors used to redirect illumination from one area of a set into another without the use of additional lighting fixtures. Good bounce-card materials include white poster board and foamcore. Poster board is much less stiff than the $\frac{1}{4}$" white Styrofoam foamcore sheets but is more difficult to position accurately. Both can be purchased at art-supply stores in large sheets and then cut to size. Bounce cards are generally used close to the subject (since their diffuse light falls off quickly) and are held in place by gobo arms on stands.

16. *Reflector boards* function similarly to bounce cards but differ in that they are specular reflector surfaces that are generally used to redirect light from the sun on exterior sets. Various types of silvered surfaces are commercially available for this purpose. Complete units made up of a reflective surface, mounting board, and specially designed stand are also available.

2. Exposure and Light-metering Techniques

EXPOSURE

The fundamentals of photography and cinematography are based on the ability of light to cause chemical changes in certain substances. Called the *actinic property* of light, this phenomenon can cause the recording of images on an emulsion, such as the silver halides in a film stock, creating an exposure and an image. If the correct amount of light strikes the film, a proper exposure will occur, and, when processed, the product will be the image of the original subject. In photography *exposure* is the product of the intensity of the light multiplied by the length of time that the film is exposed; or, expressed as a mathematical formula, $e = i \times t$.

INTENSITY

Intensity or *luminous intensity* refers to the capability of a source to produce more or less light. Measured quantitatively, the standard is the *footcandle*, first defined as the incident illumination on a surface 1' away from the point source of a standard candle. More simply, a standard footcandle is the intensity of light measured 1' away from the candle itself. The intensity of the light measured 1' away from two burning candles is called two footcandles, and so on. The exactness of the standard wax candle is questionable, so, for the sake of precision, a standard source of light, called a *candela*, that closely approximates the intensity of a candle was invented. But the term "footcandle" ("candlemeter" or "lux" in the metric system) is still used to describe illumination and luminous intensity regardless of the type of source—whether the standard wax candle or the scientific candela. In practice the luminous intensity of a source is but one factor that affects the total amount of illumination reaching the set, and other factors influencing the illumination of a subject must be considered.

Bulb Wattage

As previously mentioned, all bulbs are rated by the quantity of electrical units (power) or *wattage* consumed. The higher the wattage, generally, the greater the intensity of the illumination. Bulbs are also rated in *candlepower*, which is a more precise term for describing the intensity that a source is capable of producing, since it refers directly to luminous intensity. Most filmmakers, unfortunately, are more accustomed to dealing with wattage than with candlepower in everyday filmic applications, but this is satisfactory within certain limitations. It is safe to use the wattage of a source as a reference to measure the intensity of one source compared to that of another, but it may be used only to compare the light output of bulbs of similar construction.

For example, a 250-watt tungsten-halogen bulb will put out half the intensity of a 500-watt tungsten-halogen bulb. But HMI sources can potentially put out three times the intensity of similarly wattage-rated halogen bulbs; a 250-watt HMI source can put out a luminous intensity equivalent to a 750-watt tungsten-halogen bulb.

It is important to remember that the use of wattage to compare the potential intensity production of two similar sources is a valid criterion only if the bulbs under consideration function in fixtures of the same type and design. For example, at a given distance a subject illuminated by a 1000-watt halogen bulb housed in a broad-light fixture may receive two times the intensity of illumination produced by the same bulb placed in a softlight fixture. This is due partly to the efficiency of the fixture design in collecting, condensing, and projecting light and partly to the type of reflector used within the unit.

The Reflector

The bulb is dependent on the *reflector* for the maximum luminous intensity that actually reaches the subject. The reflector is often responsible for what is called the *efficiency* of the lighting unit. In this case the efficiency refers to the reflector's capacity to gather and project the light from the bulb in such a way as to illuminate the subject with the greatest intensity possible with the wattage being used. Although efficiency of fixtures is not necessarily the primary criterion for the selection of lighting units, the location filmmaker needs to consider it carefully when planning the exposure illumination necessary, the quality of light desired, and the electrical potential of the location.

The reflectors of most focusing spots provide an efficient means of lighting a set. When used to light the action directly, they will produce the greatest amount of intensity with the least amount of electrical potential. These reflectors are extremely efficient but produce a specular illumination. If a softer quality of illumination is desired, a fixture with a more diffuse reflector may need to be chosen. Reflectors in these fixtures (a softlight, for example) are less efficient, for they provide less usable illumination per watt than more specular reflectors.

When the electrical potential of a location is limited, the efficiency of a lighting system often supercedes illumination quality. This is more often the case with industrial and business films shot on location than with dramatic films. For example, if the filmmaker wants to illuminate a set to an intensity level of 125 footcandles, it may take 3000 watts of light bounced from a white ceiling (the reflector in

this case), 1500 watts of illumination from a softlight, or only 1000 watts of direct illumination from a focusing spot to produce an equal amount of illumination.

Another factor that influences the amount of luminous intensity that reaches a subject is the focus position of the reflector. For example, a 1000-watt bulb in a focusing fixture may produce 500 footcandles when aimed directly at a subject. When the reflector is focused, the beams are parallel and concentrated on the subject: the light's intensity is greatest. The same fixture, when flooded out, may only produce 64 footcandles, for the light rays from the bulb spread and radiate over a larger area. (For a more extensive discussion of this topic, see the section on light falloff in this chapter.)

Diffusion and Filtration Materials

Both diffusion materials and light filters, when placed between the source and the subject, are likely to affect the luminous intensity reaching the subject. How diffusion material interferes with the transmission of light has been mentioned previously: the amount of light absorbed by the material directly affects the luminous intensity available to light the subject. This absorption varies with the density of the materials available and the actual degree of diffusion that they produce, but they generally reduce the intensity of the light reaching the subject 25% or 50%.

Light filters reduce the intensity of the light reaching the set in varying degrees, expressed as *filter factors*. Light filters alter the color of the illumination produced by a source and absorb specific colors of the source while transmitting others. By absorbing specific colors the filter reduces the illumination available for exposure by restricting the amount of luminous intensity produced by the reflector-and-bulb combination that reaches the set. (See chapter 7 for a discussion of the actual effects of color filters.)

LIGHT FALLOFF

In chapter 1 the importance of even illumination was stressed in the discussion of *light falloff*, which places primary emphasis on the *distance* of the source from the subject. But certain questions regarding the intensity of the illumination that reaches a set or subject as the light is moved closer to or further away from it must be answered if light falloff is to be understood fully. What happens to the light to make it less intense when directed to a distant subject as opposed to a nearby one? Does the light actually fall off or drop out? Is it absorbed or dispersed when projected over short distances? And why does the intensity illuminating the subjects lessen as they move further away from the light sources?

The term "falloff" is a deceptive one: light itself does not "fall off" with distance. It rather travels in straight lines and continues to do so until altered or interfered with. As light radiates from a source, the relative distance between each ray increases (like the spokes of a wheel). As a point source emits light, the radiating illumination traveling in these straight lines *spreads out* to illuminate larger areas as the source is moved further away from the subject. This spreading out over a larger area is responsible for the intensity dropoff. Light does not disappear, nor is it absorbed or dispersed. It simply spreads out as it travels away from its source.

To understand this more fully, consider a hypothetical point source that produces only six rays of light (2-1). A subject placed a few feet away from the source may be illuminated by four of the rays. Moving further away from the source, the same subject may receive only two of the six beams. The more distant subject appears to be much more dimly lit than the nearer one. While it is true that intensity decreases in inverse proportion to the square of the distance, the light rays do not, nor do they become less intense as the subject moves further away from the source: they simply spread out to illuminate a larger area.

2-1. Intensity falloff due to the decreasing number of light rays that strike a subject as it is moved away from the source.

Two imaginary planes of differing size placed at two distances prove this fact (2-2). Both planes A and B receive all six of the rays. Each of the rays lights each of the points on the planes with the same intensity. But the illumination striking plane A is concentrated, while the same illumination, reaching plane B, is more spread out. The larger plane B, although lit by the same source as the smaller plane A, has less intensity falling upon it per unit area of its surface. It is this decrease in intensity, caused by the size of the area being illuminated, that is calculated by the $i = 1/d^2$ formula, provided that the illuminator is a point source.

One can also assume that, if a light source had perfectly parallel rays, its illumination would not be so controlled by the distance and area variables. The intensity would remain constant, regardless of distance, for the parallel rays would not spread out to light larger areas as they traveled away from the source. A good example of this is the sun. Since the sun, a point source, is so far away from the earth, the light rays that do strike the earth are very nearly parallel and do not appreciably fall off in intensity across any measurable distance.

The falloff principle of light theoretically applies particularly to point sources illuminating flat planes perpendicular to the source. But few point sources exist in location lighting.

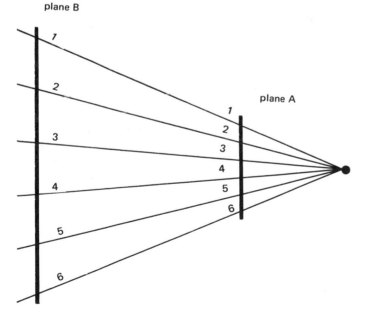

plane B

plane A

2-2. Intensity falloff due to the spread of light rays over a larger area as they travel away from the source.

The fact that most fixtures used are encased in housings with reflectors that condense and project light also discounts the ability of the falloff formula to calculate precise amounts of falloff. (The falloff formula works only with a point source.) But the principle of intensity falloff can be related to the efficiency of a fixture in producing usable exposure intensity for a subject.

For example, since specular illumination is made up of light rays that are more closely parallel than those of diffuse illumination, the intensity of the light produced by a specular reflector-bulb combination minimizes the falloff of the illumination as it is projected away from a source. Efficient sources have the potential of producing more luminous intensity because their light does not spread as much as diffuse light does. The reflector-bulb combination of an efficient specular source concentrates the beam and, by making its rays more parallel, is able to project the illumination over a great distance, providing the set with the maximum amount of luminous intensity with a minimum of light falloff.

Fixtures that usually exhibit these characteristics are focusing spots with open fronts and no condensing lenses focused into the spot position, focusing spots with Fresnel condensing lenses, and spotlights. As the efficiency of the fixture decreases, the potential falloff capability of its illumination increases. For example, a diffuse illuminator such as a softlight creates its particular quality of illumination at the expense of efficiency. The scattering of the light rays within the fixture itself further breaks up the parallel rays: they spread as they are projected from the reflector, increasing the light-falloff potential of the lamp.

CONTROLLING EXPOSURE

The filmmaker can control the exposure of the film by altering the luminous intensity reaching the set (a topic discussed throughout the book), by varying the shutter speed of the camera, and by controlling and limiting the amount of illumination passing through the lens of the camera before it strikes the film.

The Shutter

In cinematography the camera shutter opening and the speed at which the camera is operating control *exposure time*: the amount of time in which a film receives illumination. In motion-picture cameras, as the film is running (being advanced through the camera) past the film gate where the exposure is to take place, a rotating disk called the *shutter* blocks illumination from the film until it

stops for an exposure to take place. The shutter and the film-drive mechanism are mechanically linked so that they are precisely synchronized. Most shutters are not entirely opaque but are made with pie-slice-shaped cutouts or slits called the *shutter opening*. The film stops moving in the camera for an exposure at the exact moment that the shutter opening passes by the film gate. Light is permitted to strike the film emulsion, and an exposure takes place. The process repeats itself, usually at a rate of 24 times per second. The width of the slit in the rotating shutter, measured in size by degrees, controls the length of time that the film is exposed. A 175° opening is standard; by decreasing the opening (e.g., to 140°) the film is exposed for a shorter period of time; by increasing the opening (e.g., to 230°) each frame is exposed for a longer period.

Because the shutter rotates at a rate fixed to the speed of the camera, the exact measurement of exposure time can be derived only after considering the size of the shutter opening and the speed at which the camera is operating.

frames per second	shutter angles				
	90°	140°	175°	200°	235°
2	$\frac{1}{8}$	$\frac{1}{5}$	$\frac{1}{4}$	$\frac{2}{7}$	$\frac{1}{3}$
4	$\frac{1}{16}$	$\frac{1}{11}$	$\frac{1}{8}$	$\frac{1}{7}$	$\frac{1}{6}$
8	$\frac{1}{32}$	$\frac{1}{21}$	$\frac{1}{16}$	$\frac{1}{14}$	$\frac{1}{12}$
12	$\frac{1}{48}$	$\frac{1}{31}$	$\frac{1}{25}$	$\frac{1}{22}$	$\frac{1}{18}$
18	$\frac{1}{72}$	$\frac{1}{45}$	$\frac{1}{37}$	$\frac{1}{32}$	$\frac{1}{27}$
24	$\frac{1}{96}$	$\frac{1}{62}$	$\frac{1}{49}$	$\frac{1}{43}$	$\frac{1}{37}$
32	$\frac{1}{128}$	$\frac{1}{82}$	$\frac{1}{66}$	$\frac{1}{58}$	$\frac{1}{49}$
48	$\frac{1}{192}$	$\frac{1}{123}$	$\frac{1}{99}$	$\frac{1}{86}$	$\frac{1}{77}$
64	$\frac{1}{256}$	$\frac{1}{164}$	$\frac{1}{132}$	$\frac{1}{115}$	$\frac{1}{98}$

2-3. Exposure in seconds for combinations of typically used shutter openings and camera speeds.

When the camera is set to run film at a rate faster than the normal 24 frames per second, the shutter rotates at a quicker rate, cutting the length of time that it exposes each frame of film. To calculate exposure time as it relates to various shutter openings and camera speeds, consult the chart.

The Aperture

It was mentioned eariler that the normal camera running speed is 24 frames per second. Synchronous sound recording requires this speed: varying the speed of the camera to manipulate the illumination reaching the film stock is limited to nonsync filming. Of much greater use in regulating exposure is manipulation of the camera's aperture.

The *aperture* is a mechanical iris or diaphragm placed inside the body of the lens to regulate the amount of light passing through the lens before it reaches the film for exposure. The aperture is connected to a control ring surrounding a portion of the lens barrel and is marked in increments that designate the size or area of its opening. The increments are called *f/stops*; the typical f/stop scale begins with f/1 and continues through f/1.4, f/2, f/2.8, f/4, f/5.6, f/8, f/11, f/16, f/22, and f/32. The lower stops permit the maximum amount of illumination to reach the film, while the high numbers allow the least amount of light. Each f/stop in descending order allows twice as much light to reach the film, half as much in increasing order.

When the aperture ring is moved from one f/stop number to the next lower f/stop on the ring, the size of the aperture opening is widened; the amount of light passing through the lens Is Increased by a factor of two. This is called *opening up* the lens. Opening up one f/stop doubles the exposure; opening up two f/stops quadruples the exposure. Conversely, by moving the aperture ring to the next higher f/stop (called *stopping down*) the size of the aperture opening is lessened: half the amount of light is allowed to pass through.

F/stops and Intensity Measurements

Since the primary methods of controlling exposure are to change either the level of intensity on the set or the size of the aperture, it is important to understand how these two factors are interrelated. Remember that both f/stops and luminous intensity deal with limiting illumination and that they affect exposure geometrically. Doubling the amount of illumination doubles the amount of footcandles and the exposure of the film. Likewise, halving the intensity halves the exposure of the film.

The chart (2-4) lists four combinations of f/stops and intensity measurements, each set representing the same exposure. The filmmaker, by careful manipulation of the luminous-intensity: aperture-size ratio, can thus get a perfect exposure. When closing down from f/8 to f/11, for example, half the amount of light is allowed to saturate the emulsion. If the amount of illumination is then increased by two, in this case from 250 footcandles to 500 footcandles, however, the same exposure is made. By allowing twice the amount of light onto the film the reduction in exposure time is cancelled out. If a scene is correctly exposed at f/8 with 250 footcandles of light, the same exposure can be obtained at f/11 with 500 footcandles. Likewise, opening up the aperture from f/8 to f/5.6 will double the exposure time, letting in twice the amount of light. Thus only half the amount of light is needed at f/5.6 as at f/8 to get the same exposure: 125 footcandles at f/5.6 and 250 footcandles at f/8.

f/stops	f/4	f/5.6	f/8	f/11
intensity in footcandles	64	125	250	500
exposure	equal	equal	equal	equal

2-4. The exposure relationship between f/stop and intensity.

LUMINANCE AND EXPOSURE

So far the discussion has examined illumination and luminous intensity. Remember that *luminous intensity* refers to a quantitative aspect of a light source. The amount of light that reaches the set provides *illumination*, or exposure intensity measured in footcandles. Illumination, however, should not be confused with the term *luminance*. While illumination is the measure of the light *falling upon* the surface of the subject, luminance is the measure of the light *reflecting back* from that surface. Factors affecting the luminance of an object include the type of surface texture, whether light reflected from the surface is specular or diffuse, the absorption characteristics of surface colors and intensities, and the amount, type, and quality of incident illumination falling upon it. Since all objects exhibit differing combinations of these characteristics, an evenly lit scene with a constant amount of incident illumination will produce varying luminances, because each individual part of the set will reflect unequal amounts of light. The characteristic luminance of each object is partly responsible for the visual contrast of the scene.

Luminance is measured in *candles per square foot*. To avoid confusion with footcandle measurements in this book, luminance will be measured in f/stops, which aids in judging the effects of an object's reflectance on the exposure of the film as well as in evaluating the contrast of the scene.

If a luminance measurement is taken from each object on a set, the luminance range of the shot can be noted. Since the luminance range is a valid indication of the contrast of a shot, it is helpful in comparing the way in which this contrast will be rendered on the film itself. Different film emulsions are sensitive to different luminance ranges: they have different exposure ranges. If the luminance range of the subject or set exceeds the exposure range of the film stock, all the tones of the subject will not be resolved on the film emulsion. (This topic is discussed in detail later in this chapter.)

Some filmmakers think of luminance as brightness, but this term may be a bit confusing, because luminance refers to the light-reflecting properties of an object, whereas brightness is commonly thought of in relation to objects that produce light or to the amount of color saturation that an object exhibits. Because of this confusion the term "brightness" should not be thought of as luminance or illumination.

EXPOSURE AND FILM STOCK

There are many different types of film available to the filmmaker. The choice of stock is often based on aesthetic decisions that are dependent primarily on the filmmaker's own personal judgments. But certain characteristics of film stocks need to be discussed in terms of their responses to illumination. By understanding them the filmmaker will have concrete facts to back up his aesthetic judgments.

Components of the Film Stock

Motion-picture film is made up of two major components: base and emulsion. The *base* is a flexible material, usually acetate, that acts as a support for the light-sensitive ingredients in the *emulsion*. Light striking the emulsion causes a chemical change that, when undeveloped, is called the *latent image*. The latent image becomes visible after the film is subjected to a chemical process called *development*. The unexposed film is called *raw stock*, *film stock*, or *stock*; after exposure but before development it is called *exposed film* or, in the case of negative film, *exposed negative*; after development the film is

called an *original*, *original negative*, or *negative*.

Raw stock is available in two forms: reversal and negative. *Reversal* film is capable of reproducing a positive image of the subject. In other words, on the developed film will be an image whose tones are the same as those of the subject. *Negative* film stocks, on the other hand, have tones that are the reverse of those of the subject: they must therefore be printed onto another piece of film to give a positive image. Both types come in black-and-white and color stocks.

Characteristics of Film Stock

Both positive and negative film stocks can be purchased in different types of film, each exhibiting different characteristics, such as the way in which it records and reproduces the tones, colors, and contrasts of the original subject; the amount of over- and underexposure that it can accept and still reproduce a satisfactory image; and the overall amount of illumination needed to produce a satisfactory exposure, called the *emulsion speed*. Emulsion speeds are usually rated in terms of the *ASA scale*: films with a low ASA (25, for example) are considered slow and require more illumination for exposure than higher-numbered films (ASA 200, for example).

To choose the correct film stock, the filmmaker must understand the characteristics of each type. Many of these characteristics can be examined with the help of the film's *characteristic curve*, a graph that depicts the way in which a film reproduces densities in regard to exposure. In a negative-film emulsion (the following discussion concerns film's *characteristic curve*, a graph that depicts the way in which a film reproduces densities in regard to exposure. In a negative-film emulsion (the following discussion concerns only negative stocks, which are generally used by professional filmmakers—the reader should refer to the specifications furnished by the manufacturer to evaluate the stock, whether positive or negative, that he is using) the horizontal axis plots exposure levels from the subject from left to right. The vertical axis describes the densities, with the lowest at the bottom of the D axis and the highest at the top of the vertical.

A dark area reflects very little light and therefore produces a small amount of exposure on the film. On a negative emulsion this exposure would appear as a thin or transparent section. When this negative is printed, this area will permit more light to pass through and will be reproduced with a dark tone. Conversely, the lightest tones of the print are made from the densest portions of the negative, which result from a large amount of exposure from the lightest tones of the subject.

If the film's emulsion could reproduce every tone of the subject exactly as it existed, the "curve" would be a straight line. An equal increase in exposure would yield an equal increase in density (2-5). The straight line would intersect the density and exposure axes at a 45° angle; equally spaced points on the exposure scale would be reproduced as equally spaced points on the density scale, and a perfect reproduction would take place. For example, as illustrated, 16 divisions of exposure projected up to the curve and over to the density axis would produce 16 divisions of density.

A typical curve illustrates, however, that a film stock does not reproduce densities in equal proportion to exposure. They rather take the form of an S curve with three parts: the straight-line portion, the toe, and the shoulder (2-6). Although the straight-line portion is responsible for the most accurate reproduction of densities on the negative as they appear in the subject, it only reproduces the middle tones of the subject and is limited in its ability to reproduce "perfectly": the straight line is almost never on a 45° angle to the density and exposure axes. The toe or bottom of the curve represents the areas of the subject that are darker than the middle tones; the shoulder or top of the curve is responsible for reproducing the areas of the subject that are lighter than the middle tones.

To get an idea of how various sections of the characteristic curve are responsible for reproducing negative densities from differing exposures, look again at the graph (2-6). The exposure and the density are divided into units of equal length. The lowest numbers on the exposure scale represent the darkest areas of the subject and shadows; the highest numbers represent the lightest areas of the subject, the highlights. Areas between dark and light are the middle tones: they are represented by numbers in the middle of the exposure scale. To determine the amount of negative density produced by this hypothetical emulsion from a particular amount of exposure, select a point on the exposure scale, draw a vertical line from that point until it intersects the curve, and draw a horizontal line from this point until the density axis is reached. The curve in the example does not represent the subject perfectly in resulting densities on the negative: 6 units of exposure resulted in 3 of density, 14 of exposure in 12 in density, and 22 in only 18. In each case the exposure resulted in less than the "ideal" density and would therefore be reproduced in a final print with a denser or darker tone than in the original subject. But all subject tones did not show the same amount

high density—very dark
negative/very light print

16 divisions of density

density

6 divisions of density

45°

45°

low density—very light
negative/very dark print

6 divisions of exposure

16 divisions of exposure

light

exposure (log$_e$ axis)

heavy

2-5. How exposure should ideally affect the resulting film density.

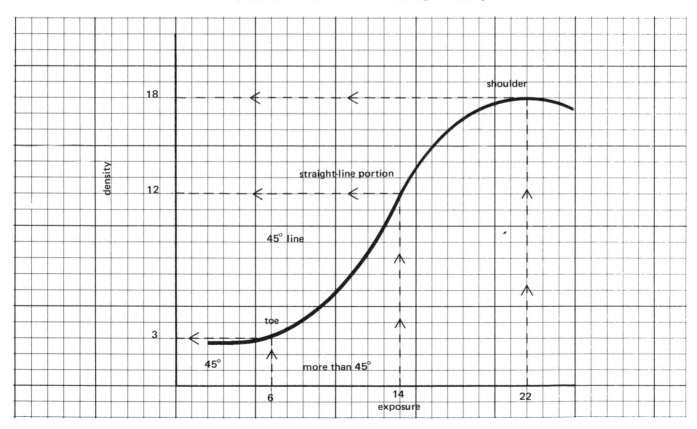

shoulder

18

density

straight-line portion

12

45° line

toe

45°

more than 45°

3

6

14

22

exposure

2-6. The characteristic curve: how a typical negative emulsion reproduces density in relation to exposure.

of decrease in approximate negative density: the straight-line portion, for example, handled the midtones with a greater degree of accuracy than did the toe or the shoulder. The toe produced densities 3 units less than the number exposed (6); the straight line produced densities only 2 less (14), while the shoulder produced densities 4 units less (22).

It should be clear by now that the factors represented by the characteristic curve have a good deal of control over the way in which the film reproduces the tones of the subject. When lighting a set, our eyes adjust and adapt to the varying degrees of tonality from the darkest shadows to the lightest highlights. We can easily differentiate between the subtleties of two dark or two light tones, but the film may not record these differences due to its "imperfect" reproductive qualities, as shown by the difficulty of the toe and shoulder in rendering the areas in the negative. Since the shape of the curve cannot be drastically altered by the filmmaker (unusual development will affect its shape and its reproductive capacity to some degree), it is necessary to be aware of the limitations of film types and to make adjustments to the set before the exposure is made.

Lighting is a valuable tool for the filmmaker: the illumination level of areas that are too dark or too light to be recorded properly on the film may be adjusted. Adding more illumination to the dark areas of a set boosts the exposure of that area and shifts the tones of the subject away from the toe and toward the straight-line portion of the curve, where they may be more satisfactorily recorded. A similar shifting of tone occurs in the highlights when the luminous intensity is lessened. By adjusting the lighting the filmmaker is in essence limiting the apparent contrast of the shot by controlling the luminance range of the scene. But before the filmmaker can adequately control the luminance range of the subject to compensate for the film's inefficiencies in reproducing certain tones, the variety of tones that a film can produce—its exposure range—needs to be specified.

Exposure Range

The useful *exposure range* of an emulsion refers to the minimum and maximum levels of exposure from which the film can reproduce satisfactory densities. It is a product of the emulsion characteristics and can best be illustrated in terms of a characteristic curve. Measurements of light reflected from various objects in a set, from the darkest to the lightest, may be converted with a light meter into terms that relate to the exposure of the film. The f/stops are handiest to use. In the drawing eight measurements were

taken from various areas of a set; the readings were graphed on the exposure axis (2-7). Point A was the darkest: it reflected a luminance corresponding to a reading of f/2. Point H was the lightest area: it reflected a reading of f/22. Points A through H represent an eight-f/stop subject-luminance range and are indicated on the graph by a spread of 21 blocks or steps of exposure. Point D is the midrange of the subject luminances and therefore represents the best overall exposure (the aperture at which the camera would be set to correctly expose a subject with this range).

From the illustration it can be seen that this negative film has compressed the eight reflectances (tones) from the subject into only five distinctly different densities in the negative. The distance from A to H on the density scale is almost one-third smaller than the distance between the same letters (f/stops) on the exposure scale. This effect is known as *tonal compression.* Although tonal compression has affected the total range of densities produced by this negative, the areas of the curve most responsible for the effect are the toe and the shoulder.

At the dark end of the subject the two tones A and B are separated by a full f/stop: B is twice as luminous as A. But on the density scale A and B are reproduced as the same thin tone. Point B represents the minimum useful exposure range of this emulsion. Anything darker (having less luminance) than point B (f/2, for example) will still have the same amount of density on the negative. Although there may indeed be measurable densities in the scene that reflect less light than f/2.8, all dark tones below the useful-exposure-range point will be reproduced as a single density. On the shoulder of the curve point F represents the other limit of the useful exposure range of the film. Any part of the scene lighter that f/11 in this example will be recorded with the same density as the part of the subject from which the f/11 reading was taken.

The highest point on the exposure range of the emulsion's characteristic curve, where the heaviest density results from the lightest portion of the subject, is called the *D max.* The exposure range of this emulsion is the subject luminance reproduced with exposure levels between B and F. With this hypothetical emulsion the film will respond to and adequately record densities in the negative from areas of the subject with a luminance equal to or more than f/2.8 or less than or equal to f/11. The useful range of this film is thus five f/stops.

Once the filmmaker has calculated the correct overall exposure for the film, the useful exposure range can be

thought of in terms of this exposure. In the current example f/5.6 was chosen as the correct exposure for this subject. Since f/2.8, the lower end of the useful range, and f/11, the higher end, are both two f/stops away from the correct exposure, this stock's range can be thought of as two f/stops under and two f/stops over the exposure of the shot. By relating the exposure range to the correct f/stop of the shot as the overall intensity of the illumination increases or decreases and the correct exposure shifts, the filmmaker is still able to keep the useful exposure range in mind.

The useful exposure range of the film cannot be found through cursory observation of the characteristic curve of the emulsion, for curves supplied from film manufacturers are not marked in subject-luminance or exposure values. The exposure axis is instead marked in logarithmic expressions of exposure that are of little value to the average filmmaker. Although a quick glance at a film's curve will not indicate the exact range of exposures in f/stops, it is helpful in comparing the exposure range of one stock to that of another. By observing the physical spread of the distance between a point near the top end of the toe and a point

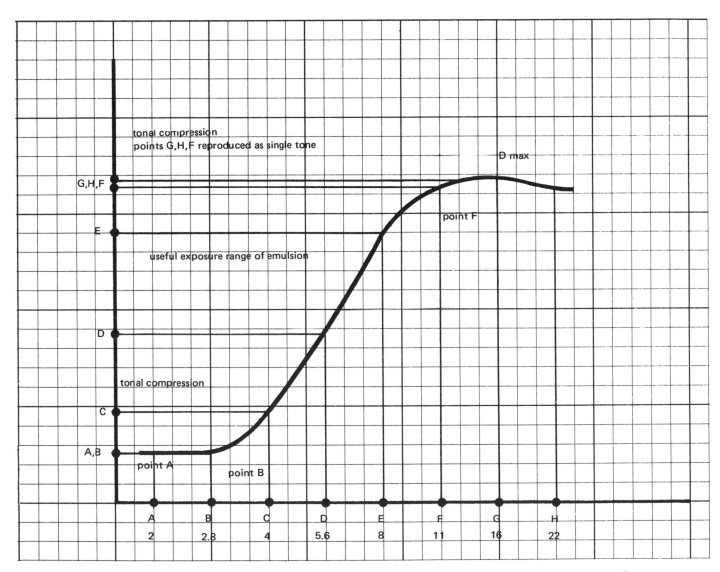

2-7. Exposure range in terms of subject luminance.

near the bottom of the shoulder (2-7) an approximation can be made. By drawing a line between these points horizontal to the exposure axis the distance is measurable. The longer the spread between the points, the greater the exposure range of the emulsion. As the steepness of the straight-line portion of the curve increases, the exposure range decreases; as the exposure range decreases, the contrast of the film stock increases. The steepness of the straight line is a good indication of the contrast of the film.

Finding the exact exposure range of an emulsion is best done by experimentation and careful measurement. As a scene is being lit, measure (preferably with a reflected-light meter) the luminance from various objects around the set. Be certain to take a good sampling of tones, especially those in the darkest and lightest areas of the set. After the film is exposed and developed, determine which tones were reproduced with noticeably visible density changes between them and the next lower and higher tones on the list of luminances recorded on the day of the shoot. The tone that reproduced on the dark end of the set's luminance range represents the minimum useful exposure range of the film; the tone that reproduced from the lightest area of the subject represents the maximum useful exposure range. Once the exposure range of the emulsion is known, the luminance range of the subject can be arranged to fall within the recording capabilities of the film. This is done either by changing the physical makeup of an object in a set (e.g., having an actor wear a light green sweater instead of a dark blue one) or by changing the lighting of the set.

Exposure-range inefficiencies are usually important in high-contrast sets in which the luminance range of the subject exceeds the exposure range of the film. To decrease the luminance range of the subject, the filmmaker may add more luminous intensity to areas that fall below the minimum exposure range of the film and at the same time decrease the intensity of the lighting on areas that exceed the exposure range. The contrast of the scene may also be changed by altering the quality of the illumination. The luminance of objects is dependent upon the quality of the illumination falling on them: a high-contrast subject lit with diffuse light will exhibit a lower luminance range than the same subject lit with a more specular source. Changing the quality of the illumination from a harder, more specular type to a softer, more diffuse type can also lower the contrast of the subject, helping it to fall within the exposure range of the emulsion.

OPTIMUM EXPOSURE

The exposure that enables the largest number of subject tones to be reproduced with the greatest accuracy in the final print is called the *optimum exposure*. It usually falls somewhere between exposures taken of the lightest and darkest areas of the subject. Remember that the subject's midtones are reproduced with the greatest accuracy. In order to set a standard midtone that would be relevant to most scenes, an 18% gray, a tone that falls right in the middle of most exposure scales, was chosen. Called an 18% gray because it reflects back 18% of the light falling on it, the *18%-gray card* is the standard upon which all exposure is measured. This means that this color, when filmed, should be reproduced with the same tone that it has to the eye. In order to do this, a system of measurement for the exposure of this tone was devised. Its purpose is to ensure accurate reproduction of this key tone no matter what amount of illumination is falling upon it.

By using a reflected-light meter calculation of the optimum exposure of objects as well as pegging the key tone is possible. *Pegging the key tone* refers to exposing a selected tone of the subject so that it is constantly reproduced in the same place on the characteristic curve of the film. When the standard key tone (the gray card) is pegged, other tones that are darker or lighter can still be reproduced accurately. If the exposure for an actor's face is not continually pegged throughout the entire filming, intercutting various shots within a single scene may become difficult. If the optimum exposure varies too much, the densities of the face would change between shots; with color film the actual colors themselves would change. Pegging the key tone not only assures proper reproduction of primary luminances regardless of varying lighting conditions but also guarantees accurate reproduction of other tones in relation to the key tone's intensity within the exposure range of the emulsion.

To determine the proper optimum exposure for any scene, simply place an 18%-gray card in the light on the set and take a measurement of the luminance from the card with a reflected-light meter. By adjusting the exposure of the camera to the reading indicated by the meter the filmmaker is actually "placing" the subject's luminance on the exposure scale of the characteristic curve in a position that will be accurately reproduced on the density scale: the reflectance of the *standard subject* will always be reproduced at a fixed density, for its exposure will always fall at the same point on the straight-line portion of the curve.

EXPOSURE LATITUDE

The effects of over- and underexposure vary with the characteristics of the emulsion: besides density changes the most noticeable effects take place in color rendering and saturation. With reversal film underexposure results in more saturated colors, while overexposure produces milkier, flatter-looking colors. When describing the accuracy of exposure needed to get a good print, many cinematographers refer to an emulsion as having a little or a great deal of *exposure latitude*. What is referred to is the amount of over- or underexposure deviation from a subject's optimum exposure that a stock will tolerate and still result in a satisfactorily exposed print.

Exposure latitude varies from stock to stock. Reversal films have a latitude of roughly half an f/stop: color-negative films generally exhibit a one-f/stop latitude; a black-and-white-negative film may have a latitude of two f/stops. But these broad generalizations may or may not apply to all situations, for latitude is directly related to the characteristics of the film stock and is affected by the useful exposure range of the emulsion as well as by the luminance range of the subject.

Latitude and Luminance Range

It is convenient to think of *luminance range* in terms of a ratio. The wider the differences in luminance between the darkest and lightest areas of the set, the higher the luminance ratio of the subject; the narrower the difference, the lower the ratio. If the luminance range is measured in f/stops, the difference between the exposure values of the lowest f/stop and the highest f/stop of the range gives the luminance ratio of the subject. For example, a subject with a two f/stop luminance range would have a 4:1 luminance ratio; with a three f/stop range, an 8:1 ratio; a four f/stop range, a 16:1 ratio; with a five f/stop range, a 32:1 ratio.

The latitude of a film stock decreases with a high-luminance-ratio subject and increases with a low-luminance-ratio subject. To illustrate this, look at the exposure-range-and-luminance scale (2-8). If a reflected-light reading is taken from a gray card and the correct exposure is chosen, the exposure will fall at the point on the characteristic curve at which it can best be reproduced. Suppose that the optimum exposure places the card's luminance at D on the exposure scale of the example. This pegs the key tone, thereby assuring faithful reproduction of the other tones within the film's exposure range, as indicated on the graph by points B and F. The subject, however, in this case the gray card, has only one tone. The number of re-flected subject tones is a good indication of what is normally described as the *contrast* of the subject. A subject with a luminance range of eight f/stops would be considered contrasty; a subject with a luminance range of only three f/stops would be considered flat and without contrast. In the example the gray card, with its low contrast, is recorded with just the right amount of negative density when exposed at point D. But if the card is underexposed two f/stops (point B) or overexposed two f/stops (point F), the resulting negative densities may still be satisfactorily reproducible in the final print.

Of course, on the negative over- or underexposure of the subject will be recorded in thicker and thinner densities, but, when printed, these densities may be brought up or down to produce a "true" 18% gray. The graph (2-8) illustrates the way in which the latitude of the film is influenced by the luminance of the subject. This subject has a luminance ratio of 1:1. As long as the exposure for the card falls within the exposure range of the emulsion, there is a good possibility that the densities can be made to be "correct" through the printing process. With this subject the film exhibits a latitude of five f/stops.

As the luminance ratio of the subject increases, the latitude decreases. This can be seen on the graph, which shows a subject with three tones (each an f/stop apart in luminance) exposed at various levels along the exposure axis. This new subject is represented on the exposure axis of the graph by three consecutive points; point D is still the optimum exposure. To find the latitude, move the three points as a unit along the exposure axis. At each stopping place project a vertical line to the curve and a horizontal line from this point until you intersect the density axis. As long as the three separate points are registered on the density axis, the subject as exposed will be within the latitude range. When one of the subject tones falls outside the exposure range of the film, tonal compression will result, and there will be a grouping of tones within the shadows or the highlights. From a look at the graph (2-9) it can be seen that this film-and-subject combination has a latitude of two f/stops, or one f/stop over and one f/stop under the optimum exposure. Selection of an exposure far greater or less than the optimum exposure will cause an overextension of the latitude of the film: the highlights or shadows of the subject will "fall off" the shoulder or toe of the curve, and satisfactory reproduction may be impossible.

Selection of an optimum exposure for a subject becomes increasingly important as the luminance range of a subject

expands. For example, with most emulsions exposure becomes more critical as the contrast of the scene increases. An increase in contrast can be a direct cause of either a lighting or a subject change. For instance, changing from a high- to a low-key scene would increase the lighting contrast. Moving from indoors to outdoors will produce a similar effect. When the luminance range of the subject becomes exactly the same as the exposure range of the film, the emulsion will have zero latitude; the only exposure that will result in satisfactory print would be the optimum exposure. A subject of this type will have a range

of tones from B to F, a luminance range of five f/stops, and a luminance ratio of 32:1 (2-9).

When working with inherently high-contrast sequences, the filmmaker must be careful to peg the key tones continually for continuity and for correct maintenance of separation in the tonal range of the subject. Under most circumstances measurement of a gray card's reflectance accurately provides the correct exposure; the filmmaker must use a reflected-light-meter luminance reading to bring the scene well within the tolerable limits of the film's exposure range.

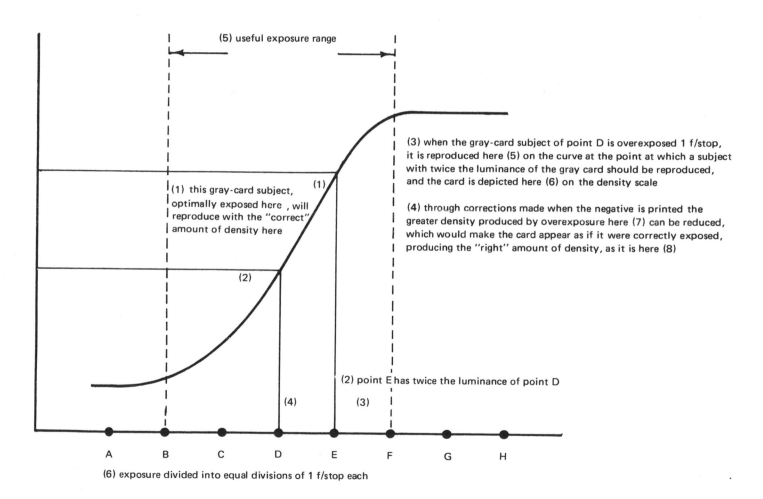

(5) useful exposure range

(1) this gray-card subject, optimally exposed here, will reproduce with the "correct" amount of density here

(3) when the gray-card subject of point D is overexposed 1 f/stop, it is reproduced here (5) on the curve at the point at which a subject with twice the luminance of the gray card should be reproduced, and the card is depicted here (6) on the density scale

(4) through corrections made when the negative is printed the greater density produced by overexposure here (7) can be reduced, which would make the card appear as if it were correctly exposed, producing the "right" amount of density, as it is here (8)

(2) point E has twice the luminance of point D

(4)　(3)

A　B　C　D　E　F　G　H

(6) exposure divided into equal divisions of 1 f/stop each

2-8. Film latitude in terms of subject luminance.

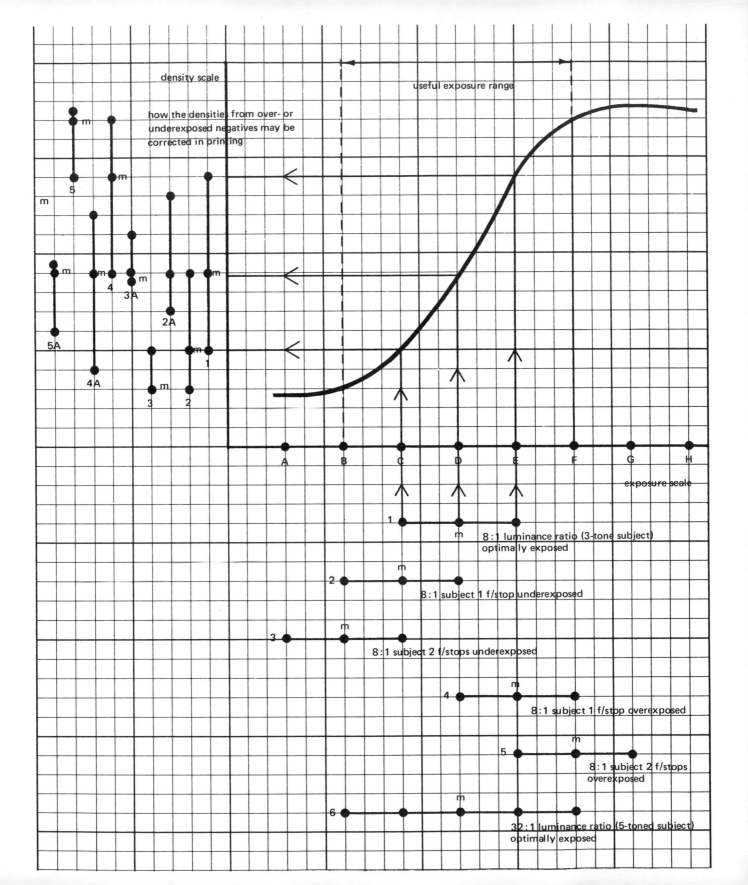

density scale

how the densities from over- or underexposed negatives may be corrected in printing

useful exposure range

exposure scale

A B C D E F G H

1 8:1 luminance ratio (3-tone subject) optimally exposed

2 8:1 subject 1 f/stop underexposed

3 8:1 subject 2 f/stops underexposed

4 8:1 subject 1 f/stop overexposed

5 8:1 subject 2 f/stops overexposed

6 32:1 luminance ratio (5-toned subject) optimally exposed

Latitude and Contrast of Film Stock

Another factor affecting the useful exposure latitude is the contrast of the film stock. The *contrast* refers to the film's capacity to reproduce subtle variations in negative density when exposed properly. Film stocks are generally divided into two types: *high-contrast* films used for titling and special effects and varying degrees of *low-contrast* films used for general filming. The inherent contrast of an emulsion can be observed by the slope or steepness of its characteristic curve, especially in the straight-line portion. The slope is a product of the chemical makeup of the stock but can be altered to some degree in development. As mentioned previously, curves with steeper slopes exhibit a more limited exposure range than those with flatter slopes; they are found especially in higher-contrast films. Since the exposure range of a stock is directly related to the amount of latitude that it exhibits with any given subject, contrastier film stocks generally have less exposure latitude than lower-contrast emulsions.

Understanding and Using Latitude

Understanding the way in which latitude is affected by a subject's luminances and the exposure ranges and contrasts of the film stock is invaluable information for exposure

2-9. How the densities resulting from various exposures of two subjects can be corrected during printing. This graph expresses the value of a "correct" exposure in terms of the latitude of a film stock and the luminance of the subject. Below the exposure scale six groups of exposures are represented with the midtone of each marked M. There are two different subjects: 1 has three tones, and 6 five tones. Subjects 2, 3, 4, and 5 represent varying exposures of subject 1. Each of these lines is dropped below the exposure scale so that its position can be easily visualized in relation to the others. Line 1, for example, should actually fall between points c, d, and e on the exposure axis; line 2 represents the same subject underexposed one f/stop, so it should fall between points b, c, and d on the exposure scale; line 3 (points a, b, c) is a two-f/stop underexposure of the subject; line 4 (points d, e, f) is a one-f/stop overexposure; line 5 (points e, f, g) is a two-f/stop overexposure. Line 6 represents the optimum exposure for a subject with five tones. Examine each line, projecting a perpendicular from each of the points to the curve and to the density axis. The densities resulting from each of the six exposures are separated from the density axis for ease of illustration. Each whole-numbered density represents the density resulting from its matching subject. The letter A illustrates the way in which over- or underexposed densities may be corrected at the printing stage by attempting to match the midtones and the optimum exposures.

and lighting control. By examining the film's characteristic curve and comparing the general characteristics of the film to those of another emulsion, the latitude of the film can be derived. An exact calibration of a film's latitude is possible only through experimentation—through testing for exposures over and under the optimum exposure.

Remember that lighting can alter the luminance ratio of the subject and therefore affect the exposure latitude of the stock. Also keep in mind that exposure latitude, in a practical sense, is a subjective term. The filmmaker, while keeping all the facts about latitude and luminance range in mind, can often extend the luminance ratios beyond the exposure ranges of the film and still obtain satisfactory results. For example, a filmmaker may light a set flatly to limit its luminance range and then expose beyond the latitude of the film to create a soft, muted look. Or a stark effect may be produced by a combination of contrasty, specular lighting and underexposing beyond the latitude of the film stock. In each of these cases the "correct" exposure was not what the filmmaker had in mind: by breaking the rules a professional may create the desired effects.

VIEWING GLASSES AND LIGHT METERS

In this section the instruments used to determine the luminous intensity of light and the contrast of a scene are discussed.

VIEWING GLASSES

A *viewing glass* is a monocular-styled colored filter that aids the filmmaker in judging the set contrast caused by the varying luminances of the subjects; different types are available for use with both color and black-and-white film. As a scene is being lit, an experienced filmmaker, by holding the glass to his eye, is able to evaluate the way in which the film will record the tones of the subject. The glass provides a convenient and quick means of subjectively analyzing the effect of the subject's luminance range on the useful exposure range of the film.

To get the full benefit of the viewing glass, a filmmaker must learn to use it correctly. The instrument, though more easily used than a light meter, requires a subjective interpretation of the contrast, which takes practice. It is sometimes helpful to start by taking luminance measurements of the set with a light meter, making notes on the readings, and then, holding the glass to the eye for a few seconds to get a feel for the contrast, to compare what is seen with what was obtained with the light meter. It may

also be helpful to pay particular attention to the lighting when screening rushes of the film in order to see how the contrast of the processed film compares to what was seen through the viewing glass. Be careful not to hold the glass to the eye for too long; the eye's local and color adaptation allows it to adjust to the luminance tones as filtered, and the effect of the glass is lost.

THE EXPOSURE METER

An *exposure meter* is a device used by the filmmaker to determine the correct exposure for a scene to be filmed. It combines a measurement of the intensity of light present with fixed relationships between the speed of the emulsion, the shutter speed, and the f/stop of the camera. Exposure meters can be divided into two categories, each indicative of the type of light reading that it uses. The reflected-light meter measures light reflected or bounced back from the subject or set and thus subject or set luminance; the incident-light meter measures the intensity of the illumination that is falling onto the subject. Each type of meter has its special uses in regard to exposure control, light-level monitoring and balancing, and lighting-contrast prediction.

Metering Cells

The light-sensitive device used in an exposure meter is called a *photocell*. The cell is the heart of the meter; its response to illumination is affected by its design and construction. There are two major types of cells in common metering systems: the voltaic cell and the conductive cell. Although they function differently, their basic construction is similar. Each is made up of two distinctly different materials that are sandwiched together so that, when light falls on the surface of the cell, a difference in electrical potential between the two layers is created. Because of this occurrence, called the *photoelectric effect*, the difference in electrical potential between the layers varies directly with the amount of light incident upon their surface; the metering device senses the variation and translates this information on to a mechanical pointer or needle whose deflection indicates the amount of light present.

A *voltaic cell*, sometimes called a *selenium cell*, generates a small but measureable amount of electricity. Within certain limits the amount of electricity produced is directly proportional to the intensity of the light falling on its surface. Without the help of an additional power supply the voltaic cell produces enough electricity to deflect a meter coil connected directly to a pointer. As light strikes the cell, the pointer moves across the calibrated dial; the greater the amount of electricity produced by the light's intensity, the greater the degree of deflection of the pointer.

Voltaic cells are characterized by a quick response time to most normal changes in light intensity, but the cell can be damaged by overloading (peaking) if subjected to high levels of illumination for a length of time. The spectral-color-light sensitivity of a voltaic cell closely matches the normal spectral response of most films; it responds to variations in illumination colors more readily than other types of cells. The primary drawback of the voltaic cell is its inability to measure very high or very low levels of illumination faithfully. This problem was solved by the invention of the photoconductive cell.

The *photoconductive cell*, also called the *cadmium-sulfide* or *CDS* cell because of its primary elements, acts as a variable resistor that increases its resistance to electricity in inverse proportion to the light falling upon it. Because it does not produce its own electricity, it requires an electrical power source, usually a tiny battery within the meter. The battery runs a meter coil, and the photoconductive cell registers the intensity of light falling on its surface and regulates the amount of power passing through the coil. At high levels the cell offers little resistance to the electrical potential of the battery, and the needle deflects a large amount; conversely, when little light is present, the cell offers much resistance and the needle deflects only slightly.

CDS cells are extremely sensitive to all light levels from one extreme to the other. For this reason they have high and low scales, providing an extended metering range that offers an accurate recording of intensity extremes. But the photoconductive cell also has a tendency to continue registering a previous light intensity even after that intensity has changed; it is slower in responding than the selenium cell. Because of this the meter must be given time to readjust itself, either when it is first put into use or when the light levels are changed. The battery powering the photoconductive meter must be kept fresh if correct readings are to be obtained, but the cells themselves do not deteriorate with age as voltaic cells tend to do.

The Standard for Exposure

Before continuing the discussion of light meters one point mentioned earlier in this chapter must be expanded. A light-sensitive cell, a moving meter coil and pointer, and all the adjustable dials and scales of an exposure meter are of no use in calculating exposure unless the intensity of the light falling on the surface of the cell can be compared

by the meter to a standard amount of illumination. Exposure meters do not arbitrarily measure intensities. They are rather designed to judge correct exposures by measuring intensity relative to a standard intensity. In this way they are capable of predicting how light or how dark a subject is: the meter can express a measurement of this value by comparing it to the measurement of the standard value. This standard, built into all meters, is the reflectance from the surface of a diffuse 18%-gray tone. All meters are calibrated to express exposure values for a subject lighter or darker than this standard subject. By comparing the luminous intensity of a scene to this standard subject the light meter evaluates the intensity and places it on a scale that in turn allows the filmmaker to be sure of the luminous intensity of the scene.

Incident-light Meters

An *incident-light meter* is designed to measure the intensity of the illumination falling upon the subject or set, reading the luminous intensity in either f/stops or footcandles. The incident-light meter does not consider the luminance of the actual subject in predicting the exposure settings for a scene: rather, using a built-in standard subject, usually a hemispherical dome or diffuser, that represents a standard gray card, the meter measures the amount of light falling upon the dome and translates it into readings.

The dome on the incident-light meter is similar to the reflectance of an 18%-gray card. Light striking the diffuser is transmitted to the meter cell below it; since the diffuser is directly over the photocell, the cell is always "pointed" at its standard subject. Diffusers for professional meters are available in two interchangeable shapes: a hemisphere, used to measure light from several sources, and a flat disk, used to measure luminous intensity from one light source.

The *hemispherical diffuser*, also called a *dome* or *bubble*, is a large, white, translucent piece of plastic that looks very much like a Ping Pong ball cut in half. Because of its large size in relation to the size of the meter's body illumination can strike the diffuser from an angle wider than 180°, sometimes as much as 300°. The dome is designed to receive light as a three-dimensional subject. Since an actor will almost invariably be lit by multiple sources, the meter must consider all of them as contributing to the exposure of the scene. A gray card cannot possibly receive light from such varied angles: it is difficult to take a reading from it without including a specular reflection bounced off the card from one of the lights. This can falsely influence the measurement and give an incorrect exposure. The hemis-

phere, on the other hand, does not exhibit such a problem, for the angle of light incident upon its surface does not appreciably affect the way in which the intensity is transmitted to the photocell.

When the hemisphere is replaced with a *flat-disk diffuser*, the angle of acceptance of light is narrowed to approximately 50°. Although the disk reproduces a standard subject, as does the hemisphere, its narrow angle of acceptance enables the meter to read the luminous intensity of a single source. This is useful when the intensity of a single light illuminating a subject lit by overlapping fixtures needs to be read, for the flat disk can isolate the light from each of the sources.

When taking an exposure reading with an incident-light meter, place the dome over the photoelectric cell and take a light reading from the position of the main subject, pointing the dome toward the camera. If the actor is present, place the meter directly in front of his face. To obtain a correct reading, the filmmaker must be certain that no shadows fall on the hemisphere. The filmmaker may have to position himself below, beside, or behind the meter's dome to accomplish this. A well-designed incident-light meter has a swiveling head, permitting the cell to be pointed toward the camera while the exposure scale remains in sight of the person taking the reading.

When taking a reading on an exterior lit by sunlight, it usually isn't necessary to walk over the subject's position to take a measurement. In most cases the intensity of light striking the subject is the same as that falling on the camera: the reading can be taken from the camera position. To get a correct measurement, hold the meter a few feet in front of the lens and point the dome toward the camera, making certain that the meter body is perpendicular to the ground and not slanting toward the sky. Unless the subject is standing in the shade and the camera is in the sun, the reading should be correct.

With interior cinematography the incident-light meter is especially useful in determining the light reading when the subject must move through the set. For example, it may be desirable to have equal amounts of illumination falling on the actor as he walks his block (preplanned movement). To light this area effectively, many lights may have to be used. To help judge the intensity of the lights at various positions along the block, the filmmaker can walk the path himself, pointing the meter toward the camera, and determine the intensity as he goes. Verbal instructions to a gaffer (the person controlling the light fixtures) to increase or decrease the intensity of each of the main sources will allow the

2-10

2-13

2-11

2-14

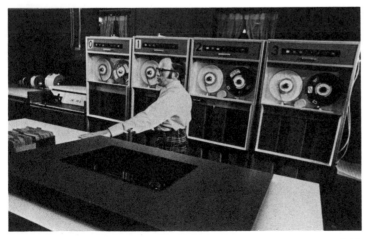

2-12

2-15

filmmaker to balance the exposure to a predetermined f/stop.

Besides balancing these areas for exposure the incident-light meter may be used to set up prescribed lighting differences between the primary areas of the set. For example, with the hemisphere in place over the photocell, the incident-light meter can help establish the lighting relationships between the foreground and background areas of the set. These differences of illumination may be referred to as the *exposure ratio* of the areas. Use of exposure ratios aids in the preservation of lighting continuity. For example, if the filmmaker would like to create and maintain a moody lighting effect throughout a sequence, the background may be deliberately lit to an intensity two f/stops darker than the foreground. To maintain this ratio as the filmmaker shoots long, medium, and closeup shots, an incident-light meter can recreate the exact intensities. By using a domed incident-light meter the filmmaker can read the exposure of the foreground of each new shot while adjusting the light to the established level. By walking around the background areas while pointing the dome toward the camera the light can be similarly adjusted to match previous shots. By adhering to these exposure ratios from shot to shot lighting continuity is established and kept. This topic is discussed further in chapters 3, 4, and 5.

Long shot/computer room/high key. 2-10. The white ceiling of the computer room provides an excellent surface for bouncing illumination onto the set. Four 1K broads key-light the foreground to 125 footcandles of diffuse illumination. 2-11. The directable 2K fixture seen to the left of the operator's shoulder key-lights the machinery to 125 footcandles. Only a single shadow falls from the operator standing near the computer, for the directable keys lighting the background do not overlap in coverage. 2-12. Long shot as seen from the first camera position. 2-13. Closeup as seen from the second camera position. A fill light located close to the subject's eye level helps remove distracting shadows from the subject's glasses. The windowed background is lit to 64 footcandles. 2-14. Taking an incident-light reading. (Photo courtesy of Miki Ehrenfeld.) 2-15. Lighting diagram.

Reflected-light Meters

The *reflected-light meter* is an exposure device used to measure subject luminance. After the meter dials have been adjusted to the correct settings for film speed, shutter angle, and frame rate of the camera, the meter is pointed toward the subject from the camera position. The reading obtained from the luminance of the subject is indicated by an f/stop. Used in this way, however, the exposure indicated will be correct only if the scene is of average reflectance and if the meter measures light only from the desired area, excluding light from lighter or darker areas.

The reflected-light meter is adjusted or calibrated during its manufacture to produce a proper exposure reading only when measuring the reflectance of the standard 18%-gray card. Whatever the reflected-light meter is pointed at will be considered a subject of average reflectance, and the meter will indicate an appropriate f/stop that will reproduce the subject as a gray tone. For example, if the meter is pointed toward the sky, it assumes that the sky is a gray card and indicates an exposure that would correctly reproduce the sky as gray on the film. On the other hand, if the meter is pointed at a blackboard, the meter assumes that the subject is a gray card with very little illumination. The meter indicates an exposure that would compensate for the lack of luminous intensity on the standard subject (the gray card) by overexposing the real subject (the blackboard), and a new subject would be reproduced on film: a gray blackboard. If the subject does not at least approximate the reflectance of the standard gray card, the scene may be incorrectly exposed unless the f/stop reading indicated by the meter is adjusted to the reflectance of the actual subject so that the camera aperture can be properly set to produce a correctly exposed picture.

Remember that the goal of the filmmaker in taking an exposure reading is to expose the midtone of the subject correctly, pegging its reproduction on the straight line of the curve, with the highlights in the shoulder and the shadows in the toe. When the reflected-light meter is pointed toward a subject, the exposure indicated will attempt to reproduce that subject as a midtone on the straight line at the location at which an 18% gray should be reproduced. The sky in the above example, instead of being reproduced properly on the curve (a bright highlight on the shoulder), became the midtone. Since the sky was the brightest part of the shot, all the other tones of this subject—the trees, for example—were reproduced further into the toe of the curve, making them darker than they should be. To compensate for the problems inherent in

taking a reflected-light reading, filmmakers have adopted several different methods.

1. *The assumption* method is probably the most widely used but also the most haphazard. With this technique the filmmaker stands near the camera and points the meter toward the subject. He is thus assuming that the scene displays an equal amount of light and dark areas and that the meter is accepting light only from the desired area. In reality the chance that this would happen is quite small. Some experienced filmmakers can get approximately correct readings. For example, in filming a long shot of a green landscape the filmmaker may point the meter slightly downward and toward the scene from the camera position. From experience the filmmaker knows that he is excluding some of the predominant bright sky. The reading indicated by the meter may also be adjusted by opening the aperture perhaps half an f/stop to compensate for the sky.

2. If it is possible to get close enough to measure the reflectance of the lightest and darkest parts of a scene separately, the *brightness* method may be used. By measuring the f/stop of each extreme and then selecting an f/stop midway between them the exposure is set for the luminance of a midtone found in the scene being filmed.

3. In the *midtone* method the filmmaker may scan the subject to find a tone that approximates a gray card. Because of variations of intensity and color this is sometimes difficult to do, especially given the local and color adaptation of the eye. If such a tone exists and if it is illuminated with the same amount of light as the rest of the scene, the filmmaker may point the light meter toward the object, holding it close to exclude the influence of surrounding luminances and setting the camera aperture according to the f/stop indicated.

4. The *gray-card* method is the most accurate way to take a reflected-light-meter reading, since it does not require a subjective evaluation of the luminance of specific tones. Instead of searching for an existing midtone or measuring extremes in reflectances the filmmaker simply places a gray card, which is commercially available, on the set being lit and takes a reading from the card. To use this technique properly, the filmmaker must be certain that the card is placed in an area of the set that receives the same quality and intensity of light as that falling on the subject, that the meter is close enough to the card so that it does not pick up any illumination from an area greater than the card, and that no glare is reflected into the meter. With the reading from the gray card the filmmaker pegs the exposure of the midtone at the optimum exposure on the characteristic curve: exposure continuity between shots will be produced, and tones other than the gray will also be continually reproduced with the proper amount of exposure and density, guaranteeing a smooth match of shots to be intercut during editing.

5. The *comparison* method operates by measuring the luminance of an object known to have a reflectance value different from the 18% gray and then correcting for this difference by adjusting the exposure equally. A useful object to use as a "standard" is a hand. Most Caucasian skin has a reflectance value of approximately 36% gray: i.e., one f/stop greater than a gray card. Taking a reflected reading directly from a hand positioned in the subject's light would underexpose the film one f/stop, but, if the camera were opened up one f/stop to compensate for the reflectance value, a correct exposure would be obtained. To measure skins lighter or darker than average Caucasian skin or to determine whether your skin is "average," compute the exposure in f/stops from a gray card placed a certain distance from a light source. Repeat the measurement with your hand in the same position and note the f/stop reading. The difference between the two indicates the amount of correction needed. For example, if your hand reads one f/stop higher than the gray card, open the camera aperture one f/stop. If your hand reads one-half f/stop less than the gray card, close the aperture one-half f/stop. This method is especially convenient, as it is much easier to carry around a hand than a gray card.

One of the most obvious drawbacks of the reflected-light meter is the fact that the photocell's *angle of acceptance of light* is difficult to judge. Depending upon the method used to measure the exposure, the angle of acceptance should either match the angle of view of the camera lens (when using the assumption method) or be very narrow (any of the other four methods). Unfortunately, only two metering devices match each of these situations. A reflected-light-metering system built into the camera body actually reads the same area as the image in the lens; a hand-held spot meter with an extremely small angle of acceptance enables the filmmaker to judge the reflectance of a small area of the set. With both systems the filmmaker is able to see the area being metered exactly: with the through-the-lens system provided by the reflex design of the camera and

with the optical system provided by most professional spot meters. With most hand-held meters it is still necessary to use the "point and hope" method to determine the photocell's area of coverage. The angles of acceptance provided in the manufacturer's specifications are often difficult to visualize and become useless to the filmmaker.

By far the best use of the reflected-light meter is to measure the luminance of small areas in the set. These measurements are used to indicate corrective changes needed to compensate for extremes in subject luminance: measuring the lightest lights and the darkest darks with the reflected-light meter actually measures the luminance range of the entire set. The reflectance of these extremes provides important information regarding the reproduction of the scene on film. For example, if the filmmaker knows that his film will accept a subject-luminance range of five f/stops, measuring the luminance of different parts of the set will indicate whether the lighting should be altered or the subject reflectance changed to bring the luminance range within the range of the film.

The experienced filmmaker normally does not measure reflectance carefully, for he can often see problems in lighting extremes visually, but it is occasionally important to check luminance readings, especially when a special effect is desired. The reflected-light meter is also used to determine how a particular object with special reflectance problems, such as an important prop that is much more or much less lumiant than the other objects in the scene, may film.

There are other everyday filming problems that can be minimized by proper use of the reflected-light meter. Measuring background luminance of a set wall is a good example. Filmmakers often light the action of a scene for a particular aperture—f/4, for example. In working with a background of average reflectance the filmmaker may for the sake of effect decide on a low-key mood and key the background illumination down two f/stops to f/2. If the back set is made up of darkly stained wood paneling or lightly colored wallpaper, however, the mood of the scene can be destroyed, unless the lighting is altered to allow for the reflectance of the set. A reflected-light-meter reading from the back wall would tell the filmmaker if the lighting on the wall should be brought up or down. The reading would not be used for setting exposure but only as a warning of reflectance problems.

The Spot Meter

The *spot meter* is a specialized type of reflected-light meter that enables a very small area of the subject to be measured from the camera position. It has a very narrow angle of acceptance of light, usually 1°. Incorporated into its design is a type of reflex viewing system that allows the filmmaker to pinpoint the area being metered.

An invaluable aid, giving quick and accurate reflectance readings, the spot meter is also used to deal with luminance-range and lighting-continuity problems. If the filmmaker has discovered and established a reflectance pattern from a cast member's face, for example, he or she can guarantee consistent exposure whenever that particular subject is present by carefully monitoring that small area with the meter. Nevertheless, when working with the spot meter, one must be aware that the reflectance from the subject is affected by many variables—e.g., the type of reflection from the face, surface absorption and reflection characteristics, and changes in makeup.

Multipurpose Meters

Multipurpose meters are dual-purpose light meters that can be easily converted to measure either reflected or incident light. Most hand-held exposure meters (the spot meter is an exception) can read both types of light but are designed primarily to read one or the other type, with the alternative offered mainly as a selling point.

The use of the light meter in its alternative form can cause problems. For instance, when the diffusing dome of an incident-light meter is replaced by a photogrid, the meter is capable of responding to reflected light. Unfortunately, the incident-light meter's photocell is constructed to respond to such a wide angle of acceptance that it is virtually undirectable for a reflected-light exposure reading. On the other hand, the most popular reflected-light meter offers a sliding dome that is placed over the photocell to read incident light. But invariably this dome is too small for the meter: too little light reaches the cell to give an accurate reading, and the meter body itself sometimes blocks the light. Though using one type of meter in two ways may seem a great convenience, it is best to own both a reflected- and an incident-light meter. Though there is a greater cost, the security of knowing that each type of light reading will be correct is worth the expense.

PRESELECTED F/STOPS

Many camera operators prefer to use a single preselected f/stop for the entirety of a film, reasoning that it is difficult to judge exactly how the film will reproduce various subject luminances and contrasts. The human eye adapts easily to luminance changes, altering the interpretation of the subject's tones by locally adapting to the deep shadows and bright highlights. The amount of reflectance from a subject also varies with the quality and amount of key-light illumination, the direction from which it comes, the specific reflection and absorption characteristics of the subject, and the contrasts in the subject itself. Preselecting an aperture establishes a continuous level of exposure illumination from shot to shot. By reducing the number of variables that the filmmaker needs to contend with in lighting the film it becomes a bit easier to judge lighting effects and contrast on an interior set.

Filmmakers often choose a wide aperture to work with. With commonly used emulsions an aperture of f/4 or f/4.5 is sufficient for exposure under dim lighting conditions; many feel that it is easier to judge lighting effects, subject contrasts, and tonal separation when the key illumination is kept down to around 250 footcandles or so. Wide apertures offer narrower depths of field, which direct the viewer's attention to the desired items on the screen. Wide apertures require less light for exposure: by limiting the number of lights needed power and money are conserved and setup and breakdown time is kept to a minimum. Lenses frequently exhibit maximum resolution and minimum diffraction when stopped down several f/stops from their widest opening, making f/4 or f/4.5 a logical choice. Finally, some filmmakers feel that contrast and saturation are increased if a lens is stopped down too far.

3. Lighting for Closeups

Learning lighting control and lighting effects is probably best accomplished by working with subjects or sets within a limited space and by using closeup shots to determine the lighting pattern. Closeups are usually static shots with little movement, have a relatively small area to concentrate on, and offer the most common situation in which the cinematographer has absolute control over the lighting effects. The exact placement of the lights in closeup filming is seldom subordinate to other factors, as it must be at times for longer shots.

The definition of the term *closeup* is ambiguous. It includes such factors as who is using the term, the shot preceding the one in question, and the use of the shot—i.e., for television or for motion pictures. In this book the closeup is considered as a shot that frames the head and shoulders.

Filming the subject in closeup usually involves much more than simply tightening up the frame around the actor and diffusing the lens for soft focus. When a closeup is to be filmed, the exact placement of the actor and the angle of view of the camera must be carefully chosen to take advantage of the lighting setup of the long shot. If this procedure does not yield satisfying results, the lighting pattern set in the long shot can be modified or the subject can be relit to model the light across the face in order to add depth and character to the image.

Although performing this adjustment does require some consideration, it should not be regarded as a disadvantage. Because of the limited area of coverage of the closeup any "relighting" necessary (of the longer shot's lighting design) can be done quickly. In fact, in location filming closeups are generally considered to be an advantage of the shooting schedule. Stand-mounted lights may be used to light the closeup subject precisely, greatly decreasing shooting time as compared to situations in which the illumination must be rigged with alternate methods.

The true advantage of using stand-mounted lights for closeup illumination cannot be fully appreciated until the filmmaker becomes familiar with other methods used to rig the lights on location sets. Of course, stands are used whenever possible, but, as the shot's area of coverage increases, the probability of using stand-mounted fixtures to illuminate the expanded area decreases. In longer shots light stands may restrict the angle of view and inhibit both camera and subject movement. In such cases any one of a number of alternate methods of rigging and placing the fixtures is used, each of which is costly to precious setup time prior to shooting.

When setup-time factors and relative screen times of closeups are compared to those of longer shots, the closeups becomes an even more desirable shot for location lighting. A closeup may take 15 minutes of setup time to light with stand-mounted fixtures and may last a minute in real screen time. On the other hand, a more involved long shot with camera and subject movement may waste hours of location-setup time in rigging the lights but may last only seconds on the screen.

CLOSEUP LIGHTS
Whether the closeup is part of a sequence that includes longer or wider shots, as in a dramatic film, or stands by itself, as in an interview situation, in a standard lighting setup three lights are needed to illuminate the subject adequately: the key, the fill, and the backlight. Although lighting styles vary with personal taste and with the situation, the function of each of the three lights seldom changes. The keys are generally used to furnish most of the lighting intensity; the fills establish the contrast of the shot; and the backlight separates the object from the background and adds a highlight to the subject.

THE KEY LIGHT
The *key light* is the main or primary light, and it provides the majority of the subject illumination. Its position and effect in closeup work are decided by three factors: the modeling on the face, the lighting mood, and the direction of any motivating sources.

Facial Modeling
Modeling refers to the patterning of light across a surface, most often a face, to be photographed. Modeling gives the closeup character and depth. Facial modeling is a result of the way in which the key illuminates the contours of the subject's face. The direction from which the key strikes the subject will determine the positioning of the shadows and the amount of facial area that remains in darkness.

Shadows from the facial profile are normally unidirectional. The number of shadows in a closeup is important, for, unless a special effect is desired, viewers will find it unnatural if more than one set of shadows falls from the face. One key is usually used, which is directed down toward the subject from an elevated position. Small shadows cast directly beneath the nose or off to either side down the smile lines of the face can make interesting closeups.

Lighting Mood

Lighting *mood* is the scene's atmosphere or feeling, created by the lighting design of the shot: it is a product of the angle from which the key fixture lights the subject and the intensity relationship of the key to the other lights in the scene. This intensity relationship creates lighting contrast and is therefore responsible for controlling the predominance of the key's positioning, patterning, and effect on the mood of the shot. In a dramatic film the lighting mood for the closeup is dictated by the lighting design of the establishing shot, which is usually filmed first. Variations on this design may take two forms. First, although the long shot establishes the lighting mood, it does not necessarily dictate the key-light placement for the closeup. It is common practice in location lighting to readjust the key's placement when moving from long shot to closeup. But if this is done, the way in which the closeup is relit must still conform to the lighting style, effect, and mood of the longer shots. (See the lighting-continuity section in chapter 4.) Matching the mood in this manner is called *lighting continuity* and is necessary to facilitate intercutting of long shots and closeups when editing. Secondly, the lighting contrast may be altered from long shot to closeup to facilitate the recording of detail, regardless of the key's position in either shot. Within the closeup frame two lights other than the closeup key may influence the mood of the shot: the closeup fill and the background key light. (The intensity and relationship of these lights to the placement of the key and the production of a lighting mood are discussed in detail later in this chapter and in the section on background illumination in chapter 5.)

Motivating Sources

At times the key's position will be dictated by the appearance of an in-frame light source that realistically and logically would provide illumination for the set. Such sources, called *motivation sources*, are commonly items such as table lamps, ceiling fixtures, or window light. Almost all location interiors have motivating sources of some sort, but the degree to which they are used to dictate the placement of the key varies greatly, although motivated lighting is predominant in dramatic films, where it enhances the realism of the scenes. But even when they are seen in closeup, seldom will the actual source provide the exposure illumination for the subject. Traditional keys will often be added instead to model the face, preserving the mood of the shot while maintaining the "feeling" of the existing illumination.

The Fixture

For location work a lightweight focusing spot is a good choice for a key light. With a diffuse reflector installed, this fixture has a short-to-medium throw and can easily be focused in and out, providing control of the intensity as well as the area of illumination. To these lights can be added barndoors, which offer control of light distribution, full and half scrims to control the beam's intensity locally, and filter frames for color balancing and diffusion.

It is helpful when shooting to have an adaptable location key light that will accept a variety of bulb wattages. This feature is especially useful in small interiors in which lower-wattage bulbs will offer enough illumination for the set, will conserve power, and will not tax the possibly inefficient power source.

Directable focusing fixtures are efficient key lights adaptable to almost any film situation, for the quality of their illumination can be adjusted from very hard to relatively soft by placing varying degrees of diffusion in front of the light. Other broader fixtures, such as softlights, are suitable key lights in specific situations, particularly those in which much of the scene is to be lit with equal intensities of illumination. Using a softlight as a key in closeups disturbs the conventional three-light setup, for softlights often serve two functions, acting both as key and as fill lights for the closeup subject. Softlights do not offer the same ease of lighting control as directable fixtures do but can be substituted for any of the key-light positions in the closeup setups mentioned later in this section. For our purposes conventional "hard" lighting with focusing spots is stressed: once the filmmaker masters these traditional techniques of lighting control, skill in the use of other lighting styles and fixtures for creating them will be acquired through practice.

Placing the Key

To light a closeup, position the key with all other set lights turned off. To position the light exactly, focus the fixture to spot. Control the intensity of the key by using bulbs of varying wattages or by using scrims. (It should be stressed, however, that the final intensity of the key should not be locked in until the intensity of the additional illumination that will fill in the shadows is established.) If desirable, alter the quality of the key illumination either by diffusing or by feathering the light. Either technique will soften the shadows as well as flatten the harshness of the light.

Diffusion is most easily achieved by placing silk, gauze, or diffusion material between the subject and the fixture

or in the filter frame of the fixture itself. *Feathering* is achieved by focusing the spot slightly away from the subject's face, thereby illuminating the subject with the more diffuse rays radiating from the lamp reflector's edges.

THE FILL LIGHT

In almost all lighting situations the shadows cast by the key must be lightened so that the rest of the subject may be seen: this is done with a *fill light*. A fill keeps the lighting contrast of the face within the acceptable exposure range of the film and helps produce the mood of the shot. The fill also plays a major part in maintaining lighting continuity of shots within a sequence.

Fixtures for Closeups

Two types of fill-light fixtures are commonly used for location closeup lighting: the softlight and the diffused focusing spot. The *softlight* is frequently utilized for filling in closeups on high-key sets, especially if there are large areas that must be illuminated to an intensity not much lower than that provided by the key lights. For this purpose it is best to use a softlight fixture that will accept diffusion frames and filter holders for color-balance problems, as well as bulbs of varying wattages, each separately wired for intensity control.

When a closeup calls for a directional fill, a *diffused focusing spot* is often used. Any key-light fixture may be used for a fill, provided that it is not more intense than the key light and that its quality is more diffuse than that of the key. In location closeups, in which the fill must be accurately and precisely controlled, a heavily diffused focusing spot can produce the necessary fill light without excessive spill, a condition often unavoidable if broader softlights are used for this purpose.

In some situations there is a possibility that the proper amount of fill light needed to lower the contrast of the closeup may not be produced by a fill-light fixture but instead by light reflected into the scene off a *bounce card*. This is especially practical in scenes in which closeups are to be shot on sets with a very high amount of ambient illumination. In these circumstances a bounce card positioned near the proper location of a fill-light fixture may be able to pick up and reflect some of the ambient light reflected from the ceiling of a brightly illuminated interior and redirect it to "fill-light" the closeup subject.

Shadow Problems

Regardless of the type of fixture or method chosen to fill the closeup, it should not add another set of noticeable shadows to the face of the subject. This is best avoided in closeups by placing the fill light in front of the subject, near the camera, with the light striking the subject from an angle near or equal to the subject's eye level.

Although properly positioned fill lights do not add shadows to the face of the closeup subject, they may cast apparent in-frame shadows directly behind the subject onto the back wall of the set. Regardless of the type of fill light used, this problem is common, especially because it is necessary to place the fill close to the camera lens axis. Shadows cast in line with the camera view directly behind the closeup may prove to be unattractive and unnatural and should be lessened to the extent that they will not distract the viewer. This may be accomplished by one or more of the following procedures.

1. *Diffusing the fill* will produce a softer illumination and a less distinct shadow.

2. *Moving the fill closer to the subject* will also produce a more diffuse shadow directly behind the closeup.

3. *Moving the subject and the fill further away from the back wall* will dissipate the shadow to a less noticeable and intense pattern.

4. *Switching fixtures*—a more directional fill light may permit the fill-light shadow to be repositioned to a more desirable location behind the subject without destroying the facial shadows.

Fill-light Spill

Another problem related to the fill light's position in which unwanted areas are illuminated is called *fill-light spill*. It occurs primarily when the scene to be filmed contains expansive areas of darkness and a great deal of lighting contrast. In such low-key situations it is best to use a tight focusing spot as the fill. Confining the area illuminated by the fill prevents unwanted light from falling onto the background and preserves the lighting mood of the closeup. (This problem does not exist in high-key-lighting situations, where the foreground and background are lit with nearly equal amounts of illumination, causing any slight unevenness created by fill-light spill to go unnoticed.)

THE BACKLIGHT

The *backlight* is the third fixture needed to complete the closeup-lighting setup: it adds contrast to the shot while providing separation between the subject and the background. This fixture is sometimes referred to as a hairlight or kicker. Although any fixture that strikes the subject from the rear may be called a backlight, the hairlight and kicker both have specific functions.

Hairlights and Kickers

A *hairlight* is a backlight consisting of a small spot whose wattage is generally lower than that of the key. This fixture, fitted with a specular reflector to narrow the throw and placed high and to the rear of the subject, highlights the hair and produces an attractive closeup.

The term *kicker* applies to either the *type* of lighting fixture or the *quality* of reflection produced by the fixture. A kicker lamp is used to provide separation between a subject and a background. This is done by directing a narrowly focused spot toward the back or side of a subject from a position that produces a controlled specular reflection that rimlights part or all of the subject's shape. This terminology may seem a bit confusing. For example, the word "kicker" is often used to refer to a specular highlight emanating as a reflection from the illuminating source. The reflection itself is described as a kicker regardless of the *type* of fixture used to produce the effect.

Intensity

The impact of the backlight on the filmic image is often difficult to predict, for it is hard to judge the backlight's intensity. The backlight's effectiveness relies upon the specular highlight produced as it reflects from the subject. The intensity of the illumination that reaches the camera may change when similar subjects with slightly different reflective characteristics are filmed. Since the illumination from the backlight is specular, the intensity of the highlights produced also changes rapidly from one camera position to another.

It is important to remember when illuminating subjects by specular sources that the light beam's angle of incidence is equal to its angle of reflection. If there is any camera movement at all in a closeup, the highlight produced by the back light may burn out (grossly overexpose) in one angle and completely disappear in another. The careful filmmaker must be aware of this possibility when checking the lighting through the viewfinder of the camera.

Light Meters and Viewing Glasses

Although the light meter is a reliable and precise method for measuring intensity relationships between key and fill lights, it may be of little value in judging the intensity of the backlight effect. A specialized spot meter may be used as an aid in evaluating the subject's highlight created by the backlight's reflection, but it can never be placed where it will yield the most accurate reading: inside the camera. Because readings taken from other set locations would prove to be misleading, the use of this technique can at best act as a base from which an experienced filmmaker can judge the backlight effect.

To interpret the intensity of the backlight most accurately, a viewing glass should be used. It both increases the contrast of the lighting setup and estimates its appearance in the finished film. By increasing the contrast of the lit scene through color filtration the filmmaker viewing the set through the glass may approximate the way in which the filmed image will record the various contrasts of the scene. It should be stressed, however, that viewing glasses are only meant to be lighting aids: accurate use requires an interpretive evaluation on the part of the filmmaker.

The position from which the set is observed through the glass is of importance. For best results view the scene from a location as close to the camera angle as possible. In this way the intensity of any highlights actually reaching the camera can be fully evaluated. Some reflex cameras are designed with built-in viewing glasses that slip into place behind the lens, filtering the image reaching the ground glass for contrast evaluation. Many filmmakers who do not have the luxury of such cameras often hold their own glass in front of the camera lens while viewing the set through the reflex finder.

Placement

In many location situations the placement of the backlight becomes increasingly difficult. Walls may be too close to the subject, and the ceiling may not be sufficiently high to allow proper placement of the light. A backlight placed on a light stand behind the subject may restrict the camera's position, but if the fixture is moved too far from the camera-lens axis, it may spill unwanted illumination onto the face of the closeup, spoiling the visual impact of the shot. For these reasons alternate methods of backlight placement may be needed. Each of the following techniques will aid in the placement of the backlight without interfering with the framing of the shot.

1. The light may be *attached to a bracket* and held in place on the wall or ceiling behind the subject, eliminating the stand.

2. The lamp may be *hung from a horizontal support* stretched between two adjacent walls. (The horizontal support is called a *rigging* and is similar in function to the lighting grids found in studios.)

3. The light can be *attached to an aluminum pole* or piece of lumber and hidden from the camera by painting or papering it to match the background.

4. The light can be *mounted to a horizontal boom arm* that is attached to a floor stand. The backlight is then positioned high overhead and in back of the subject, and the stand remains out of frame.

LIGHTING RATIOS

Contrast in lighting created by varying intensities of key light to fill light is expressed as a *lighting ratio*. By measuring the balance or intensity differences between the key and fill lights the light and shadow on the subject can be assessed. The measurement of a lighting ratio has traditionally been applied only to relatively small areas. But it can also be useful in establishing lighting contrast and in maintaining the mood and lighting continuity of shots within a sequence.

CLOSEUP FILMING

Lighting ratios for closeup filming specifically involve manipulating the intensity of the fill light in relation to that of the key. As mentioned earlier, the key light affects the direction of the predominant shadows and establishes facial modeling. Although the position from which the key strikes the face may change from shot to shot, its intensity should never change. If the key's intensity remains constant, the degree to which the facial modeling is noticeable, the mood of the shot, and the contrast of the subject in the closeup rely not on the intensity of the key but on that of the fill light.

Mood

Lighting ratios are helpful in that they offer a concrete method of expressing the lighting mood, enabling the filmmaker to reproduce and preserve it from shot to shot.

Daylight moods are produced by using a fill light that approaches the intensity of the key. Called a *high-key* shot, modeling and contrast decrease proportionally as the fill light is increased: a flatter but brighter closeup is created. High-key closeups almost invariably have a low lighting ratio. On the other hand, *low-key* shots that create dark, somber, or *nighttime* moods often have high lighting ratios. Produced by restricting the intensity of the fill illuminating the subject in relation to that of the key, varying degrees of low-fill levels add depth and contrast to the frame and accentuate the modeling of the subject.

Continuity

The establishment and maintenance of a lighting style or mood from shot to shot is called lighting *continuity*. By keeping the lighting ratios of closeups within a sequence constant continuity can be preserved. This is especially important if retakes of a scene become necessary. Good lighting continuity also facilitates the editing of sequences, producing a smooth, well-filmed image for the screen.

Appearance of the Subject

Measurement of the lighting ratio is a reliable method for predicting the appearance of the filmed image. If the film's contrast and tonal response to various lighting ratios are known, a more accurate previsualization of the filmed image is possible. Of course, each film stock exhibits different tolerances to exposure extremes, but, if the filmmaker is familiar with the characteristics of the stock, normal filming as well as special effects may be produced by keeping the lighting ratio either well within or at the limits of the film's exposure range.

CALCULATING LIGHTING RATIOS

Lighting ratios are expressed as a numerical ratio between the intensities of the key and fill lights. When measuring small areas, such as faces in closeup, the ratios may be calculated in one of two ways, depending on whether or not the key and fill overlap in their illumination of the subject.

In the first and most common setup the key is positioned to the side of the subject. The fill is close to the camera in front of the subject, illuminating both the side in shadow and the side lit by the key. The lighting ratio for overlapping lights is expressed as *the relationship between the key plus the fill to the fill light alone, or lr =*

(k + f)/f. At other times the fill and key do not overlap. Under these circumstances the lighting ratio is expressed as *the relationship between the key alone to the fill alone*, or lr = k/f.

Measuring Lighting Ratios

Light readings for ratio purposes are commonly taken in footcandles (fc). If the key plus the fill measure 250 fc and the fill alone measures 125 fc, then the lighting ratio would be 2:1. If the intensity of the fill is decreased to 32 fc, then the ratio would be 250 fc/32 fc, or 7.8:1, rounded off to 8:1.

Lighting ratios may also be expressed as differences in f/stops. Since the f/stop progression is actually based on calculations derived from the relationship between the focal length of the lens and the diameter of the lens diaphragm, the f/stop numbers themselves cannot be used in the same manner as footcandle measurements in determining a lighting ratio. The differences between the f/stops must instead be converted to a geometric ratio (one in which the succeeding factors are multiples of those preceding them) before lighting ratios can be assigned. Translation of the variances between f/stops into geometric ratios may be more easily understood by studying the f/stop scale (3-1). A direct correlation between camera aperture, geometric ratio between the f/stops, and lighting ratio is depicted.

Consider the scale from f/4 to f/16. The amount of light reaching the film at f/11 is twice as much as f/16. This factor of two represents the geometric difference between the values assigned to the f/stops. Opening up the aperture from f/11 to f/8 lets twice the intensity through. But 4 times the amount of light passes through the lens at f/8 than at f/16, 8 times as much at f/5.6, and 16 times as much at f/4.

The geometric ratio between two f/stop readings corresponds to the lighting ratio of the shot. If lighting ratios are taken in f/stops, a one f/stop difference between the key plus fill to the fill alone is a 2:1 ratio. A two f/stop difference is a ratio of 4:1, a three f/stop difference 8:1, and a four f/stop difference 16:1. Likewise, a 3:1 ratio would be a difference of one and one-half f/stops; a 6:1 ratio would be a difference of two and one-half f/stops; a 12:1 ratio would be a difference of three and one-half f/stops.

TAKING THE READING

Whether you are measuring the lighting ratio in f/stops or in footcandles with an incident-light meter, one of two techniques can be used. Either is acceptable: the *incident-dome* method requires more time and two people but is easier to use, while the *photodisk* technique is more difficult to master but requires less time.

Incident-dome Technique

Turn off all set lights except for the key and the fill that illuminate the closeup. With the integrating hemisphere in place over the incident-light meter's cell, place the dome as close to the subject's face as possible. Measure the light either in footcandles or in f/stops, making certain that none of the light falling on the subject or meter is blocked by your body. Turn off the key. Take another reading with the meter in the same position. Measure the illumination from the fill light alone. A comparison of the two readings will give the lighting ratio on the subject.

Photodisk Technique

Replace the integrating hemisphere of the incident-light meter with a flat photodisk diffuser. The meter will still read incident light, but the photodisk will limit the meter's angle of acceptance of light to as little as 50° (check your meter specifications for the exact angle of acceptance). Since the key and the fill, in most overlapping-lighting arrangements, are generally placed within a limited angle in relation to the subject, they may thus be metered without interference from other set fixtures located outside the disk's angle of sensitivity. Leave on all the set lights, including any backlights and practicals. Place the meter close to the subject's face, with the photodisk pointed directly at

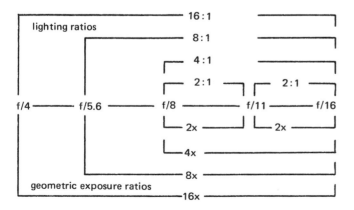

3-1. A visual correlation between apertures, geometric ratios, and lighting ratios taken in f/stops.

the key. From this position slowly rotate the cell of the meter until the highest possible reading is observed on the scale. This mixes the light intensity of both key and fill lights. Point the flat photodisk directly at the fill light from the subject position. Shade or block with your hand any light from the key that may be falling onto the flat diffuser. This will give a reading of the fill alone. Comparison of the two readings will give the lighting ratio of the setup.

In this technique the shading of the cell for the fill-alone measurement is most important. With a little practice it is well worth learning, considering the time-consuming disadvantages of turning on and off the set's lights.

EXPOSURE RATIOS

The use of ratios is helpful in maintaining the lighting continuity between any two areas of the set with established lighting patterns. Every set area actually exhibits two types of lighting ratio. One refers to intensity differences within a subject of limited area created by the relationship of the keys to the fills lighting that area, as with an actor's face lit for a closeup. The second refers to the relationship between the relative amounts of exposure intensity of one small set area and another area. Called an *exposure ratio*, it involves the total illumination of set areas and does not differentiate between the relationships between or the coverage of the key and fill lights.

To measure the exposure ratio of any two areas of a set, use an incident-light meter with the hemispherical dome in place. After the location's lights are set to their working intensity, take an exposure reading in each area of interest. The exposure ratio is expressed as *the exposure of one area divided by that of the other*, or $er = e_1/e_2$. For example, suppose that the exposure ratio of the subject in closeup and the background seen in the frame of the shot is needed. After the lighting setup has been established, measure the exposure on the face of the subject and the exposure of the background. By comparing these two readings the exposure ratio is determined. If the subject reads 250 footcandles and the background reads 64 footcandles, the exposure ratio is 250:64, or approximately 4:1.

It is important to remember the following points regarding ratios when lighting location sets.

1. Given any small area, *lighting ratios* refer to the lighting effect created by the keys and the fills illuminating the area, while *exposure ratios* refer to the overall exposure intensity of that small area compared to another area of the set.

2. Exposure ratios can be used to compare the relative illumination values of any two or more areas of a location set.

3. Exposure ratios are taken after the lights in every area of the set are adjusted to their working intensity and after the lighting ratio (if any) for each area is set to the desired proportion.

MAINTAINING LIGHTING CONTINUITY

Exposure ratios are especially important in maintaining lighting relationships between the closeups and the other matching shots within a filmed sequence. In each of the following examples the exposure ratios between the subjects and their respective backgrounds are important if proper lighting continuity is to be maintained.

Long-shot-to-closeup Ratios

When the long shot is lit, the exposure ratio between the subject's position and the background is also established. To preserve this lighting mood in a matched closeup, the exposure ratio between the subject and the background of the closeup must be nearly equal to the exposure ratio between these two areas of the long shot. This lighting-continuity match will facilitate intercutting of the two shots by creating a smooth visual transition.

To maintain continuity in the closeup, four readings are required:

1. exposure of the subject in the long shot

2. exposure of the background in the long shot

3. exposure of the subject in the closeup

4. exposure of the background in the closeup

By placing these readings into two exposure ratios the desired continuity can be kept. If the actor's block in the long shot reads 500 footcandles and the background reads 64 footcandles, this 8:1 exposure ratio must be duplicated in the closeup shots as well.

Closeup-to-closeup Exposure Ratios

Just as the exposure ratio between similar areas of the long shot and the closeup must be kept constant, so must the

same exposure ratio be maintained throughout the close-ups within the sequence. Of course, if no long shot is included in the sequence, the exposure ratio set in the first closeup should be duplicated in following closeups.

EXPOSURE RATIOS FOR LIGHTING CONTINUITY
Closeups Filmed to Match Long Shots
The following points should be remembered when working with exposure and lighting ratios in matching closeups to long shots.

1. Always duplicate the exposure ratio between the subject's position and the background in the long shot in the exposure ratio in similar areas of the closeup.

2. It is not necessary to duplicate the lighting ratio of the subject in closeup to that of the subject in the matching long shot. In fact, it is often advantageous to lower the lighting ratio of the closeup compared to that of a similar area in the long shot in order to facilitate the recording of detail. Once the lighting ratio of the closeup has been set, however, it must be adhered to whenever similar tight shots of the same sequence and subject are to be intercut. Even though the lighting ratio of the closeup may be lower than that of the long shot, the exposure ratio of the long shot should still be maintained in the closeups.

Continuity Between Closeups
To maintain lighting continuity between closeups filmed without matching long shots, remember the following points on exposure and lighting ratios.

1. Establish an exposure ratio between the subject and the background as seen in the frame of the closeup. Maintain this ratio with all subjects filmed on the same set within the sequence. The only exception to this rule concerns a subject moving in front of or near a motivating-light source. The exposure ratio between the closeup and the background may then be altered in accordance with this justified change in lighting intensity.

2. Establish a pleasing lighting ratio for each subject in closeup and maintain it throughout the filming of the sequence. Again, an exception occurs with motivating sources of light. The lighting ratio of the affected closeup should be changed according to the intensity of the motivating light.

CHOOSING A LIGHTING RATIO
Choosing a lighting ratio for a film depends on many factors. Some of these, such as the amount of modeling desired, the need to keep lighting continuity, and the choice of lighting to affect mood, have already been mentioned. Other factors include the amount of contrast already found in a certain shot and the characteristics of the type of film stock in use.

Color Contrast of the Subject
In choosing a lighting ratio for color filming the color contrast of the subject should be considered. *Color contrast* refers to the inherent amount of tonal separation within a subject created by the differences in color found in the shot. The color contrast of any colored object is influenced by three properties of color: hue, brightness, and saturation. *Hue* might be thought of as the color itself, *brightness* as its lightness or darkness, and *saturation* as its vividness, or departure from gray.

When filming in black and white, the inherent color contrast of the subject is not recorded in the same manner as it is in color, so a higher lighting ratio is usually needed to accentuate tonal separation. On the other hand, since color films record each of the above-named properties, tonal separation is achieved without the need to create the contrast through lighting. A lower lighting ratio can thus be used for color filming. When filming subjects with inherently high color contrast, use a lower lighting ratio, change from specular to softer keys, or alter the color contrast by changing the color of the set.

The Brightness Range
Any film stock has certain lighting-ratio tolerances that limit its use. These limits occur primarily because the ability of the film to record exposure contrast relates directly to the brightness range of the subject. The *brightness range* refers to the total contrast found in the subject, a contrast produced by the subject's luminous range and the lighting of the shot. Since the properties of the subject that affect brightness—its color contrast and its reflective characteristics—are often difficult to alter, the subject's lighting ratio must be relied upon to bring the total contrast within the exposure tolerance of the film in use. If the brightness range exceeds the recording capabilities of the film, faithful reproduction of the entire tonal range will not take place: highlights will burn out and dark tones will lose detail.

Since brightness-range difficulties are most easily dealt with by changing the lighting, film manufacturers usually suggest "safe" lighting ratios for most general-purpose filming. This information and other pertinent specifications are included in the data sheets packaged with the raw stock or published in other sources, such as the American Society of Cinematographers manual. The lighting ratios suggested in the data sheets for normal filming are usually quite low. A 3:1 lighting ratio for most color stocks is recommended; a 4:1 ratio is suggested for dramatic effects. Of course, the extent to which these recommendations are followed is determined by the lighting effect desired and by the nature of the subject. To determine the best working ratio, it is sometimes useful to run lighting tests before the actual shoot. In this way the filmmaker can determine the exact effect that the lighting ratios will give.

D Max of the Film

The maximum density that any film stock can reproduce is called its *D max*. The maximum density of a closeup is that portion of the frame that will reproduce with the darkest tones: i.e., an area in shadow or one that is actually black in color. The reproduction of the darkest area of the shot is influenced by the lighting ratio of that area. For example, films exposed to subjects lit to a high lighting ratio may never produce black or neutral-colored shadows. Other films used in similar conditions may pick up unnatural colors tinting the shadows unless a lower ratio is used to light the subject. A typical example of this is a situation in which Eastman Commercial (7252) film stock is shot under a high lighting ratio. Under these lighting conditions the film produces green-toned shadows. Neutral and untinted dark areas are obtained only by using a lower lighting ratio.

Problems with the coloration of the darkest areas of the subject cannot be corrected at the lab and are best discovered by shooting a test roll of film before the actual filming takes place. Test shooting has additional advantages. Through careful examination of the test rushes it is easy to become familiar with the actual appearance of a lighting ratio. An adept filmmaker can become familiar with the desired lighting effect and may be able to predict the effect of a lighting setup before the film is shot. Pretesting the ratios may actually conserve shooting time by eliminating the need to take continual ratio readings on the set.

LIGHTING THE CLOSEUP

In lighting any shot on location selection of the position of the key and other lights is often difficult. Because of the limitations imposed by the location itself it may be impossible to light the closeup in the most aesthetically pleasing manner. The choice of lighting pattern can be affected by such factors as the lighting mood desired, the location of motivating sources, the lighting continuity with the other shots, the lighting ratios needed in the closeup, the necessity of using a fill light, the type of key- and fill-light fixtures required, the movement of the camera and the subject, and the physical limitations imposed by the location. Because of these variables it is impractical to suggest exact lighting setups, but general guidelines for the placement of the key and other lights can be valuable. Experienced filmmakers can then modify these guidelines to light their own filmic situations.

Suggested closeup-lighting patterns fall into four general categories: broad-, narrow-, frontal-, and side-lighting setups. The filmmaker will discover that some of these same lighting setups or variations on them can be used to light the wider shots of a sequence as well. If this is the case, the filmmaker can simply adjust the position of the actor instead of moving the lights in order to produce the desired lighting pattern for the closeup. It is therefore important to pay special attention to the appearance of these various setups *as they model the actor's face*. This will help in situations in which the closeups are to be filmed "alone" and in which they are to follow other shots of the scene that are already lit to a particular lighting pattern.

THE BROAD-LIGHTING SETUP
Modeling

In a *broad-lighting* setup the section of the subject's face that is closest to the camera is lit by the key (3-2). The exact key position is chosen in such a way as to cast a triangle of light onto the dark side of the face, highlighting the subject's cheekbone and throwing the shadow of the nose into a barely noticeable position along the smile line. The shadow may be long or short, depending on the exact angle at which the light strikes the actor.

Broad lighting is also known as *on-camera* lighting, because the key is generally rigged on the camera side of the subject. This, of course, encompasses a myriad of angles, and with each the length of the facial shadows, along with the size of the triangular area lit (on the subject's dark side), varies accordingly.

Since facial shadows modeled by the key are located opposite the camera and are less predominant than those produced by other lighting setups, precise positioning of the key is not so important as it is when the shadows are more clearly in view from the camera angle. This can be a timesaving advantage on some sets. The key is easy to place, and by opening the fixture's barndoors an area larger than the closeup's coverage can be lit without destroying the facial modeling of the shot.

The broad-lighting setup can be differentiated from other lighting designs in that facial shadows always fall *away* from the camera and the subject at a *downward* angle. Shadows streaking across the face are caused by another key setup (i.e., a side light), usually from a fixture located closer to the eye level of the subject instead of at a more elevated position, as is the case with the broad-key-lighting design.

Lighting Effects

Broad lighting is somewhat flatter in appearance than that produced by the other setups. If the brightest part of the frame is near the camera, the feeling of depth in a closeup shot is limited. This may not be always a detriment: broad lighting is frequently used in high-key sets, and the relative lack of depth is accepted by the viewer as the result of a natural light source. For this reason broad lighting is frequently used to light locations that are to resemble daylit interiors. In such high-key situations broad lighting, balanced to half an f/stop less than the intensity of the natural illumination coming through the location's exterior windows, creates a light and airy mood for the scene.

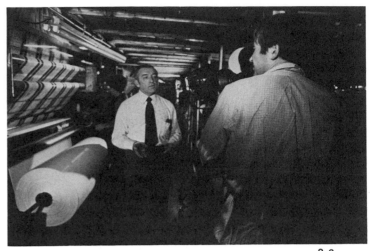

3-3

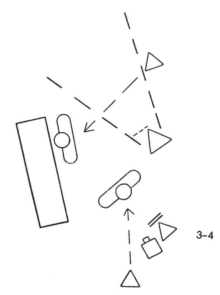

3-4

Closeup/supervisor/interior. 3-3. This head-and-shoulders closeup is keyed by a broad-lighting setup. The fill light is heavily diffused and positioned close to the camera, lowering the lighting ratio on the face to 2:1. To provide contrast and separation the machine and its operator, seen in the background, are lit from an angle that throws the operator's shadow across the white fabric roll to the left of the frame. 3-4. Lighting diagram: the distant background is lit to two f/stops below that of the closeup; the near background, to one f/stop below that of the closeup.

3-2. Broad-lighting setup.

3-5

3-6

Closeup/Danny/low key. 3-5. Broadly lit closeup seen from the camera position. The lighting ratio is 4 : 1; the exposure ratio between the subject and the background is 6 : 1. This exposure ratio, rather than the lighting ratio on the face or the lighting design, provides the low-key mood of the shot. 3-6. Focusing spots rigged on stands act as key and fill lights. Barndoors are narrowed to a vertical position, limiting the spread of light onto other areas of the set.

In industrial filming broad lighting is often used in high-key interior scenes such as those lit by overhead fluorescent tubes. In an office scene, for example, broadly placed softlights or diffused focusing spots produce a relatively flat and shadowless closeup, which is a realistic lighting design for the location. Although the keys do not duplicate the direction of the existing source, the quality of the illumination closely resembles that of the natural light. In this, as in similar location situations, compromises may have to be made and a lighting design chosen according to the priorities of the filmmaker.

Fill Lights
The fill for a broad setup overlaps the coverage of the key light. It is placed close to the subject's eye level on the opposite side of the camera to the key, where it is directed to control the lighting ratio of the setup. It should not cast noticeable shadows on the subject's face, and its adjustment should take into account the positioning of noticeable shadows on the background.

Fill lights specifically directed to illuminate the closeup may be unnecessary in some broad-lighting setups. The function of lighting-ratio control is often left to the general overall fill illumination rigged for the long shots. This occurs especially in high-key dramatic scenes in which the closeups are filmed after the long shots: the high fill ratio and the direction and position of the fills need not be changed from that of the long shot to fill the closeup adequately. In these situations mat-white reflector boards may be able to reflect into the face any additional fill light needed.

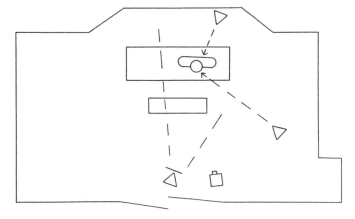

3-7. Lighting diagram: the background is lit by spill light from a diffused fill; a backlight rigged to the ceiling molding aids in separation.

NARROW-LIGHTING SETUPS

Reversing the placement of the key and fill from that of the broad-lighting setup forms a *narrow-lighting* design (3-8). A much more flattering lighting setup for a closeup, the narrow key leaves a portion of the side of the face closest to the camera in darkness. The narrow key should be located above subject height so that it produces a triangle of light on the dark side of the subject, but it should lie closest to the camera. Narrow-key lighting is also called *off-camera* lighting. Since the narrow key can strike the subject from a large number of angles, the length of the facial shadows and the degree to which the subject closeup (dark side) are lit can vary greatly. It is important to remember that in all narrow-lighting designs the shadows fall *downward* from the subject *toward* the camera. With the key positioned on the far side, the subject's shoulder nearest the camera is naturally left dark, adding depth to the shot. Because of the large area of darkness included in the frame of such a closeup narrow keys provide perfect illumination for low-key scenes. Key-light fixtures that produce either hard or soft illumination may be used equally as well for this effect, although large softlights can destroy the modeling characteristics of the narrow-lighting design, especially if used to light subjects from a close range.

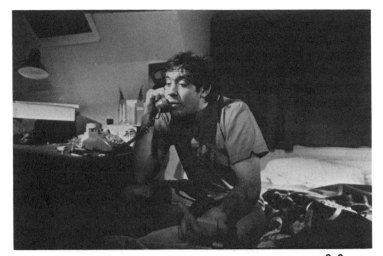

3-9

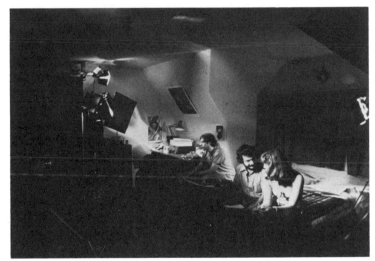

3-10

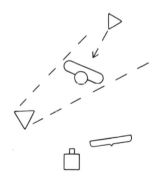

3-8. Narrow-lighting setup.

Closeup/phone call/low key. 3-9. Closeup from near camera position. The actor is keyed by a narrow-lighting design with a 4:1 lighting ratio. Dark draperies behind the actor are keyed to one f/stop below the exposure on his face. (The desk lamp that acts as the motivating practical in this setup is not lit in this photo.) 3-10. Notice the rectangular black flag used to control further the spread of the key light. The flag blocks the edge of the bed, keeping this area one f/stop darker than that of the face of the actor, adding depth to the shot. 3-11. Lighting diagram: a localized fill is used to control unwanted illumination that would destroy the mood of the scene.

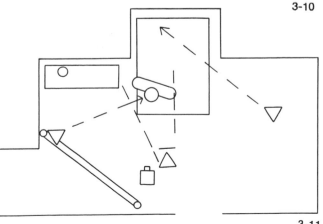

3-11

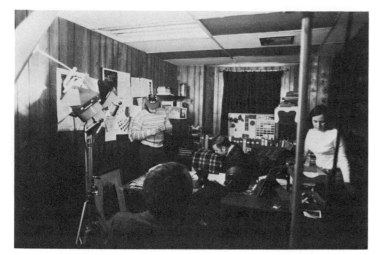

3-12

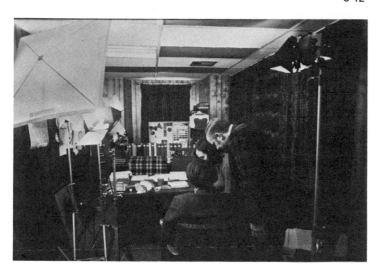

3-13

Key Placement and Subject Movement

Unlike the broad setup, the narrow key's placement is extremely critical and must be meticulously set, because facial modeling is highly visible from the camera angle. The main light must be high and angled to the front of the subject enough to prevent the bridge of the nose from casting a large shadow. If placed correctly, the subject will be free to move his head without forming undesirable shadows on his darkest side. The narrow key also permits a fair amount of subject movement. Even though the subject may look directly toward the key, the light striking him will still preserve depth on the shoulder and on the side closest to the camera. If the subject faces the camera, the key will side-light the face. Although the lighting design on the subject's face changes with each of these movements, the low-key mood still prevails. In each case the dark side remains closest to the camera, permitting the fill to illuminate the subject to the correct lighting ratio. If the subject turns his head further toward the key, however, the side of the face closest to the camera will be the most lit: a broad-lighting setup will result, and the facial modeling may be destroyed.

Fill Lights

The fill light for the narrow-key closeup is positioned to overlap onto the area lit by the key. As in the broad-lighting setup, the fill should be located near the subject's eye level and close to the camera and should not create any shadows of its own on the subject.

Closeup/designer at desk/high key. 3-12. The closeup filmed from this angle shows the designer sitting at the desk. The soft umbrella key-lights him with a narrow setup. The lighting ratio on his face is 2:1, even though a traditional fill light is not used. 3-13. Focusing spot lights the background to within $\frac{1}{2}$ f/stop of the closeup. 3-14. Lighting diagram: the background is keyed separately because umbrella key light falls off rapidly, often before it reaches the background.

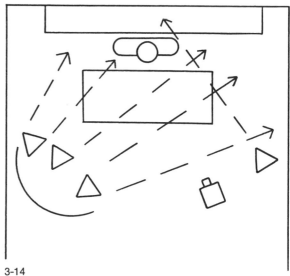

3-14

Of all the closeup-lighting setups the fill light's function in the narrow setup is the most critical. Since most of the narrowly lit closeup is in darkness, proper selection and placement of this fixture are important. On low-key sets emphasis is placed on contrast in lighting, and some location long shots may not be lit with fill at all. Others may be lit with a small amount of fill, which is unsuitable for closeup filming. When filming narrowly lit closeups on sets rigged for low-key long shots, the fill illumination may therefore need to be reset or adjusted from that of the long shot.

The fill-light fixture for the narrow closeup should be diffused to help soften any shadows that it casts. Sharp shadows will be more noticeable on low-key sets, for spill light from the fill may fall on set areas other than those for which it was intended.

Lowering the Lighting Ratio

It has already been mentioned that lighting ratios lower than those of the matching long shots are frequently used for closeups. This technique is especially beneficial in dramatic films when low-key long shots are to be intercut with narrowly lit closeups. The moody effect of the long shot is preserved in the narrow-lighting arrangement of the closeup, while the additional fill in the closeup opens up the shadow details but still maintains the feeling of the low-key sequence.

The specific amount of extra fill varies with personal taste and with the lighting effect desired. It is not uncommon, however, to fill in the closeup with twice the amount of fill illumination used in the matching long shot. The lighting ratio of the closeup is in effect halved from that in the long shot. For example, a subject lit to an 8:1 lighting ratio in the long shot may be lightened to a 4:1 ratio for the closeup shooting.

3-15

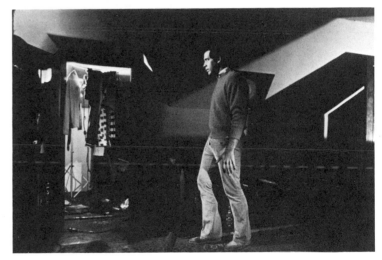

3-16

Closeup/closet scene/low key. 3-15. A 6:1 narrow-lighting design is keyed from a stand-mounted focusing spot. The bright streak behind the actor is 1½ f/stops over the exposure of his face. 3-16. From a long-shot position the action, keyed with the same light as for the closeup, is frontally lit. The exposure ratio between the action area and the closet interior is 1:1. The lighting ratio on the face is higher than that of the closeup: in this example it is 8:1. 3-17. Lighting diagram: the patterned-background effect is produced by shining a key through a half-opened door. Fill is provided by a diffused 1K softlight.

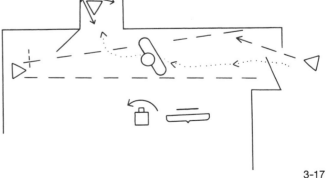

3-17

ADVANTAGES AND DISADVANTAGES OF NARROW AND BROAD SETUPS

Both narrow and broad setups are well suited for closeup location filming. Variations in lighting ratios used with each setup produce a pleasing range of visual effects as well as effective modeling. If the mood of the long shot is maintained by the narrow- or broad-lighting setup selected for the closeup, either may be used to add desirable modeling and emphasis on the subject without producing a lighting-continuity mismatch with the longer shot. A further advantage of both is that either setup may be designed to light the closeup from stand-mounted positions. This saves setup time and aids in focusing the lighting fixture.

There are two primary drawbacks to the use of narrow and broad lighting for a closeup. The shadows cast by these setups fall slightly to the side and behind the actors and have a tendency to fall into frame when the actor moves close to the background. Although the shadow isn't necessarily distracting, its position on the background tends to suggest that the illumination is coming from a motivating source. This condition may be unnatural or unrealistic in some filming circumstances. These setups also allow the actors only a limited area in which to move. The third closeup-lighting design, the frontal setup, does not have this disadvantage.

3-18. Frontal-key-lighting setup.

FRONTAL-LIGHTING SETUPS

Frontal-lighting keys are positioned to illuminate the face of the actor in such a way as to produce a small shadow underneath the nose and neck. They illuminate both sides of the subject at the same time and are generally positioned high overhead and in front of the subject (3-18). Although they flood the face with light, frontal keys also allow a great deal of freedom of movement while casting a believable and natural lighting pattern on the face. Because of their position frontal keys attractively highlight the hair and forehead of the subject. The exact angling of the key in relation to the front of the subject controls the size of the facial shadows and, of special importance, the degree to which the keys illuminate the eyes.

Mounting the Keys

The key fixture for the frontal setup must be located far enough away from the subject to produce an even illumination without appreciable intensity falloff across the frame. This poses a problem in mounting the keys, for many location-interior ceilings are too low for this placement. Stand-mounting the keys is possible, but it sometimes interferes with the position of the camera. The best way to avoid these difficulties is to mount the keys in an alternate manner, such as from a temporary grid placed near the ceiling of the set.

The Key Fixture

When filming closeups to be lit with a frontal key, select a lighting fixture with a more diffuse reflector than those normally used for other setups. A focusing spot will do, but some units may require diffusion to soften the beam further. A less specular illumination will cast less harsh shadows beneath the neck and nose of the subject. Softer facial shadows may not require additional fill-light illumination, a definite advantage when setup time is at a premium.

Fills

Since the facial shadows cast by the keys are minimal in size, the importance of the closeup fill light in frontal-key sets is not as great as in the other setups. For example, with a high-key sequence the general ambient fill light already positioned to illuminate the room in a long shot may often be sufficient to illuminate the closeup as well when bounced into the face from reflector boards. Of course, depending upon the subject and the actual length

and density of the facial shadows, a fill light may become necessary. When this is the case, its position is not unlike those used in the other setups. Fills for the frontal closeup most effectively lower closeup facial contrast when directed to strike the subject from an eye-level position. The fill is frequently mounted on the camera just above the lens housing. From this position it is diffused or scrimmed to create a pleasing lighting ratio on the face of the subject.

3-21

3-19

3-20

3-22

Closeup/man typing/low key. 3-19. A key light rigged directly over the camera lights the closeup frontally. 3-20. Closeup view from near the second-camera position. The key is angled to produce a small shadow beneath the nose of the actor. 3-21. The background is lit three f/stops below the exposure of the closeup. 3-22. Lighting diagram: the background light is bounced to provide a shadowless illumination.

Versatility

The frontal-key-lighting setup is an extremely versatile and efficient method of lighting closeups as well as longer shots. Since the position of the key deemphasizes facial

3-23

modeling and offers freedom of subject movement, little time is required to set up the lights. As a frontally keyed subject moves his head to either side in closeup, the modeling changes, casting patterns similar to those of narrow or broad designs but with short facial shadows. Frontal lighting closely resembles the quality and direction of illumination that would be provided by interior ceiling lamps or hanging practical lights. Used to approximate motivating-light sources, these keys can be used in both low- and high-key moods. Their positioning allows accurate and precise control of the lighting on the foreground and background areas of the set.

When used to light a closeup near a back wall or prop, little of the key light spreads onto the background. This is because the steep angle from which the key strikes the subject causes the shadows to fall behind and nearly straight down from the subject. For low-key effects one particular advantage of front lighting is its lack of facial

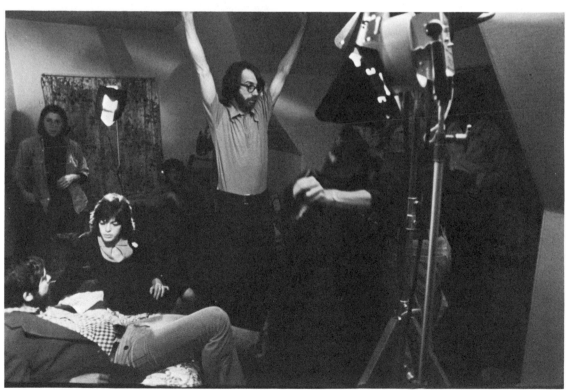

3-24

shadows: the position of the light causes them to be small and for the most part inconsequential. Much of the general fill illumination needed to lower the contrast of the shot might therefore be eliminated or switched to a more directed fill-lighting unit. Removal of a great deal of the overall fill illumination reduces the chance of fill-light spill and helps preserve the low-key mood.

Medium shot/Sandra and Danny/low key. 3-23. View from the camera angle. A single focusing spot frontally keys the woman and side-keys the man. The lighting ratio on the faces of the subjects is 4:1; the exposure ratio between the action and the background is also 4:1. The closeup shot from this angle is of the woman. 3-24. The position of the backlight can be seen just outside the camera view. It is fine to rig such lights on a stand. 3-25. Streak light on the background is produced by the lower of the two focusing fixtures seen here. The small table practical motivates the angle from which the keys light the action. A 2K softlight bounced off the ceiling provides the fill. 3-26. Lighting diagram.

3-26

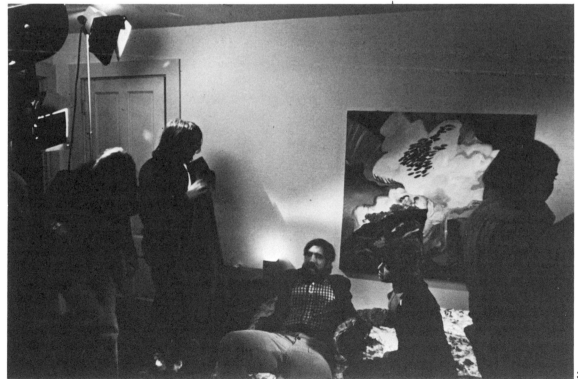

3-25

73

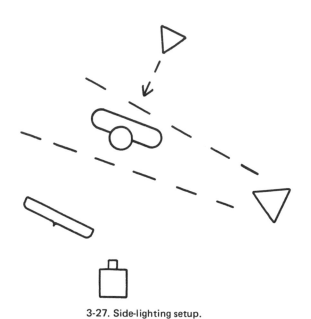

3-27. Side-lighting setup.

SIDE- AND CROSS-KEY-LIGHTING SETUPS

Side lighting is usually used to duplicate the realism of specific types of interior and exterior natural-light sources. With this setup one side of the subject's face is key-lit while the other side is left in shadow, lit by the key only when the actor turns his head into the light. This position casts elongated shadows onto the darkened side of the face as the *key* strikes the subject from a height close to his eye level. Modeling is not important, as the emphasis is placed on a motivated-light effect in which the source of illumination suggests an eye-level practical.

`Either specular or diffuse illumination is used with this setup. The directable light of the focusing spot` is ideal for duplicating conditions that simulate light from hard interior and exterior sources—i.e., streetlights, porch lights, and eye-level table lamps with translucent shades. The diffuse, spreading illumination of the softlight is used as a side-light key to simulate natural-lighting conditions of interior closeups lit by window light.

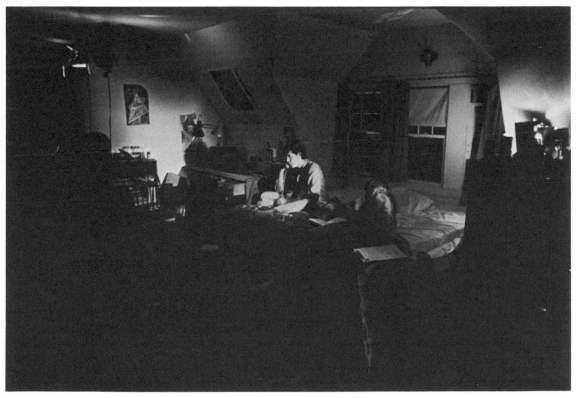

3-28

Positioning Side-light Fixtures

The side-light setup keys the subject at an angle of about 90° from the front (3-27). Generally placed on stands at eye level, side lighting can be used to illuminate the subject from either side, regardless of the position of the camera. As in more traditional setups, the side of the face that is not lit by the key is filled in by a fixture placed directly in front of the subject. From this position, depending on the quality of the illumination provided by the key, the fill illuminates both sides of the face and is able to control a noticeably visible lighting ratio through variable degrees of intensity. The eye-level fill of the side-light setup casts no appreciable shadows, especially if a very soft and diffuse light is used.

Closeup/phone call II/low key. 3-28. A focusing spot (seen at far left) rigged to a grid near the camera position provides directional diffused-fill illumination. In this position the shadow falls behind the actor off the background, where it is not noticeable. The desk lamp is fitted with a 250-watt balanced flood, providing illumination for this area. The back wall is lit to the same intensity as that of the actor in the closeup. 3-29. The closeup as seen from the mid-point of an arc-shaped camera dolly. The subject is keyed with a side-lighting setup, with the side light mimicking the motivated-lighting effect from the practical. The lighting ratio on the face is 8:1; the exposure ratio between the subject and the background is 6:1. 3-30. Lighting diagram: a 1K softlight bounced off the ceiling supplements the illumination on the background and provides additional shadowless fill.

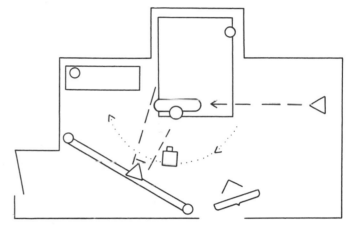

3-30

3-29

3-31

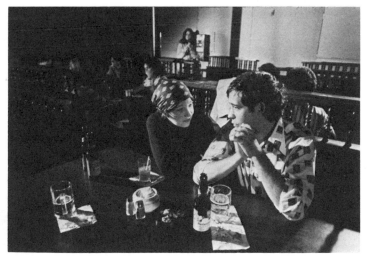

3-32

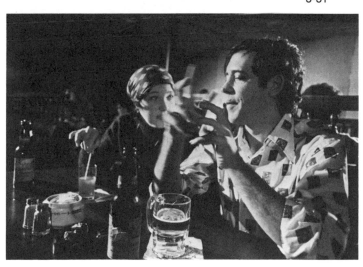

3-33

Positioning Cross-key Fixtures

The fill light in the side-lighting setup becomes a *cross key* when it is moved to light the side of the face opposite that toward which the side key is directed (3-35). This setup utilizes two key lights. Both keys are approximately on the same lighting axis, and each illuminates only one side of the face. Since no traditional fill-light fixture is needed in the cross-key-lighting setup, both fixtures selected to key the subject should be similar in type or design. One of them provides the exposure illumination for the closeup, while the other's intensity is adjusted until the desired lighting ratio is achieved.

Variations of the cross-key setup appear frequently in television lighting. Two keys are rigged high above the set, each fixture at a 45° angle to the subject's front. Shadows are cast to either side of the face onto the shoulders of the actor. Used in this way, the lighting provides a great deal of freedom of movement. The abundance of multiple shadows created by this arrangement, however, generally discourages its use in location motion pictures.

Closeup, medium, long shots/bar/low key. 3-31. A stand-mounted key, with the barndoors in the vertical position, is directed to light the male character and allowed to spill illumination onto the female. A bounce light, seen to the left of the frame, fill-lights the foreground. To provide atmosphere for this bar sequence, all backlights are filtered with a blue gel. A gelled light, seen to the right of the frame, backlights one character and side-lights the other. 3-32. To provide depth and separation, the people in the booth to the left are lit at two f/stops below the exposure for the closeup; the person at the phone in the background is lit to one f/stop below the exposure of the main action. The back wall to the extreme left is lit to four f/stops below the exposure of the scene. 3-33. As the camera booms down from this angle, closeups of each character are filmed. The man is lit by a narrow-lighting setup to a 4:1 lighting ratio; the woman, lit to the same ratio, is illuminated by a side-lighting design. 3-34. Lighting diagram: camera angles similar to the one illustrated here are used to film this scene in long shot, medium shot, and closeup. The key lighting remains the same throughout, but the bounce-light fills are increased for the closeups. The lighting ratio on the faces of the actors in the long shot is 8:1; in the closeup, 4:1.

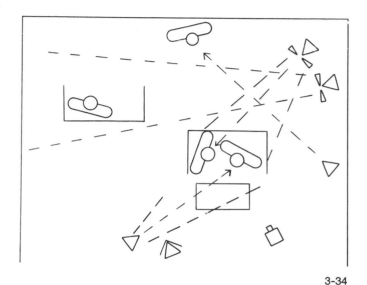

3-34

3-35. Cross-key-lighting setup.

MOTIVATED LIGHTING

Any in-frame light source may be used to dictate the direction from which a key should illuminate the subject. Such a light is called a *motivating source:* along with a directed key it can be used to produce the effect of natural, realistic lighting. Whether used for a documentary or a scripted production, motivated lighting is the most practical method of choosing a direction from which the key should light the action. It is effective in situations in which actual light sources are seen with the subject but may also be utilized if the mood of the location action indicates it, even if there are no in-frame sources.

Motivated lighting should not be confused with natural illumination. With motivated lighting the lighting design is seldom created by the motivating source itself but is produced through the judicious use of an appropriate lighting setup plus a careful balance of other set lights that illuminate the various portions of the closeup frame.

Selecting a Setup

Any type of lighting setup is suitable for motivated lighting as long as it duplicates the direction from which the natural source of light strikes the subject. In location filming side-key and narrow-key lights are frequently used to approximate the quality of illumination created by an eye-level, motivating practical.

Although the subject should always be keyed from the general direction of the motivating source, it is not necessary to duplicate it exactly, as the choice of the proper lighting setup can enhance modeling without destroying the feeling of reality created by the directional characteristics of the existing illumination. Use a side-light setup if the natural source flanks the subject. In filming a subject supposedly lit from an above in-frame fixture key the closeup with a narrow or frontal setup. If the illumination appears to be coming from the direction of the existing practical, a motivated-lighting effect will be produced.

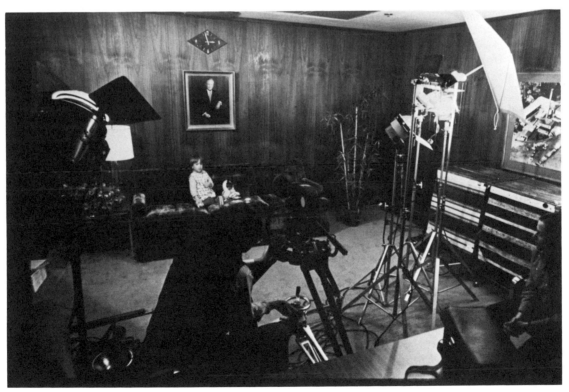

3-36

78

Motivated Closeup Effects

If an existing practical, such as a table lamp, is included in the frame, replace the lamp's bulb with a boosted 3200°K photoflood bulb. A 250-watt bulb works well for this setup, but be sure to use the balanced photo bulb and the table lamp for effect only. Do not attempt to use the bulb to produce the exposure illumination of the subject.

Direct a side-key light, placed at the same height as the subject, toward the side of the face closest to the table lamp. Adjust the intensity of the key to conform with the preselected aperture used throughout the production. By adjusting the side-key light to the same exposure level as that used in other shots lighting continuity is assured.

If the practical lamp has a translucent shade, measure the light with an incident-light meter held about 1' away from the shade. This reading should be about one f/stop over the exposure of the closeup. Switch the boosted bulb to one of lower wattage or cover the inside of the shade with a neutral-density filter to achieve the intensity desired. Use a diffused frontal fill to lighten shadows. To get the effect of natural illumination, keep the lighting ratio on the subject's face fairly high: at least 4 : 1.

Closeup/little girl/interior. 3-36. A dark velvet couch and dark but shiny paneled walls present a lighting problem, which is solved by using bounce light for key and fill. The soft, scattered light helps desaturate the color of the couch, lowering the luminance ratio of the shot, and prevents glare in the wall lighting. The 2K fixture to the left of the frame is the key light for the shot. The majority of its illumination is bounced off the white ceiling, but the lamp is angled in such a way that some feathered light spills directly onto the subject, adding contrast to the shot. The key's position is motivated by the practical. 3-37. Extremely soft fill light is produced by bouncing four 1K fixtures off a photographic umbrella located close to the camera position. 3-38. The closeup as seen from the camera position. The feathered light from the key lights the subject with a side-lighting setup; the lighting ratio on the face is 2 : 1. The foreground and the background wall behind the couch are lit to $\frac{1}{2}$ f/stop below the exposure of the subject. The dark wall to the left of the table lamp is lit to two f/stops below the camera exposure for the scene. This area is left at this intensity so that illumination produced by the practical will appear noticeably bright. The shadow cast by the lampshade onto the back wall, which results from the feathered spill of the key, is later removed by flagging the key light. 3-39. Lighting diagram: the intensity fall-off of the diffuse fill light is responsible for lighting the background to the left of the practical to two f/stops below that of the exposure of the rest of the shot.

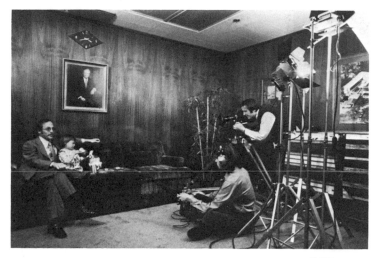

3-37

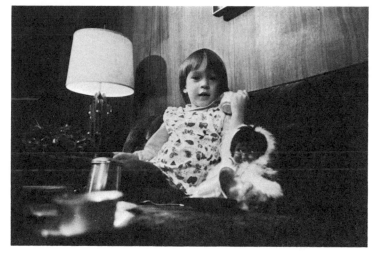

3-38

3-39

Mood and Background Considerations

Although the motivating source itself is not used to produce measurable exposure illumination for the closeup, its intensity must be bright enough in relation to that of the scene's other set lights to provide a believably realistic appearance. The intensity of this source specifically relies upon two factors: the relative brightness of the background and the lighting mood of the shot. In a high-key scene, for example, a practical that has to compete with a bright background may have to be two or three f/stops over the exposure keyed on the subject's face before its illumination becomes noticeable. If, on the other hand, the background illumination of a scene is one or two f/stops below the key light's exposure of the subject, a practical lit to one f/stop over the subject's exposure may look very natural. If the motivated effect is to be preserved, the intensity of the illumination produced by the motivating source must increase as the background illumination increases with the lighting mood of the shot.

Pretesting for the Effect

These suggested setups should be used only as starting points for balancing the intensities of lights in a scene. Actual testing on the location interior will provide the exact relationships desired in a sequence. If pretesting for lighting ratios and effects is not possible before shooting, take a Polaroid camera along. Set up the desired lighting and exposure ratios with the subject in place. A Polaroid picture of the setup will provide an approximate indication of how the selected ratios may film.

SOFTLIGHTS FOR LOCATION FILMING

In recent times motion-picture photography has seen an increasingly noticeable shift toward softlighting. In many locations soft, shadowless light is the only answer to many problems that would arise if conventional setups were used. One problem with softlights is that they offer little control over lighting ratios, for their illumination spreads widely over large areas of the set. They are also inefficient sources for lighting, which can prove to be a problem on larger locations, especially those for which limited electricity is available.

As previously mentioned, softlights are excellent for lighting location closeups, but the filmmaker must be careful not to mix softlight closeups with others shot with harder and more specular illumination: this would cause a noticeable lighting-continuity mismatch. The exception to this rule occurs when both the softlight and the harsher light are motivated by existing practicals. For example, shots of an actor lit by a softlight whose direction is motivated by a window can be mixed with shots of another actor lit by the harsher light of a table lamp.

4. Lighting for Medium Shots

Coverage of the medium shot is even more variable than that of the closeup. Usually defined as a shot that falls between a closeup and a long shot, the *medium shot* frequently includes a middle-length view of the subject. The frame isn't limited to a single waist-up figure: medium shots are often composed to include more than one subject.

When the medium shot is framed to include only one subject, its expanded area of coverage changes the lighting setups and considerations used in filming similar but tighter shots only slightly. As long as the subject remains in a more or less similar position for the medium shot, the position from which the keys and the fills light the closeup need not be altered to light the slightly larger area effectively. Unless the keys are extremely close to the subject for the tight shot, the same versatile focusing spots used for the closeup will easily cover a similarly composed medium shot. A slight redirection of the key may become necessary to accommodate the larger frame, but the key's primary positioning will most likely remain unchanged. To light the wider area, the fixture's vertical barndoors can be spread slightly or the throw of the lamp adjusted to expand the fixture's coverage. In doing so, however, parts of the set may have to be flagged to preserve the mood of the lighting design in the remaining shots in the sequence.

As the frame expands to include larger set areas with more than one subject, lighting problems often become more involved. Although the lighting setups for medium shots may be less meticulously set than for closeups, especially in terms of facial modeling, more attention must be paid to the following factors:

1. intensity falloff

2. balancing exposures between multiple key lights

3. directional-lighting continuity

4. shadow placement

5. background illumination

LIGHTING FALLOFF
The term *lighting falloff* refers to the lessening of the intensity of illumination that reaches a subject due to the tendency of light to spread over a larger area as the distance between a subject and a light source increases. More specifically, light intensity "falls off" in inverse proportion to the square of the distance between the source and the subject, or $li = 1/d^2$.

Intensity-falloff problems become more noticeable when single fixtures are used to illuminate large areas, especially if there is a great deal of subject movement on the lighting axis. This problem is unfortunately quite common. If lighting-falloff problems cannot be alleviated through lighting-placement or -control techniques, the subject movement may often have to be restricted or the camera angle compromised.

Remember that lighting falloff is maximized when the subject is close to the light source. The further away from the source, the more freedom of movement the subject has without creating lighting-falloff difficulties. When lighting medium shots with a lot of movement, the keys should therefore be placed as high and as far away from the subject as possible. Of course, this ideal position can be restricted by the ceiling height of the location and by the availability of specific rigging and mounting equipment. The location filmmaker is frequently placed in the undesirable position of having to light a medium shot with a single stand-mounted key positioned not far above the subject being lit.

ONE-LIGHT SHOTS
Lower stand-mounted fixtures placed at the side of the subject may be used to illuminate medium shots with limited movement if precautions are taken to prevent falloff. The two primary techniques for accomplishing this are to increase the distance between the lighting and the subject or to use scrims.

4-1. A couple in medium shot, one in profile and one head-on. The camera frame is indicated; a stand-mounted key is included.

If one key must be used to illuminate two subjects from a side stand-mounted fixture (4-1), the intensity falloff between the two would be a definite problem, for, with the key placed at a normal working distance from the set, the intensity difference between the couple in frame may vary by at least one f/stop (4-2). In practice this intensity problem would be dealt with in one of two ways. When the distance between the subjects and the light is increased, the falloff within the area included in the frame is lessened. It is usually possible to even out the exposure intensity between the two subjects by moving the fixture to a more advantageous position (4-3).

At times the physical layout of the location prohibits this type of lamp placement and a half scrim must be used. For example, for a medium shot lit by a single source keyed close to the subjects (4-2) a half scrim correctly positioned in the fixture in a vertical manner will decrease the intensity of the illumination reaching the subject nearest the fixture by one full f/stop (4-4). It will not alter the intensity or the quality of the light that reaches the far subject, and it will balance the light on the couple lit from a side stand-mounted key without increasing the proximity between the lighting fixture and the subject.

MULTIPLE KEYS
SETUPS

A *multiple-key* setup is one in which more than one key light is used to illuminate the scene. This lighting design is often used in medium shots with more than one subject in the frame, and it offers several advantages to the location filmmaker. Multiple-key-lighting setups alleviate intensity-falloff problems and aid in balancing the exposures between the subjects in the frame. They produce variety in lighting design and are helpful in dealing with special reflectance and subject-luminance difficulties. The use of one key light for each actor in the frame permits the precise lighting mood and design of the overall shot to be maintained without interfering with the modeling or the exposure balance of any other individuals seen in the frame.

TERMINOLOGY

The terminology used to describe the positioning of the keys for medium shots is similar to that used for closeup lighting. Although there may be one key for each subject included in the frame of a medium shot, the description of each key is derived from the way in which it strikes the subject as it relates to the camera position. Multiple-key setups designed to illuminate medium shots may therefore be made up of combinations of individual narrow, broad, side, or frontal keys, each directed to light one of the many actors in the frame.

4-4. Controlling the intensity falloff with a half scrim.

4-2. The intensity falloff from one stand-mounted light at a "normal" working distance from the medium shot.

4-3. Controlling the intensity falloff by increasing the distance between the key and the subjects.

NUMBER OF KEY FIXTURES

As the number of actors in the shot increases, it may or may not become necessary to use a key for each one. In fact, the number of fixtures needed and the necessary redirection of each in the course of filming will vary according to the lighting effect and the mood. For example, in high-key scenes closeups, medium shots, and long shots are often lit in much the same lighting pattern, and there may be little need to change the lighting from above as the coverage of the frame decreases. High-key medium shots usually don't require individually precise lighting on each of the subjects and often need fewer key fixtures. On the other hand, multiple keys narrowly placed for low-key shots may have to be *individualized* (one for each actor) to provide ultimate control of lighting design and mood. Of course, this greatly increases the number of fixtures needed to light the shot and often necessitates a change of direction of the key lights as the filming progresses.

EXPOSURE BALANCE

Areas lit with similar amounts of luminous intensity are referred to as being *balanced* for exposure purposes. A further advantage of using multiple-key-lighting setups is the fact that the filmmaker can easily produce an exposure balance between many subjects in a frame simply by key-lighting each one individually, adjusting the level of illumination on each so that all are similar in intensity. To illustrate this, reconsider the methods used in solving the problem of intensity falloff (4-1, 4-2, 4-3, 4-4). By adding another key the falloff problems are eliminated without the use of scrims or increased subject-to-lamp distances. Another key, directed toward the second subject (4-5), would leave the ultimate intensity, quality, and coverage of each light in the control of the filmmaker, alleviating difficulties associated with balancing the exposure between the subjects in frame.

Reflectance and Luminance Problems

The use of one key for each actor also helps balance *reflectance* differences between two subjects framed in a medium shot. For instance, problems often arise when a person with a light skin color is to be filmed with someone with a darker complexion. If makeup is not used to control the extremes in facial reflectances, a tight shot, especially one lit by specular illumination, would require special lighting attention to bring the faces within a desirable *luminance* ratio. Multiple keys permit such a compensa-

tion of luminance differences by enabling the illumination on the lighter face to be toned down or decreased by altering the balance of exposure between the two faces.

Altering the Exposure Balance

To alter the exposure balance, first balance the exposure on each of the faces in the frame, varying the intensity of the keys by focusing them in or out or by adding full scrims that decrease their intensity. A balanced exposure exists when each of the two faces is illuminated with an equal intensity of light. Take a spot reading from each of the faces to determine whether there are serious reflectance differences. A difference of more than one and one-half f/stops indicates a luminance problem. To alter the balance of exposure to compensate for such extremes, decrease the level of illumination incident upon the "brighter" face by focusing out the lamp or by adding scrims to the lamp until a satisfactory luminance ratio between the faces is achieved. At all times keep in mind the following precautions.

1. Use this technique only if makeup is not used to remedy the particular balance problems.

2. If the balance of exposure between the actors is altered, the alteration must be adhered to throughout the filming under similar circumstances.

3. Use this technique to control reflectances. Do not attempt to match the luminance values of the subjects or to destroy the reflectance extremes entirely.

4. If in doubt, shoot a test roll or use a Polaroid to check the luminance of the shot.

4-5. Multiple stand-mounted keys control the exposure balance in medium shot.

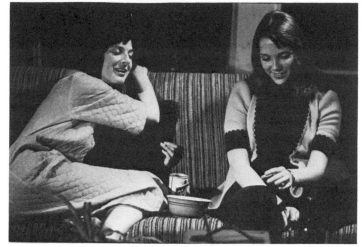

4-6

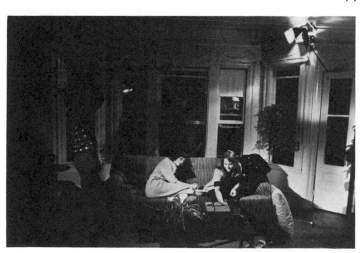

4-7

4-8

DIFFERENT LIGHTING SETUPS

A distinct advantage of a multiple-key setup is that it allows the use of a variety of lighting designs within a single shot. In a location medium shot under controlled conditions, for example, the presence of numerous actors in the frame does not dictate that similar lighting setups must be used for all of them. In fact, if the filmmaker wants some variety in the modeling of the subjects, a different lighting setup may be used for each actor. In a two-character medium shot, for example, it is not uncommon to light the first actor narrowly and to use a side or frontal setup to illuminate the second. The possible combinations of lighting setups are infinite. For the location filmmaker the criteria for selecting combinations that work well together include such diverse elements as lighting continuity, establishment of motivating sources, and availability of lighting fixtures and electricity to meet the expanded needs of the situation.

Medium shot/watching TV/low key. 4-6. The shot seen from near the camera position. The subject on the left is frontally keyed; the subject on the right is keyed with a broad-lighting setup. The intensity on each subject is 125 footcandles; 50 footcandles light the background. (Because this picture is not taken on the camera axis, the full effect of the lighting design, especially the subject separation, cannot be fully seen.) 4-7. A stand-mounted key light lights the subject on the right side of the frame. 4-8. A focusing spot clamped to the molding controls the background illumination, backlights the subjects, and spreads light onto the foreground table. 4-9. Lighting diagram: heavily diffused softlight fill-lights the subject area, producing a 2:1 lighting ratio on the subjects and providing additional illumination on the background.

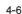

4-9

LIGHTING CONTINUITY

The importance of good *lighting continuity* cannot be overstressed, yet the establishment of conditions in which it may be preserved from shot to shot is often more difficult for the location filmmaker than for the studio cameraman. Lighting continuity is often inherent in the studio environment. Sets are constructed and the lighting is often planned and rigged for all the shots of a sequence. Regardless of the filming order of a particular scene, lighting designs and specific balances of exposure are maintained and preserved: they are generally not struck until an entire sequence has been filmed. Such a situation is more often the exception than the rule in location films. Since location films are not always shot in the manner that is most advantageous to the preservation of lighting continuity, it is important to use methods that assure a continual match between shots.

It should be pointed out that lighting continuity is a variable that, along with others, must be assigned a priority in accordance with the type of film being shot and with the situation at hand. For the dramatic filmmaker its importance is paramount. In other filmic situations such as industrial filming attempting to adhere to the "rules" of lighting continuity by matching the illumination of some huge machine, for example, to the lighting of an operator interviewed in another part of the location is needless. Remember also that with certain planned sequences, such as those in dramatic scenes, much of what is discussed in this book as lighting continuity is an integral part of the lighting design that takes place automatically in the natural progression of shooting long shots before medium shots and closeups. Even if this is the case, however, the basic principles of lighting continuity must be kept in mind in order to prevent any unusual change in the lighting situation from interrupting the flow from shot to shot.

LIGHTING STYLE AND DESIGN

The three primary elements of lighting continuity are lighting ratio, exposure ratio, and lighting style or design. The use of lighting and exposure ratios has already been examined in detail in chapter 3. Lighting style and design are explained here, as they are frequently relevant to the maintenance of lighting continuity between longer and closer shots.

The term *lighting style* refers to the total filmed visual effect of the scene produced through the manipulation and control of the lighting. Any particular style of lighting can be recognized by its characteristic and distinctive appearance. This appearance is often responsible for the visual mood of the scene. The lighting style or design (sometimes referred to as the *lighting mood*) is always selected to match and reinforce the tenor of the sequence being filmed.

MATCHING SHOTS
Medium Shots to Medium Shots

The same criteria used in maintaining lighting continuity from closeup to closeup are used to match medium shots. Even though multiple keys are used to light the actors in the frame, consider the lighting on each character as a closeup in order to match medium shots. (For a review of the criteria applicable to lighting continuity from medium shot to medium shot, see the section on closeup-to-closeup exposure ratios in chapter 3.)

Medium Shots to Closeups

When filming medium shots and closeups, strict adherence to the established lighting setup is critical, for the viewer's emphasis shifts from the *action* of the long shot to the *actors* within the tighter camera frames. To maintain lighting continuity, the same *direction* and *quality* of lighting should therefore be used from medium shot to closeup. Regardless of which is shot first, the same lighting design must be used for each of these shots to assure a smooth flow for editing purposes. Of course, if the two shots are filmed consecutively, many of the lighting-continuity considerations become secondary. In such situations lighting ratios, exposure ratios, and lighting design should be automatically reproduced.

Long shot/artist/high key. 4-10. A 3000-watt lighting setup, focused into the umbrella, softly and evenly illuminates the foreground and action area and remains unchanged for the long and medium shots. 4-11. Lighting diagram: the wraparound quality of the umbrella enables this high-key shot to be made without a fill light.

Medium Shots to Long Shots

Lighting continuity between medium and long shots will be maintained if similar lighting *styles* are used in both and if a matched exposure balance between the primary-subject areas and the background areas of each is maintained. Two deviations from previously stated rules of continuity should, however, be kept in mind.

1. Any shot lit to "match" the long shot in the same sequence does not necessarily have to be lit with the same key-lighting setup as that of the long shot. *Similar lighting styles* are used, but the direction and positioning of the keys used to illuminate the movement of the long shot will often be changed to light the closer medium shot more effectively.

2. Although exposure ratios between primary areas of medium and long shots are maintained, lighting ratios of smaller areas will frequently be altered in the closer shots to preserve detail and to promote modeling within a tighter frame that includes and highlights an area not significantly noticeable in the long shot.

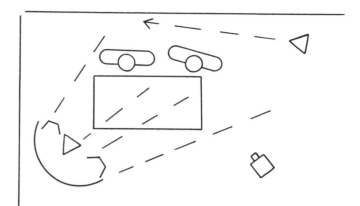

4-11

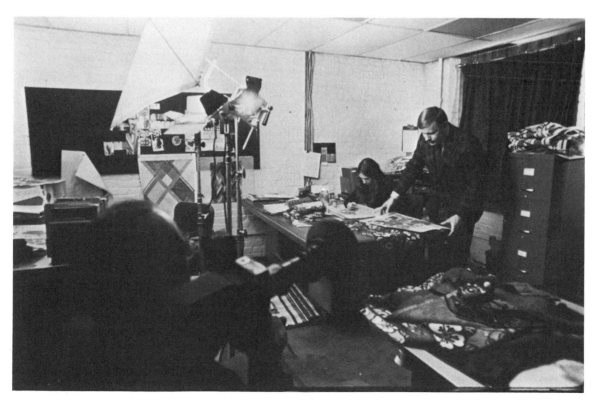

4-10

MAINTAINING SIMILAR LIGHTING STYLES

It is common practice to use similar lighting styles but different key positions for long and medium shots. This is especially true in location filmmaking, since the position of the keys for a long shot is primarily influenced by the blocking of the actors and the overall mood to be produced. Modeling of smaller areas becomes secondary to the specific visual effect produced by the lighting, such as the direction and position of the character's shadows. The medium shot may have to be "relit" so as to produce a more pleasing lighting effect. An appropriately similar style of lighting is selected by altering the direction from which the keys light the long shot, often improving facial and subject modeling. If the long shot is low-key, light the medium shot from a direction that reinforces the characteristic mood. An example of a typical lighting change from a long to a medium shot is illustrated here (4-12, 4-13).

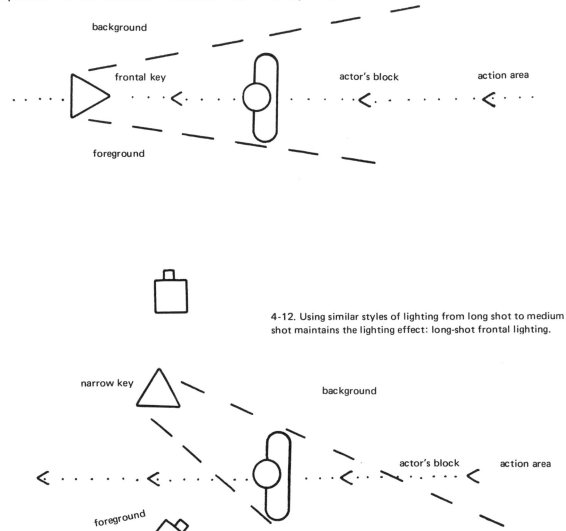

4-12. Using similar styles of lighting from long shot to medium shot maintains the lighting effect: long-shot frontal lighting.

4-13. Using similar styles of lighting from long shot to medium shot maintains the lighting effect: medium-shot narrow lighting.

The first illustration (4-12) depicts a low-key long shot lit by a frontal-key light. This lighting design was chosen because a key directed to light the subject from the front can be controlled to light the action without spilling light or interfering with the lighting of the other set areas. In this long shot the darkened, moody effect of a low-key scene was produced by careful manipulation of the intensity of illumination on the other set areas compared to that of the action area. Modeling of the subject was a secondary consideration. In the long shot primary emphasis was placed on producing and establishing the mood of the sequence through controlling the lighting of the wide frame.

If the frontal key used in the long shot proves unattractive for the medium shot, it may be repositioned to produce satisfactory modeling, provided that it does not alter the lighting style of the long shot. The principle of similar lighting style is illustrated in the second illustration (4-13). The frontal-key light is redirected to a narrower position for the medium shot, yet a similar lighting style is maintained in the two shots. The narrow key of the medium shot emphasizes the low-key effect of the long shot, for a great percentage of dark area is visible from the medium shot's camera position. When using this technique to match the lighting style of the medium shot to that of the long shot, follow these guidelines.

1. Select an appropriate direction for the medium-shot keys—e.g., a low-key long shot may be matched more successfully to narrowly or frontally lit medium shots than to broadly lit medium shots.

2. Always match the intensity of the medium-shot key or keys to the intensity of the long-shot keys.

3. Always measure and maintain the exposure ratios of primary areas to be seen in "matched" frames of medium and long shots.

LIGHTING AND EXPOSURE RATIOS

At times situations arise in filming medium shots after long shots when it is not necessary to reset the lights of the long shot in order to produce a different lighting setup but a similar lighting style for the medium shot. This may instead be achieved by simply adjusting the position of the subject in medium shot so that the lighting setup of the long shot strikes the actor differently, creating more attractive modeling. Due to the expansive area included in a long shot, lighting ratios on the faces of the actors are only of minor importance. It is therefore not uncommon to lower the lighting ratio of these areas when filming medium shots. The lower lighting ratio will maintain the mood of the long shot but will also add the necessary detail.

To simplify lighting-continuity problems and to avoid confusing directional changes when moving from longer to closer shots in the sequence, the filmmaker should predetermine these directional changes as well as the lighting ratios. Once these have been decided upon, they must remain unchanged if proper continuity is to be maintained. Following this procedure will eliminate common continuity problems in nonsequential filming, for closeups should automatically match similar medium shots in lighting ratio, exposure ratio, and key-light direction.

It should be pointed out that, although the lighting ratio from long to medium shots may change, the exposure ratio of similar areas seen in the frames of both shots should be maintained if proper lighting continuity is to be kept. The important exposure ratios between medium and long shots are those between the action areas or subjects of each shot and the background areas seen in matching frames with varied coverage.

Following is an example in which matched exposure ratios between primary areas of long and medium shots were maintained, while the lighting ratio of the actor in the medium shot was lowered from that of the long shot. The actor's position (4-12) is keyed for 250 footcandles; shadows of the action are lit by a fill light to 40 footcandles. The actor in the long shot is therefore lit with a 6:1 *lighting* ratio. If the background illumination in the long shot is 64 footcandles (two f/stops down from the exposure of the main action), there would be a 4:1 *exposure* ratio between the subject and the background. Moving in for the medium shot in this example, the key's position changes, but its intensity is still set at 250 footcandles (4-13).

To facilitate the recording of detail in the closer medium shot, the fill illumination on the actor may now be brought up to 64 footcandles, lowering the *lighting* ratio of the medium shot to 4:1. The background illumination of the medium shot, however, should not be altered from its original 64 footcandles, since all the shots within the sequence must match in lighting continuity. The 4:1 *exposure* ratio between the action areas and the background established in the long shot should be continued until the scene or sequence is completed.

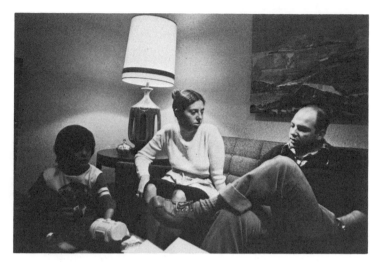

4-14

Long shot, closeup/salesman/low key. 4-14. Wide-angle framing from one of the camera angles. The man is keyed with a side-lighting setup motivated by the practical included in the frame. The woman is frontally keyed; the child is lit only by the fill light in the room, which is approximately $1\frac{1}{2}$ f/stops below the intensity of the main action. 4-15. A cathedral ceiling enables the lights to be rigged high above the actors. The distance decreases intensity falloff across the subjects being lit. The lighting ratio on the back wall near the practical is 1:1. 4-16. A 2K softlight, bounced off the ceiling, fills the action area to a 4:1 ratio. 4-17. A heavily diffused focusing spot positioned near the camera is used to lower the lighting ratio on the actor's faces locally to 2:1 when the camera is repositioned for a closeup. 4-18. Lighting diagram.

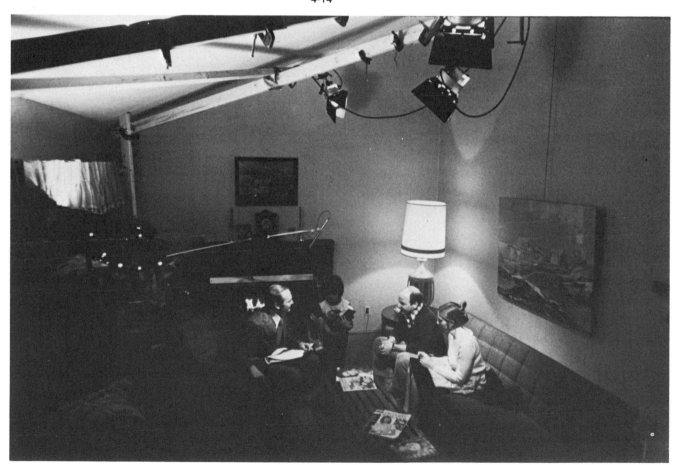

4-15

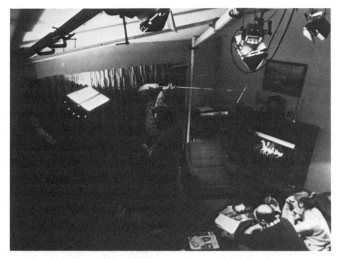

4-16

THE SEQUENCE OF FILMING

Most films contain long shots, medium shots, and closeups. The majority of location filmmakers find it easiest to shoot the long shots first and then to move in for medium shots and closeups. Sequencing the shooting in this manner eases lighting-continuity problems among the shots of the sequence and saves setup time in that directing the fixtures to illuminate all the shots adequately need only take place once after the long shots have initially been rigged.

Changes in the positioning of the fixtures used to light the long shot may be necessary to enhance the modeling of the tighter shots. If the adjustments are made after *all* the long shots are filmed, lighting continuity between the wide shots of the sequence will be guaranteed. Lighting continuity between medium shots and closeups will also be assured, because, once the repositioning of the lighting for the tighter shots is made, this "adjusted" lighting design will generally be used for all the remaining close shots within the sequence.

4-18

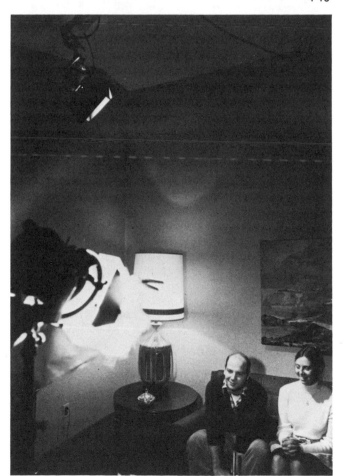

4-17

SHADOW-CASTING CONSIDERATIONS
DIRECTION AND NUMBER OF KEY SHADOWS

The key lights produce the most troublesome shadows: they are the harshest; they indicate the direction of the light source; and they sometimes reveal the type of light source used to illuminate the scene. Unless there is a justifying motivation source, shadows from more than one subject that fall into the medium-shot frame should come from the same general direction.

SHADOW PLACEMENT OF KEY LIGHTS

Although each of the multiple keys may be placed according to the effect and style of lighting desired, its final placement is also influenced by the location and direction of the shadows that it casts onto the subject and the background. Since each multiple key creates its own set of shadows, the final positioning and effect may have to be slightly compromised to allow for problems of shadow direction and intensity.

Medium, long shots/record-player sequence/high key. 4-19. The barndoors of the key lights rigged to the grid are spread wide, many in a horizontal position, to pool the light evenly across the scene. The white walls and ceiling reflect a great deal of light: much of the fill light comes from the ambient illumination of the keys bounced off the white surfaces. 4-20. A 2K softlight fills the scene from a location near the camera. Its position is chosen so that it can fill both seated and standing characters adequately. The window to the left of the frame is not included in the shot. The other windows are gelled with 85N6 material. 4-21. The medium shot seen from the camera angle. The subjects are frontally keyed and lit to a 2:1 lighting ratio. The exposure ratio for the medium shot and the matching long shot is 1:2:1. Notice the dark vertical pole near the window: it is a vertical support for the grid, which is actually a 2-X-3 piece of lumber painted a dull gray. 4-22. Lighting diagram: although the motivating source is the windows, the actor, with his back to them, is lit from the front. A frontal-light setup creates an inconspicuous shadow on the character that it lights and does not draw the viewer's attention to the direction from which it strikes the subject. The lighting for the blocking and for the stationary position of the second actor duplicates the direction from which the natural source lights the room. The keys are rigged to project the actor's shadow behind him onto the floor of the set and away from the white wall.

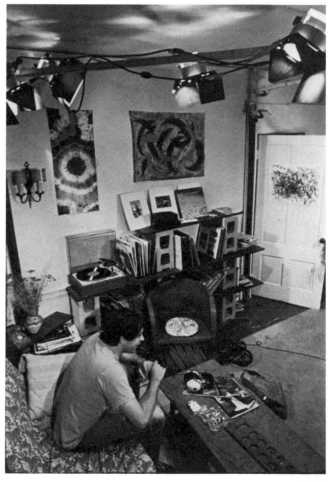

4-19

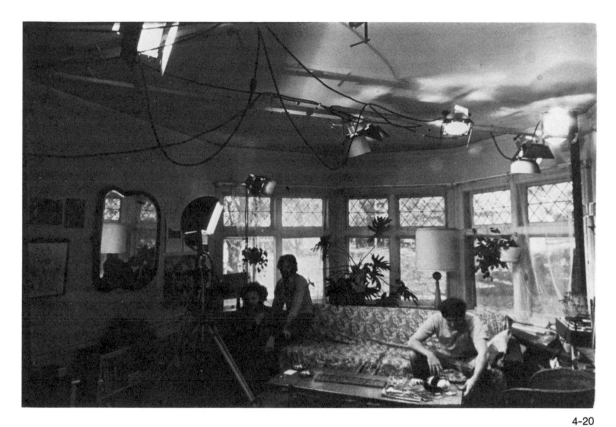

4-20

4-21

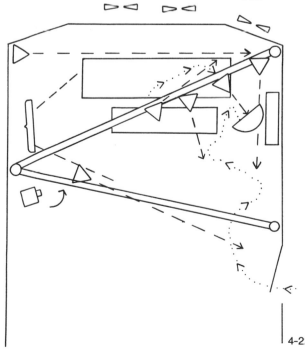

4-22

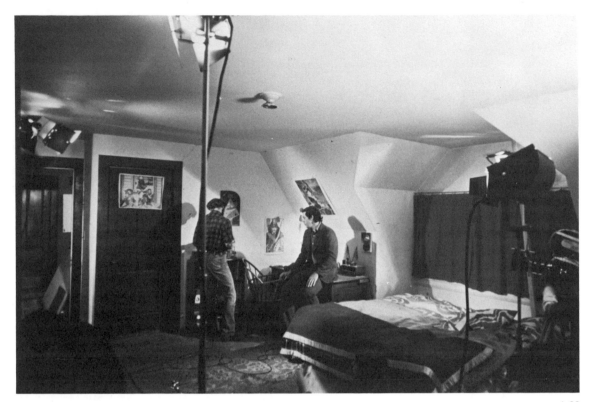

4-23

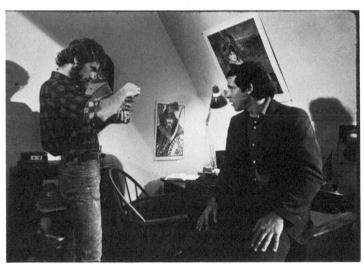

4-24

Medium shot/Danny and John/low key. 4-23. Barndoors on focusing spots are placed in a vertical position so that the beam does not spread uncontrolled light onto the white walls of the set. Shadowless fill light is provided by a 1K softlight bounced off the white ceiling. 4-24. The shot as seen from the camera position. The actors are frontally lit; their shadows result from the keys. The area lit by the desk lamp is $1\frac{1}{2}$ f/stops above the intensity on the subjects. A sharp shadow falls on the background behind the standing actor, providing separation and adding to the low-key mood of the shot. 4-25. A reverse angle showing the lighting setup. All lights except the key are rigged on stands at the left of the frame. The key is rigged to a 2 × 3 capped with a spring-loaded timber topper. 4-26. Lighting diagram.

BACKGROUND SHADOWS

In close shots background shadows cast by the keys cannot be successfully removed or lessened by increasing the illumination on the background without disturbing the lighting continuity of the sequence. The texture and color of the background also make a difference in the clarity of the projected shadows. For example, key-light shadows that fall onto dark or textured backgrounds are less noticeable than those that are projected onto lighter and smoother surfaces. This is especially relevant to the location filmmaker, who is often forced to shoot in small rooms in which the presence of background shadows is inevitable.

KEY-LIGHT HEIGHT AND SUBJECT BLOCKING

In addition to the physical characteristics of the background the height of the key light and the blocking of the subject are variables that affect the placement of multiple-key shadows. It is advisable to place the keys as high as possible. Shadows from key lights located high above the action fall onto the floor of the set and are out of the camera's view.

This ideal position for the keys is often impossible, however: even if it is possible, shadow problems may still exist when actors stand close to walls or near doorways. In such circumstances the actor's position could be moved away from the walls: the key's shadows will fall further down the wall nearer the floor, where they will be less noticeable.

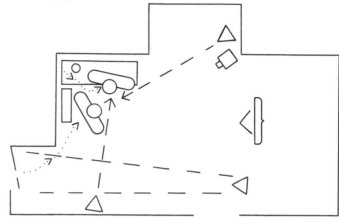

4-26

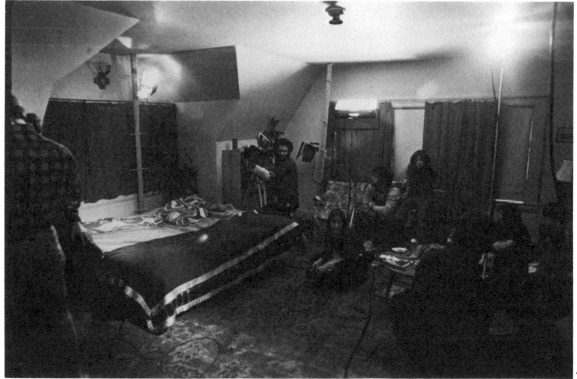

4-25

95

THE FILL LIGHT

Although many keys may be needed to light a medium shot, especially if the framing contains more than one actor, only one fill is necessary to produce the desired lighting ratio for the action area. In addition to the advantages in saving setup time, power, and money the use of a single fill is helpful, for the shadows that it casts from each of the actors fall onto the background in the same direction.

In medium shots the fill is frequently located close to the camera and not much higher than the subjects themselves. In this position it can lower the contrast of all the subjects in the frame equally. A single fill can be used to illuminate multiple subjects keyed from similar directions, or, depending upon the mood of the shot, it may be possible to use a single fill fixture to light multiple subjects, each keyed from a different position. For example, each of the two actors illustrated (4-27) could be filled with the same frontally located light, even though one is keyed from a narrow angle and one from the side. The fill creates a similar lighting ratio on both, although the degree of the fill's effect is noticeably different on each, for, because of the positioning of the keys, varied amounts of shadow are in view.

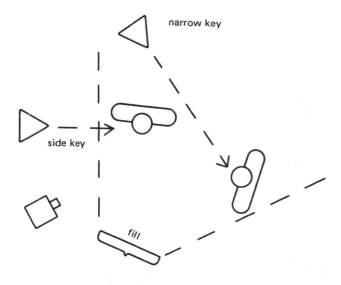

4-27. One fill light illuminates two differently keyed subjects.

FILL-SHADOW CONSIDERATIONS

Shadows from multiple keys, although the densest and the most distracting, are not the only shadows with which the filmmaker must contend in lighting medium shots. Fills add yet another set of shadows that must be consciously placed to avoid or at least to lessen the distracting visual impact of multiple multidirectional shadows within the frame.

Background Fill Shadows

Due to the usual location of the fill in medium shots the shadows that it casts will generally fall in frame directly behind the actors onto the background of the set. Luckily, the illumination from most fills is diffuse and drops off in intensity rapidly as it travels away from and behind the subject that it is lighting. To avoid distracting shadows from the fill, many location filmmakers attempt either to move the subject away from the background or to move the fill as close to the subject as possible. Either of these procedures will alleviate noticeable fill-light shadows.

Medium shot/men in kitchen/high key. 4-28. Key lights are placed above the action and attached to a simple grid to ease camera and subject movement. The focusing spot with a soft reflector, located above the camera, lights the jacketed subject with a frontal-lighting setup. The barndoors are narrowed to prevent the light from falling on the other character. 4-29. The focusing spot to the left of the frame is directed to light the second character with a frontal setup. Its barndoors are open wide to light other parts of the shot as well. 4-30. The 2K softlight fill-lights the subject's face to a 2:1 lighting ratio. It is positioned higher than the eye level of the subject to throw the shadows downward onto the floor rather than directly behind the subject. This must be done because the subjects are positioned very close to the walls. An N3 gel is placed over the windows to lower the intensity of the light to two f/stops above the exposure for the scene. The blue-colored daylight seen through the windows highlights the mood of this morning interior. 4-31. The shot seen from the camera angle. The foreground and the action are lit to 125 footcandles, and the background (to the right of the frame) to 64 footcandles. The softlight reflection (called a *catch-light*) seen in the window is removed from view by placing a larger prop on the windowsill. 4-32. Lighting diagram: a broad light is hidden in the closet to light the background. The third key, rigged to the grid near the entrance, lights the actors' movement for a matching long shot. The half scrim, placed in the bottom of the lamp, evens out the intensity of the illumination across the movement.

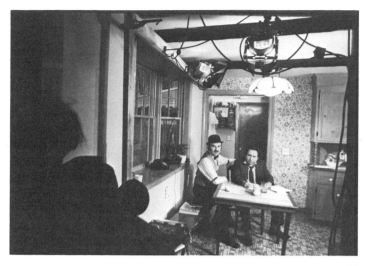

4-28

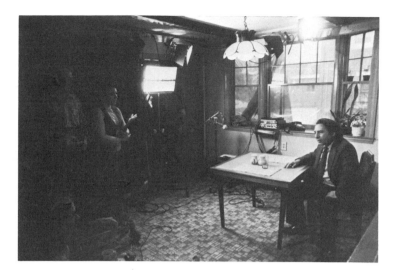

4-30

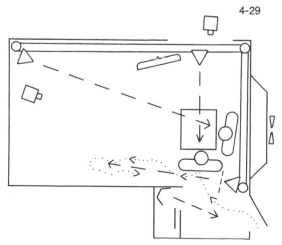

4-29

4-31

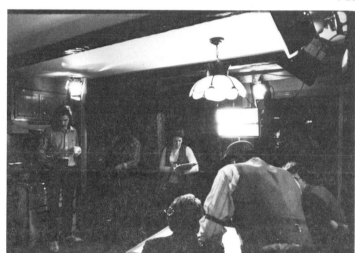

4-32

The first maximizes the effect of intensity falloff from the fill. Keeping the distance between the fill and the subject equal but moving the subject further away from the background simultaneously moves the fill further away from the background. The greater the distance between the fill light and the background, the greater the intensity falloff of the illumination reaching the back wall of the set.

The second technique is used if fill shadows are distracting and if the actor cannot be moved away from the background. If the fill is moved close to the subject, the background shadows will be less noticeable than those that it would cast if it had to be kept a great distance from the subject. This is due to the fact that the light from a diffuse fill located close to a subject tends to wrap around the subjects, minimizing shadow visibility by producing shapeless, diffuse, and less distinguishable shadows on the wall of the backset.

Shadow and Contrast Reproduction

After the keys and fills are set in a multiple-key-light situation, block the actors and view the lighting effects as well as the position of the shadows from the camera angle. Always keep in mind that, compared to how the scene will look recorded on film, the contrast will appear much lower to the eye. Fill shadows that may be acceptable to the filmmaker at the time of shooting may prove to be quite distracting when finally seen on the screen.

CHOOSING THE CORRECT FILL LIGHT

In filming medium shots on location large softlights may be moved close to the subjects to provide the fill illumination. Their intensity is controlled by switching on and off any number of the multiple bulbs contained within the unit until a desirable fill-to-key ratio is obtained. Although the choice of which fill light to use may solve background-shadow problems, one must keep in mind that it may also increase the possibility of fill-light spill onto areas of the set other than the action for which the illumination is intended. Fill-light spill may or may not be a problem, depending on the size of the location, the lighting mood of the sequence, and the amount of distance between the subjects and the background. When choosing a fixture to be used as a fill for medium shots, shadow-casting characteristics must be weighed against spill-light production. If there is too much spill, more directional but diffused fill lights may have to be used, even though harder shadows will result.

COPING WITH FILL-LIGHT SPILL

When filming medium shots, fill-light spill onto undesirable set areas frequently becomes a problem: the filmmaker must carefully select the positions of both the subject and the camera to avoid difficulties. Remember that a camera-angle change from long shot to medium shot tends to disorient the viewer slightly as to the correct perspective and placement of similar items seen in both shots. If spill light on the background (as well as shadow placement) becomes a problem in a medium shot, move the actors away from the background by a step or two and select a camera angle that includes desirable areas in which the background is free from spill and shadow difficulties. The angle and shot changes should mask the continuity error; the mismatch in position will probably go unnoticed.

OTHER MEDIUM-SHOT LIGHTS

The function of rim and backlights in medium shots is similar to that in closeups. Many location filmmakers, considering the difficulty generally found in mounting and positioning, find these lights unnecessary and not worth the trouble. Nevertheless, if time, money, and fixtures are available, these lights can add to the film's effect.

THE BACKLIGHT

In medium shots the backlight serves two purposes: it acts as a separator of the subject from the background and adds highlights and contrast to the scene. When using the backlight for these purposes, remember to apply some moderation. Overly bright backlights draw attention to the lighting. Make certain also that the backlight's intensity is consistent from medium shots to closeups and that the fixture highlights similar areas in both shots. Mismatches in lighting continuity may occur if this is not done.

Backlights are also used to create special lighting effects, such as mimicking the quality of outdoor light at night or reproducing the expected effect of a person standing in front of or near an existing practical. Backlights used for these special effects are generally less specular than those used as separators. Due to the greater amount of subject area that is illuminated by a backlight used in this way a method has been devised for predicting the visual impact of the effect prior to filming the subject.

SPECIAL-EFFECT-LIGHTING METHODS

The method used to predict the appearance of special backlighting that mimics "existing" lighting effects involves taking exposure-ratio and lighting-ratio measurements. In this specialized use the backlight is not used to produce a highly specular highlight: its illumination may be accurately measured with an incident-light meter. The backlight in this case illuminates such a large area of the subject (an entire outline or rim) that its intensity may be set in relation to the other lights illuminating the scene. Duplicating this special effect with the backlight is easy in practice, since the setup normally involves only two lighting fixtures: a backlight and a fill. The backlight strikes the subject from behind and from the direction of the "existing" source. A stand-mounted frontal fill located near the camera brings up the detail of the medium shot.

This setup may at first seem confusing. It utilizes no traditional key light, and, though the backlight provides the more directional and intense illumination of the two fixtures lighting the scene, the camera exposure *is not* set in accordance with the measurement of the total illumination on the subject. In fact, to maintain the brilliance of the highlighted rim produced by the way in which the backlight strikes the actors, its intensity is set to slightly overexpose the rim-lit area, as compared to the camera exposure measured from the rest of the shots in the sequence. This "camera" exposure level represents a constant in that it is predetermined prior to the beginning of the shoot and is consistently reproduced in all "normal" interior-filming situations through manipulation of the keys' intensities.

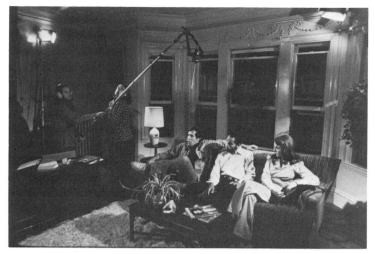

4-33

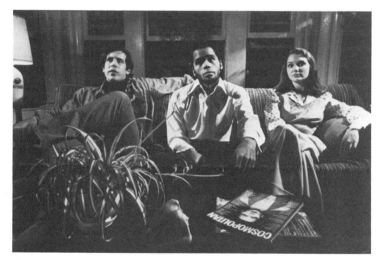

4-34

Medium shot/three on the couch/low key. 4-33. To mimic the light produced by the two practicals flanking the couch, the subjects are cross-keyed. A stand-mounted key, seen to the left of the frame, is used to avoid fill-light spill on the background. Above the couch, rigged to a gator grip and clamped to the molding, the backlight is visible. 4-34. The shot, seen from the camera position. The lighting ratio on the faces of the actors is 2:1; both the foreground and the background are two f/stops below the exposure of the action area. 4-35. Lighting diagram: the cross key to the right of the actors is diffuse: this softens the quality of the illumination on the actors and spreads softlight, which adds to the background illumination.

4-35

To predict the visual impact of the effect, position the backlight behind the subject, observing the location of the rim-lit area from the camera angle. Point the dome of an incident-light meter directly toward the backlight from the subjects position, measure its brilliance, and set its intensity for one f/stop over the exposure of the other shots in the sequence. This 2:1 exposure ratio will produce a moderate but believable backlighting effect. Adjust the intensity of the frontal fill lighting the shot. Measuring the lighting ratio between the section of the actor lit by the fill and that lit by the backlight will help in predicting the lighting effect prior to shooting. Keep the ratio high (8:1) for stark effects, lower (3:1 or 4:1) for more moderate lighting.

BACKGROUND ILLUMINATION AND SEPARATION

The amount of background illumination in relation to the luminance of the background surface and to the mood of the shot are established in most circumstances in the long shot and are carried over into medium shots in the form of matched lighting designs and exposure ratios in order to preserve lighting continuity. If medium shots without any corresponding long shots are to be filmed, guidelines that help to establish factors relevant to the lighting of the background may be adopted from the background-illumination section in chapter 5.

If the lighting design used to illuminate the background of the areas seen in the long shot remains unchanged in the tighter subject framing, problems sometimes arise in separating the subject from the back wall when the actor is reframed for the medium shot. A subject in medium shot who is not separated by tonal contrast or color from a particular section of the set should therefore be moved, or *cheated*, to a slightly different location where the separation is better. Or, if the section of the set behind the subject has not been seen in the previous shots, a little extra background illumination can perhaps be added. A weak rim light can also be used to bring up the contrast. Once these steps are taken, however, they must be consistently followed when shooting similar angles of the same set during the same sequence.

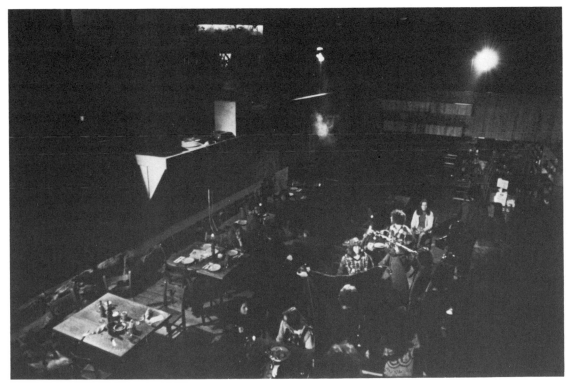

4-36

4-37

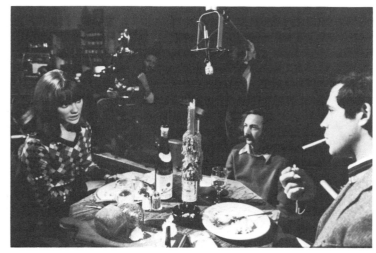

4-38

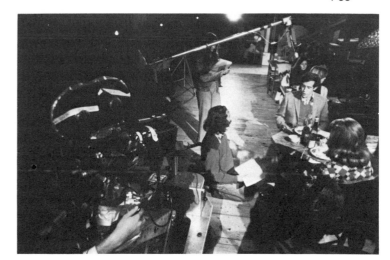

4-39

Medium shot/restaurant/low key. 4-36. Two focusing spots are seen on the balcony. The fixture to the right of the frame, fitted with a mirror reflector, produces a throw that is long enough to cross-key the movement far below. The fixture in the center of the frame, also fitted with a mirror reflector, key-lights the male charac-ter with a narrow-lighting design. 4-37. The shot seen from the camera position at the start of a dolly. When the characters look toward each other, a narrow-lighting design is seen on each. Filled with a 2K softlight located close to the camera position, the lighting ratio on the actors' faces is 4:1. The background is illuminated by boosted practicals rigged to replace the existing lighting fixtures. Light from these bulbs, bouncing off the white background, silhou-ettes the people seen at the other tables. The lighting ratio on the background is 6:1; the exposure ratio between the light areas of the background and the main-action area is 1:1. 4-38. A reverse angle shows the camera at the start of the dolly while the sound is being readied. 4-39. A cross key that provides additional illumi-nation on the actors' block is located at floor level. 4-40. Lighting diagram: illumination from the key used to light the woman is permitted to spill onto other tables below. This key is fitted with a mirror reflector to increase its throw.

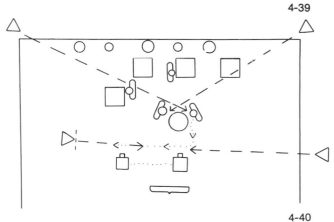

4-40

101

5. Lighting for Long Shots

The lighting criteria employed in preparing a sequence for a *long shot* center around two words: *mood* and *movement.* Modeling becomes secondary: the overall impact and effect of the total wide shot are of primary importance. In long shots the filmmaker sets the required background illumination, plans the lighting ratio of the action, and establishes the lighting-intensity relationships (exposure ratios) between the action areas and the rest of the set. The importance of careful construction of a functional yet aesthetically pleasing long-shot-lighting setup cannot be overstressed.

Long shots, especially those in which movement of characters is involved, are often hindered by the physical limitations of the set. Problems involving the establishment of mood, the occurrence of multiple and ill-placed shadows, and the need to institute and maintain the effect of a motivating source are among the most common. Interior-location long shots are hard work. Closeups can often be lit by stand-mounted fixtures, but the same long shots, with their large amount of camera movement and subject blocking, usually require alternate methods for mounting the lights. Specialized equipment is available for attaching fixtures to moldings, pipes, furniture tops, walls, and just about any structure that can hold a light, avoiding the use of floor stands.

PLANNING AND RIGGING THE LIGHTS FOR THE LONG SHOT

Setting lights for an establishing shot, especially in location work, can be time-consuming. The filmmaker should properly plan the lighting pattern before the actual shoot. A knowledge of the blocking, the set to be lit, and the electrical plan of the interior are all prerequisites if shooting time is to be kept to a minimum. With this type of pre-planning the filmmaker, aware of where the lights should *ideally* be placed, is able to *practically* contemplate the means of mounting them in position. For the location filmmaker theory and practice separate at this point, and the extent to which attaching the fixtures (called *rigging the lights*) becomes a complicated procedure depends upon the type of film being made and on the time, money, and effort necessary to carry out the desired plan. Lighting generally receives top priority in dramatic productions, but in many other types of commercial films nonaesthetic considerations may dominate, limiting the lighting and rigging choices.

The use of stands to hold location lights is the quickest and easiest method of rigging fixtures, but their presence may interfere with camera and subject blocking, making it quite difficult to light a scene that contains a good deal of movement. If floor stands are necessary, it may be imperative to limit subject blocking and to confine the action to a tighter area or to move the stands frequently to relight a section of the scene at a time.

Attaching the lights to walls or other objects on the location gets the fixtures off the floor but does not always offer the most desirable placement for the chosen lighting plan. One system that allows maximum flexibility in positioning the lights on the location is the lighting grid. In this book the lighting grid is illustrated as one method of rigging the fixtures to produce the desired lighting plan. It must be pointed out, however, that in practice combinations of all three mounting methods are often used for a single long shot, each being utilized to advantage on various parts of the set.

THE LOCATION LIGHTING GRID
The *location-lighting grid* is a temporary structure secured to the walls or across the ceiling of the location interior that is used to mount lighting equipment. Its primary advantage is that it can be used to suspend lights *over* the action area high above the set and out of view of the camera. Floor stands are not needed: the grid provides efficient coverage in lighting movement, as the lights can be placed almost anywhere without interfering with the camera or the subject blocking. Setting the lights up high on the grid is helpful in controlling subject shadows and in producing the mood of the scene as well as the background patterning of the set.

A prepared location filmmaker will diagram layouts of lighting for the majority of shots and rig the fixtures at the start of the shoot, avoiding major delays due to rerigging and redirecting the lighting between angle and scene changes. Prior knowledge of the positioning of the camera and the subject for the tighter shots will enable any desirable modeling or separator lights to be roughed in (put in place without being accurately directed) while the lights are being set for the longer shots.

The lighting setups for the action are roughly positioned at the beginning of the shoot—and, when it is time to film the part of the sequence for which the lights were set, the fixtures will then be exactly positioned. If enough lamps are not available, the initial placement of lights on the grid can be set to cover only the long shots of the sequence or shots whose stands would interfere with the camera or blocking. If necessary, fixtures may then be either redirected or moved to floor stands to cover the closer film-

ing situations. (For an in-depth description of the mechanics of constructing and installing the lighting grid see chapter 6.)

PLACING THE KEYS TO LIGHT MOVEMENT CONVENTIONAL METHODS

To emphasize the difficulties and considerations involved in lighting subject movement, the following example illustrates an approach to a situation in which conventional methods of lighting medium shots and closeups are used to light the moving action in a long shot. Use a simple movement, such as one in which a person enters a room and walks parallel to the wall toward the opposite windowed side of the set. Filmed from the side in the long shot, the camera would pan with him as he enters (5-1). The filmmaker's first problem is where to position the key for this shot. Rigging the key to a stand somewhere near the camera would throw a very harsh and almost life-size shadow onto the wall directly in line with the lens. The shadow would be obtrusive, and the lighting would appear unnatural (5-2).

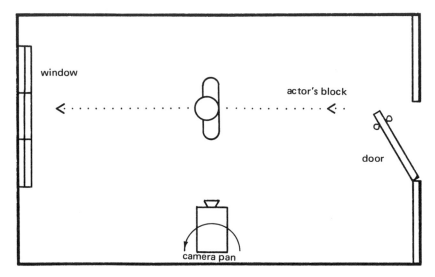

5-1. Key position, actor's block, camera pan, and set for a long shot.

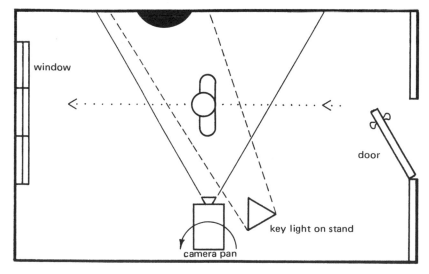

5-2. Stand-mounted key near the camera.

On the other hand, placing the stand and the key near the window would give the appearance of window light (5-3). The shadow cast behind the subject onto the door is quite acceptable. But how should the exposure be set? By walking the block of the actor, with the hemispherical dome of the incident-light meter pointed toward the camera, a reading is obtained. For the sake of our example let's say that it is f/4 at the door and f/16 near the window. But these readings are too uneven: if these two extremes were averaged in order to set the exposure for the camera, the subject would be two f/stops overexposed while standing near the window and two f/stops underexposed while standing near the door.

Adding More Keys

To retain the positive features of the illumination's directional characteristics but to prevent the light stand from interfering with the shot, the fixture must be mounted by some other means. At the same time any rigging method considered should also provide a means of positioning fixtures to even out the exposure of the entire movement. To tackle these problems one at a time, suppose that the ceiling in this room is high enough (12' would be ideal) to place a grid or that the room offers some other opportunity to mount the lighting off the floor above the action.

One key, positioned high and slightly in front of and pointing down toward the subject, could be used to illuminate a limited area of the movement to the proper exposure level—i.e., f/4 (5-4). The shadow from the actor would not fall within prominent view of the camera lens, and the light would appear to be coming from the direction of the window. But the rest of the block would be underexposed—a difficulty that could not be overcome solely by reangling and opening the barndoors of the fixture, for this would again create an intensity-falloff problem across the length of the movement.

One solution is to add more key lights to illuminate the remaining portions of the subject's movement and to balance each to equal intensity (5-5). Now the camera can pan with the actor as he walks from the door. The exposure will be constant; no stands will enter the frame; and the light will appear to be coming from the direction of the motivating source. The shadows from the subject will fall back onto the floor and out of the frame.

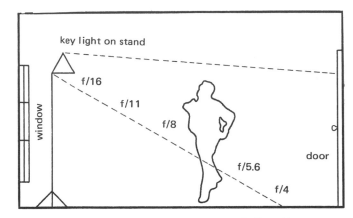

5-3. Stand-mounted key near a window with falloff problems expressed with various exposures along the action axis.

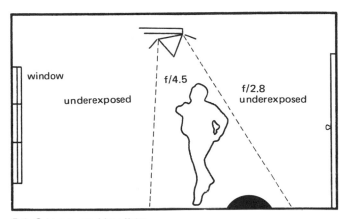

5-4. Grid-mounted key light.

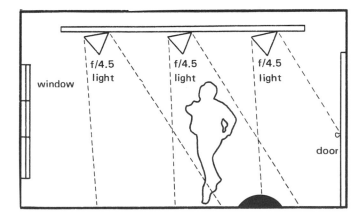

5-5. Multiple key lights on a grid "balanced" to the same intensity.

POOLING THE LIGHT

The above example is a good illustration of a basic principle used in location lighting to illuminate the blocking of the actor in long shot. It exemplifies the lighting of areas of the actor's block with pools of light. *Pooling* the light with multiple keys is an ideal method for effectively lighting an action sequence. Intensity-falloff problems are lessened when this procedure is used: evenness of exposure over the block is easily maintained, and the shadows cast by the keys always fall from the subject in a one-directional pattern onto the background or the floor of the block. Since each multiple key only lights one section of the blocking and does not overlap with the others, multiple shadows never become a problem.

Pooling the light does not interfere with the traditional methods of producing an effective lighting design in long shot. In fact, this method offers the advantage of a variety of lighting designs in that it enables multiple-lighting effects to be produced in various parts of the movement of the action, for the location filmmaker has control over the direction and the intensity of each of the key lights illuminating individual areas of the long shot.

5-7

5-6

106

5-8

5-9

Long shot/party/nighttime interior. 5-6. Extensive camera blocking and subject movement require all direct keys to be rigged to a grid. A 2-X-3 grid holds the key lights, and the stand-mounted softlight at the left of the frame adds fill. 5-7. Key light is pooled and not overlapped so that the actors do not cast multiple shadows on the background. 5-8. The woman standing in the main-action area is lit to 250 footcandles; the medium-colored background walls are lit to 125 footcandles from floor to eye level but are permitted to fall off to less than 64 footcandles toward the ceiling in order to enclose the large expanse of the room. 5-9. The bay-window area is diffusely lit by boosted practicals placed in the table lamps. Bounce illumination from these practicals provides a base illumination for the room. Note the pole covered with contact paper in the right of the frame. 5-10. Subjects seen around the perimeter of the room are side-lit to a 6:1 ratio. 5-11. Lighting diagram: the walls seen through the door are keyed to one f/stop less than the main-action area. Frontal-lighting setups are used to cover the subject movement.

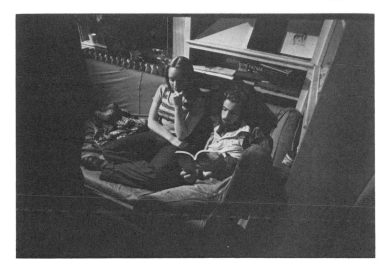

5-10

5-11

CHOOSING A KEY-LIGHTING SETUP

Choosing the exact placement and type of key-lighting setup to cover the block of the actor in long shot depends upon many factors. The choice varies with the personal taste of the filmmaker, the type of film being shot, and the lighting style to which he or she has become accustomed. In the ideal interior the filmmaker may have adequate control over most of the factors affecting the use of particular lighting setups. But even the best location interiors often have drawbacks that restrict or limit the choices available for implementing the lighting desired, and concessions must be made.

Priorities for choosing a key-lighting setup vary greatly between the kind of film being made and the situation at hand. Documentary filmmakers, for example, may emphasize an easily installed lighting setup; an industrial shoot may rank shadow production of the keys a high priority; dramatic filmmakers may place particular emphasis on lighting for realism and mood by working with motivated lighting. It is not possible to review all the criteria that might be applicable to the selection of a key-lighting setup for the many different types of motion-picture scenes that one might encounter. It is possible, however, to illustrate situations lit by sample key-lighting setups, the basic principles of which can be adjusted, adapted, and applied to almost any scene that the independent filmmaker is likely to confront.

POSITIONING

To direct light from near the ceiling, the keys can strike the subject or action with either hard or soft illumination from four fundamental positions. As with tighter shots, long-shot keys can illuminate the subject from the front, creating a *frontal*-lighting design; from the on-camera side, creating a *broad*-lighting design; from the off-camera side, creating a *narrow*-lighting pattern; and from the subject's side, creating a *side*-lighting setup.

Considerations

Although the lighting setups for long shots are similar to those employed in tighter shots, several new points need to be considered when these setups are used to cover a moving subject.

1. With multiple keys illuminating the long shot, *each* key is capable of lighting the action area from *any* of the four setup positions. Although all four setups might be used to light a particularly long block, this is usually the exception rather than the rule. The movement is generally lit by multiple keys, each striking the subject from the same setup position unless other key-light directions are justified by a motivating source.

2. In long shots the camera often moves independently of or simultaneously with the subject. If this is not kept in mind, the lighting effect designed for one camera position may be destroyed after the subject and/or the camera starts to move as the shot progresses. In some cases the lighting design is not destroyed as the camera moves: the terminology describing the design simply changes. This occurs particularly with narrow and broad setups, since they are defined by the way in which the key strikes the subject blocking (called the *action area*) in relation to the position of the camera. For example, a narrowly lit off-camera subject becomes a broadly lit on-camera subject if the camera were to move in an arc around the front of the action during the course of the shot.

3. Subjects are lit with side light in long shots from either an eye-level or an elevated position. Both are associated with "natural" lighting effects and are described later in this chapter in the motivated-lighting section.

Mood

In choosing a lighting setup for a dramatic film the mood or atmosphere of the scene should be considered. Various key positions for long shots and their respective advantages in producing various lighting designs from high- to low-key do affect the atmosphere of the shot. The overall lighting style of the long shot, however, is also heavily influenced by the exposure and lighting ratios seen in the frame. The overall mood of the lighting effect is created by a combination of four factors:

1. the direction from which the keys strike the action area or subject's block

2. the lighting ratio of the action area

3. the exposure ratio between the background and the action area

4. the exposure ratio between the foreground and the action area

Any of the common lighting setups or variations can be used to produce any desired effect from low- to high-key if the exposure ratios of the other visible set areas are considered and adjusted for this purpose. There are no hard

and fast rules for using any one setup for a particular effect. For example, low-key effects are generally established with narrow lighting, but a frontal key with a high exposure ratio between the action, background, and foreground areas of the set may work just as well.

BROAD-LIGHTING SETUPS
POSITION OF THE KEY

By placing the keys close to the ceiling in an arrangement parallel to the moving subject on the camera side of the set a *broad-lighting* setup is created (5-12). Broad on-camera keys are directed to angle light onto the front of the action (5-13), causing the shadow from the moving subject to fall

to the side of the frame (5-14). In this front-angled position the broad key provides contrast and modeling for the subject. If it is desirable to lower the lighting ratio of the block, a supplemental fill may be used.

Due to the angling of the lights little of the subject, viewed from the camera position, is left in shadow. This decreases the feeling of depth in the shot, which makes broad lighting particularly suitable for illuminating high-key scenes. The light is generally permitted to spread over large areas of the subject's blocking by positioning each of the fixture's barndoors horizontally. Used in this way on high-key sets, a surprisingly small number of properly directed broad keys will light a long block.

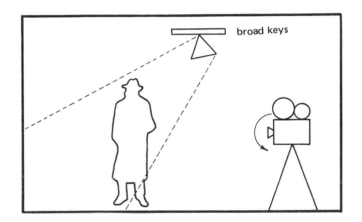

5-12. Broad-key light on a grid.

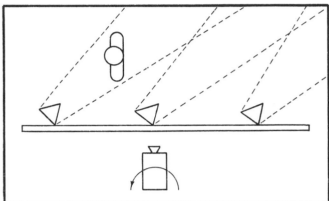

5-13. Broad keys on a grid.

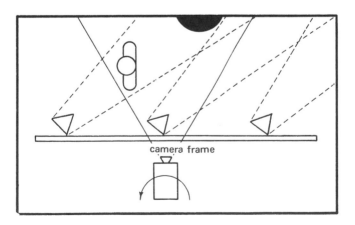

5-14. Broad keys, with the shadow thrown to the side of the frame.

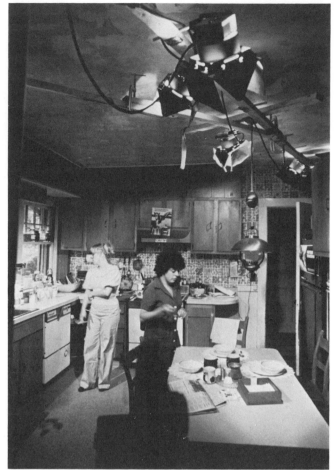

5-17

Long shot/kitchen morning/high key. 5-15. Barndoors on the key light are opened and the lights adjusted to illuminate large areas to equal intensities, producing the high-key effect. 5-16. The shot as seen from the camera position. The seated subjects are broadly keyed from the direction of the motivating source; the exposure ratio of the foreground to the action area is 1:1. Intensity is permitted to fall off one f/stop across the cabinets to add some contrast to the shot. The windows are gelled with 85N3. 5-17. Lighting diagram: a direct-focusing key side-lights the subject as she approaches the window area with a specular illumination simulating bright sunshine.

5-15

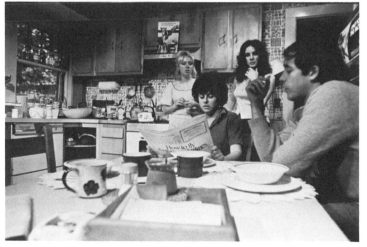

5-16

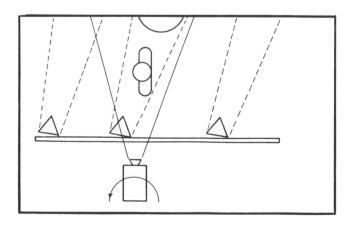

5-18. "Broad keys" angled incorrectly.

PRECISE ANGLING OF THE KEY

If the keys are placed in a flat position to strike the subject from the side and are not angled to light the front of the actor as well, the broad lighting tends to destroy the feeling of depth in the shot by illuminating all parts of the subject equally, leaving no areas in darkness to add contrast (5-18). Light striking the subject from this position may also cast a shadow in the center frame onto the background. The appearance of this dense shadow will draw the viewer's attention to the position of the lights and may prove to be disorienting and unnatural if it is not justified by a practical on the set or by some other motivating source.

Long shot/handloom/high key. 5-19. Direct softlight from the umbrella evenly illuminates the small area to 125 footcandles. The focusing spot above the door provides backlight for the subjects, separating them from the background by adding specular highlights to the shot. 5-20. Bounced light from the umbrella gives a wraparound quality: notice the softlighting on the standing subject. The position of the umbrella is chosen to light the subjects with a broad-lighting setup. 5-21. Wide shot framing the scene from the camera position. Notice the effect of the backlight on the subject. 5-22. Lighting diagram: the single 1K is specifically positioned to bounce light onto the wall to the right of the loom. This boosts the exposure of this area to $\frac{1}{2}$ f/stop below the main area.

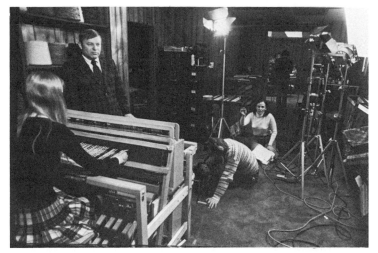

5-20

5-21

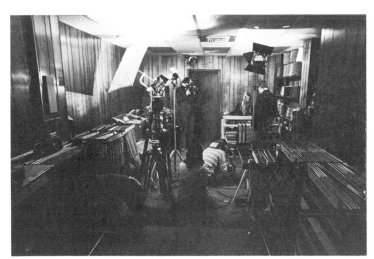

5-19

5-22

111

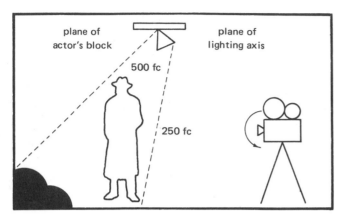

5-23. Broad keys and the proximity of the lighting axis to the blocking axes for shadow placement.

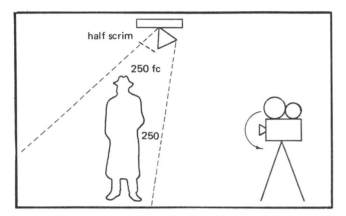

5-24. Broad lights with scrim.

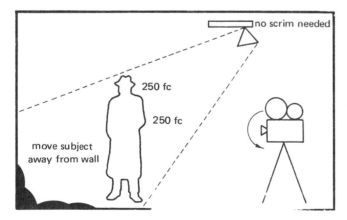

5-25. Broad keys lessen the falloff intensity as the actor moves away from the wall.

SHADOW CONSIDERATIONS AND INTENSITY FALLOFF

When using a broad setup to key the action in long shot, the filmmaker should try to limit the number of dense, sharp, in-frame subject shadows to *one.* There is nothing more distracting than multiple-key-light shadows from a single subject cast onto the background. The fill may add another shadow behind the subject, but as it is generally softer and less dense, it is also less noticeable.

The key-light shadows should be kept as low and as out of frame as possible (5-23). To produce this shadow direction, the keys must be placed very near the plane of the actor's block. With a low ceiling, however, directing the keys from this position may cause a noticeable falloff in intensity across the length of the body. Following are several methods of avoiding the combined problems of shadow placement and subject intensity falloff when using multiple broad keys to light the movement.

1. Place a half scrim in each of the keys. This balances the intensity between the head and the foot of the actor and minimizes light falloff (5-24).

2. Alter the actor's block so that he is further away from the wall. This enables the light to be angled as prescribed and keeps it away from the subject (5-25). Though the shadow will be longer than that produced by a more ideally angled key, this technique directs the shadow to a less noticeable position in the frame.

3. Change the lighting setup. It may be possible to use a narrow or frontal setup instead. Drastically repositioning the keys will certainly alter the placement of the shadows cast by the actors.

Long shot/shuttleless loom/high-key interior. 5-26. The overhead fluorescents are turned off, and 3200°K tungsten illumination is used to light this machine to 125 footcandles. Daylight coming from the windows produces only 25 footcandles, so it is easily overpowered. The machine is keyed from the side rather than from the front to emphasize any texture separating the various planes of the machine and to throw multiple shadows to the side. 5-27. Stand-mounted focusing spots located just outside the camera view highlight areas that exhibit little luminance with specular light. Other focusing spots are rigged high above to an existing pillar: they backlight the scene and provide separation. 5-28. A wide-angle frame seen from the camera position. The same lighting setup is also used to match closeups and medium shots filmed from the front. 5-29. Lighting diagram: the background is lit by broad lights located as close to the machine as possible in order to eliminate problems caused by the short throw capacity of these fixtures.

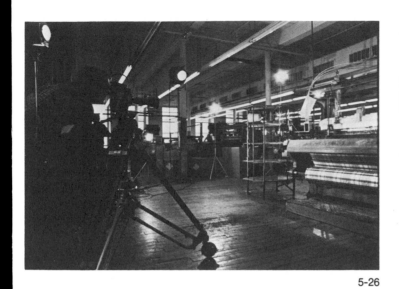

5-26

5-28

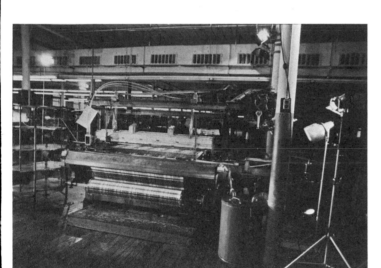

5-27

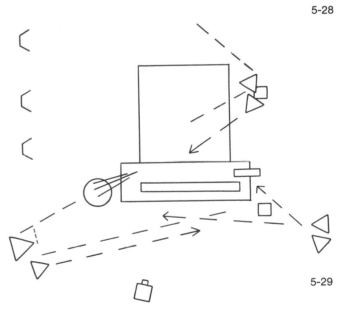

5-29

113

5-30. Narrow key and its cast shadow.

5-31. Narrow keys and their cast shadows.

5-32. Incorrectly placed narrow keys, with the resulting shadows.

NARROW-KEY-LIGHTING SETUPS
POSITION OF THE KEY

A *narrow-key-lighting* setup keeps the side of the subject nearest the camera in darkness (5-30). This is done by rigging the keys off camera parallel to the block on the far side of the subject, normally between the actor and the background and as close to the ceiling as possible (5-31). Again, as with the broad-lighting setup, the narrow keys are angled to model the opposite side of the actor from the front. In order to be used as a yardstick in setting the fixtures, off-camera long-shot lighting should be roughed in to skim the actor's body and face, throwing a triangle of light on his dark side in much the same manner as in closeup lighting. A variety of off-camera lighting designs in long shot can be created with narrowly placed keys by adjusting the exact angle of the light's incidence in relation ·to the position of the actor. The keys, however, should not generally be arranged to light the subject flatly from the background position (5-32), as this location will destroy all characteristic modeling and backlight the movement (not a bad effect if it is desirable).

LOW-KEY EFFECTS

Narrow keys are frequently used in low-key long-shot sequences for three reasons: they leave a great portion of the action area in darkness; they seldom cast a shadow on the background; and they rarely spill light onto the back areas of the set.

Modeling the Action Area

Narrow setups may require more lighting fixtures than other setups and must be carefully positioned and controlled, as their barndoors are generally narrowed in a vertical manner to limit the light's spread in order to obtain a pleasing effect. Although precise modeling of the action area is of little importance to the filmmaker designing the lighting for the long shot, the size of the subject area left in darkness due to the positioning of the keys is important. Viewed from the camera position, the narrow key leaves a great portion of the subject in shadow, and the lighting contrast of the action area is therefore very noticeable. Since this relatively large area of darkness (contrast) can be precisely controlled with fill illumination to produce a variety of low-key lighting ratios, narrow lighting is often used on low-key long shots where it is important to increase the feeling of depth.

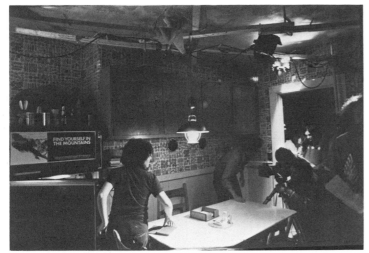

5-33

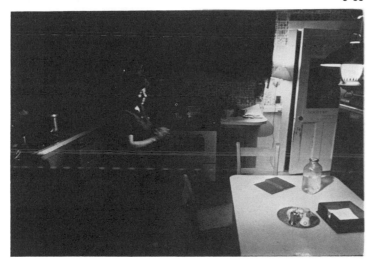

5-34

Shadow Considerations

Prominent shadows may alter the mood of a low-key scene and draw attention to their presence. They are especially noticeable in long shots, in which it is sometimes next to impossible to exclude them from the frame. In such situations the narrow key is helpful in maintaining the low-key effect, for its shadow is seldom cast onto the background and usually falls within a limited area. The shadow will generally fall toward the camera from the side of the actor and never behind him or in line with the lens.

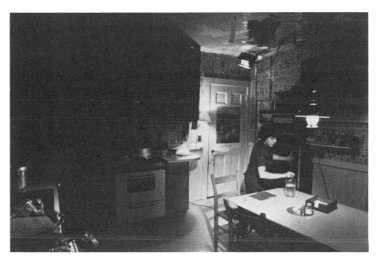

5-35

5-36

Long shot/kitchen/low key. 5-33. The overhead gridwork is made of 2-x-3 lumber. The focusing spot over the camera will be positioned to act as a fill light, bouncing light onto the set from the white ceiling. The grid also supports the hanging practical, which is fitted with a balanced 250-watt ECA. 5-34. The shot as seen from the camera position. The subject is cross-keyed; a narrow-lighting design lights the block as the actor moves toward the table. The lighting ratio on the actor is 8:1. The dark background is not keyed but rather lit evenly by indirect fill at an intensity three f/stops below that of the action. 5-35. The doorway area is lit by a wall-mounted practical to $\frac{1}{2}$ to 1 f/stop over the exposure of the action. 5-36. Lighting diagram.

115

Key-light Spill

Keeping the actor's shadow off the background also prevents light from the keys from reaching the background. In this way narrow lighting helps to keep spill light down to a minimum. Controlling and balancing the back set's illumination separately without the interference of key light facilitates the adjustment of the long shot's mood. Lack of spill makes possible the selection of appropriate exposure ratios between the action areas and the background. The narrow key may spill some light onto the foreground of the set. If this becomes a problem, it may be eliminated by flagging the unwanted light or by switching to a frontal-key-lighting setup.

5-37. Frontal keys.

5-38. Frontal keys and the cast shadows. (A grid is not shown.)

FRONTAL-KEY-LIGHTING SETUPS
POSITION OF THE KEY

Fixtures placed directly over the actor's block and slanted toward the front of the subject at approximately a 45° angle from the ceiling create a *frontal-lighting* setup (5-37). They light the action area head on, casting a shadow directly behind the actor onto the floor of the set (5-38). The actor is fully lit by the frontal keys, leaving little of the action area in darkness.

ADVANTAGES OF FRONTAL KEYS

One of the most frequently used setups for location shooting, the advantages of the frontal-lighting setup are numerous, especially in the placement of the key's shadow, the ability to produce high- and low-key effects, and the limited number of fixtures needed to light the block.

Shadow Placement

In terms of the placement and direction of shadows the frontal key is the most versatile setup. The shadows cast are never a problem, for they fall behind the subject onto the floor of the block. In this location the shadows cast are less noticeable and distracting than those cast to the side or toward the camera. The lack of distinct key-light shadows on the walls of the set sometimes eliminates the need to include a visible justified-light source. When the shadows from the actor are noticeable in the frame (such as when the actor stands near a door or entrance), they generally fall so far down toward the bottom of the frame that they will probably go unnoticed.

Long shot/formal party/high key. 5-39. Large amounts of camera and subject movement make it necessary to construct a grid for rigging the lights. The keys are rigged to light the subject movement from a frontal position. Although the subjects move through pools of light, the lighting on the action axis is leveled to an even 250 footcandles. Notice the position of the two 2K softlights used as fill. 5-40. The textured, medium-colored interior walls are lit to within $\frac{1}{2}$ f/stop of the action areas. The polecats supporting the grid are painted to match the background. The area to the right of the frame is exposed to $1\frac{1}{2}$ f/stops below the main-action area: its only source of illumination comes from the 500-watt bulb placed in the table lamp. 5-41. An over-the-shoulder view of the set from the camera position. The seated characters cast only one shadow behind them: a single focusing spot is responsible for their illumination. The pictures, framed behind glass, are tilted toward the floor to remove glare. 5-42. Lighting diagram: as the camera dollies back and the subject approaches, the subject is lit with an off-camera lighting setup and filled to a 4:1 lighting ratio.

116

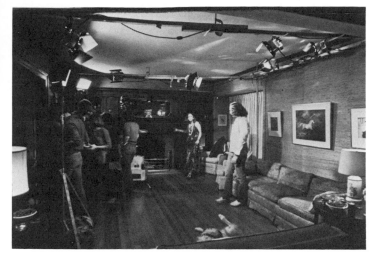

5-39

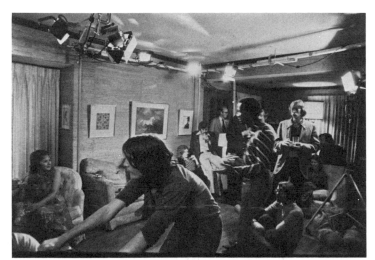

5-40

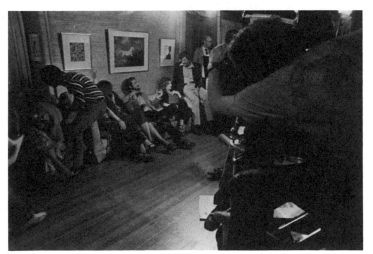

5-41

High- and Low-key Effects

The frontal-key-lighting setup is completely adaptable to both high- and low-key lighting effects. This is primarily due to two characteristics of the setup: its ability to produce a "neutral" lighting direction and its failure to interfere with the illumination of any of the other scene areas.

Since frontal keying leaves little of the subject in shadow, many filmmakers have adopted it as "standard" indoor-location illumination. The viewer usually sees overhead illumination as well as the shadows that it produces as natural, even if an in-frame practical is not included. It may be a lighting convention, but it has generally been accepted that frontal keys are a "safe" setup to use when no in-frame motivation is present. For this reason frontal illumination may be thought of as producing a "neutral" lighting direction, and long shots filmed with these setups may be easily intercut with narrow or broad tighter shots that are lit for the desired ratio and effect.

Frontal keys light only the action area of the set. They do not spill light onto the background or the foreground (as narrow or broad keys may): each of the three areas of the set—the *background*, the *action area*, and the *foreground*—may thus be lit separately without interference from the others. Precise exposure relationships among all three areas can easily be established, making the frontal-lighting setup adaptable to either high- or low-key long-shot effects.

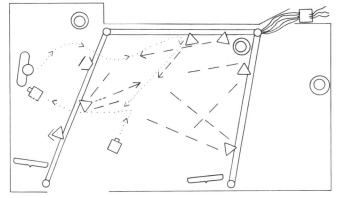

5-42

Number of Fixtures Needed

Fewer key-light fixtures are generally needed to light a block with a frontal setup than to illuminate the same area with narrower lighting designs. The number of fixtures necessary to cover the block may be further decreased by

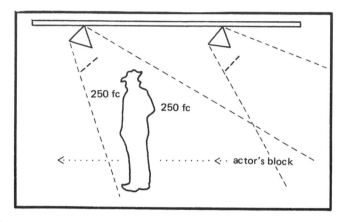

5-43. Frontal keys with half scrims. (The camera is not shown.)

using half scrims, provided that the keys are rigged high enough above the actor's head as he moves through the scene. Adding the half scrim enables each fixture to light a larger area and maintains an even illumination on the subject as the blocking progresses (5-43).

Long shot/supermarket/high-key-tungsten balance. 5-44. The existing fluorescent illumination is turned off, and the area to be filmed is limited in size so that it may be lit with a reasonable number of tungsten fixtures. 5-45. To reproduce the flat quality of illumination commonly associated with fluorescent lighting, a combination of bounced lighting and direct softlighting is used. The softlights are positioned to strike the action from a high angle to limit the production of telltale catchlights (reflections) in the glass display cases. 5-46. Wide-angle framing seen from the camera angle. The lighting and exposure ratios are nearly 1:1. Light-colored panels to the left of the butcher are actually glass panels covered with contact paper to eliminate glare problems. 5-47. Lighting diagram: two direct-focusing fixtures are used because it is necessary to light the background from a distance, which could not be done with bounce illumination.

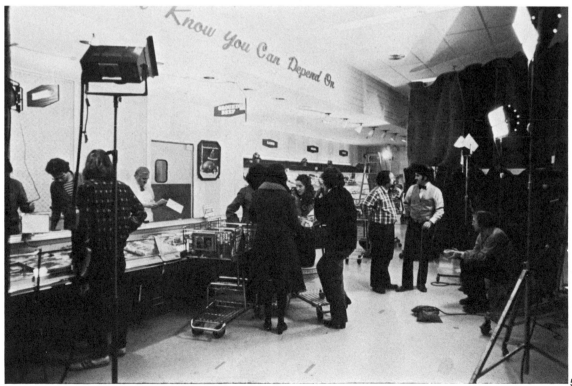

5-44

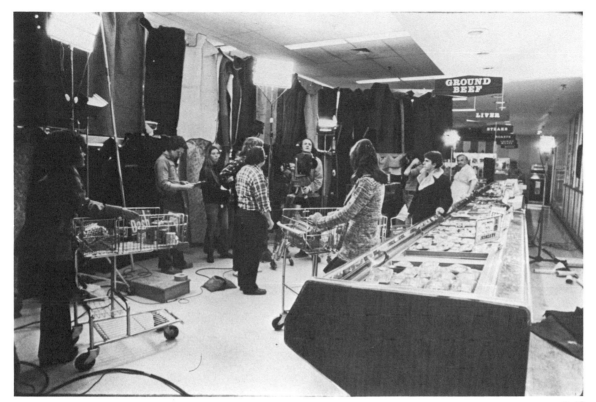

5-45

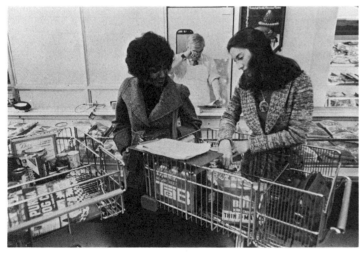

5-46

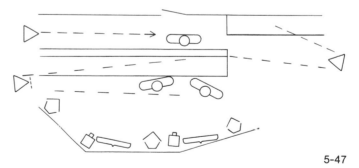

5-47

5-48

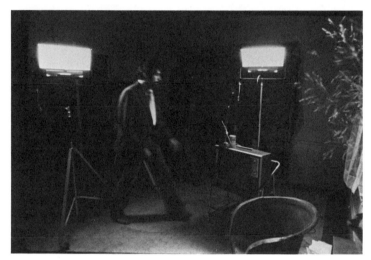

5-49

After the key lights have been set and before the fill or background light is added, *balance* the illumination of the key lights for exposure. With the dome of the incident-light meter in place, walk the block of the action. Point the dome toward the camera at all times and monitor the changing light levels, making certain that your shadow doesn't prevent any light from reaching the meter. Moving between the pools of light, note the fluctuations of the meter in footcandles or f/stops. Have the intensity of each light adjusted while walking through the block. Balance the intensity to the level of illumination desired and have a stand-in block the scene while you view the action through the camera to analyze the lighting effect and shadow production.

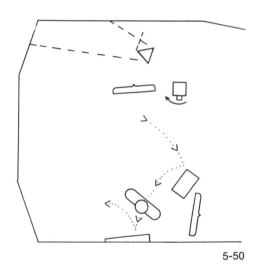

5-50

Long shot/walk to mirror/high key. 5-48. To simulate the high-key mood of a daylight interior, softlights are chosen to illuminate a limited-movement long shot. 5-49. Placed slightly higher than the subject's eye level to prevent shadows cast by the moving subject onto a nearby wall, two 2K softlights evenly illuminate the shot to 125 footcandles. 5-50. Lighting diagram: the character walks from camera right toward the TV set on camera left and then up to a mirror, where the camera view includes the reflection of the opposite side of the room in the mirror. To avoid a reflection of the camera and lights, the mirror is angled away from the wall; the side of the room reflected in the mirror is lit to the same intensity as that of the main-action area.

Long shot/beamer/high-key interior. 5-51. The luminance ratio of the white threads against the dark spools is extremely high: to lower the contrast of the shot, the dark areas of the spools are lit to one f/stop over the exposure of the white thread. Stand-mounted broad lights are angled to key the machine in such a way as to throw the shadow of the moving camera far to the right of the frame. 5-52. To take an exposure reading, the incident dome is held toward the camera position. Care is taken not to block any illumination falling on the dome. To aid in the visual separation of this white-on-white subject, key lights, seen in the background, illuminate the rolls of thread rather than the thread traveling on top of them. 5-53. Hidden from the camera view, a broad light placed on the floor illuminates a dark portion of the machine. 5-54. The machine operator is side-lit with tandem-mounted keys. The background is unlit and left dark. 5-55. Lighting diagram: a half scrim is used with the 2K lighting the dark areas of the beams to produce an even exposure across the length of the machine.

5-51

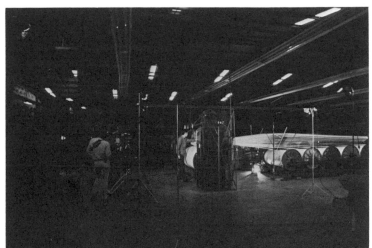

5-53

5-52

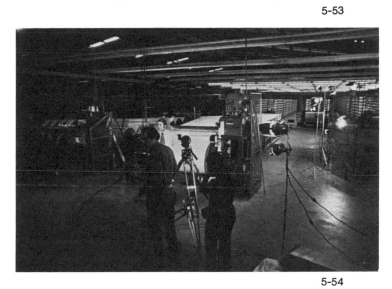

5-54

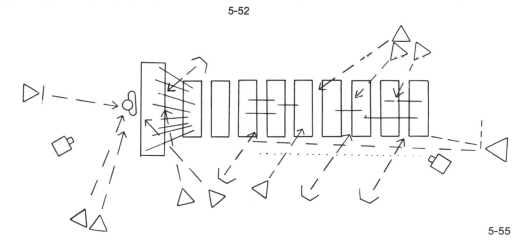

5-55

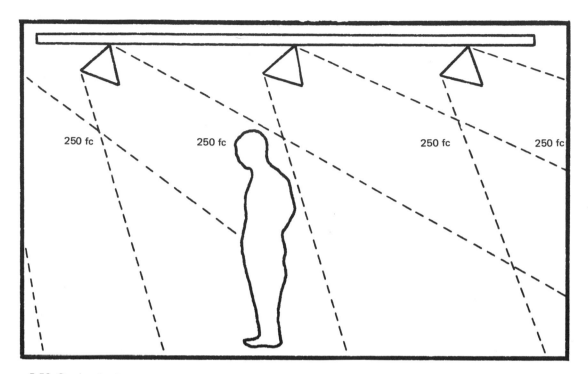

5-56. Overlapping keys.

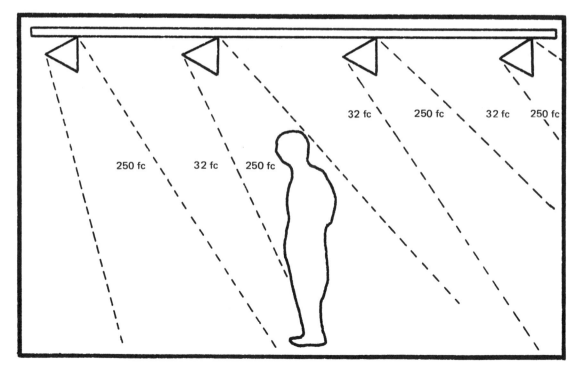

5-57. Pools of light: nonoverlapping keys with no fill light.

OVERLAPPING THE KEYS

It is not necessary to overlap the keys in order to provide an even exposure over the entire block (5-56). Although evenness of lighting looks fine in high-key scenes, the filmmaker will often purposely leave gaps between the pools of light to control the mood of the shot (5-57). For a low-key shot the filmmaker may wish to separate the action from the background strictly by the light from the background itself.

For example, in a low-key interior the actor's block may be key-lit only in areas in which he appears against a dark part of the background. In those areas in which background light is brightest (e.g., from a practical) the portion of the block in which the actor is seen against the illuminated areas will not be keyed. If this particular portion of the movement is lit at all, it may be keyed to a lesser intensity than that of the main exposure. This pooling of key light, coupled with an alternatingly illuminated background, will produce interestingly low-key-lighting effects for movement in long shot.

Nonoverlapped pooled light may be also used in more normal filming situations, but the gaps between the areas lit by the keys should be fairly narrow. This may create a slight unevenness in the lighting of the subject's block but will be less noticeable if a high overall-fill ratio is used to lighten the separation (5-58).

USE OF THE FILL LIGHT

In theory the primary function of any *fill light* for a long-shot sequence is to lower the contrast of the scene in order to produce the desired effect of lighting styles, lighting ratios, and exposure ratios within and between the action areas, the background, and the foreground. Each area would ideally be keyed separately for directional and exposure-balance purposes. The fills would help control the contrast in each section of the set by overlapping the key's coverage. In practice, unfortunately, this is often not the case, especially with location films. The fill lights at times have a dual purpose: they both lower the contrast of the shot by adding illumination to those areas lit by the key and provide the only source of illumination for areas of the set other than the action areas.

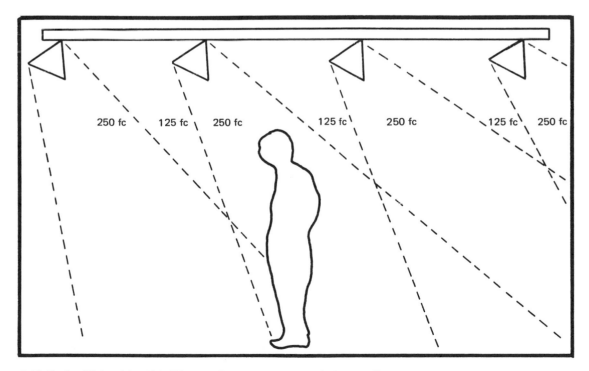

5-58. Pools of light with a high fill ratio. The measurements are in footcandles.

GENERALIZED AND LOCALIZED FILL

Fill illumination for long shots can be divided into two categories: *generalized* and *localized*. The division is based on the area of coverage of each type. Since the addition of varying amounts of fill is one factor in controlling the lighting mood of the scene, the categories also relate to particular lighting styles with which they are commonly employed.

Generalized-fill illumination covers a very large area of the set. It may be thought of as an "overall" base illumination: one that lights most of the long-shot set areas equally. This type of fill is commonly used on high-key sets to lessen the densities of the shadows created by the keys and to bring up detail by illuminating the background and the foreground.

Localized-fill illumination covers small, defined areas of the long shot. Local fills are pinpointed to bring up detail specifically in a darkened portion of the wide shot or are directed to control the lighting ratio of a particular section of the scene that is already keyed for effect. Since the directional properties of the local fill prevent spill from affecting other portions of the set that it was not intended to light, local fills adapt well to low-key filming situations. With their use a high contrast ratio and a delicate exposure balance between the three primary set areas become possible.

Long shot/bedroom/low key. 5-59. As the actor turns on the light switch, a gaffer turns on the key that lights this section of the movement. The brightly lit hall, seen behind the actors, is illuminated to one f/stop over the doorway action. 5-60. The actors, seen from the camera position, are lit with 250 footcandles; the background is lit with 100 footcandles. 5-61. The backgrounds are unevenly illuminated: the 4:1 lighting ratio on the closet doors helps establish the moody atmosphere of the shot. 5-62. The shot seen from the camera position. At the edge of the bed the action is lit with 125 footcandles; the background directly behind the action is lit by the practicals to 200 footcandles. 5-63. The localized lighting on the background is produced by the motivating practical. 5-64. All the lighting fixtures are rigged as close to the ceiling as possible except for the single key, which, to emphasize the texture of the bedclothes as it skims across the surface, is positioned on the vertical support. 5-65. A reverse angle showing the lighting and rigging. 5-66. Lighting diagram: because of the position of the keys the shadows from the moving actors always fall out of frame. Focusing spots, heavily diffused to soften the beam, are used to fill the action area locally, avoiding unwanted spill onto the back areas of the shot.

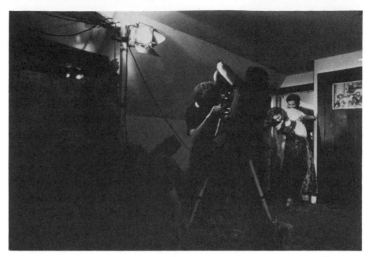

5-59

5-60

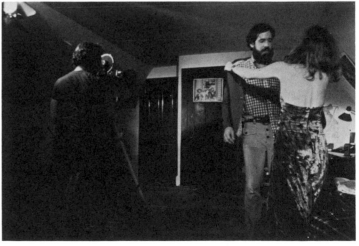

5-61

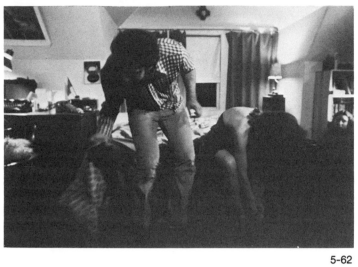

5-62

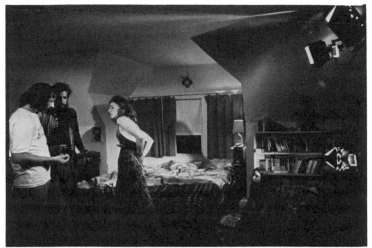

5-64

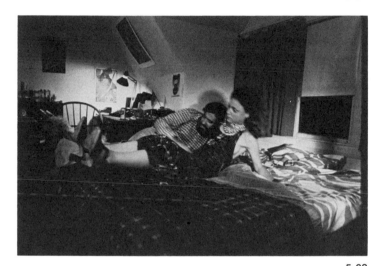

5-63

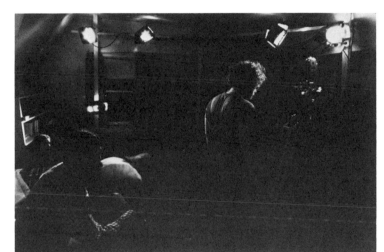

5-65

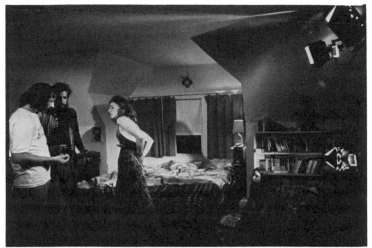

5-66

POSITIONS, PROBLEMS, AND FIXTURES

Fill light for long shots may be produced with fixtures mounted on floor stands, as with closeups and medium shots, or it can be directed onto the set from fixtures mounted by some "standless" means above the action. There is no way to suggest rules for fill-light positioning that would apply to every situation, but two general guidelines for selecting and locating fixtures may be useful.

1. Choose a fill-light fixture that produces more diffuse illumination than that of the keys.

2. In placing the fixture avoid noticeable multiple shadows on and behind the subject wherever and whenever possible.

Large, very diffuse softlights are ideal for generalized fill but often illuminate the background of a small set to an uncontrollable degree. From a floor-stand position they cannot be placed close enough to the subject and still stay out of frame (5-67). This restricts the camera movement and cancels the advantage of the fixture's light-falloff potential, creating background problems and shadows (5-68). (Remember that background shadows of subjects lit by diffuse sources tend to be less dense and less noticeable when the source can be placed close to the subject.) Broad lights or flooded spots may be used in situations in which fill must be thrown into the scene from a position far from the set, but these lights unfortunately can cast fairly harsh and noticeable shadows, especially when directed from stand-mounted positions close to the camera angle.

If it is possible to mount the lights above the action (perhaps to a grid or molding along the perimeter of the room), many of these fill-lighting problems may be eliminated. But large softlights are often too heavy or too bulky to be placed in such a position in a small interior. Therefore the long shot must often be filled with a combination of lightweight, diffuse-directed fills mounted deep into the set. Flooded variable-focus spots that are heavily softened with gauze or silk work well for generalized as well as localized fill yet remain out of the frame when set close to the ceiling of the location.

Overhead- and Stand-mounted Fills

In addition to alleviating the difficulty of placing, directing, and balancing the intensities of fill illumination, fixtures mounted overhead supplemented with floor-mounted fills can solve problems of shadow production that commonly plague the filmmaker when fill-lighting small interiors. Background shadows from subjects lit from overhead fills fall downward and out of the camera view. Although this shadow direction is ideal for action that takes place in the background, a similar arrangement of fill-light shadows may appear unnatural and distracting on near-camera foreground subjects, where modeling is more noticeable. In these cases it is best to combine the overhead deep fill light with a shallow frontal fill from a diffuse source such as a softlight, which can light the foreground from an eye-level, stand-mounted position. The stand-mounted softlights used to fill in foreground areas, due to the great falloff of illumination between their location and the back wall of the set, generally don't produce undesirable shadows on the back wall.

While floor-stand eye-level fills are perfect supplements for the overhead fills in lowering the contrast of the long shot, they should not be used alone without others located overhead and deeper into the set if exact control over the lighting ratios of various parts of the scene is desired. Even high-key shots with a generally high level of fill should be lit with a combination of deep-overhead and shallow-frontal fill light or with base illumination, a technique described later in this chapter.

Eye-level Fills

On a small set, especially if the scene being filmed is high-key, the tendency to light with eye-level frontal fills alone should be avoided. By themselves they will illuminate all three major set areas, foreground, action areas, and background, simultaneously. Under such circumstances the fill intensity illuminating *all* parts of the shot would be set by the lighting ratio of the subject or action for which it was primarily intended.

Subject blocking may be severely limited by this lighting arrangement. For example, in a small interior a general frontal fill may produce a 2:1 lighting ratio in the main action area. Action moving toward the fill, even if keyed from above, will have close to a 1:1 ratio. The lighting ratio of a subject moving away from the light (controlled by the fill) may likewise fall off to a distractingly darker condition.

Under similar conditions there is also a tendency to use the fill light as the only source of illumination for the background. This, too, should be avoided if possible. Although any front-mounted fill will illuminate the background to some extent, the background's illumination should be

separately controlled. This is especially important for lighting continuity and for mood establishment in a low-key scene.

Shadow and Spill Problems

In long shots fill-light shadows are always a problem. Although the shadows cast by the fills are generally more diffuse and softer than those cast by the keys, they are usually more conspicuous. They frequently fall in frame on the camera axis or onto the backdrop, for it is often necessary to place some fill near the eye level of the subject. A singular subject shadow produced by the fill will generally be accepted by the viewer, but multiple fill-light shadows must be avoided at all times. Multiple shadows may occur if two similar types of fills overlap or if a locally directed fill illuminates an area also lit by a general fill that strikes it from a slightly different angle.

Problems common to both high- and low-key sets, fill-light spill and distracting shadow production are sometimes impossible to correct, due to the directional and placement restrictions imposed by the physical properties of the location. The size of the location interior may influence not only the way in which the fills are arranged and rigged but also the solutions used to cope with spill and shadow difficulties. For example, a set of sufficient size will enable the actors to move their blocking further away from the walls. This may provide enough distance between the actors and the background to increase the intensity falloff between the action and the back areas of the set, producing less noticeable shadows as well as less damaging fill-light spill. A large room with a high ceiling also permits the installation of a temporary lighting grid. Placing the fills on an overhead support aids in moving the shadows cast by the fill to a less conspicuous location in the frame (5-69).

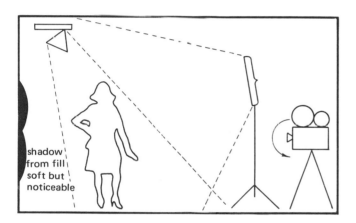

5-67. Stand-mounted fill and cast shadow with a narrow key on the grid.

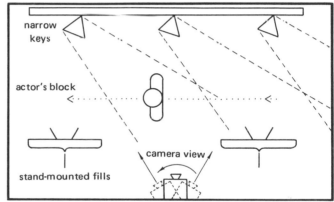

5-68. Floor-mounted fills correctly positioned but interfering with camera movement.

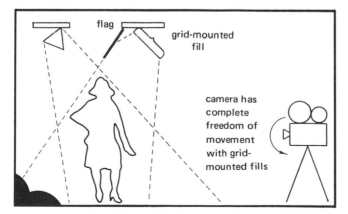

5-69. Grid-mounted fill and cast shadows.

ADDING TO A BASE ILLUMINATION

Because of all the difficulties involved in rigging, direct- ing, and positioning fill lights to avoid shadow, spill, and light-leveling problems, many location filmmakers use a generalized-fill-light procedure known as *adding to a base*. This technique involves the production of an overall soft, shadowless fill illumination throughout the entire interior, a base or foundation level of illumination that both lowers the contrast of those areas lit by the keys and provides primary illumination to other areas of the set. Base light is a "fill" light that illuminates the action area, the fore- ground, and the background equally: its intensity is pre- cisely controlled in relation to that of the keys, which are brighter than the foundation illumination. The keys pro- vide direction lighting and modeling only to the *action* areas, and their *intensity* is finally adjusted *after* the foun- dation level of illumination has been set. This is the situ- ation from which the term "adding to the base" is derived.

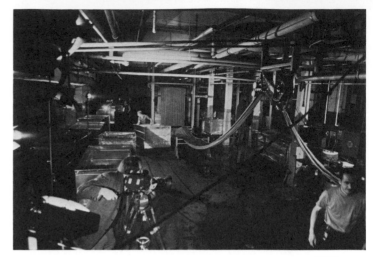

5-70

5-71

Long shot/drying machine/high-key interior. 5-70. The great dis- tance between the spots and the subjects makes it necessary to use focusing spots to light the large areas. The focusing fixtures used as key lights must be directed to strike the subject from a similar angle so that their coverage overlaps. 5-71. Broad lights are used for fill illumination. They strike the subject from a flatter angle than that of the keys and are stand-mounted at a height lower than that of the key lights, enabling them to fill in the shadow areas created by the focusing spots adequately. The focusing spot seen at the bottom of the frame is directed to boost the exposure of a low-luminance area to $\frac{1}{2}$ f/stop higher than that of the rest of the shot. It is directed to light this particular area of the machine from a low, stand-mounted angle: there is no fill-light overlap with its illumination. 5-72. Focusing spots fitted with mirror re- flectors light the arched fabric from a position out of the camera's view. Located behind the support columns and rigged on low stands, these lights highlight the subject by rim-lighting parts of the machine, separating it from the background. 5-73. The shot seen from the camera view. The entire length of the machine is lit to an even 125 footcandles. The highlighted portion of the arched fabric is lit to 200 footcandles; the dark turntable under the cart in the foreground is also lit to 200 footcandles, effectively lowering the luminance ratio of the shot. Backgrounds and ceilings are lit to 64 footcandles. 5-74. Lighting diagram: existing "props" such as support columns are often used either to camouflage lights from the camera's view or to rig lights. If these columns were not part of the scene, the rim lights would have been placed far to the right of the set, which would probably have decreased their effec- tiveness by reducing the intensity available to separate the subject from the background.

5-72

128

Base light is shadowless and omnidirectional and is best achieved by one of three methods.

1. Broad or flooded-out directional fixtures may be hung along a temporary grid and directed toward the ceiling (if it is white) in order to bounce fill illumination equally into all parts of the set below.

2. If a grid isn't available, direct-focusing fixtures may be rigged along the perimeter of the room (or even placed on stands if they do not interfere with the camera's framing) and directed toward the ceiling of the set to provide a base illumination.

3. Heavily diffused softlights can be hung onto a grid directly over the set: enough fixtures are placed overhead so that their spread will eventually fill-light the interior when they are pointed directly downward into the room.

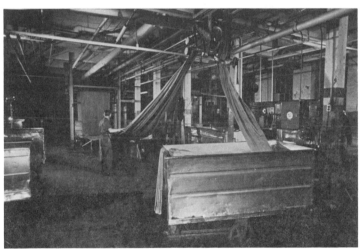

5-73

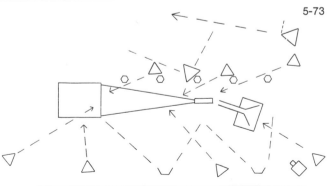

5-74

Although producing a base level of illumination for fill light works best for high-key scenes, it may also be effective in some low-key situations, especially if the walls and furnishings of the interior are of a darker color.

To select the level of intensity to balance the base lighting, the filmmaker must first know the level to which the directional keys lighting the action are to be set. For example, suppose that the action areas are to be key-lit at 125 footcandles. Adjust the base illumination to one or one and a half f/stops below the exposure level selected for a high-key scene and between two and three f/stops below that for a low-key scene. If the filmmaker has selected 125 fc for the keys, then the base level is adjusted to 64 or 40 fc for a high-key effect, producing a 2: or 3:1 exposure ratio between the action areas and the rest of the set. If a low-key effect is desired, the base can be adjusted to 32 or 16 fc. This would produce a 4 : or 8:1 exposure ratio between those areas lit by the keys and the rest of the interior. Variation of the ratio is due primarily to the reflectance of the walls: a darker-colored room would demand more light than a lighter one.

As in all interior lighting, the key light should be positioned and roughed in first. With the keys off and the room divided into areas of projected coverage by the base lights, the base-level fills are rigged. If the fill illumination is being bounced into the set, the angle of the fixtures is important in obtaining the greatest efficiency from the lights. To check for a constant level throughout the set, walk around the interior with the hemispherical dome of the incident-light meter pointing toward the camera position, monitoring the light intensity. After the base is checked and leveled to the predetermined intensity, turn on the previously positioned keys and check their intensity by walking the block with a light meter in hand. Point the dome toward the camera position and adjust the level of the keys, not the fills, to obtain the lighting balance and exposure ratios desired.

129

THE LOW-KEY LONG SHOT
LIGHTING RATIOS

The subject of the action area of a low-key long shot is generally lit with a higher lighting ratio than subsequent closeups and medium shots of the same subject. This is especially true of small location interiors, in which traditionally positioned keys and fills would spill an undesirable amount of light over the set, making the low-key-lighting design impossible to achieve. To restrict the amount of spill light in such instances, the long shots are lit without an excessive amount of fill light: the recording of subject detail is left to successive closer shots in which the lighting ratio of the action may be lowered.

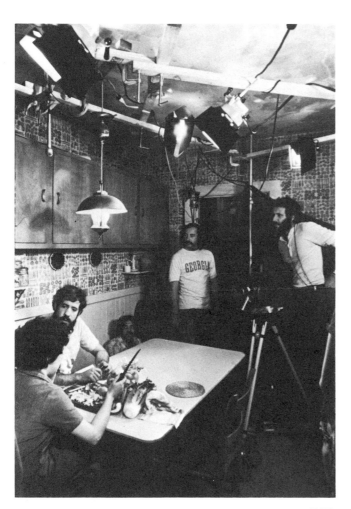

5-76

Long shot/onion scene/low key. 5-75. A frontal-lighting design is used to key each of the three stationary positions for the actors as well as their movement. The 2-X-3 gridwork is fastened together with C-clamps and attached to the vertical polecat located behind the camera, which also carries the wiring to the floor. Note the vertical position of the barndoors. 5-76. Heavily diffused fill light rigged to a cabinet door in the background serves a dual purpose: it sets the lighting ratio of the action area to 3:1 and lights the back of the standing actor, separating him from the back wall. An incident-light reading taken 2' away from the bottom of the lamp-shade practical attached to the wall near the door measures one f/stop above the exposure for the scene. 5-77. The shot as seen from the dollied-back camera position. The action area is lit to 250 footcandles, the foreground to 225 footcandles, the light background to the right of the frame to 100 footcandles, and the dark background to the left of the frame to 64 footcandles. 5-78. Lighting diagram: this interior is so small that it is impossible to prevent the lighting of the foreground, the action area, and the background from overlapping. An ideal situation is often available to the location filmmaker only on the largest of interiors.

5-75

130

POSITION OF THE LIGHTS

If the use of a base illumination for a fill light for a low-key long shot proves to be unsuccessful (this may occur if the interior is extremely small or if the walls and furnishings are light in color), another technique must be used. It involves rigging all the fixtures to the grid if possible (or getting them out of the frame by any other means) and segregating their illumination into three parts, each responsible for the total illumination of only one of the three set areas. Keys are used to light the actor's position; another set of diffused floods or focusing spots is the sole illumination for the foreground; a third and separate set of diffuse floods or diffuse keys lights the background.

Two important points should be remembered. (1) None of the three separate areas of light should overlap in coverage: i.e., the key-light illumination of the action area should not be used also to light the foreground; the foreground floods should not light the background; and so forth. (2) Although the background and the foreground lights may be the diffused or broad type that are generally used for fill-light functions (i.e., the quality of their illumination is softer than that of the keys), in this situation they act as the only source of illumination for these areas. They are the key lights for the areas that they illuminate.

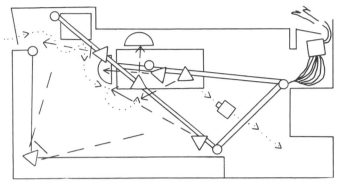

5-78

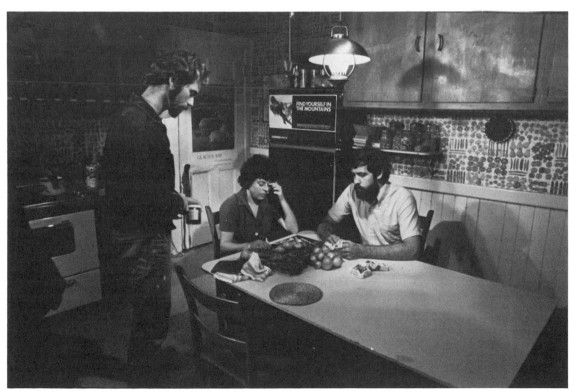

5-77

131

SETTING THE EXPOSURE RATIOS

By varying the exposure balance between the background, the action areas, and the foreground the mood of the lighting effect can be altered with this technique. For example, if the action areas of a low-key scene are keyed to 250 footcandles, the illumination of the foreground might be set at 64 footcandles. The exposure ratio of the action area to the foreground would be 250:64, or 4:1 (a two-f/stop difference).

To prevent traditionally mounted fills from spilling light onto the background, the action area may not be filled in at all, leaving the keys as the only source of illumination. In keeping with the moody effect the background may be lit with separate keys rigged from above, close to the back wall of the set. Depending upon the background's reflectance, it may be lit to two f/stops under the exposure of the subject, also creating a 4:1 exposure ratio between it and the action area. Because all exposure ratios used in setting the lighting mood of the long shot are based upon intensities relating to the intensity of the action area,

it can be seen from the example above that the exposure ratio of the long shot would be 64 (foreground):250 (action area):64 (background), or 1:4:1.

MEASURING FOR LIGHTING CONTINUITY

Measuring and maintaining the intensity relationship between the three separate areas of the set is necessary for proper lighting continuity. Measuring the long-shot exposure ratio facilitates the reproduction of the same lighting design and mood if matching long shots become necessary after the original shoot. The long-shot ratio also sets a precedent for the closer shots that are to follow in the sequence. When medium shots or closeups are filmed to match the long shot, they must be lit for the same exposure ratio as that of the long shot, or lighting-continuity problems may occur.

The lighting ratio of closer shots may be lowered from that of the long shot to aid in recording shadow detail, but a lower lighting ratio in the closer shots should not alter the overall exposure intensity of the lighting on the subject

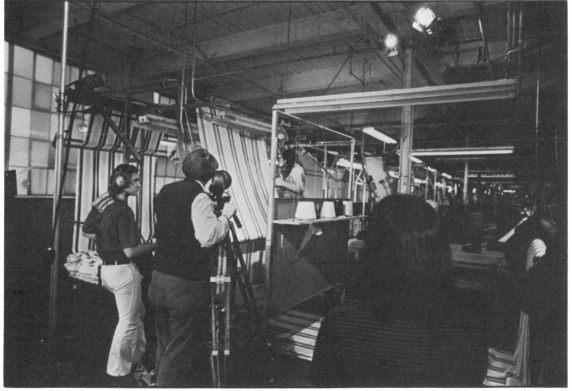

5-79

or the relationship between the subject's exposure and that of the background and the foreground seen in the frame of the matching long shot. In this way modeling and contrast can be improved in the closer shots, yet acceptable continuity between shots will still be maintained.

MEASURING EXPOSURE RATIOS

Measuring the exposure ratios between the three primary set areas of the location is a simple task that may be performed with an incident-light meter. Pointing the hemispherical dome of the meter toward the camera position, walk through the three areas of the set, measuring the exposure level of each separately. Be certain that none of the illumination covering the set is blocked by your own shadow as the measurements are taken. The correct exposure ratio is determined by comparing the foreground and background readings to that obtained from the action area of the set. Remember that exposure ratios for long shots can be expressed by the formula $er = fe : ae : be$.

PRETESTING EXPOSURE RATIOS

The importance of pretesting long-shot exposure ratios cannot be overstated, especially when working on a location film on which reshooting is undesirable. Pretesting with a practice roll helps familiarize the filmmaker with the effect of the lighting setup so that constant measurements are unnecessary on the day of the shoot. If pretesting is not feasible, shoot some Polaroid snaps on the day of the shoot so that unexpected adjustments can be made before the filming takes place.

5-80

5-81

Long shot/tufting machine/high-key interior. 5-79. The exterior windows offer less than 32 footcandles of illumination. Most areas are lit to 125 footcandles of 3200°K light, overriding the color mismatch with the window light. The main action is keyed from behind and above with focusing spots rigged to the existing pillar. 5-80. The action area is filled with broad lights located behind the camera, producing a lighting ratio of 2:1 on the subject. Due to the harshness of the fill-light illumination the fills are located higher than normal so that the shadows fall into a less noticeable position. 5-81. Wide-angle shot from the camera position. The two lights to the right of the frame are angled to backlight the rear portion of the spools. (Before this angle was filmed, boxes were placed so as to conceal these lights.) 5-82. Lighting diagram: keys light the background to one f/stop below that of the main-action area.

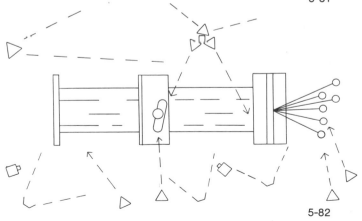

5-82

133

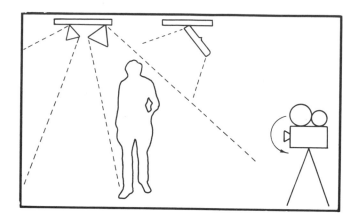

5-83. Background light, narrow key, and fill.

5-84. Background lights, narrow keys, and fills on grids.

5-85. Improperly positioned background light, which spills onto the subject's blocking.

BACKGROUND ILLUMINATION
LIGHTING MOOD

The overall intensity of the background lighting and its patterning on the back walls are frequently overlooked as variables affecting the lighting mood. High-key scenes usually lend themselves to an evenly lit, bright background keyed not far from the exposure of the action area. Low-key backgrounds are often streaked with light: the actual effect relies heavily on the pattern or design of the illumination. These backgrounds are sometimes partially lit or lit by existing practicals. For many typical low-key location backgrounds the exposure is set far below that of the action areas.

RIGGING THE BACKLIGHTS

Background illumination is most controllable if it is keyed from above. If portions of an overhead grid have been installed, the same grid used to rig the keys and fills may also be used for the background lights (5-83, 5-84). In rigging these lights make sure that they do not interfere with the action areas, as they may spill light onto the subject's blocking (5-85). Broad lights or focusing spots may be used for the background lights. A specular light will bring up the contrast of the backdrop by creating shadows and sharp highlights. Since this illumination is unidirectional, shadow placement should mimic that of the motivating sources if a "natural" (motivated) lighting style is being used for the sequence.

Backlights may also effectively illuminate walls if they are rigged to tops of window moldings or, if necessary, even to furniture tops. Stands, of course, can be used but may restrict the framing of the long shot, so some compromises in height and positioning may have to be made. To avoid interference with the subject blocking, stand-rigged backlights are frequently directed to skim across the back wall at an angle nearly tangent to its surface. If this becomes necessary, use half scrims in the fixture to even out its intensity over the spread of the wall and to maintain the directional characteristics of the motivating sources, as the shadows cast by this lamp placement tend to be elongated and noticeable.

TYPES OF BACKLIGHTING

Some types of background illumination are adaptable to both high- and low-key interiors. An example is found in the evenly lit long-shot backdrop keyed from above.

The drawing (5-86) shows a popular backlighting setup: the light spreads evenly over the backdrop and is imper-

ceptible to the audience. It can easily be altered to produce high- or low-key effects simply by altering the intensities of the fixtures in relation to the exposure level set for the action area. For example, when used in high-key sets, this backlight design is generally keyed to a level close to the intensity of the key lighting the actor's block. When employed on lower-key sets, the evenly lit background may be brought below the illumination level of the action area; the exact effect of the low-key shot depends upon the amount of variance in the exposure ratio between the two areas.

As soon as the background illumination is modified to produce lighting patterns, this setup's adaptability lessens. Patterned background lighting is often used in low-key scenes to set a moody atmosphere by varying the amount of light separating the subject and the background (5-87, 5-88). Keeping the background light noticeably uneven creates a natural feeling of depth and increases the low-key impact of the long shot. Sharp, defined lines of illumination may be created by rigging the fixtures and adjusting the barndoors to pattern the light or by flagging the illumination before it reaches the back wall.

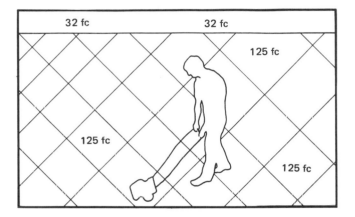

5-86. Background illumination with an evenly cast pattern. The cross-hatching indicates illumination.

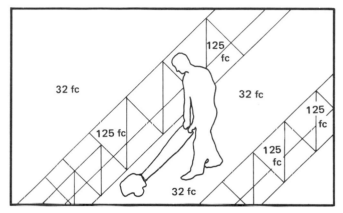

5-87. Background illumination patterned by background lights for subject-and-background separation. The intensity of the back wall is indicated in footcandles.

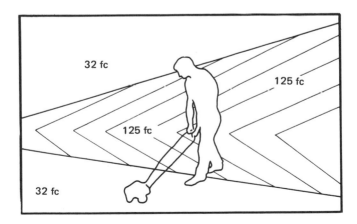

5-88. The patterned intensity of the background illumination is indicated in footcandles.

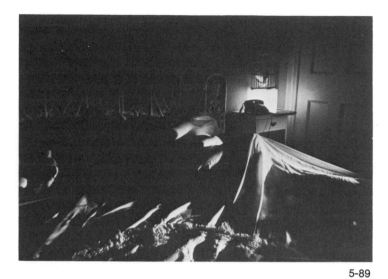

5-89

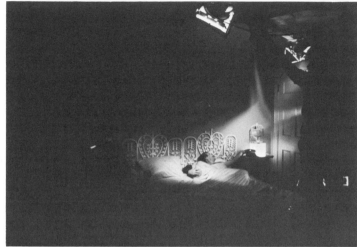

5-91

5-90

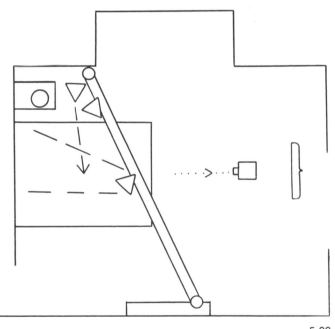

Long shot/Joan's bedroom/low key. 5-89. The shot from the camera position. The extremely high-contrast lighting is created by a 16:1 lighting ratio. 5-90. Texture is brought out by positioning a side light close to the height of the bed. 5-91. The patterned effect on the background wall is produced by an overhead key that is switched on by a gaffer as the actor reaches up to turn on the practical. At the same time a second key lights the action from above. The background is lit to an exposure equal to that of the action. 5-92. Lighting diagram.

5-92

AMOUNT, MEASUREMENT, AND REFLECTANCE CONSIDERATIONS

The amount of background illumination preferred varies from filmmaker to filmmaker and from effect to effect. To create a high-key lighting pattern, placing the background half an f/stop under the key light is sufficient; for a low-key shot a reduction of one to three f/stops is used. Although the illumination is measured in footcandles or f/stops by the incident-light meter, the reflectance of unusually bright or dark backgrounds should be considered when lighting the scene. White walls, for example, are extremely reflective and should always be lit at least a full f/stop below the key for normal or high-key filming. Since bright white picks up illumination from all over the room, it may be impossible to achieve a very low-key setup in some locations. Dark paneling or dark-painted walls, on the other hand, seem to absorb a great deal of light and should generally be overlit one f/stop above that of a wall with average reflectance to yield the same lighting effect and separation.

CORRECTING REFLECTANCE PROBLEMS

The following examples illustrate relative amounts of lighting-intensity correction that may be needed in dealing with backgrounds of unusual reflectance on high- and low-key scenes. If the background is of average reflectance, a typically lit high-key interior may be set for 250 footcandles in the action area and 175 footcandles in the background. The exposure of the action areas never changes, but the intensity of the illumination on the background may be altered to compensate for reflectance problems in some scenes. (Remember that the background illumination should not be altered between *shots* within a sequence.)

On a high-key set with background-luminance problems the background's exposure would be altered to compensate for extremes in reflectance. To produce the same effect on a high-key set surrounded by white walls, the illumination on the walls would most likely be lowered to 125 footcandles. Likewise, if the set has dark-colored panels on the walls, the background illumination would probably be brought up to 200 footcandles.

By taking the reflectance of the background into consideration by "over-" and "under-" lighting the visual effect of all three of the above-mentioned sets would be very much the same. The filmmaker is in effect adjusting the brightness range of the scene so that it more adequately falls within the same portions of the exposure range of the film in each case. This same procedure may also be adapted to achieve low-key effects. For example, a typically lit low-key interior may be keyed for 250 footcandles in the action area and 64 footcandles in the background. This produces a pleasing low-key mood with a background of average reflectance. To achieve a similar effect on a set with a bright white background, the background's illumination may be lowered to 40 footcandles. A dark wall in a similar set may be boosted up half an f/stop from the exposure of the average background by increasing the intensity to 100 footcandles for a matched effect: the reflective characteristics of the new surface would be taken into account and "corrected" for exposure purposes.

OTHER BACKGROUND CONSIDERATIONS

When lighting a background, subject shadows and the separation of the subject should be considered. Subject shadows from key and fill lights are most noticeable on smooth and light-colored backgrounds. Furniture, draperies, or textured walls such as brick or stone tend to make shadows less noticeable and less distracting.

In color filming the colors of the subject's clothing as well as that of the background can add sufficient color contrast to separate the subject and the background, making other lights unnecessary. Rim and backlights are certainly a luxury for location filming and are not used extensively unless the scene calls for a particular special effect in long shot.

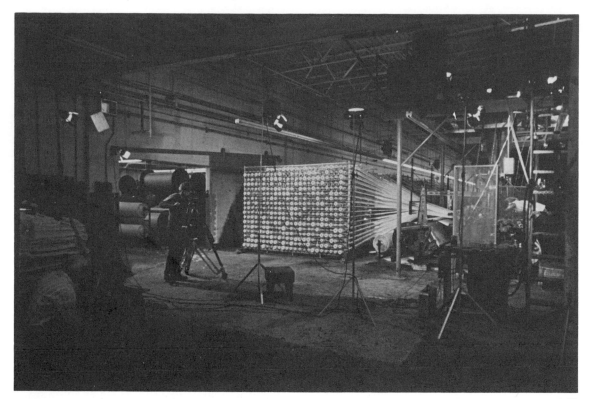

5-93

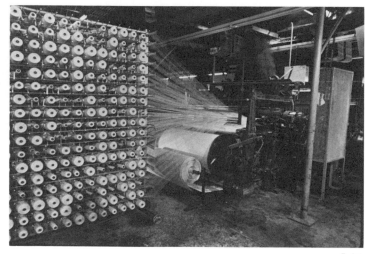

5-94

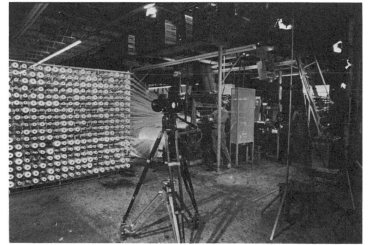

5-95

138

5-96

5-97

Long shot/plush loom/high-key interior. 5-93. Focusing spots and broads are used to light the spools and the part of the machine closest to the camera. Their coverage overlaps: they light the machine from a high angle, providing contrast by producing controlled shadows. 5-94. Wide-angle shot from the camera position. The light-colored threads leading from the spools to the machine are lit to two f/stops below the exposure of the other areas. To provide separation between the threads and the large roll beneath them, the roll is keyed to the proper exposure. 5-95. Dark metal areas of the machine that offer little luminance, such as the area in which the cameraman is taking a light reading, must be lit to $\frac{1}{2}$ f/stop above the exposure of the lighter areas (e.g., the spools) in order to decrease the luminance range of the scene. Notice the 1K positioned directly over the camera on the overhead gridwork. 5-96. The spools as lit by the 1K focusing spot. 5-97. Part of the machine is used as an overhead gridwork to hold two broad lights that evenly illuminate the operator below. The broad lights are attached to the gridwork with gator grips. 5-98. Medium shot of the operator seen from one of the camera positions. This area is keyed to the same exposure as that of the spools. 5-99. Lighting diagram: a focusing spot lights the area directly behind the machine to one f/stop below the exposure of the operator.

5-98

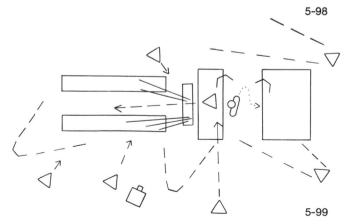

5-99

139

MOTIVATING-LIGHT SOURCES

A *motivating source* is any real interior or exterior source of illumination in the scene that would naturally be expected to produce light. Unaided location sources usually generate poor lighting conditions for interior photography, but by adding keys and a low-level fill to the existing illumination a very real, lifelike lighting effect can be achieved in the long shot.

INTERIOR SOURCES
The Practical

A *practical* is an existing artificial-light source in an interior. Common motivating practicals may be table lamps, floor or hanging lights, or other sources that are working props actually seen in the frame. By replacing the ordinary household bulbs with balanced 3200°K photofloods the lamp will produce useful illumination for filming. The photoflood color balances the illumination and boosts its intensity so that it may produce a "believably bright" appearance. The light from the motivated source is seldom used as a key illuminator for the actors in long shot. It may be employed to fill in a background locally with a realistic lighting pattern or to add to the base-level illumination of the interior by spreading light onto the ceiling that, if great enough in intensity, will bounce onto the set. In long shots it will most likely be coupled with a directed key positioned to strike the action area from an angle similar to that of the practical.

A simple action sequence (5-100) illustrates the use of practicals to provide natural lighting effects in long shots. With the practical table lamps located against the back wall

5-100. Background illumination from motivating-light sources (set practicals).

of the set only the general frontal fills would be needed to bring up acceptable detail in those areas of the backdrop not lit by the practicals. Additional fill may also be achieved with low-level base illumination. In a low-key long shot, however, the action blocking must still be keyed with a directional source. A low-key narrow-lighting setup may be most appropriate in this case, as it easily duplicates the general direction of the light falling on the subject from the table lamps seen in the background. A frontal-key setup may also work, as long as the rest of the back wall is kept fairly dark at two f/stops below the level of the main action.

Closeups and Long Shots within the same Sequence

The criteria for selecting the correct position for the keys in motivated long shots are similar to those used for closeups. (See the section on motivating light in chapter 3.) It may not always be possible, however, to place the keys in the best position for the "practical" effect in long shot, and some lighting concessions may have to be made to accommodate movement coverage in the wider frame. This generally poses no real problem, as any concessions made in the long shot may be corrected in further closeups. The long shot's success in achieving the "practical"-lighting look relies heavily upon two factors that are controllable: the exposure ratios of the shot and the pattern and the intensity of the practical's illumination on the background.

The Bow-tie Pattern

Unless an unusual special effect is desired, the bow-tie lighting pattern on the wall should not be more than two f/stops brighter than the action key itself. The intensity of this lighting pattern is controlled by the wattage of the bulb selected to replace the ordinary household lamp, but it may be lessened by placing a neutral-density gel in the top and bottom of the shade. A 250-watt photoflood generally works best for small- and middle-size lampshades, while a 500-watt photoflood is better for large lamps. To obtain the effect of natural lighting from practicals, the lampshade itself must not be overpowered in intensity by any of the action keys. It must appear very bright to the eye but not so bright to the camera that it would cause any type of glare. To maximize the practical effect, the background-lighting ratio should be kept quite high, as much as 6: or 8:1. The ratio of this pattern is expressed by the difference in exposure intensity between the bow-tie pattern on the back wall and the rest of the wall. If the shades are large, they may spill fill light onto the back wall.

If this added spill is undesirable, it can be controlled by lining the inside back and sides of the shade with as many layers of gel (or even cardboard) as are needed to restrain the unwanted illumination.

EXTERIOR SOURCES
Window Light
Window light is a motivating source that is handled in many different ways in interior scenes by location film-makers. Because of the inherent intensity, contrast, and color-balance problems associated with its use, filmmakers go out of their way to exclude any exterior motivating sources from the frame in many situations. The dramatic filmmaker, however, frequently takes the time to cope with these problems, utilizing the natural source to pro-duce a realistic lighting effect. Its illumination can be supplemented with keys directed to light the long shot from a similar direction. (See chapter 7 for ways to color-correct and balance window light.)

Side Lighting
Key lighting directed to illuminate the long-shot action from the subject's side is called side lighting (5-101). Often used in motivated-light interiors, its quality and direction are selected to match those of a natural source. Side-lighting setups are generally keyed to illuminate the subject from an angle close to eye level, casting elongated shadows directly across the actor, usually in a horizontal direction. The choice of fixtures used in a side-lighting setup varies with the quality of the existing source. Diffuse window illu-mination is easily duplicated with large softlights (5-102), whereas hard directional sunlight is best mimicked with specular focusing spots in a side-lighting setup.

A definite advantage of side lighting is that it produces an existing natural-lighting effect even when a natural motivating source is not included in the frame. For many viewers the long, horizontal shadows produced by this lighting arrangement automatically suggest a "natural" source and understandably so, since a large number of motivating sources are located at or near eye level. There are two disadvantages of side lighting in long shots: diffi-culty of fixture placement and falloff-potential and shadow-projection problems resulting from certain placements.

Locating the fixture at eye level is trickier with long shots than with tighter angles. To keep the fixtures out of the expanded area of coverage in the long-shot frame, it may be necessary either to move stand-mounted fixtures farther away from the subject than originally anticipated,

compromising on the *direction* from which the light strikes the action, or to rig the lights above the set without the use of stands, probably compromising on the *angle* from which the illumination strikes the action. Either of these solu-tions is acceptable, especially since any undesirable model-ing can be corrected by slightly readjusting the positioning of the keys in the following closer shots. Locating the side light further away from the subject, however, may create a problem with light falloff across a long-shot set, especially if diffuse sources such as softlights are used. This problem may be handled in one of three ways.

1. Use stand-mounted softlights but decrease the coverage of the frame so that the fixtures can be moved closer to the action area.

2. Rig the softlights overhead and maintain the directional characteristics of the natural source, but utilize multiple

5-101. Side lighting with focusing spots mounted above the set.

5-102. Side lighting with a stand-mounted softlight.

softlight keys, each overlapping the next in coverage, to light the action, eliminating dead spots created by light falloff.

3. Switch to a more specular source with a longer throw. This enables the fixtures to be placed further away from the action and simultaneously eliminates the intensity falloff.

Long shadows generally become a problem with side lighting when specular keys are used for the lighting effect. Although they may be justified as creating a natural effect, their presence is potentially distracting in smaller-location interiors, in which their projection reaches clear across a small set onto the opposite walls. To remedy this situation, raise the height of the key slightly. This will angle the subject's shadow a bit downward toward the floor, which may prove to be more attractive without destroying the integrity of the motivating source.

EXPANDED SUBJECT MOVEMENT

When the action expands into a more complicated movement, follow this simple rule: light the action areas, the subject-blocking movement, and any path that the actor may follow during the course of the long shot. If the subject is going to sit in a chair after he enters the room, light the path and then light the chair. Key-light all the action areas. If the subject is to move to another part of the set and sit down again, light the new block as well as the resting place at the end of the shot. The keys covering the movement should be positioned so that the shadows are in the best location for the subject and camera blocking. The type and positioning of the key lights will aid in creating the lighting mood of the scene.

Remember that the mood of the scene also depends on the amount of foreground fill as well as on the design of the lighting and the reflectance of the background. For a low-key atmosphere limit the area of the lights by narrowing the barndoors. Position the keys to illuminate the side of the subject away from the camera. For high-key effects add more fill light. Light the foreground, action areas, and background with lower lighting ratios. Overlap the keys to produce smooth, even action-area illumination. Even out the background intensity and raise the level of foreground illumination. Open the barndoors of the keys and spread the light over a greater area but avoid multiple shadows from any two sources covering the same area.

6. The Location

CHOOSING AN INTERIOR LOCATION

Working in a studio has many advantages. In addition to the fact that it is usually quiet and has unlimited electrical power and smooth floors a studio has high ceilings and lighting grids from which lights can be hung. This last asset is particularly helpful in shooting. Positioning the key lights high and out of the way offers the best possible lighting control over many situations. For instance, key shadows cast by the actors may be easily positioned if the light is angled sharply from above and toward the subject on the set. Spill light can be kept off the background walls. Keys can also be supplemented with diffuse but spotted fill, permitting the lighting mood of the scene to be easily set up and established. Subject movement and blocking need not be as precise if multiple keys are used from above to light the action, for hot spots, often unavoidable with lower, floor-mounted single keys, are eliminated. The camera's movement and blocking are also free from obstacles such as floor stands if lighting grids are used: the grids facilitate precision placement, and their intensity and direction may be easily controlled.

Independent producers unfortunately often find themselves restricted to the use of actual locations, on which almost all the advantages of the studio are lost or severely limited. The location filmmaker may therefore be confronted with many technical problems in the interiors that he is expected to film. One of the greatest difficulties encountered is how to place the fixtures where needed while also keeping them out of the frame. In most larger productions this is the responsibility of the gaffers, but seldom can smaller productions afford this specialization: all the lighting rigging, correct placement of lights, and camerawork fall upon the filmmaker himself. He must know how to deal with any lighting problems encountered while shooting. It is mandatory that the filmmaker, with script in hand, troubleshoot the set *prior* to the actual filming. Reviewing the locations enables the filmmaker to decide on the lighting and camera movement necessary to film the action on the set. The physical features of the location, such as the size of the room, the height of the ceiling, and the available power, are considered in relation to the type of filming desired. The filmmaker can then plan the lighting arrangements, the number and type of fixtures needed, and the method of fixing them into the desired locations. If such prearrangements are not made, satisfactory filming may not be possible: the filmmaker will not be ready to cope with the limitations of the set.

Following is a list of items to note when reviewing a location for interior filming.

1. The *size of the room* not only limits actor blocking but usually defines the type and amount of camera movement that can be expected. The *height of the ceiling* is also important: the higher, the better. Suspended grids or other means of attaching lights can always be used in locations with lofty ceilings without worrying about interference with the framing of the shots. Stands need only be used for fill lights: the fewer the number of stands, the greater the freedom of both subject and camera movement.

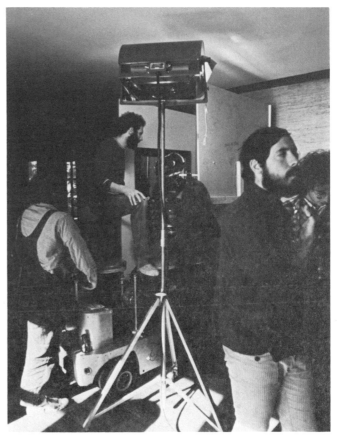

6-1

Long shot/beard shave/high key. 6-1. One 2K softlight, gelled with blue to match daylight, provides the only source of illumination for the shot. The light is gelled to match other daylight-interior shots in the same sequence. The large size of this interior permits the erection of a small set on location. 6-2. To save time, this bathroom set, made of three 4-X-8 flats, is built on the location interior. The soft illumination mimics the quality of light from an exterior window. 6-3. Lighting diagram.

Intensity falloff is also minimized if the lighting units are placed at a greater distance from the action. And higher ceilings offer more control of the lighting direction and the mood of the shot.

2. The filmmaker should know the *script* inside and out before stepping onto the location to review *camera angles* and *lighting positions*. Make a preliminary plan of the lighting and filming and visit the location to determine the feasibility of the lighting and shooting sequences called for in the script. Have someone walk through the actors' *blocking* and observe the action through a *director's finder*. The finder, which approximates the angle of view of various lens focal lengths, helps determine the correct lens for the shot. As the scene is being previewed, notice which background and ceiling areas are seen and which are excluded from the frame. This will help you determine whether these areas need to be lit and/or whether lighting fixtures or stands can be placed nearby. Before leaving the set take notes of the findings made.

3. In larger productions the *floor layout* and *dimensions* of the set are often provided by some other member of the production crew. For smaller ones you'll have to do this work yourself, so take along a pad of $\frac{1}{4}''$ graph paper to make diagrams. The blocking, camera moves, and angles which will save time in setting and rigging the lighting. A rough measurement of the floor space helps determine the placement of the lights as well as the means of locating and fixing them to the location. From this sketch the filmmaker can rough in the lighting on paper so that the action can be best lit for the camera angles already chosen. The floor measurements are also a valuable aid in predicting the amount of material needed to carry out the specific lighting plan. For example, if you plan to build a temporary support system for the lights near one portion

6-3

6-2

145

of the set ceiling, the measured floor plan would indicate the amount of material needed to construct it in the most versatile position.

4. It is important to know the *power input to the location*. How many amps can the power main carry? What is the condition and location of the household plugs? Where are the usable separate circuits within the location and how many are there? How far is the fuse box from the set? What is the load-carrying ability of each fuse or breaker? Is a tie-in to the power source necessary? Depending upon the power available, is a step-down transformer or a generator necessary to supplement the existing power?

6-4. The two right-hand windows are covered with 85N3 conversion gel. When reviewing the location prior to the shoot, take note of what is seen through the window at the same time of day at which the shoot is to take place.

5. Determine whether any *special lighting situations* exist. Specialized equipment such as daylight-balanced lights or gels may be called for on a set with numerous windows (6-4). Note the size and location of the exterior windows and the position of the sun on the exterior when reviewing the set. Fluorescents are a special problem. With a light meter measure the amount of ambient fluorescent light illuminating the set. Take note of the bulb-code type (printed on the end of the tubes) and the location of in-frame fluorescent bulbs. Gels, balanced fill lights, or camera filters may be required to balance this type of illumination.

HOW TO RIG A LOCATION INTERIOR

The term *rigging a set* refers to the manner in which the lighting fixtures are mounted or supported. The rigging can be done in various ways. In the majority of cases with closeups and medium shots the lights can be rigged on stands quickly, easily, and efficiently while remaining out of view of the camera. This becomes increasingly more difficult, however, as the coverage expands in the long shot, where stands may interfere with the camera framing.

Nevertheless, the independent filmmaker is often restricted and/or limited in his choice of rigging methods, and in many situations the use of stand-mounted fixtures is un-

Long shot/leaving the party/high key. 6-5. Three 1K lights, rigged to stands, are placed just outside the camera view: they provide a soft-key light for the action area when bounced off the white ceiling. Additional bounce illumination is supplied by the 3200°K photo bulbs installed in the practicals. 6-6. As the action approaches the exit doorway, the subjects walk through a pool of direct-key light supplied by the stand-mounted focusing spot. The position for this key is motivated by the table practical nearby. 6-7. The shot as seen from the camera position. To produce a motivated-practical look in this high-key scene, the intensity of the light spreading from the practicals must be noticeably brighter than the rest of the area in the shot. To add contrast to this scene, the intensity of the light passing through the lamps' translucent shades is controlled with a neutral-density gel wrapped around the interior of the shades. The light passing through the top and bottom of the shades is not restricted so that the full intensity can cast a pattern on the surrounding walls. A light reading taken with an incident-light meter pointed toward the camera position midway between the bottom of the shade and the tabletop against the white drape seen in the left of the frame measures one f/stop above the exposure for the scene. A reading taken in the same way near the glass on top of the table to the left of the frame is also one f/stop above the exposure for the scene. 6-8. Lighting diagram: in this case the light stands did not interfere with the actors' blocking or with the camera angle.

fortunately unavoidable. For example, consider an industrial filming situation. When shooting in a large plant with airplane-hanger-type ceilings, the only way (within reason) to light a floor operation on the ground level is with floor mounts. The subject's shadows may be a bit long and a camera shadow may appear in the frame now and then (along with the legs of a couple of light stands), but under the circumstances it is the best that can be done, given the *un*available time and money necessary to rig it in any other

way. Even in smaller interiors similar drawbacks occur. The filmmaker constantly has to contend with stands intruding into the camera frame and limiting cast and crew movement: camera angles may have to be chosen that allow you to shoot around them. Due to the lack of space in many small interior sets these worries are anything but trivial.

Whenever possible, rig the fixtures *above* the set *without* using light stands. It is better to mount the lights to clamps

6-5

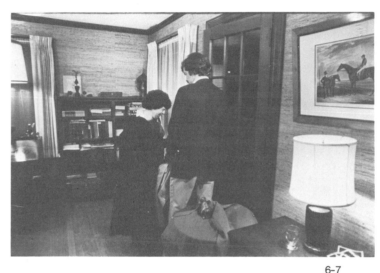

6-7

6-6

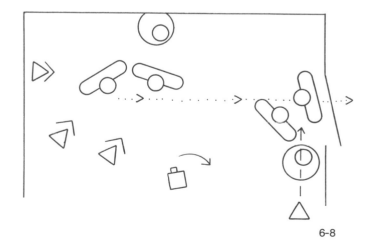

6-8

and to attach them to a molding near the ceiling or to a door or to rig them to poles that don't have tripod legs (which interfere with floor movement) and can be easily camouflaged as part of the set. In some situations it may be necessary to set up a portable grid by placing vertical poles around the perimeter of the room, attaching horizontals between them, and rigging the lights anywhere along the horizontals (6-9). The fixtures are near the ceiling and out of the camera frame. It is not as time-consuming or as complicated as it sounds and is well worth the effort, especially when shooting dramatic sequences, for it is usually the most efficient method of controlling the lighting for long shots with a lot of movement. Even in filming more static medium shots and closeups portable grids permit a wider variety of rigging choices. Eliminating most floor stands from the set also avoids unnecessary and troublesome light repositioning when changing camera angles. With a grid system all the lighting for the scene may be rigged and switched on only when needed.

RIGGING EQUIPMENT

There are many types of specialized rigging equipment made for location work. To attach the fixtures to door tops, edges of furniture, or moldings, *grips* are used. They are large, lightweight, spring-loaded alligator clips with $\frac{5}{8}''$ studs that mount the fixture (6-10). The jaws close tightly on anything over $\frac{1}{2}''$ thick. The rubber teeth inside the jaws prevent damage to the mounting surfaces and assure a slip-free hold on flat surfaces.

Another fixture used by location filmmakers to attach lights to the location resembles a *C-clamp*. Used to replace the cast-iron pipe clamps often used in studios to attach lighting fixtures to the hanging grids, these specialized clamps are available in many slightly different styles. The most useful have the following features: they are lightweight (usually made of aluminum); have a movable $\frac{5}{8}''$ stud, used to mount the light; have thumbscrew-type levers, used to tighten the clamp to the mounting surface; have a span of $2''$ to $3''$, which enables them to be attached

6-9. Lights being rigged to a portable grid on a location set.

to a variety of odd-shaped surfaces; and are able to be attached to both flat and curved surfaces. Clamps are one of the most useful mounting devices, for they are equally adaptable to rigging a light to a round pipe, a door top, or any other object on the set. Since the clamps fasten securely, they can hold heavier lighting fixtures than grips and resist twisting when attached to round objects such as pipes or poles.

Small C-clamps with studs are often used in conjunction with another type of clamping device, the *pipe clamp* (6-11). A tool borrowed from the carpentry trade, it is a two-piece clamp with adjustable jaws that attach to and slide along an aluminum or cast-iron pipe. The width of the object that it can be attached to is limited only by the length of the pipe that the jaws are mounted on, usually 1' to 3'. By changing the length of the pipe these clamps can easily adjust to large objects, such as columns, exposed ceiling beams, or archways. After the clamp is positioned, the lighting fixture may be attached to the pipe with a C-clamp with a mounting stud.

6-10. A spring-loaded grip attached to a ceiling-height molding. (Photo courtesy of Francesca Morgante.)

6-11. A pipe clamp attached to an 8"-thick archway is rigged with two focusing spots. (Photo courtesy of Francesca Morgante.)

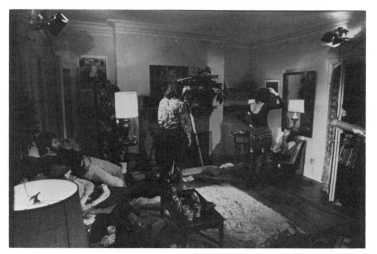

6-12

One of the major advantages of using clamps to mount lights to a location is that they can be set up quickly, usually on existing objects or parts of moldings. Floor stands are eliminated; nothing has to be built or attached to the set that might cause damage or mark the walls or ceilings.

Lighting fixtures can be directly attached to a wall with an *L-plate*, a rigging device made up of an L-shaped mounting stud attached to a thin, flat or round metal base. These plates, however, must be taped, nailed, or screwed into the mounting surface. Finishing nails may leave a few small holes in wooden walls or moldings. Gaffer-taping the plates to the wall is an alternative means of mounting plates but may remove wallpaper and paint unless it is used on a smooth, hard surface, such as wood paneling or metal

Medium shot/Joan's living room/night interior. 6-12. The ceiling-height molding around the perimeter of the room provides an ideal means for rigging key lights without the use of stands. 6-13. When in position, the sitting subject is keyed frontally, while the standing subject is keyed from a position designed to keep the side of the face closest to the camera in darkness. Fill light is provided by the soft illumination filtering through the practical lamp. 6-14. Lighting diagram: background subjects are side-lit with a single key positioned to simulate a motivated-lighting effect from the nearby practical. These subjects are keyed to one f/stop below that of the main action area.

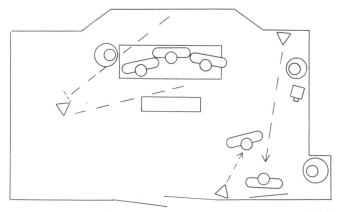

6-14

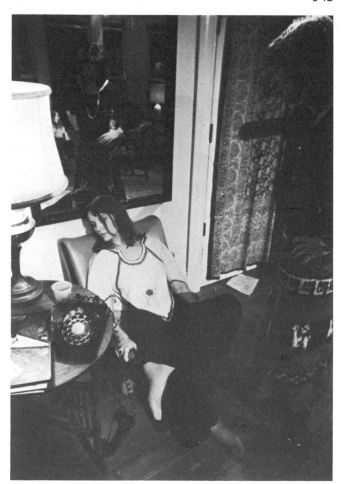

6-13

cabinets. Use of clamps or L-plates enables the lights to be placed high and along the perimeter of the room. They can not only attach the fixtures to walls, moldings, and furniture but also to any vertical inside the set. Electrical wires from lights rigged in this manner should be stretched along the ceiling or along moldings and, if possible, draped behind props out of view of the camera. At all times the cables and extension cords should be accessible so that they may be checked for malfunction or overloading.

If none of these rigging techniques can be used successfully, stretch a vertical pole close to the wall where the lighting fixture will be placed; spring-loaded, expandable aluminum *poles*, usually in lengths from 4' to 16', are available for this purpose. They are lightweight and unobtrusive and do not need tripod legs for support. When in place, the poles are sufficiently rigid and stable to support almost any size and weight of lighting fixture. Lights mounted with clamps can be rigged in any position along the length of the poles.

If aluminum poles are not available or are too expensive for your production, *framing studs* (popularly called 2 × 3s) can be used. Sold at any lumber store, the wood may be cut and pushed snugly into place between the ceiling and the floor or turned into a spring-loaded vertical with the addition of a *timber topper*, a tight-fitting metal cap housing large internal springs. Slipped over the end of the 2 × 3, it performs in a similar fashion to the spring-loaded aluminum poles. Neither the poles nor the wood verticals damage the floor or ceiling, provided that undue force is not used in installing the support. If either must be positioned so that it is seen in the shot, it can be painted or papered to match the background.

Lights mounted on the walls or on poles are not necessarily used exclusively in dramatic films. Documentary filmmakers find this method of rigging especially useful: an unobtrusive bounce illumination can be provided by mounting fixtures to the verticals or clamps and directing the light toward the ceiling. Floor stands are eliminated, and soft, even exposure illumination will light the set.

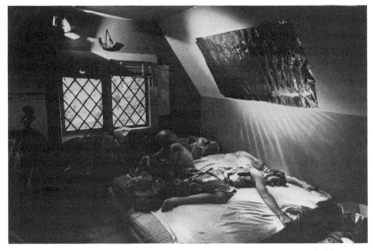

6-15

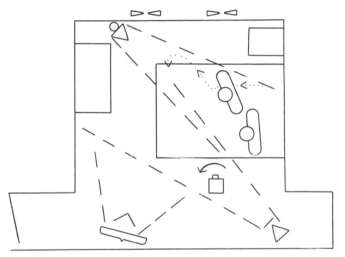

6-16

Long shot/John's bedroom/low-key interior. 6-15. Key light is mounted on a vertical 2-x-3 piece of lumber painted to match the background. The barndoors are spread both to key the action from the direction of the natural source and to bounce light off the wrinkled silver reflector placed above the bed to reflect a streaked-light pattern below. An 85 gel is used on the windows to color-balance the outside light. (A combination filter is not used, because it is not necessary to cut down the intensity of the exterior light). The exterior seen through the window is three f/stops over the exposure of the action area, adding to the morning-light effect of the shot. 6-16. Lighting diagram: a diffused, stand-mounted fixture key-lights the remaining areas of the shot to an exposure two f/stops below that of the action. A 1K softlight bounced off the ceiling fill-lights the action to bring the lighting ratio on the actors to 4:1.

THE PORTABLE LIGHTING GRID

The use of *portable grids* permits the lighting of long shots and movements involving intricate camera and subject blocking by enabling the lights to be placed in the most desirable position and to cover the action with the most efficiency. Rigging the lights to grids is often the only method of achieving exact lighting control over direction and mood. (This, of course, does not restrict the use of stand-mounted fixtures for generalized-fill and modeling purposes.) Horizontal grids not only facilitate the lighting of difficult shots but can also support props, hang pictures, brace draperies and backdrops, and hold sound blankets. They can even allow hanging practicals to be repositioned as the props of the set are moved (*cheated*) to a new camera angle.

Grid Components

The grid is nothing more than a horizontal, usually running parallel to the ceiling of the set and attached between any two vertical supports (6-17). Although vertical poles of aluminum or wood make ideal supports, horizontal grids can be attached between combinations of supports found on the set (the tops of props, windows, door moldings) and verticals placed on the set by the filmmaker for this purpose.

6-17. Horizontal grid with focusing spots used as bounce lights.

The most common materials for the location-lighting grid are aluminum and wood. Aluminum grids can be purchased from professional supply houses, but both aluminum and wood grids can be made inexpensively with readily available materials. Aluminum lighting grids are preferably constructed of multiple lengths of aluminum conduit, which is available from electrical-supply houses. It comes in 10' sections that are threaded on either end: they can be screwed together with couplers to form a straight pipe of any length, cut to another length with a hacksaw, or drilled into or through for special support needs: the material is extremely lightweight and sturdy. It comes in diameters of 1", $1\frac{1}{4}$", and $1\frac{1}{2}$"; which to use depends on the length of the horizontal's span and on the weight that the tubing is expected to carry. The $1\frac{1}{4}$" conduit is generally strong enough to carry the average load of location fixtures and wiring across a span of 20'. If longer spans are needed, choose the heavier, larger tubing; for short spans the smaller is sufficient.

Ordinary aluminum conduit may also be used for the vertical supports if necessary, but, since there is often no means of attaching the vertical in place between the floor and ceiling, expandable aluminum poles specially designed for this purpose are usually more convenient and suitable.

The material for wooden grids is nothing more than common framing lumber, available from lumberyards and building-supply houses. Lengths of 8' 2-X-3 studs are generally best. Lighting grids made of wood are much heavier and more inconvenient to work with than those made of aluminum, but wood is less expensive. Since the weight of the wood itself makes up much of the weight of the horizontal grid, only short distances should be spanned, unless an extremely stable means of support for the vertical is available. Wooden horizontals are most easily attached to large, flat pieces of molding or to a wooden vertical. Wood is a good material to use for vertical supports. It may be cut either to fit snugly between the floor and ceiling or 3" shorter than the ceiling and slipped into timber toppers.

Building the Grid

Assembling a grid on the location requires two people, usually two ladders, hardware for attaching the horizontals to each other and for attaching the horizontals to the verticals, clamping or hanging devices for mounting the lights to the grid, and an exact plan for the location of the grid, the position and direction of the lights, and the

point at which the wires will run down to floor level.

Preplanning makes the erection of any overhead-lighting arrangement quick and efficient. Although the primary criterion for selecting a position for the grid is usually no more than a location from which the lights ideally cover the action, the physical design of the interior often limits this placement: alternate camera positions or actor movements must be designed so that the desired lighting style can be achieved. It is usually best to locate the grid in a position that can cover the action from several camera angles. Look for the most unobtrusive means of attaching the horizontals (which hold the lights) to the interior. Avoid, if possible, vertical aluminum or wooden supports, unless they are out of the camera view or can be easily camouflaged. A grid does not have to be an elaborate system of multiple overhead horizontal light supports. A single span may often be the only grid necessary when used in conjunction with other rigging methods.

Start the actual assembly on the set an hour before the shoot to allow ample time to place the grid, rig the lights, and rough in the illumination. Select the vertical supports. If poles are to be used, install them in place between the floor and the ceiling. Stretch out the horizontal between the verticals across the floor. Screw aluminum pieces together to make up the length of the span, cutting off the excess. Clamp multiple lengths of wooden horizontals together securely with 4″ aluminum C-clamps to cover the length of the span. The type of clamp needed to hold the lights in place on the horizontal should be decided upon before the grid is raised into position and attached to the verticals: this is especially important if wood horizontals are used, for materials other than clamps can often be used to attach the lights to the grids more easily. For example, since most lights mount to a round $\frac{5}{8}$″ stud, the filmmaker can nail short 5″ pieces of $\frac{5}{8}$″ pipe or wooden doweling to the crosspieces at equally spaced points across the span instead of using clamps (6-18). After the horizontal pieces are attached and adjusted or cut to fit between the verticals, raise them into position and attach them to the support pieces, leaving at least 6″ between them and the ceiling. Use C-clamps to secure the grids to the verticals or drill a hole through each end of the horizontal and secure the grid to the mounting or support with a long finishing nail. Once the grid is up, place one or two sandbags around the base of the vertical support to make sure that no one bumps into it before the shooting starts.

6-18. Wooden dowels for rigging lights to 8′ 2-x-3 location grids.

6-19

6-20

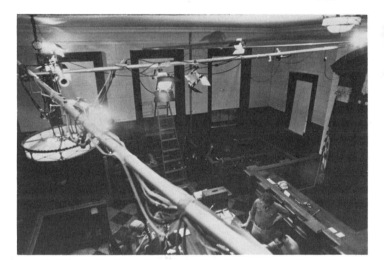

6-21

Multiple angles/courtroom/high key. 6-19. Because of the varied subject movement and the roving, documentary style in which this sequence is shot all the lighting has to be rigged from above. 6-20. The grid is made of 10'-long sections of $1\frac{1}{2}$" aluminum conduit threaded on either end. 6-21. A centrally located chandelier acts as an anchor to which the grids are C-clamped. The other ends of the aluminum grid are attached to the tops of existing moldings by driving small nails through holes drilled through the couplings on the ends of the conduit. 6-22. Wiring is strung along the gridwork and taped to the piping. Slack is left in the wires so that the lights can be repositioned if necessary. An 85N3 gel is placed on the windows. 6-23. From one of the camera positions the lighting of the courtroom is not flat: all the action areas and areas in which the actors remain stationary are keyed to 250 footcandles. To provide contrast on the set, direct-focusing keys are used: shadows from these keys create a 2:1 lighting ratio. Removable dulling spray is used to soften the glare reflected from the shiny lacquered surfaces. 6-24. Medium shot of a stand-in for a witness seen from one camera angle. This stationary position is frontally keyed. The half-paneled walls of the courtroom add natural separation to a subject seen in front of them. The dark wood of the background is lit to 175 footcandles, $\frac{1}{2}$ f/stop higher than that of the lighter color. The flag to the right of the witness helps hide a polecat supporting one end of the grid upon which the wiring runs. 6-25. A stand-in for the judge seen from the camera position. 6-26. Taking a light reading from the witness stand, the incident dome is pointed toward the camera; the body of the meter is swiveled so that the light scale can be read. 6-27. Lighting diagram: the action is cross-keyed with diffused illumination to decrease the production of multiple shadows. Broad lights are used in two ways: both as a direct and as a bounced source of illumination for the set. Light bounced from the white ceiling fill-lights the areas keyed by the focusing spots. Half scrims covering the bottom half of the spot's beam help even the throw of light into the courtroom areas. The gallery section is lit to 175 footcandles, $\frac{1}{2}$ f/stop less than the illumination of the main-action area.

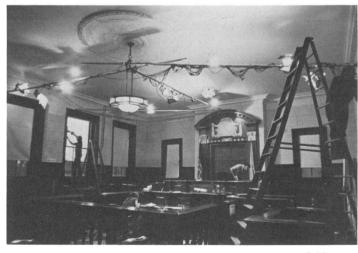

6-22

6-23

6-24

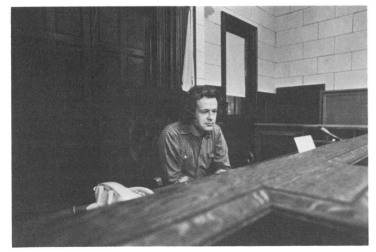

6-25

6-26

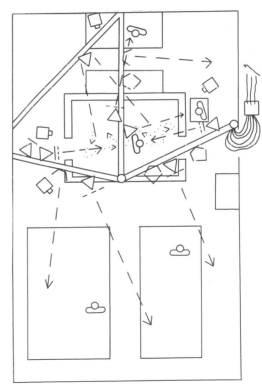

6-27

ROUGHING IN THE LIGHTING AND THE ELECTRICITY

Roughing in the lighting is the process of rigging the lights into a position that closely approximates the fixture location and direction that best covers and illuminates the set. To rough in the lights on the grid, attach the fixture to the clamping device to be used for mounting and securely tighten the lamp onto the grid. Adjust the barndoors and the fixture, inserting any necessary half scrims or diffusion material to the lamp. Plug the fixture into the electrical extension cord and run the wiring across the grid and down to the floor. Do not tape or tie down the wiring, for the lamp may have to be readjusted later. A loop of wire that contains the off/on switch should hang below the grid at a convenient height that can be reached.

Plug in one fixture at a time, switching on the power and adjusting the lamp to light the area desired; have someone measure the intensity from each lamp separately. When roughing in the lighting, work on a darkened set: this makes it easier to judge the spread of the lamp beam.

Work with one fixture at a time. After all the lights have been roughed in, turn them on and make the final adjustments. As someone walks through the scene, balance the lights to the desired intensity, measuring the illumination with a light meter. After this "fine-tuning," or "trimming," of the lights, the wiring can be tied up to the grid out of view of the camera, but be sure to allow a large enough loop of cable near the fixture to allow small adjustments to be made.

PLANNING THE SHOOTING SEQUENCE

An important part of the preplanning procedure involves grouping together shots with similar camera angles and similar lighting so that they can be filmed consecutively. This saves time and money, matters of great importance for low-budgeted location work. If preplanning is done carefully, changes in lighting and camera positions can be cut down or simply organized into logical patterns.

Grouping of similar shots is especially helpful when shooting a dramatic film on a small, cramped interior.

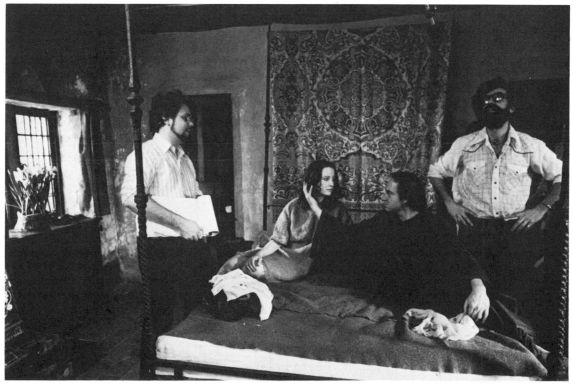

6-28

156

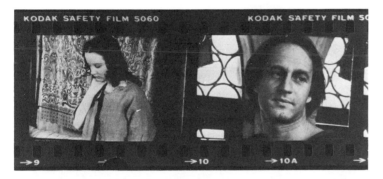

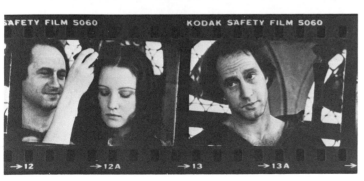

6-29

A Little Death. (Director, Alan Ritsko; director of photography, Jeffrey Gurkoff, diagrams, photos, and frame blowups courtesy of Cinema 14 Inc. and Jeffrey Gurkoff.) 6-28. A shot from a sequence being rehearsed prior to lighting the scene. At this point the key technical personnel watch as the final blocking is settled. The set is located in a very small room: lights and sound equipment will be crowded close to the camera framing, and radical rerigging will take a great deal of time. Keeping this in mind, the director must break down the action into shots to be filmed from similar angles and from reverse angles. This separation will require a minimum of time-consuming lighting changes, since only one side of the room will be lit: all the action (regardless of the continuity in the final film) that is to take place on that side of the room will be shot at the same time. The set will then be relit, and the reverse angles and any other angles needed will be filmed. 6-29. Six frame blowups from the actual film. Each blowup, numbered on the frame line, represents a cut in the scene. The blowups are arranged in sequential order from the beginning to the end of the scene. 6-30. Lighting diagram and camera angles for action filmed from the left side of the room: frames 3, 4, 10, 12, 13, and 14 (seen in the blowups) were shot from this side. 6-31. Lighting diagram and camera angles for action filmed from the right side of the room: frames 5, 6, 9, 15, 19, and 20 (seen in the blowups) were shot from this side. 6-32. Positioning camera and lights on the left side of the room leaves the right side free to be filmed. 6-33. Positioning camera and lights on the right side of the room leaves the left side free to be filmed.

There is often much camera and subject movement for the small area. Props must sometimes be shifted and moved around the set to accommodate certain camera angles; lights need to be repositioned for closer shots or for reverse angles; and dolly boards need to be moved. If the filmmaker groups similar angles together, the mechanics of set rebalancing and light repositioning are simplified, and time and money are saved.

One limitation of this procedure should be kept in mind. By shooting nonsequentially problems with acting continuity may arise: the filmmaker must pay special attention to the continuance of acting moods, eye lines, movements, entrances, and exits in order to ensure a smooth, even match between shots. The person in charge of continuity should be especially alert, making sure that everything is kept in its proper place.

6-32

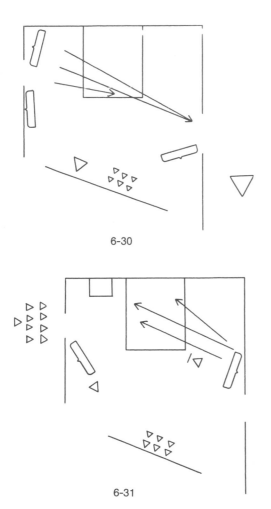

6-30

6-31

6-33

7. Color Temperature and Balance

Many people are unaware of the color of the light illuminating their world. Whether standing in the sun, the shade, or a room illuminated with fluorescent or table lamps, they are unaware of the visual appearance of the light itself. Most think of it as colorless or white. As explained in chapter 1, color adaptation of the eye is responsible for this phenomenon. The fact is that all light has a specific color: daylight is blue, fluorescent is green, and tungsten is yellow.

To describe the color of a light source, it must be compared to a *standard*. The standard has no real visible color of its own: it consists of a scientifically selected chunk of material called a *black body.* When heated to varying temperatures, it becomes incandescent, glowing and radiating visible light. The color of the light emitted changes from red to blue as the temperature of the black body rises. The temperature is calculated in degrees on the Kelvin (K) scale (a temperature scale that defines $-273°$ Celsius as absolute zero). Since the visual appearance of the light radiating from the standard changes in a regular and predictable way as its temperature increases, measurement of the temperature at any particular point is a valid method of describing the color of the light emitted at that point. The color of the light given off by the standard as it is heated moves in a smooth, natural, gradual progression from red to yellow to blue to purple. When the visual appearance of any light source (that emits illumination in the same manner as the black body) matches that of the standard, both have an equal *color temperature.* The temperature (in degrees Kelvin) of the black body, when this match occurs, is used to describe the color temperature of both sources. The lower the color temperature, the *redder*, or *warmer*, the light; the higher the temperature, the *bluer*, or *cooler,* the light.

All light sources have a prescribed set of conditions by which they produce a particular color temperature. With artificial sources such as bulbs the condition is the voltage supplied to the lamp. With natural illumination such as sunlight the atmosphere and the angles at which the rays strike the earth can affect the color temperature, making it appear white at midday and yellowish or reddish at sunset.

Light radiates from the sun in a form of energy called *waves*. The distance between any one point and the next point that is in a similar position along the wave varies. Called *wavelengths*, these variations are directly related to the visual sensation of color. Light of *longer* wavelengths tends to be perceived as warm in color; light of *shorter* wavelengths, as cool in color. When the eye receives illumination from a source that radiates equal amounts of all visible wavelengths, the mixture is called *white.*

The earth's atmosphere is a vast diffuser. It tends to dissipate and to absorb the shorter wavelengths, producing the blue color of the sky. The longer, "warmer" wavelengths are less affected by the atmosphere and pass through to a greater degree. The greater the distance through which the rays must pass, the greater the dispersion. When the sun's rays strike the earth at a tangent (at sunrise and sunset), they must penetrate a greater area of atmosphere than at midday when the sun is directly overhead. At sunset most of the shorter blue rays are absorbed by the atmosphere and never reach the earth. The longer red waves pass through, causing the light from the setting sun to appear warm or reddish in color.

COLOR BALANCE

The sensitivity of a color-film emulsion must be adjusted to the predominant color temperature of the light source illuminating the scene if visually correct color rendition of the subject is to be obtained. Two types of color emulsion are manufactured to produce realistic color reproduction from the two most commonly used sources of illumination: *daylight* and *tungsten light.* The sensitivity of a film to specific colors of illumination is referred to as its *color balance.* Emulsions with a daylight color balance reproduce colors most accurately when exposed to illumination of $5800°$ K. Films balanced for tungsten faithfully reproduce colors when the light exposing the scene is $3200°$ K. Film manufacturers use a code system to clarify the color-temperature balance of various film stocks. Daylight stock is designated by the code *D*; tungsten stock, by the code *B.*

When the color of the illumination does not match the balance of the film stock, a *color mismatch* occurs. The actual amount of mismatch that a film can tolerate depends upon whether the mismatch can be corrected in the lab during printing and upon the filmmaker's subjective evaluation of the "correct" color of the scene. Film manufacturers and film labs generally set the limit for color correctability of a scene to within $200°$ K of the ideal temperature. This means that, as long as the stock is exposed under illumination that is within $200°$ K of the illumination for which the stock is balanced, perfect color reproduction of the scene is possible. Extending the mismatch between the color temperature of the light source and the balance of

the film beyond this limit may still yield satisfactory results, but less than perfect color reproduction may occur. Perfect color, however, is often not needed or called for, leading many filmmakers to expose film under greatly mismatched conditions and to hope that the lab can correct it to an acceptible color.

The degree to which this approach is successful is somewhat haphazard depending on the type of film stock used as the original and on whether or not the entire film is to be shot under the same mismatched conditions. Because of the inherent amount of intensity and color control in the negative-positive process itself negative emulsions exhibit a greater tolerance for color correction than reversal emulsions. Remember that visual color evaluation is a subjective measurement on the part of the viewer. If an entire film (rather than scenes from a particular part of a film) is shot under the same mismatched conditions, there is a better chance that the audience will accept the faulty color rendition. If there is no standard (such as a flesh tone exposed under balanced lighting conditions) to which one may refer for comparison, the viewers' eyes may adjust to the overall color cast and the deviation may go unnoticed. Of course, it is to the advantage of the filmmaker to provide the lab with the best color-balanced film possible: unless a special effect is desired, it is usual to correct a mismatch at the time of exposure. This is done by filtering either the camera lens or the light source.

Either D- or B-type films may be used for indoor or outdoor filming as long as the emulsion is "adjusted" through filtration to the color temperature of the illumination source. Although the filmmaker has a choice of film in any situation, the majority of motion-picture filming is done with B-type tungsten film balanced for 3200° K illumination. This film requires no filtration when the common tungsten light is used, enabling it to be exposed with a lower footcandle intensity than any "daylight"-balanced film filtered to 3200° K. The B film can easily be converted to record colors in outdoor illumination by filtering the lens. (See the section below on conversion filters.) The fact that the filter absorbs some of the luminous intensity that would normally be available for outdoor exposure is advantageous, for it helps to cut down the intensity of the light. This is often necessary because of the great difference in the amount of light produced by the sun compared to the small amount necessary to expose the film emulsion.

B-type films are fast indoors (have a high ASA-speed rating), because they do not require filtration when used with movie lights, and slower outdoors, for they require filtration to convert their color balance to outdoor light. The film is fast when there is little light available and slow when there is much light available. These features, coupled with the fact that manufacturers find it easier to provide consistent color rendition from batch to batch in B-type films, make the B film the most widely used in professional motion pictures, and most of the filter techniques are geared to a tungsten emulsion.

COLOR-TEMPERATURE METERS

Since it is next to impossible for the eye to detect slight changes in color temperature, a measuring device must be used. A *color-temperature meter* is an instrument that measures the color temperature of light incident upon the set. When pointed directly at the source of illumination, the meter indicates the color temperature in degrees K and the color and degree (strength) of filtration necessary to bring the light source and the film to a predetermined balance. This is indicated on either a self-contained scale or an accompanying chart, depending on the make and style of the meter.

There are two types of meters in use today: the two- and the three-color meter. The *two-color meter* measures the color temperature by considering the relative amounts of only two colors of light present on the set: blue and red. It will provide accurate measurements on sets illuminated by sources that produce wavelengths in a gradual and uninterrupted manner (all sources except fluorescent lighting). Because of the wide use of fluorescent lights, especially in industry, manufacturers designed the *three-color meter.* It measure blue, red, and green, the predominant color of fluorescent light. As will be seen below in the section on fluorescents, they can be a most troublesome light source: the three-color meter is an invaluable aid in this situation.

CORRECTING A COLOR MISMATCH
FILTERS

Filters for color-correction purposes are pieces of glass or acetate tinted with varying degrees of color that selectively transmit their own color while absorbing other wavelengths of illumination. They are commonly placed over the camera lens and/or over the light source to create a color match between the sensitivity of the film and the primary source of illumination. A yellow filter, for example, transmits yellow light and holds back other colors. The

degree of transmission and absorption of each filter depends upon its spectral characteristics and is described by a coded numbering system called *Wratten numbering*. The numbers correspond to the specific filters suggested by a color-temperature meter or accompanying charts to correct a mismatch between a source and the color balance of the film. For example, if a color-temperature reading of an indoor incandescent source measures 2800°K and the film is balanced for 3200°K, the filmmaker would simply have to place a blue Wratten 82C filter over the camera lens to correct the mismatch. The correct filter to use in a specific situation is indicated either by a scale on the face of the color meter or by a conversion table attached to the meter or included in its instructions. (See the section below on light-balancing filters for further information.)

Filter Factors

Most filters used for light-balancing purposes absorb exposure light. When the filters are used over light sources, the light absorption is immediate: light-level readings do not require adjustment of the loss of light. When the filter is used over the camera lens, however, the absorption must be allowed for in the camera exposure, or underexposure will occur. The amount of absorption is expressed as a *filter factor*, which is directly related to an increase in exposure. A filter factor of two requires an exposure increase of one f/stop; a factor of four, two f/stops; a factor of eight, three f/stops. If two or more filters are used, the total filter factor is found by multiplying the individual factors. For example, a filter with a factor of two and another with a factor of four have a combined factor of eight.

Since some filters are consistently used over the lens during the course of filming (for example, an 85B is usually used for all daylight filming with a B-type film), many filmmakers adjust the light meter to reduce the speed rating of the film automatically by an amount equal to the factor of the filter. This saves time in taking a reading and eliminates the need to remember the filter factor. For example, to incorporate a filter factor of two into the metering procedure, set the meter to an ASA-speed rating that is half the "correct" speed normally used for the film. With a 100-ASA film set the meter for 50 ASA and take a reading in the normal fashion. These effective ASA numbers (sometimes refered to as *exposure indexes*) can be found in the instructions packed with the raw stock.

Camera Filters

Camera filters that correct color mismatches are available in various shapes and sizes of glass and are fitted onto the front of the lens or in optically clear pieces of gelatin film that may be either used on the front of the lens or cut to fit into a filter slot between the lens and the film plane inside the camera. Although each type of filter is optically clear, it is best not to use more than one filter on the lens and one in the filter slot at the same time. Any more than two filters piggybacked together in either position can degrade image quality. Three types of camera filters are used to correct mismatches: conversion, light-balancing, and color-correction filters.

Conversion filters are used to correct gross color mismatches between film stocks and light sources. These filters effectively balance drastic differences between the color temperature of the scene's illumination and that for which the film was balanced. The table (7-1) categorizes common conversion filters by number, with the filter factors translated into f/stops and the color-conversion capabilities listed in degrees Kelvin.

The most commonly used conversion filters are the *80A*, which converts daylight-balanced film to indoor lighting, and the *85B*, which balances tungsten film to outdoor illumination. The 85B (and the *85*, which also balances for outdoor light but gives a slightly cooler temperature) is also available in *combination filters*, which combine *color conversion* and *neutral density*. The amber color of these filters corrects the color balance of the light; the neutral density reduces the intensity of the light passing through without further affecting the color. An N3 neutral-density filter has a filter factor of two, an N6 a factor of four, an N9 a factor of eight. When calculating the exposure for an 85B combination filter, remember to multiply both filter factors to obtain the total factor.

Light-balancing filters are specifically designed to correct slight mismatches in color temperature between the film and the light source. These filters are available in multiple varieties of two colors: blue and yellow. The bluish filters are referred to as *cooling filters*, as they are used to remove the reddish cast that appears in tungsten film when the color temperature of the light is visually more yellow (lower in temperature) than that for which the film is balanced. The yellowish colored filters are often called *warming filters:* they remove the bluish cast that appears when tungsten film is exposed to bluer light (higher in temperature) than that for which the film is balanced. To

select the correct light-balancing filter, take a color-temperature measurement of the source with a meter and choose the proper filter or combination of filters from the chart (7-2).

Color-compensating (or *CC*) *filters* are available only in gel form. They are used to correct slight color mismatches or to compensate for deficiencies of particular color wavelengths in the light source. They are available in tints of primary (red, blue, green) and secondary (cyan, magenta, yellow) colors, each of which specifically transmits its own color while absorbing specific amounts of the others. Each of the six colors is graduated in a seven-step scale (7-3). The density and the effectiveness of the color increase as the numbers on the scale increase.

Since these filters can selectively absorb and transmit specific wavelengths of light, they can correct color mismatches exactly. The red absorbs both blue and green light;

filter color	filter number	exposure increase in f/stops*	conversion in °K	mired shift value
blue	80A	2	3200 to 5500	−131
	80B	$1\frac{2}{3}$	3400 to 5500	−112
	80C	1	3800 to 5500	−81
	80D	$\frac{1}{3}$	4200 to 5500	−56
amber	85C	$\frac{1}{3}$	5500 to 3800	81
	85	$\frac{2}{3}$	5500 to 3400	112
	85N3	$1\frac{2}{3}$	5500 to 3400	112
	85N6	$2\frac{2}{3}$	5500 to 3400	112
	85N9	$3\frac{2}{3}$	5500 to 3400	112
	85B	$\frac{2}{3}$	5500 to 3200	131
	85BN3	$1\frac{2}{3}$	5500 to 3200	131
	85BN6	$2\frac{2}{3}$	5500 to 3200	131

*These values are approximate. For critical work they should be checked by practical test, especially if more than one filter is used.

7-1. Conversion filters for color films. (Reprinted with permission from a copyrighted Eastman Kodak publication.)

or combinations of filters, as indicated by a meter. If there were an even greater deficiency of blue in the above example, the meter would suggest a stronger filter: a **CC40Y** might be needed. In practice a complete selection of color-compensating filters is generally very helpful in correcting mismatches. When they are used along with a three-color meter, practically any light-source-and-film combination can be balanced to produce realistic colors.

the blue absorbs both red and green; the green absorbs blue and red. The cyan absorbs red light; the magenta absorbs green; the yellow absorbs blue. The effect of the filter on the color reproduction of the scene depends on its strength: to absorb a small amount of blue, for example, the film-maker may choose, with the help of a color-temperature reading and a correction table, a **CC10Y** (a yellow color-correction filter with a peak density of 0.1). This acts as a warming filter, for it lowers the color temperature of the illumination reaching the film. Greater deficiencies in the lighting may be corrected with either single CC filters

filter color	filter number	exposure increase in f/stops*	to obtain 3200°K from:	to obtain 3400°K from:	mired shift value
bluish	82C + 82C	$1\frac{1}{3}$	2490 K	2610 K	−89
	82C + 82B	$1\frac{1}{3}$	2570 K	2700 K	−77
	82C + 82A	1	2650 K	2780 K	−65
	82C + 82	1	2720 K	2870 K	−55
	82C	$\frac{2}{3}$	2800 K	2950 K	−45
	82B	$\frac{2}{3}$	2900 K	3060 K	−32
	82A	$\frac{1}{3}$	3000 K	3180 K	−21
	82	$\frac{1}{3}$	3100 K	3290 K	−10
no filter necessary			3200°K	3400°K	−
yellowish	81	$\frac{1}{3}$	3300 K	3510 K	9
	81A	$\frac{1}{3}$	3400 K	3630 K	18
	81B	$\frac{1}{3}$	3500 K	3740 K	27
	81C	$\frac{1}{3}$	3600 K	3850 K	35
	81D	$\frac{2}{3}$	3700 K	3970 K	42
	81EF	$\frac{2}{3}$	3850 K	4140 K	52

*These values are approximate. For critical work they should be checked by practical test, especially if more than one filter is used.

7-2. Kodak light-balancing filters. (Reprinted with permission from a copyrighted Eastman Kodak publication.

Color-compensating filters are also useful in balancing mismatches for which few "prepared" filters are available. This is especially true of the many types of fluorescent lights found in offices and industry and of the mercury, xenon, or other lights found in street lamps and sports arenas. Although an FLB filter, for example, is specifically manufactured to correct B-type film shot under fluorescent light, no commercially prepared filter can offer the exactness of a CC filter.

The charts (7-4, 7-5) list common filter packs that are used with fluorescent and mercury lamps. Remember, however, that these are only suggestions and not absolutes. Especially with the wide variety of available fluorescent lights it is best to shoot a test roll, using the filters suggested by a three-color meter. Screen the results after they are color-corrected by the lab, correct the filtration if necessary, and reshoot.

peak density and exposure increase in f/stops					
cyan (absorbs red)		magenta (absorbs green)		yellow (absorbs blue)	
CC025C	—	CC025M	—	CC025Y	—
CC05C	$+\frac{1}{3}$	CC05M	$+\frac{1}{3}$	CC05Y	—
CC10C	$+\frac{1}{3}$	CC10M	$+\frac{1}{3}$	CC10Y	$+\frac{1}{3}$
CC20C	$+\frac{1}{3}$	CC20M	$+\frac{1}{3}$	CC20Y	$+\frac{1}{3}$
CC30C	$+\frac{2}{3}$	CC30M	$+\frac{2}{3}$	CC30Y	$+\frac{1}{3}$
CC40C	$+\frac{2}{3}$	CC40M	$+\frac{2}{3}$	CC40Y	$+\frac{1}{3}$
CC50C	$+1$	CC50M	$+\frac{2}{3}$	CC50Y	$+\frac{2}{3}$
red (absorbs blue and green)		green (absorbs blue and red)		blue (absorbs red and green)	
CC025R	—	—	—	—	—
CC05R	$+\frac{1}{3}$	CC05G	$+\frac{1}{3}$	CC05B	$+\frac{1}{3}$
CC10R	$+\frac{1}{3}$	CC10G	$+\frac{1}{3}$	CC10B	$+\frac{1}{3}$
CC20R	$+\frac{1}{3}$	CC20G	$+\frac{1}{3}$	CC20B	$+\frac{2}{3}$
CC30R	$+\frac{2}{3}$	CC30G	$+\frac{2}{3}$	CC30B	$+\frac{2}{3}$
CC40R	$+\frac{2}{3}$	CC40G	$+\frac{2}{3}$	CC40B	$+1$
CC50R	$+1$	CC50G	$+1$	CC50B	$+1\frac{1}{3}$

NOTE: Values given for exposure increase in f/stops are approximate. For critical work they should be checked by practical tests, especially if more than one filter is used.

7-3. Kodak color-compensating filters. (Reprinted courtesy of the Eastman Kodak Company.)

type of fluorescent lamp	Kodak Ektachrome EF film, type 7241 (daylight)		Kodak Ektachrome EF film, type 7242 (tungsten)	
	Kodak color-compensating filters	effective exposure index	Kodak color-compensating filters	effective exposure index
daylight	40M + 30Y	80	85B* + 30M + 10Y	64
white	20C + 30M	80	40M + 40Y	64
warm white	40C + 40M	64	30M + 20Y	64
deluxe warm white	60C + 30M	50	10Y	100
cool white	30M	100	50M + 60Y	50
deluxe cool white	30C + 20M	80	10M + 30Y	80
*Kodak Wratten filter no. 85B				

7-4. Guides for initial tests when exposing Kodak Ektachrome EF films with fluorescent lighting. (Reprinted with permission from a copyrighted Eastman Kodak publication.)

	white mercury	deluxe white mercury	color improved mercury	xenon
7241 & 5241 EF daylight	70 R	50 R	20 R	no filter
7242 & 5242 EFB tungsten	90 R	80 R	40 R	30 R

All filters listed are Kodak Wratten CC filters. To compensate for the absorption of each filter, open up the camera aperture one-third f/stop for each ten units of red filtration used. For example, with the 70 red open up two and one-third f/stops. This chart is only a starting point for suggested filtration. Shoot a test roll to determine the exact filtration to meet your needs and place a gray card and color patches on your slate to aid the lab in timing the print.

7-5. Suggested camera filtration for filming under mercury and xenon lamps.

Light-source Filters

Light-source filters for correcting mismatches are available in many forms: pliable sheets, ridged plastic panels, even tubes that fit around fluorescent lights. They come in two forms: conversion and light-balancing filters.

Conversion filters alter the color temperature of the light source to correct a *significant* imbalance between the light illumination and that for which the film is balanced. They are generally cut to size and attached either directly to the barndoors of the light source or to frames or flags that are rigged into position on gobo arms to filter the light before it reaches the set. They may also be placed on windows to balance daylight and tungsten illumination. They come in three colors: amber, blue, and green.

The amber (85) conversion filter is used to convert a source of daylight (5500°K) to one balanced for tungsten illumination (3200°K). Like a camera filter the 85 light-source filter is also available in a combination neutral-density filter. The most commonly used 85 filters are the noncombination 85, which absorbs one f/stop of light; the 85N3, which absorbs two f/stops; and the 85N6, which absorbs three f/stops. When selecting a filter, consult the manufacturer for the correct filter factor, for it often varies with the brand and with the material of which it is composed.

Blue filters are used to convert the 3200°K illumination from lighting fixtures to a daylight-balanced 5500°K color temperature. These filters are known by many trade names: the filter factors again vary with the manufacturer, usually absorbing one and one-half to two f/stops of exposure.

Green conversion filters are used to convert the color of daylight and of most tungsten lights to that of fluorescent sources. They come in three shades: the lightest converts natural daylight to fluorescent light; the second converts "daylight"-balanced lights such as FAY lights to fluorescent light; and the densest converts 3200°K to fluorescent illumination.

Light-balancing filters that are placed over light sources produce slight shifts in the color temperature; they are similar to those used in the camera. They are not listed by number, however, but are described by their individual color and density. To select the correct filter, determine whether the light needs to be warmed or cooled. If you are using a B-type film, for example, and the color meter indicates a reading below that of the film's balance (say, 2500°K), the source needs a cooling filter. If the temperature reads higher than the film's balance (say, 4100°K), the source needs a warming filter. Select the filter, place it over the source, and remeasure the color temperature. Keep adding, subtracting, or changing filters until the correct balance is achieved.

OUTDOOR SHOOTING

There is more tolerance for color mismatches with outdoor than with indoor illumination. All daylight-balanced films, whether D- or B-type converted to daylight use, reproduce the colors of outdoor subjects most accurately when the color temperature of the illumination is 5500°K. As discussed previously, the color temperature of sunlight changes as the day progresses, for the light is striking the earth from different angles. The 5500°K color temperature usually occurs only around midday: its light, mixed with an average amount of skylight (which is very blue, or high in color temperature), produces the color temperature that matches outdoor film. At other times the filmmaker must use corrective techniques to achieve proper color balance. When filming outdoors under mismatched conditions, the color can be corrected either by filtering the lens or by filling in the area with light fixtures or colored reflectors.

Filtering the Lens

If the sky is overcast, the illumination bouncing off the cloud cover will make the scene excessively blue. To counteract this tendency, the filmmaker can place a warm-colored filter over the lens or in the filter holder. If the filmmaker does not want facial tones to be overly orange or red when filming at sunset, a cooling filter can be used to achieve a truer color balance.

If a color meter is not available, use your judgment to select the filter. It is better to use some correction at the time of shooting, even if imperfect, than to use none. If the sky is overcast or the conditions seem blue, a yellow 81 filter will warm the scene up. If the light seems reddish or yellowish, an 82 blue filter will cool the scene down.

Adding a Fill Light

Problems with exterior color balance are particularly troublesome in closeups. In the longer shots facial colors are not as noticeable, and the audience may accept mismatches. The green of leaves or the brown of a tree trunk, objects that have no exact color, would be judged in general terms, and everyone's eyes would adapt readily to the color imbalance of the shot. The faulty color cast may not be

apparent until a skin tone appears in closeup. The closeup, however, is a situation whose lighting can be tightly controlled and whose small area makes it ideal for the use of daylight-balanced fill light. A fill on the face would keep the background the same color as in the unfilled long shots yet would correct the color-balance problems in the closeup.

Remember that the fill should not act as a key light. Select a position that casts no shadows on the face in closeup. This is generally possible if the light strikes the subject directly and flatly from the front at eye level. The exact amount of daylight fill to add is critical: overexposure will result in washed-out, flat-looking tones. A quarter f/stop of balanced light may be all that is necessary to lower the color temperature to the acceptable limit when the closeup is filmed under cloudy conditions. This small "extra" amount of light would not appreciably affect the exposure of the scene. To determine this amount, use an incident-light meter fitted with a flat-disk diffuser. Adjust the intensity of the light to the required level but do not change the f/stop of the camera. Set the exposure to the same f/stop used for the longer shot: a precise continuity match will be assured.

Adding daylight fill has other contrast-related uses in outdoor-filming situations. On a cloudy day balanced lights are used mainly to correct colors in small areas. When filming outdoors under bright sunlight or in shady areas, balance difficulties are compounded by new contrast problems. Under intense sunlight outdoor shots are extremely contrasty, often exceeding the emulsion's exposure range, and contain dense, distracting shadows, particularly in closeups. The fill lights used to balance the color may also alleviate contrast problems.

The strong, specular illumination from the sun, if bounced off a reflector, can be used as a fill. *Reflectors* are generally large paper or wooden cards covered with a surface that is capable of bouncing the sun's illumination back onto the set. There are many types of reflectors, and their size, design, and surface significantly contribute to the quality, color, and throw of the projected light. Some of these factors are described below.

1. *Large* reflector boards have a greater light-gathering and -reflecting capability.
2. *Flexible* reflectors can control and direct light more precisely than *flat* reflectors. *Concave* reflectors focus light into specular bundles; *convex* reflectors spread light more evenly.
3. *Mat* cards produce short-throw, soft light; shiny, mirror-like *silver foil* produces harder, more distinct, longer-throw light; crinkled or cut-up pieces of *textured foil* produce a
4. *Silver* and *white* reflectors mirror the color of the source onto the set; *gold* reflectors warm up the color of the reflected light; *silver-blue* reflectors cool the light reflected onto the set.
5. Slight variations in the placement of the reflected light are very noticeable. Reflectors should not be hand-held: many permit *mounting* onto stands with weighted bases or have pointed center posts that may be implanted into the ground. The main advantage of reflectors over lights for outdoor fill is that they can be used in places where no power or electrical generators exist. Their color balance and intensity, however, are not as controllable as are those of lights. Reflectors must be constantly refocused as lighting conditions change. Because of their flat design they are impossible to keep in place on windy days.

Lights used for the same fill and color-balance purposes are usually specular. The fill must generally be placed at a distance from the subject and must therefore have a long throw and a narrowly focused beam. Its intensity must be strong enough to lessen the contrast of the shadows created by the high level of illumination present under sunny conditions effectively.

The location crew involved in balancing daylight with fill must be aware of the great amount of electricity required to power the fixtures filling the scene. For example, the typical location fixture may be fitted with a 2000-watt bulb. When used in an interior, it may produce approximately 500 footcandles of usable light, but, when moved outside and filtered to match daylight, that same 2000-watt lamp must match the intensity of the sun, with its 25,000 footcandles, to within a couple of f/stops. Depending upon the size of the area to be filled and the distance from which the fixtures must throw the light, it may take as much as 10,000 watts of artificial light to fill the scene successfully. The same scene, on the other hand, may be adequately filled with three or four large reflector boards. The advantages and disadvantages of reflectors and lights must be weighed by considering such factors as the efficiency of the system, the time and people required to set up and control it, the weather conditions, and the budget available for specialized equipment.

Lighting the Closeups

When filming outdoors in sunlight, the practical luminance range of the subject is great. This contrast, caused by the

7-6

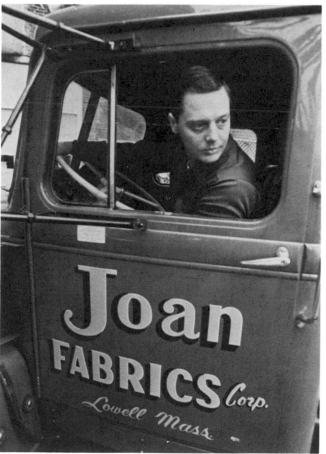

7-7

7-8

Medium shot/truckdriver/daylight exterior. 7-6. Even on an over-cast day the inside of this truck cab is two f/stops under the exterior exposure. A 1K focusing spot is gelled with a blue filter and used to boost the exposure of the driver inside the cab to a level equal to that of the exterior. The daylight-balanced illumination is directed to fill-light the driver's head from a location near the camera. 7-7. The shot as seen from the camera position. 7-8. Lighting diagram.

specular nature of sunlight, the direction from which it strikes the subject, and the general lack of natural fill light present, creates harsh shadows that are filled in only by the reflection of the sun's own light from surrounding objects. This naturally contrasty lighting may be acceptable in long shots, but in closeups of faces it inevitably must be filled in to bring the overall contrast of the subject within the exposure range of the film. The filmmaker should be careful to direct the lights to strike the subject frontally and should not overfill the scene on a sunny day, which would destroy all shadows. Although most experienced filmmakers judge the degree of intensity balance by sight, a lighting ratio of between 4:1 and 2:1 on the face of the actor is usually a good starting point.

Find the lighting ratio of the outdoor lighting in the following manner: measure the intensity of the sun (the key light) with the flat disk of the incident-light meter. Shading the disk from the direct rays of the sun, point it at the fill light or reflector and take another reading. Compare the f/stops or footcandles of each reading to find the lighting ratio. For example, if the key reads f/11, the fill, balancing two f/stops down, should be f/5.6 to give a 4:1 ratio. Once the lighting ratio has been established, keep it constant to facilitate lighting continuity between shots. This technique will work in every situation except one in which the subject is backlit by the sun.

When lowering contrast in this manner you can select the camera exposure in bright sunlight in several different ways. Since the addition of a fill light of this intensity may add a significant amount of illumination to the closeup, especially when a lower lighting ratio is chosen, some filmmakers read the face with a dome incident-light meter after the fill has been added, taking a chance that the change in exposure (from that of the matching long shots in which no fill light was used) will go unnoticed. Others underexpose the long shots (anticipating the addition of the fill in the closeups) by an amount equal to the degree of exposure increase provided by the fill light. In this way similar areas seen in the matching shots (especially the backgrounds) will always be rendered with the same exposure. The technique chosen depends upon foresight and the degree to which continuity between shots is valued.

The intensity of the fill light from a reflector can be controlled by changing its shape, focus, or position. If a lighting fixture is used to provide the fill illumination, the fixture may be moved closer to or further away from the subject for intensity control; or, if the lamp being used is a focusing spot, its light can be varied by focusing the beam

in or out. With any fill light the amount of illumination reaching the subject may be further decreased by adding a full scrim to the fixture or by diffusing its beam with gauze.

The color temperature of the fill should be close to that of daylight. To measure the color temperature of the fill, stand at the subject's position and point the color-temperature meter directly toward the lamp or reflector. Shade the meter from the sun's direct rays. The color temperature of a fill light may be altered by hanging light-balancing acetate gels near the light to filter the beam. Reflectors tend to pick up and project light from surrounding objects, such as walls and the sky. On a cloudless, sunny day facial shadows filled in with a reflector may be noticeably blue. A gold-foil reflector will "warm up" the shadows' color temperature by adding its own colors to the face.

Lighting the Longer Shots

When filming areas that include large but equal portions of sun and shade, contrast problems become more complex. The exposure ratio between the two areas can be as much as 64:1. Exposing for the bright area would grossly underexpose the shade; exposing for the shade would grossly overexpose the sunlit portions of the scene. Selecting an exposure midway between the two would probably be worse, for detail may be lost in both the sun and the shade portions, with shadows becoming one large area of black and highlights washing out. Because of the large area in the frame fill lights or reflectors used to lighten the shadows would have to be located a great distance from the subject. An entire wall of specular reflectors may be needed to throw in the desired amount of fill. Positioning, relocating, and adjusting them to change the illumination can be a time-consuming task.

To solve these problems, special-purpose arc lights can be used to bring the exposure ratio between the two areas down to a more reproducible limit, such as 4:1. Their intense point sources burn at a temperature approximating daylight balance and have an extremely long throw. Unfortunately, they are also bulky and expensive, and they require an operator to monitor the carbon arcs. PAR or FAY lights are more suited to the low-budget filmmaker and work well for long-throw outdoor-fill situations: they can produce a daylight-balanced illumination, do not require monitoring, and are fairly portable. By far the most efficient source for any outdoor-fill light is the HMI source. It is also daylight-balanced but requires about a third less electricity to produce the same amount of

illumination as the PAR or FAY light. One of the most practical ways to avoid the fill-light problem is simply to reframe the shot to include only sunlit or completely shadowed areas. Though this suggestion may seem too simple, it may be the only practical solution to save the setup time and expense needed to balance the light adequately.

If the scene takes place in open shade, even if there is sun elsewhere, there are other considerations. Open shade is illuminated mostly by skylight, with a small amount of bounced-in sunlight. Everything filmed in the shade is therefore likely to be reproduced with a bluish cast. The scene may be corrected or warmed up with CC camera filters: a color-temperature reading will indicate the most balanced set for matching the color of the existing illumination with the color balance of the film. Other methods of balancing open shade for color correction include the use of gold-foil reflectors or daylight fills. If there are nearby areas of open sunlight, gold-colored reflectors may be used to bounce in a warmer light. Fixtures can also be used, but power-consumption and budget considerations again become factors. The added illumination from daylight-balanced lamps would automatically color-correct the scene and would also provide additional intensity that would increase the exposure of the shot.

WINDOWS

A major color-balance problem exists when two significantly different color-temperature sources illuminate the same scene. There is some leeway within a scene shot entirely with tungsten illumination, as long as the keys are correctly balanced. Practicals can be yellower; even the kickers can be down in temperature. The scene will still film well when shot and balanced for the temperature of the key lights, 3200°K.

When shooting daylight location interiors with windows opening outdoors, however, a major problem arises. The film must be balanced for one or the other illuminating source. Both the interior and the exterior color temperatures must consequently be made to match approximately if the scene is to be free of color-balance problems. This can be done with filters for the windows, filters for the lights, camera filters, a change to daylight-balanced lights, or a combination of these solutions. A decision on how to bring the two sources of illumination to a common balance best is influenced by several factors: the size and amount of window light in the scene, the degree to which the color temperature and intensity of the light are to be balanced,

and the expense and time involved with the various correction procedures are all important.

Window Filters

The most popular method for balancing interior locations is to convert the light coming through the window to 3200°K. This is done by placing an 85 conversion filter over the inside or outside of the window itself. Several types of material are available for such conversion-filtering purposes in large 4'-wide rolls 25' to 50' in length.

The rolls are manufactured in both acetate- and gel-based types. The *acetate* materials are fairly stiff, tear easily, and tend to rattle when wind hits them. The filter sheet is frequently stapled to 4' X 8' frames and placed outside the window. It may also be stapled into the molding of the windows without stretching. If the filter material is to be used and rerolled, however, it must be removed carefully, which adds to the breakdown time. The acetate base is clear enough to yield very sharp images outside the window, but it is seldom used if the principal action is to be filmed through the conversion material.

The other type of roll-filter material is made with a softer, more rubbery *gel* base: it adheres to glass in much the same way as plastic food wrap clings to glass jars. This filter may be cut with scissors and applied to the *inside* of the window either in small pieces to fit the individual panes or in a full sheet covering the entire window. It will also adhere to large exterior window surfaces. The gel may be stapled in place as a sheet and stretched taut to achieve a flat, wrinkleless fit. It is reusable and doesn't tear. After several uses, however, it tends to attract dust and static electricity. It is not optically clear (or even as clear as the acetate filters) and therefore cannot be used when in-focus exteriors are to be filmed from the inside.

There are *optically clear* 4' X 8' panels of filter material available for use when the exterior is going to be seen distinctly. Made of $\frac{1}{4}$"-thick *acrylic*, these rigid plastic filters are the best (and most expensive) method of converting the daylight to a tungsten balance. The plastic may be laid up against the outside of the window if the set is on the ground floor. Setup and breakdown time is cut to nothing, as there is never a problem with wrinkling. By changing the angle at which the material rests against the window reflections and catchlights from fixtures inside the interior can be eliminated. The acrylic sheets are large and heavy and must be carefully treated when moving to avoid scratching.

All these conversion materials are available as an 85

filter, converting the blue daylight to an indoor balance. They will also cut the exterior illumination approximately two-thirds to one full f/stop, depending on the product. But in most cases the balanced window will still be overexposed. For example, say that the interior exposure is lit to 250 footcandles of light, yielding an exposure of f/4. Even with the conversion material the filtered window may still be five f/stops over the exposure for the scene. This extreme exposure ratio would be far from the exposure range of the film: the balanced window would appear washed-out unless the intensity of the daylight is also controlled. To lessen the intensity of the daylight, neutral-density materials (available in rolls or ridged panels) may be used in conjunction with the conversion filters. But when intensity and color correction are required, it is often more convenient to use combination filters, which incorporate into one filter the conversion characteristics of the 85 and the extra intensity reduction offered by varying degrees of ND filters. Both 85N3 and 85N6 combination filters are available for window treatment: the 85N3 combination would balance the light and reduce the intensity of the illumination by two f/stops; the 85N6 would cause a three-and-one-half f/stop reduction. Through experience many filmmakers become used to a particular filter combination for balancing and exposing sunlit windows. Of course, the exact filter used depends upon the intensity of the interior and exterior illuminations and upon the personal tastes of the filmmaker. Under normal conditions an 85N3 filter will keep the exterior fairly bright and about two or three f/stops over the interior exposure, which is an acceptable balance for some. Others prefer a narrower exposure range and use stronger neutral-density materials.

There is one method of metering the scene that can help determine which combination of filters to use when shooting with color film. The filmmaker should first be familiar with the exposure range of the film in use and determine the effect of intensity control desired—i.e., the number of f/stops over the exposure of the interior that should be used when shooting the exterior from inside the room. Using 3200°K illumination and B-type emulsion, the filmmaker meters the exposure of the interior and the exterior with a domed incident-light meter without changing the exposure index selected for the indoor balance. While outdoors, pointing the dome toward the window, the filmmaker measures the illumination in an area that the camera will view. If it is sunny outside the window but the camera sees mainly shade across the street, for example, measure the outdoor exposure in the shade. Compare the exposure

ratios and select a conversion-and-intensity-filter combination to bring the scene into the preselected balance. For example, if the interior reading is f/4 and the exterior reading is f/16, placing an 85 filter over the windows would balance the light and make the exterior look as if it were exposed at f/11. If an 85N3 filter is used, a level approaching f/8 would be observed; an 85N6 would give a range between f/5.6 and f/4.

If you are in doubt about which combination to choose, begin by selecting one that would keep the exposure ratio at about 4:1. Adjust the filtration to leave the exterior exposure two f/stops higher than that of the interior. It is important to remember that this system of measurement is meant for color filming. If the scene were shot in black and white, the color balance would not be a problem. The ASA index of the meter should be adjusted to the film's indoor speed for the interior reading and then readjusted to the exterior ASA rating. This would give the proper exposure ratio: any balancing of intensities would be taken from there.

It is not advisable to stack more than two sheets of material together. Filters used together over windows multiply reflections and increase the chance of image-quality degradation. Multiple filters may be successfully stacked only if the window is to be consistently out of focus or if it is located behind translucent materials, such as sheer draperies. In situations such as this an 85 filter may be used alone or with an ND3 or ND6, which would maintain a consistent ratio between interior and exterior as the intensity of the sunlight varies.

Using 85 and ND rolls to convert and balance daylight to tungsten is a common procedure. It requires little or no interior-lighting modifications or concessions. In this way the filmmaker can work under the same illumination levels for "window" scenes as for other interior shots, making lighting effects easier to judge because the same working aperture is used throughout the production.

Daylight Fill

There are some situations in which different lighting approaches and filtering techniques must be used. When the window area included in the shot is large compared to the size of the room or when the majority of exposure illumination for the scene comes through in-frame windows, the set may be best shot with a daylight balance. This involves two major changes: the B emulsion in the camera must be balanced with an 85B camera filter to convert the film to daylight, and the keys and fill lights used to light the

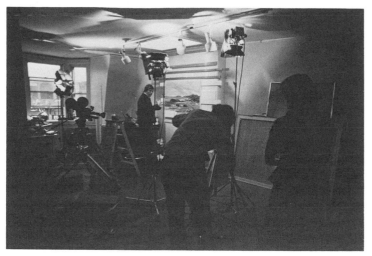

7-9

7-12

7-10

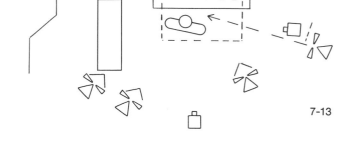

7-13

Long shot/painter/daylight balance. 7-9. All lights are covered with a blue gel, which produces a daylight-balanced illumination that matches the color temperature of the light filtering onto the set from the skylight above. One directable key light, seen on the right, produces a single subject shadow. 7-10. Subject seen from the first camera position. The ceiling and white walls seen behind the subject measure one f/stop below that of the main-action area. 7-11. Filtered light produced by bouncing the three 1K fixtures off the ceiling mimics both the quality and the color of the illumination from the natural skylight. 7-12. Subject seen from the second camera position. In this position the subject is lit to one f/stop below that of the main-action area. 7-13. Lighting diagram: note the use of a half scrim on the key light.

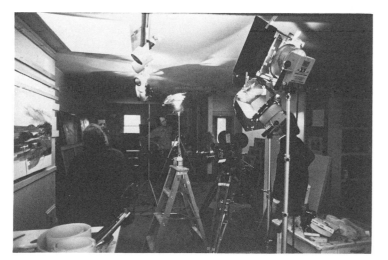

7-11

173

interior artificially must be of the type that produces a daylight-balanced illumination. The windows may also have to be gelled, not for color conversion, for the light will already be balanced, but for intensity control. Since it may be very difficult to obtain sufficient daylight fixtures and a large amount of energy is needed to balance the indoor and outdoor exposure ratios, neutral-density sheets may have to be placed over the windows.

Determining the Exposure Ratio

If you decide to shoot in daylight instead of tungsten light, the first thing to do is to determine the desired intensity balance or exposure ratio between outdoors and indoors. If you decide to shoot within a 2:1 ratio, keep the outdoors one f/stop higher than the interior. Set the exposure meter to the daylight balance of the film, which takes into account the filter factor of the 85 filter over the lens. Take an exposure reading outside of the area that the camera will see through the window. After metering the interior for lighting intensity gel the windows with the appropriate number of ND filters to bring the outdoor intensity within the exposure ratio desired.

For example, suppose that the outdoor-exposure measurement, with the meter set to the daylight ASA for the film being used, reads f/16. To achieve the 2:1 ratio, either light the interior to f/11 and do not use an ND filter on the window or illuminate the interior to a lower exposure and gel the windows with the correct ND filter to bring the outdoor exposure as viewed through the windows within one f/stop of the indoor exposure. If you light the interior to f/4, use an ND filter that absorbs three f/stops of exposure light so that the exterior will have an intensity of f/5.6 when filmed. If you light the interior to f/8, the use of an N3 on the window will produce the proper 2:1 exposure ratio.

Choosing the Lights

Four types of fixtures might be used in this situation: arc lights, PAR or FAY lights, filtered tungsten-halogen lamps, or HMI lights. Arcs are large, messy, and expensive but give off a large amount of illumination. PAR or FAY lights, with built-in dichroic filters, are much more compact. They produce a daylight specular illumination, but their harsh quality can easily be diffused. PAR lights are not as intense as arcs but are very directable and have a long throw. Tungsten-halogen lamps, with a color temperature of 3200°K, may be used if converted to daylight balance with a blue gel. The filters cut down the intensity

of the light by a factor of two. The gels melt on occasion and change color if subjected to intense heat. Since these fixtures normally have a medium throw, they may be capable only of lighting limited areas of the set when filtered. The best, most portable, and most intense daylight source, which uses the least amount of electricity to produce illumination equivalent to that of other sources, is the HMI source, a fixture ideally suited to interior "daylight" shooting. Regardless of the type of light chosen, the filmmaker needs to pay particular attention to the direction of the motivating source, the shadow production of the lights, and the reflections produced by the lights in the windows when setting the fixtures.

Since the background illumination is constantly changing as the day goes on, lighting continuity is of particular concern in "daylight" interiors. The outdoor illumination should be measured periodically so that the interior light can be brought up or down or the ND filters can be changed to maintain the desired exposure ratio. If this is not done, late-day closeups that include a window background will not match long shots taken earlier.

Other Daylight Interiors

For most interior shots with small or less dominant windows it is usually advisable to filter the window to match the interior 3200°K illumination. There are other situations, however, in which it is desirable to key-light the interior with daylight illumination. On locations on which *exterior* filming takes place outside the window any action on the interior set that is seen in frame must be lit with matching color-balanced illumination. With the camera outdoors, filter the film with an 85B and light the interior set with

Long shot/shearing machine/daylight balance. 7-14. Daylight passing through the large bank of exterior windows provides sufficient exposure illumination for the area of the machine closest to the windows. The lighting strategy is to key-light all areas of the machine with daylight-filtered illumination matching the intensity of the light from the windows. 7-15. Located close to the machinery, broad lights filtered with blue gels evenly illuminate large areas of the machine. Filtered focusing spots are used to highlight less luminant areas. Notice the position of the lights used to illuminate the background. 7-16. Subject as seen from the camera position. The window light is soft and diffuse. 7-17. Fixtures illuminating areas in which no subject movement takes place light the machine from an eye-level location. 7-18. Lighting diagram: a 1K and a 2K focusing spot are used to light the machine from a near-backlight position, providing highlights and contrast and separating the machine from the background.

7-14

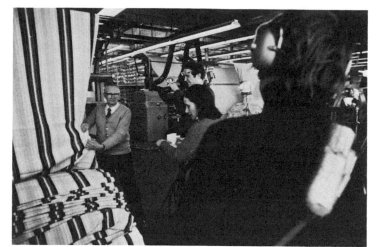

7-16

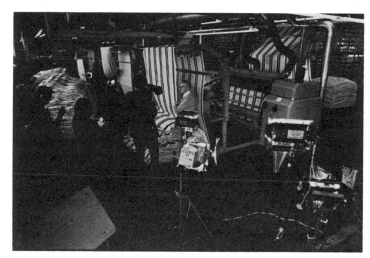

7-15

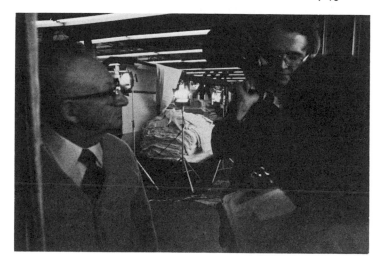

7-17

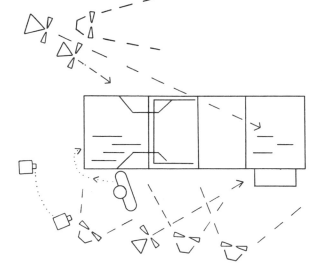

7-18

daylight-balanced fixtures. The exposure between the interior and the exterior should be within one f/stop, with the exterior the brighter of the two. No filter is needed on the window. The same lighting technique can be used when an exterior shot is framed to include a doorway opening on interior action. The interior of the entrance should be lit by blue illumination balanced for daylight. Any background seen through the door should be similarly lit.

FLUORESCENT ILLUMINATION

The color temperature of an unknown source, when matched to the visual appearance of the burning standard, is said to have the same color temperature as the standard. For this comparison to be valid, however, the unknown source must produce light when heated in the same manner as the standard. As the standard increases in temperature, the energy emitted as heat and light gradually decreases in wavelength. More important is the fact that, starting with the red colors, waves given off by the heated standard decrease proportionally in length as the temperature increases. The standard source reproduces colors and wavelengths in a gradual, uninterrupted scale. All the colors produced by any light source make up its *spectrum*. Since the black body used for color-temperature measurement reproduces waves in an even, uninterrupted manner, it is said to exhibit a *smooth* spectrum. Sources with this characteristic may be defined as having an *uninterrupted* spectral emission. For "unknown" light sources to be accurately measurable in color temperature, they must also have a smooth spectral emission.

Fluorescents do not exhibit these qualities. *Fluorescent* light is not produced by burning or heating a tungsten filament or carbon rod but rather by the glowing gases in a glass tube. The wavelengths produced by their illumination are erratic and generally deficient in the warm reds and yellows. The color temperature of the fluorescent tubes cannot be measured with the typical color meter in order to select balancing filters. The traditional color-temperature meters are designed to be sensitive to varying amounts of blue and red in the spectrum of the unknown source. The amount read is compared to an internally calibrated standard derived from the smooth spectral response of the black body. Fluorescents cannot be compared to a black body: readings taken of their illumination would not be accurate measurements of color temperature.

Some meters can be used to measure any type of visible light. Called *tricolor meters*, they read the color of any light source by comparing its spectrum to a series of computer-matched filters inside the meter. The trimeter will suggest color-compensating or light-balancing filter combinations to be used over the lens to produce true color reproduction regardless of the type of illumination or film being used. The meter is capable of reading both smooth and erratic spectrally emitted sources.

There are approximately six different types of fluorescent tubes in use: each one produces a slightly different color cast. To complicate matters further, their illumination changes in color with voltage, age, and other unpredictable variables such as variations in manufacturing processes. Many tubes illuminate a scene with a light close to the visual appearance of green. Each of the different types of tubes has its own trade name, which sometimes refers to the general color of the illumination emitted by the bulb. Cool-white tubes are the most widely used, and many of the prepared filters available to filmmakers are designed for use with this type of illumination. Fluorescents have other deficiencies. In addition to the color-balance problem the light's transformers often generate a humming noise, which produces a high ambient-sound level for location recording. The fluorescent fixtures also tend to flicker on and off or to strobe when filmed with shutters set at an angle less than $170°$: this pixilated lighting effect is called *phasing*.

The best method of dealing with all the problems of fluorescents is to turn them off and to shoot a B-type film with tungsten illumination. This is especially useful if all the shots are limited to a relatively small area. This is often impractical, however, and some use of the existing fluorescent light is usually necessary. Examples of situations in which existing fluorescents may have to be used include: long shots in fluorescent-lit interiors, closeups with in-frame tubes, and closeup and medium shots with fluorescent-lit deep backgrounds. Many of these circumstances inevitably occur in commercial shooting of supermarkets, industrial plants, and offices.

The extent to which a scene involving fluorescent lighting is "color-corrected" usually depends upon such factors as available time and money. If there is a sufficient budget for appropriate gels, labor, and power, there is no reason why accurate color reproduction cannot be achieved. More often than not, however, lower-budget independent productions must make certain compromises in color quality when filming interiors lit by fluorescents. Following are the most popular methods used to deal with fluorescent filming. All of them will yield far superior results when used with a B-negative emulsion rather than with a positive-reversal stock.

Turning Off the Fluorescents

One method is to turn off the fluorescents and to use a B-type emulsion and 3200°K light. Do not expect to intercut any of this footage with other footage of the same sequence lit by any other kind of light. Closeups shot with tungsten light may not match long shots lit by combined fluorescent and filtered sources in color balance or lighting quality.

Fluorescent light appears to be extremely even and shadowless. In shooting on a location in which the viewer may expect this particular quality of lighting, fixtures should mimic the fluorescents. In a medium shot of a tungsten-lit supermarket scene, for example, the use of traditional spots and floods may cause unwanted shadows and highlights. Softer, more diffuse illumination should instead be used. It will duplicate the visual appearance of the soft, shadowless fluorescents without color-balance problems.

If the location has a fairly low, white, suspended ceiling, light from ordinary spots or floods can be bounced onto the set. These may either be used alone or along with large softlights mounted on stands at camera height. The stand-mounted spots bouncing off the ceiling will produce the general illumination; the softlights will help to fill in the shadows. The effect will match the quality of the light that one normally associates with supermarkets and department stores.

Existing Fluorescent Light Plus a Camera Filter

If the ambient level of the fluorescent lighting is high enough, a camera filter can be used to balance the location without the need for auxiliary lighting. Two commercially produced glass filters are available for shooting under existing fluorescent illumination, the FLB and the FLD. The *FLB* balances cool-white illumination to a B-type film emulsion, while the *FLD* corrects the light to a daylight-balanced film. These prepared filters have a filter factor of two, cutting down one f/stop of light. Combinations of gelatin color-correcting filters may also be used to balance the fluorescent scene. Kodak suggests several starting filter packs for balancing various types of tubes with the commonly used emulsions (7-4).

A tricolor meter can be used to calculate "correct" film-and-filter combinations when filming entirely under existing fluorescent illumination. If the scene is illuminated by more than one type of light-source color, however, the overall balance may be acceptable but there may be distracting off-color highlights from each of the different sources. An example of this situation is commonly found in industrial filming, where tungsten work lamps or table lamps are often mixed within a set lit by overall fluorescent light. Long shots balanced with a tricolor meter would yield acceptable colors: the meter will average and integrate all the colors of light falling on it, but neither of the two different sources actually seen in the shot would appear white. Each would have its own slightly different color cast: if neither source can be eliminated from the scene, be certain to adjust the filtration when moving in for a closer shot. A more localized tricolor reading would assure more accurate reproduction of subject tones.

Filming entirely under fluorescent illumination without fill lights often has exposure and contrast drawbacks. Because of the decrease in exposure caused by filter absorption films filtered for fluorescent shooting must often be "pushed" to increase their exposure sensitivity. *Pushing* refers to the overdevelopment of the film to compensate for its exposure at a higher ASA rating than that for which it is intended. For example, an ASA-100 film pushed to 200 will require a full f/stop less exposure light than that required for proper exposure. The use of reversal emulsions should be avoided in these situations, since the most printable reversal emulsion is still too slow for low-light filming and since films with a low-ASA rating generally do not push well. Pushing tends to increase the size of the grain structure of the film. Greenish shadows and desaturated blacks may also be unavoidable if some emulsions are filmed under fluorescent light.

Another major drawback of available-fluorescent-light filming is that the scene often appears much more contrasty on film than it does to the eye. This is especially true when filming under a low ceiling with suspended fluorescent fixtures, such as in office interiors. Under such conditions deep, hollow eye shadows may be a problem unless some type of fill light is used. The contrast is usually less noticeable with negative emulsions and may be slightly reduced on any film by having the lab "flash" the film after exposure but before processing.

Flashing is a technique for lowering the contrast of the film. It is done by subjecting the emulsion to a very low-level light source that uniformly exposes the film stock. There are two types of flashing: postflashing and preflashing, or hypersensitization. *Postflashing* decreases the contrast of the emulsion and is performed by the lab after exposure and before development. Often done on reversal films, this technique aids in print reproduction by compressing the original's exposure range slightly.

Preflashing, or *hypersensitization*, is performed by the lab before the film is exposed in the camera. Frequently done on negative emulsions, this technique effectively increases the exposure index (ASA) of the film without significantly modifying its grain structure or color rendition.

Existing Fluorescent Light Plus an FLB Filter and "Artificial" Fluorescent Light

The advantages of using a fluorescent camera filter to color-correct the film to the visual color of fluorescent illumination can be further extended by *boosting* (adding more intensity) the level of the existing illumination with fill lights. But if fill light must be added to a set lit by cool whites, for example, and the shot is being filmed with a camera filtered with an FLB or other fluorescent-filter combination made up of CC gels, the fill must be of the same color quality as the existing illumination—*fluorescent fill* must be used.

Fluorescent-balanced fill light is useful in producing an exposure balance between two areas lit with existing fluorescents, one of which is much more intense than the other. This common situation occurs, for example, when action to be exposed with natural overhead fluorescents (as in a department-store sequence) moves closer to display cases lit with brighter fluorescent tubes. The display lights can be turned off, but this may make the scene appear unnaturally flat. One way to control the intensity of the display lights, if they are not visible from the camera angle, is to wrap diffusion material around them. Another method is to boost the exposure of all other areas in the shot in which the cases are seen by fill-lighting with a fluorescent-balanced illumination, lowering the exposure ratio between the two areas (the cases and the surrounding action area) to more tolerable limits. The fill should be adjusted to bring the two areas to within one or one and one-half f/stops of exposure in order to preserve the realism of the shot. A fluorescent fill might also be used to lighten facial shadows created by low ceiling tubes or to fill in the foreground of a long shot lit by high, overhead fluorescent fixtures.

Special fixtures made for these purposes are actually made of fluorescent tubes mounted into shallow reflectors. To fill in a scene, they are used in much the same way as tungsten softlights. Acetate filters are also available to convert $3200°K$ light to the approximate color of fluorescent illumination. The acetate is green in color and comes in rolls similar to window-filter material. Placed over large softlights, the diffusely filtered illumination should adequately fill in and balance the shadows created by the existing fluorescents. The filters may be attached by clips to the fixture or barndoors or held in place by a flag or gobo. For background illumination, in which a longer throw is desirable, the filters can be used to convert tungsten spots to "narrow-beam" fluorescents.

The combination of fill plus camera filter can be adapted to fluorescent interiors for industrial, commercial, and documentary films. The use of the green acetate and the camera filter enables existing background tubes to be filmed without any color mismatch in successive shots in which similar lighting setups are used. The filmmaker should be careful with the gel material, for the filter may discolor with age and heat and should be used only with cool-white fluorescent illumination.

Long, medium shots/supermarket butcher/fluorescent balance. 7-19. The ambient light of the market is cool-white fluorescent, which lights the majority of the aisles and walking areas to 95 footcandles. The showcase fluorescent lights the products to 125 footcandles. To take advantage of the illumination lighting the large area to be included in the long shot, the lighting strategy of building on a base is used. The camera is filtered with an FLB, and the $3200°K$ lights are gelled with green acetate, which matches the color of the existing fluorescent illumination. 7-20. Stand-mounted focusing spots rigged slightly above eye level throw light from the edge of the camera's view to illuminate the actors' blocking. Sandbags hold the lights in place to prevent them from being moved unintentionally. 7-21. Several 2K softlights illuminate the foreground action evenly and flatly. Since the foreground is the most prominent area in this wide shot, it is important that the characters are lit by an illumination quality that matches that of the overheads. 7-22. Wide shot seen from the camera angle. The shadows created by the overheads are filled in by illuminating the action with color-balanced light, directed to strike the actors from a low angle. In this high-key scene all the action is lit to 125 footcandles, $\frac{1}{2}$ f/stop above the base illumination. The people in the background are not silhouetted against the bright bulbs of the displays but are also lit with artificial green illumination. 7-23. Half scrims are used in the lights that illuminate long blocking movements such as that of the man to the left of the frame. Contrast is further reduced when characters are dressed in neutral-colored clothing. 7-24. Lighting diagram: the exposure ratio between the artificially lit areas and those lit only by the base illumination is 1.5 : 1. All the lights are positioned just outside the camera angle except for the 2K used to light the background. It is hidden from the camera by the display case. Most of the action is frontally lit so that actors' shadows are not noticed. The three-sided projection is a 12'-high barrier of sound blankets erected by the sound engineer to help deaden the sound in the room.

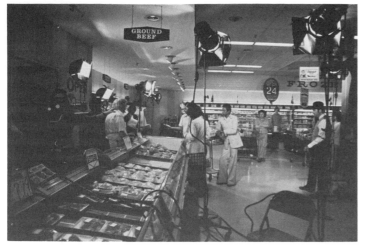

7-19

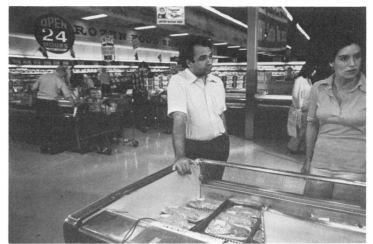

7-22

7-20

7-23

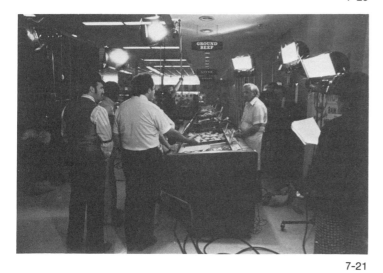

7-21

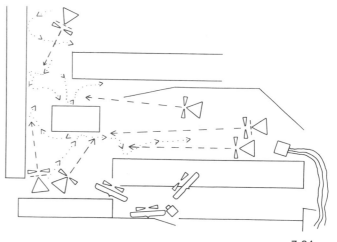

7-24

Existing Fluorescent Light Plus Daylight Fill and an 85B Filter

Using the green filters for the lights and an FLB for the camera effectively cuts down the exposure level two f/stops or more. The exact camera filtration selected may use one to one and one-half f/stops of exposure light; the green filters for the lights may reduce the exposure illumination available by one f/stop or more. This decrease is often too great for the speed and type of emulsion used. Although this combination will produce fine color rendition with both positive and negative emulsions, the B-negative film's color correctability permits yet another technique to be used: filtering the B emulsion with an 85B conversion filter and lighting the fluorescent scene with *daylight-balanced illumination*.

Filtering the camera with an 85B converts the B film to a daylight balance. This is helpful because cool-white fluorescent is close in color to daylight, although it tends to have a greenish-blue cast. By adding artificial illumination to fluorescent illumination filmed with a daylight-balanced film just enough color correction may be produced to obtain a satisfactory print. Artificial daylight-balanced illumination can be produced with greater efficiency than can fluorescent-balanced light made by converting $3200°K$ illumination with green gels. PAR, FAY, or HMI lights are ideally suited for this purpose, although conventional $3200°K$ light can also be used if converted to daylight balance with a blue gel. For daylight-balanced fill-light purposes large blue-filtered softlights, placed at approximate camera height, work well. Filtered spots add balanced background light as well as added punch to dark corners or ceilings. Spots can also be used to fill in showcases or displays lit by open fluorescents. Adding enough daylight to these areas will balance the color fairly well and keep the exposure consistent. A negative film balanced, filled, and lit in this manner should reproduce the scene with an acceptable rendition of tones.

The following set of drawings and photographs (7-25, 7-26, 7-27, 7-28) shows a department-store sequence lit by this technique. The closeups and medium shots were done against a wall and could have been lit with a limited amount of tungsten light, probably 8000 watts. But long shots and the establishing reverse angles, as seen in these illustrations, included expansive areas. There was not enough electricity or fixtures to light the shots with tungsten, so the existing illumination from the overhead fluorescents, boosted with daylight fill for color correction, was used to expose the scene. To avoid color mismatches be-tween closeups and long shots, all the filming was done under fluorescents balanced with daylight fill. The film was Eastman negative 7247, and the camera was filtered for daylight: in all the shots blue acetate gels were placed over the $3200°K$ lights.

In the long shots the background spots lit only prime areas: they did not fill-light the entire background. Their illumination was controlled to equal that of the main foreground area lit by the blue fills. Backlights were used to add highlights and separation. The reverse-angle long shot was also lit by limiting the balanced lighting to prime areas: a shallow foreground, the back walls, and counters. Faces were spotted with blue illumination. The foreground was filled with a soft blue fill, but the existing fluorescents still accounted for the general level of illumination. The ratio of the filled foreground to the naturally lit background was kept to within half an f/stop: all artificially lit areas were kept to within half an f/stop of each other. In the final film the flesh tones of the foreground appeared very real, and the background colors, although not as true, reproduced extremely well. This sequence could also have been shot with green acetate fills and a fluorescent filter. The lighting positions and strategy would have been the same for either filtering approach. The daylight-balanced approach, however, required less filtration, both in the camera and on the lights, and thus produced a higher level of exposure.

Other Color-correction Methods

Some other techniques that can be used to film under fluorescent conditions include the following.

1. The fluorescents can be overpowered with tungsten lights. Use a B film, no filter, and $3200°K$ lighting. Direct, diffused, bounced-spot, or fill light can be used to provide the majority of the illumination for the scene while leaving the overhead fluorescents on. This technique may be required if the fluorescent tubes are very high and cannot be reached, filtered, taken out, or turned off. Depending on the area to be covered, a significant amount of tungsten light may be needed.

2. Existing fluorescent light may be mixed with $3200°K$ light and used with a daylight-balanced film. This technique should be used only as a last resort. Bounce $3200°K$ illumination onto a white ceiling on the set. Try to get enough $3200°K$ illumination in as much of the set as possible in order to supplement the fluorescents with the needed reds and yellows.

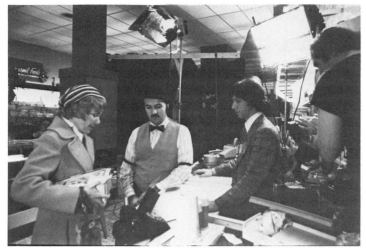

7-25

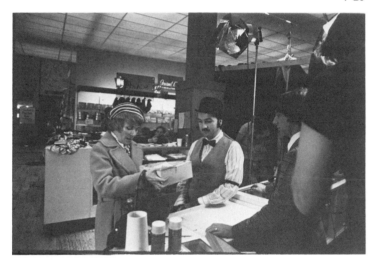

7-26

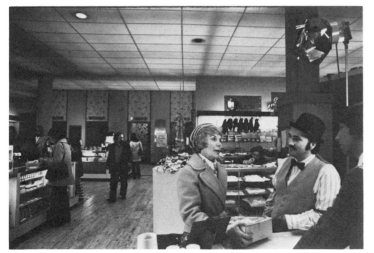

7-27

7-28

Long shot/department store/fluorescent interior balanced for daylight. 7-25. Adding to a base is the strategy for lighting the wide shot and the subsequent closer shots. The overhead cool white fluorescent illumination produces 64 footcandles at floor level. All artificial illumination is blue-filtered for a daylight balance; the camera is also filtered with an 85 filter to a daylight color balance. The 2K softlights are placed to either side of the prominent foreground subjects to light the action $\frac{1}{2}$ f/stop over the base level of the fluorescents. The diffuse quality of the illumination matches that expected from a fluorescently lit interior. 7-26. Daylight-filtered focusing spots are directed to light stationary and moving subjects. They are placed at various levels high above the action so that the downward beams will not overlap at subject height and cause a hot spot. The intensity of each light is adjusted to produce an exposure on the subject area equal to $\frac{1}{2}$ f/stop above that produced by the overheads. 7-27. The shot seen from a position near the camera. The daylight illumination adds enough color-corrected light to reproduce flesh tones acceptably. It eliminates the hollow eye shadow that is normally produced in naturally lit fluorescent interiors filmed without fill lights. The elevators in the background are lit in the same way as the subjects, adding to the high-key effect of the shot. The exposure ratio between any of the characters and any other part of the set is 1.5 : 1 except for the showcase areas, which are lit by their own fluorescents to one f/stop over the exposure for the scene: their intensity is brought down by wrapping the bulbs with a layer of diffusion material. 7-28. Lighting diagram: the lighting strategy of adding to a base enables vast areas to be lit and color-corrected with a minimal amount of light fixtures and electricity.

3. The actual fluorescent tubes can be filtered. Use a B-type film and light the scene with 3200°K light, either bounced or direct. Remove each fluorescent tube and slip the bulb into a jacket tube of filtered transparent acrylic: it will balance the cool white to 3200°K light. This method works well, especially if the exposed tubes are to be filmed. But the fixtures involved in some shots often require too much time to rig and balance in this way, and the expense is high.

Strategy

Either fixtures balanced for fluorescent color temperature can be used for key lights and the ambient fluorescent illumination as a fill, or the location fluorescents can be used as the keys and color-balanced lights for the fills. The former is more desirable, for the keys are by definition the strongest lights on the set and will produce a larger amount of balanced illumination. There is thus a greater chance that balanced light will expose the film stock properly: the filmmaker maintains a greater amount of control over the color temperature of the illumination.

When expansive areas are to be filmed under fluorescent illumination, the strategy is to light the action areas approximately half an f/stop over the exposure of the rest of the areas seen in the frame. In other words, use the existing fluorescent illumination as a base illumination and then "build" on that base by lighting the areas in which color-balance and contrast problems are found— e.g., places in which actors move or their faces are seen. Artificially light the foreground in which action takes place close to the camera but light only those sections of the background in which principal action is found or in which color-balance or contrast problems exist. Keeping the exposure ratio between these areas and the rest of an expansive shot low (1.5:1) doesn't disturb the high-key nature of the illumination expected in a fluorescently lit interior. This technique eliminates the need to "color-correct" all the areas seen in the frame of the shot: it saves setup time, electricity, and fixtures while still yielding an acceptable color rendition of the scene.

OTHER INDOOR COLOR-BALANCE SITUATIONS

There are three other common situations in location filmmaking that involve color-balance differences between the film and the illumination present on the set. These color mismatches are due to: the electricity reaching the bulb, the actual color of the set itself, and the special effects created by the filmmaker.

Voltage Fluctuations

For bulbs to produce their designated color temperature, 3200°K or 5500°K, the voltage must be correct and constant. Most of the quartz-halogen bulbs used in location fixtures are manufactured for 117 volts. A drop of 10 volts at the power source will alter the color temperature of the illumination by 100°. In average locations served by city or town electrical power the standard voltage will usually drop at peak-load times: this condition generally occurs in the morning and early evening. Even if a tie-in is used to tap the location's power at its source, nothing can be done to eliminate fluctuations due to low incoming voltage in such situations.

Variances in available power may be measured at the source (fuse or breaker box) with a voltage meter, but a reading obtained in this manner does not indicate the *usable* voltage reaching the lighting fixtures. If an undersized cable is used to carry electricity to the fixture, full voltage will not reach the lamp and the color temperature of the illumination will drop. The size, gauge, thickness, and length of the cable carrying the electricity to the fixture also affect the load-carrying ability of the wire. The most accurate method of measuring the correct color temperature of an interior scene is to take a temperature reading at the subject position on the set. Regardless of lamp voltage or wiring inefficiencies, the color temperature will accurately measure the color of the light finally reaching the set and suggest filtration corrections. Color-compensating gels are generally used to alter indoor color-balance problems and to achieve "perfect" color.

Set Colors

Another difficulty in dealing with the color balance of indoor sets concerns reflections from surfaces within the set area. Parts of the subject or set often add their own color cast to the illumination. When filming a two-shot of actors sitting at a yellow table, for example, the color from the table surface itself may reflect a strange, undesirable warm cast over their faces. Such reflections may never be noticed in long shot but may cause a problem when moved in tight for closeups. For extremely close shots deal with this problem by eliminating or covering the offending surface if it is not in frame. For slightly longer shots the lighting may have to be redirected or flagged to avoid overlighting the offending surface.

The color of the interior walls also influences the color rendition of subjects within a room. Walls in a small interior that are painted with a saturated color are likely to reflect

that color onto the subject, creating a color cast, even when the set is lit with light balanced to the color sensitivity of the film. Such situations can be dealt with by using camera filtration and CC filters, the exact amount of which is often difficult to determine. The cast is often very small and is not produced by the source of the illumination but rather by the reflection of the source's light from a surface, a situation with which color meters have trouble. If in doubt, use less filtration rather than more.

Special Effects

Mismatched or heavily filtered light sources are frequently used to create a particular colored-lighting effect. For example, the rim light backlighting the talent in a smoky bar scene, if filtered with a blue gel, will accentuate the feeling of the smoky atmosphere. In night-for-night shooting similar filtering may be used on the key lights. Some filmmakers feel that the blue color in these circumstances suggests moon or night light.

At other times practicals are purposely left their own color for special effects. To get a warm glow from a practical lamp in a scene, do not replace the ordinary household bulb with a balanced one. Change the wattage to get the exposure level desired or put the lamp on a dimmer to control the intensity and the color. The lower the voltage reaching the bulb, the warmer the color of the light.

Bright-colored lights are often found in restaurants and bars to influence the mood and atmosphere of the set. Lighting such a scene with an abundance of $3200°K$ would completely alter the mood and effect of the existing lighting. Although some balanced light is necessary, kickers and rims may be filtered for a moderating effect. This would yield colored highlights and still preserve the basic flesh tones.

And, of course, if unnatural and unrealistic lighting is desired, the filmmaker's imagination is the only criterion for the proper balance.

8. Night-for-night Filming

LIGHTING A NIGHT SHOT

Night-for-night filming refers to a filmic situation in which nighttime scenes are actually shot during twilight or evening hours. Of course, to expose the film properly, lighting of some type must be used. The purpose of this chapter is to explain how to manipulate the existing sources or to add artificial illumination to a night shot in order to produce a controllable and functional lighting design without destroying the natural feeling of the dark exterior.

To get an idea of some of the problems involved in night-for-night shooting, consider a blocking action in which a person walks from an illuminated interior across a porch and down the house steps into the yard (8-1). With the existing illumination the brightness ratio may be as high as 500:1 or more, yet the eye, because of its adaptation to the lighting pattern, will not perceive so great a difference.

The camera, however, if set for the existing light, either on the porch or in the visible interior, would probably record most of the set as completely black.

If you want the complete scene to be visible to the viewer, you must light the set artificially. To do this, it is best to determine the lighting pattern for several different blocking positions on the set. For instance, consider an actor standing at a door. As long as the actor opens the door and stays in the doorway, a silhouette will be seen against the lit interior of the set. This will probably produce an acceptable exposure on the film. As the door closes, however, the doorway light will be lost: the film-maker will have to decide how much of the actor is going to be seen and lit and whether the existing practical can be used to create the exposure intensity needed. If the intensity of the light from the practical matches the intensity of

8-1. A night exterior of a porch lit by existing illumination.

the indoor illumination in the doorway, the exposure may be proper, but the subject may appear to be walking into a spotlight as he passes in front of the porch light: the bulb illumination would be much too bright and might destroy the illusion of night. If an ordinary light bulb (100 watts, for example) is placed in the fixture, it would probably not throw enough light to illuminate more than the porch-lamp fixture itself. And, as the subject walks into the yard away from the light fixture on the porch, once again he would go completely black.

To solve this problem, the filmmaker must go back to a basic assumption of night-for-night photography: he or she is merely creating the *illusion* of night by using artificial-light sources that appear to be those illuminating the scene. They needn't be the actual practicals seen in the scene: the illumination simply has to mimic the quality of light sources that would realistically provide the illumination for the scene being filmed.

Because of the difficulties inherent in night photography filmmakers have used certain visual devices that an audience accepts as what nighttime "should" look like. Nighttime is usually dark, contrasty, and shadowy. For example, a long shot that establishes the scene, especially if it includes existing practicals such as streetlamps (8-2), can be lit by a few streaks or patches of light placed approximately where the light from the practicals might be expected to fall. The streetlamps themselves offer little usable light, but they will glow, and, if the street is lit below by some light skimming the pole, the illusion of nighttime can be created and photographed.

In this case the inclusion of the light practical in the frame simply establishes the motivation for the illumination: it only loosely establishes the light's direction. This is an example of a night-for-night lighting convention. If the characters are side-lit from the same side as that of the light from the streetlamps, most audiences will never stop to think that the light isn't coming from the lamp above. Consider a porch light. One side key, skimming across the windowed wall, would side-light the subject, separating him from the background. Placed in the proper position, the light will look as if it is coming from the practical (8-3).

Side lighting is commonly used in night-for-night photography. It offers a great deal of contrast and gives the appearance of illumination from eye-level artificial sources. Side lights cast no back shadows, which is particularly useful, for shadows in the background of nighttime low-key shots would certainly draw the viewer's attention to the placement of the source and to the direction from which the light strikes the subject. And, because side lighting is most often done with stand-mounted lights, the filmmaker is able to take advantage of their portability.

Although side-light setups should not be thought of as a panacea for key-lighting night shots, light originating from a near 90-degree angle in relation to the camera positioning is a popular method of keying subjects in night-for-night settings. The positions for the key lights are chosen to best cover the movement of the action, with careful attention given to creating the impression of light coming from a motivating source. When key-light directions other than the "basic" side-lighting setup are justified, by all means position the keys to mimic the direction as well as the quality of the existing motivator.

MATCHING CLOSEUPS AND LONG SHOTS

The key lights in long shots for night-for-night filming should establish the lighting pattern and the strong contrast inherent in this type of lighting. The closeups, however, do not have to be shot in the same lighting ratios used in long shots. As long as the wide shots create the darkened mood, the closeups can be filled in to some extent to pick up detail in the subject. Of course, the direction of the motivating-light source must still be maintained, but fill and rim light may be added. For example, a long shot may be filmed with no fill at all, using only cross keys and one or two background lights. When a subject moves through the scene in long shot, streaks of light can be seen (8-2). But when the filmmaker moves in for a closeup, the lighting ratio should be lowered, possibly to 4:1, by filling in the shadow side with a frontal fill or another cross-key fill. A directional frontal fill can be used to minimize shadows on the background and to maintain the foreground-to-background lighting continuity (8-4).

8-2. A night exterior of a street, with existing overhead streetlights used to motivate artificial lighting.

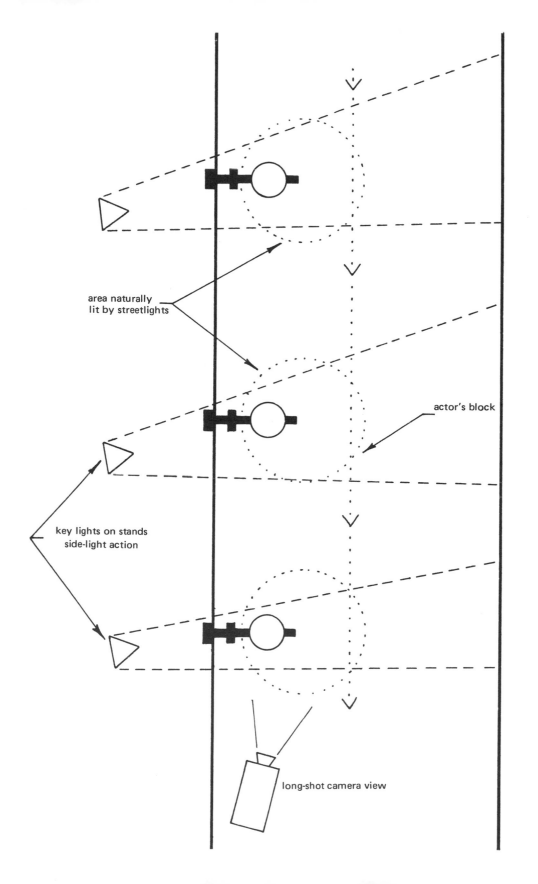

area naturally
lit by streetlights

actor's block

key lights on stands
side-light action

long-shot camera view

187

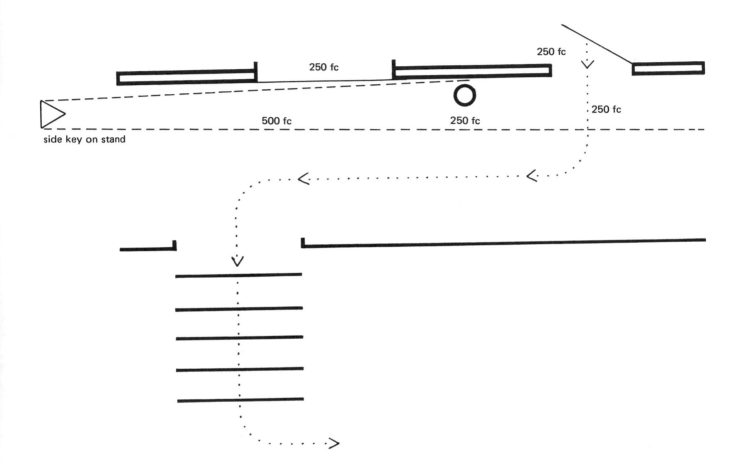

250 fc

250 fc

250 fc

500 fc 250 fc

side key on stand

8-3. A side key illuminating subject movement across the porch.

8-4. A directional frontal fill lowers the lighting ratio of the closeup.

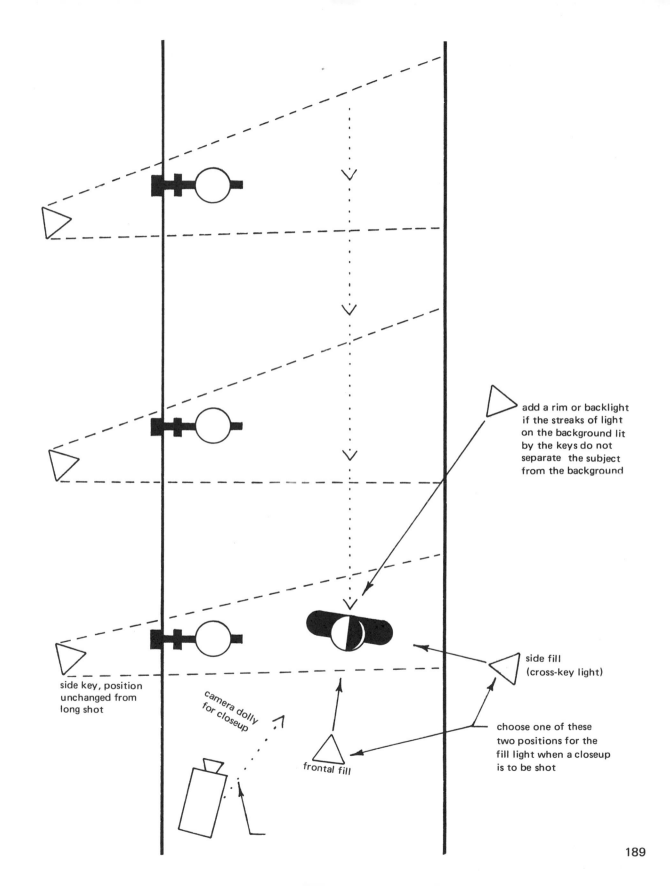

add a rim or backlight
if the streaks of light
on the background lit
by the keys do not
separate the subject
from the background

side fill
(cross-key light)

side key, position
unchanged from
long shot

camera dolly
for closeup

frontal fill

choose one of these
two positions for the
fill light when a closeup
is to be shot

189

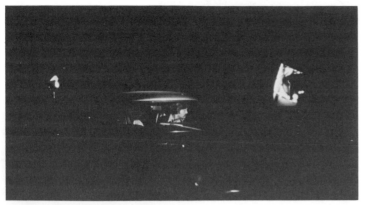

8-5

8-6

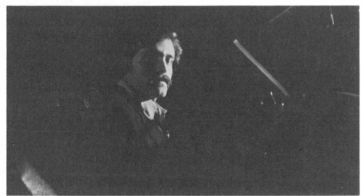

8-7

USING PRACTICALS AS KEYS

There are many situations in which traditional lighting fixtures cannot be used to illuminate the night-for-night shot: the practicals found on the location must provide the total illumination for the scene. Such a dependence may be caused by a lack of electricity to the exterior, outlets placed in nonusable locations, or excessive time required to light the shot adequately for the proper effect. If the conditions demand that the existing illumination be used, the filmmaker must be prepared to compromise picture quality if necessary, especially in terms of contrast, shadow reproduction, and subject separation.

Because of the direction from which they light a subject, overhead practicals such as the hanging lights found in outdoor canopies outside hotels offer better possibilities for key lighting a shot than lower, wall-mounted fixtures. To be effective for exposure purposes, the lights must be very intense. Higher lights are less likely to be seen in the shot, an advantage at times in that their inclusion in the frame may cause excessive flare and local overexposure. Streetlamps make poor motivating practicals for exposure sources, and they are generally too high to light the scene effectively.

The greater the number of practicals on a location, the better: larger numbers will offer greater illumination and a greater supply of electricity. If stand-mounted spots cannot be used for key lighting, it is best to replace the bulbs in the existing practicals with color-balanced photofloods of the highest wattage that the existing socket can handle. If the existing practicals cannot be replaced, the filmmaker may have to use other methods to rig the practicals as key lights.

Rigging the Practicals

Rigging the practicals often requires more than simply boosting the existing sockets with higher-wattage bulbs.

Closeup/car driver/night exterior. 8-5. Two cross keys side-light the driver. The fixture to the front of the car is fitted with a mirror reflector to throw a harsh, specular light. The shot is filled in by the fixture to the rear of the car, which is fitted with a soft, wrinkled reflector. 8-6. Side light illuminates the subject from near eye-level position. The lighting ratio on his face is 8:1. The background, which is not yet lit here, will provide separation and contrast to the plane of the subject. The background-to-subject exposure ratio will be 6:1. 8-7. Lighting diagram: a cross key is used instead of a frontal fill so that fill shadows are placed in a less noticeable position.

The practicals may be too small to accept the larger balanced source, or the wiring may be of insufficient gauge to carry the large amount of current safely. One way to avoid these difficulties is to use the practical but not its wiring or socket. It can be rigged instead with a bare-bulb fixture, purchased either as a ceramic socket made for a "peanut" quartz light or as a "peanut" quartz light already mounted in the ceramic socket that is commercially available as a bare-bulb fixture.

A *peanut* quartz light is a bulb balanced for tungsten light: it comes in 250- and 500-watt sizes. It is rigged into the practical fixture in such a way that, from the camera position, the illumination appears to be emanating from the practical itself. With a hanging, open-faced practical this is best done by wrapping the key's wiring around the existing wiring that supports the hanging fixture from overhead and by placing the balanced source inside the shade of the practical. With a porch light the fixture is attached directly behind the practical (either C-clamped to the practical or placed on an L-plate and mounted directly to the wall behind the practical). Always be certain that the bulb itself does not touch any surrounding objects and that air can circulate around it. Staple or attach the wiring from the fixture down the wall toward the floor of the exterior where it won't be noticed.

Falloff Problems and Exposure

Measuring the exposure of a scene lit by night-for-night practicals is difficult as there is often a great amount of uncontrollable intensity falloff. Remember that the falloff across subject and movement decreases as the source is placed further away from the subject. When key-light practicals are used at night and are located close to the head of the subject, the falloff may be too great to film with any amount of realism. If the practical can be moved further away from the subject, usually higher into the ceiling, a compromise in camera exposure may have to be made, especially if the entire length of the subject is included in a long shot. Instead of setting the camera for an incident-light reading of the subject's face open it up one f/stop from this exposure. This will overexpose the top of the subject but may still be acceptably "realistic," depending on the type of practical used, and more detail will be seen in the darker areas of the frame.

Different problems exist when a side-lighting practical such as a porch light is used as a key light. This practical illuminates the subject to a greater extent, since it is located next to instead of above the actor. To set this exposure, measure the light on the subject's face: have the subject try to maintain this distance from the source as much as possible. When he moves closer to (overexposing) or further away from (underexposing) the light, the latitude of the film stock may be able to handle the variation.

COLOR BALANCE

Film used in exterior night-for-night shooting is usually color negative, a B-type film whose latitude makes it the best stock for this type of shooting. Since it is made to balance with 3200°K sources, no filtering is needed, even though the filming is taking place outside. This is a simple but important point to remember: the lighting is tungsten, so the film must also be balanced for tungsten.

A problem can arise in night-for-night filming if different types of lights are used to expose the film. For example, balanced bulbs in outdoor fixtures have a warm glow; fluorescents in storefronts are green; and streetlamps, depending on the type, may be yellow (tungsten), greenish-blue (mercury vapor), or pink (sodium vapor). The filmmaker should keep in mind that, if he is using lights over which he has no color-balance control, he should be even more careful with the lights over which he does have control. A proper balance will be secured part of the time, and the off-colors of the other lights may be more acceptable as natural.

Other balance problems may occur in night-for-night shooting, even when color-corrected keys are used without mixed sources in frame. The electrical cables often have to run great distances from the power source (a generator or a nearby building), causing a voltage drop, so the color temperature of the illumination will also drop, causing the light to redden. Most viewers see nighttime light as cool (blue) in color: the warmer colors of the tungsten lights will look unnatural. Many filmmakers do not settle for 3200°K light but actually filter the light to increase its color temperature further. The degree to which this is done depends upon the personal taste of the filmmaker. Most use a blue gel, which raises the color temperature about 400°K, although for heavier filtration an 800°K gel can be used. To measure the color temperature of keys used for night-for-night filming, take a color reading of each source by standing in the subject position and pointing the color meter toward the illumination.

OUTDOOR-NIGHT FIXTURES

Since outdoor lighting for night is acceptably contrasty and hard, especially in scenes in which a justifiable light source or motivating source is present or suggested, specular focusing units are usually used. A mirrored reflector, placed to give the fixture a long throw, and large, vertical barn-doors, used to control and direct the pattern of light, are especially helpful for key-light fixtures. Fill light is useful for closeups, but specular light carefully directed from the front or cross-keyed from the sides is also often used when contrast-reducing illumination must be projected into the set from a great distance.

If no justified source is suggested in a scene, a less specular key illumination is more effective, even though the fixtures may be positioned in the same side-lighting pattern as that used for specular keys when a motivating source is present. To produce a more diffuse light, a softer reflector can be used in the fixture itself, or diffusion material may be placed over the light. The latter may be more effective, because it produces the desired softness without hampering the long throw of the lamp.

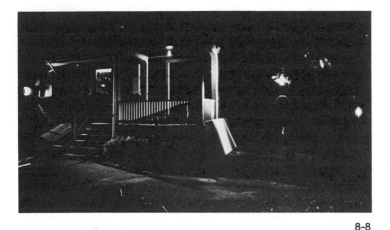

8-8

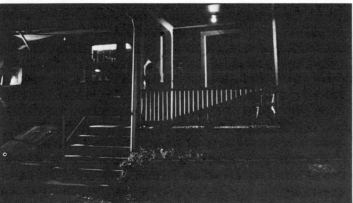

Long shot/porch/night exterior. 8-8. The lighting strategy is to key the subject from the direction of the light sources included in the frame, the overhead porch lamp and the window. With a soft reflector installed, the 1K focusing spot (the highest fixture on the right of the frame) side-lights the subject's movement as he exits the interior and walks along the side of the house to the steps. The 1K to the left of the key is fitted with a specular mirror reflector: it is used to backlight the porch railing with a sharp, contrasty pattern of illumination. The key to the far left of the frame side-lights the subject with a pool of light coming from the direction of the window. The lowest key, seen to the far right, fills in the porch front and key-lights the subjects' final movements from an eye level. 8-9. The shot of the scene with the subject in place. The 500-watt practical, which was not part of the original location, is rigged to the ceiling with an external wire that is hidden from the camera. This bulb acts as a fill light, lowering the lighting ratio to 6:1. 8-10. Lighting diagram: at each position through which the actor moves a pool of 125-footcandle light is set. The interiors are lit to 300 footcandles; the specular lights at the porch railing, to 250 footcandles.

8-9

8-10

The number of lights used to illuminate a set varies greatly, depending upon the size of the location, the degree to which the filmmaker wants to light the set, the effects desired, and the amount of separation needed between the subject and the background. This last consideration is especially important, for, if little separation is desired, the number of fixtures used can be cut greatly. The illustrations show an actual night exterior lit with 4000 watts of light. Several more fixtures could have been used to complete the effect, but breakdown and setup time, coupled with the lack of adequate power, led to the decision to light smaller areas and to reposition the action to fit the scene.

The efficiency of the lighting setup increases if careful thought is given to preplanning the shoot. Changing a lens to one of a faster speed allows the film stock to be exposed more efficiently, as wide-open apertures of high-speed lenses have tremendous low-light-filming potential. The filmmaker may also plan on flashing or pushing the film stock in order to film with less light.

By combining these two factors with a little ingenuity potentially difficult night-for-night-filming sessions can be problem-solved. For example, consider this night-for-night setup. One small generator is available; it produces 120 amps, enough to power six 2000-watt lamps. The zoom lens on the camera is an f/4; the film stock is Eastman negative 7247, with an ASA of 100. The meter reading on the subject is 250 footcandles; the lens is wide open, and none of the lighting overlaps in coverage. The filmmaker finds that he needs more lighting fixtures for separation and light in more places than are possible with the six fixtures. The chart (8-11) shows some possibilities that can be used to produce a proper exposure while increasing the number of sources that stay within the limits of the electrical potential available.

8-11. The number of fixtures can be increased and sufficient exposure illumination maintained by altering the film-speed-and-lens-opening combination.

speed of film	maximum lens opening	footcandles needed to expose wide open	number of lights	wattages of lights	total wattage
100 ASA	f/4	250	6	2000	12,000
200 EI (exposure index—ASA pushed one f/stop—twice the sensitivity requires half the light)	f/4	125	12 (double the number of lights and half the intensity)	1000	12,000
100 ASA	f/2.8 (switched zoom to a fixed focal length, maximum aperture of 2.8—two times the light-gathering power)	125	12	1000	12,000
200 EI (exposure index—ASA pushed one f/stop—twice the sensitivity requires half the light)	f/2.8 (use a fixed-focal-length lens, maximum aperture of 2.8)	64	24 (double the number of lights and half the intensity)	500	12,000

SEPARATING THE SUBJECT FROM THE BACKGROUND

There are two ways to separate the subject from the background in night-for-night photography: to light the background or to rim-light the subject. It is not uncommon to illuminate the background, for this defines the background itself, silhouettes the subject, and separates and creates depth in the shot. The practical can be used to produce the illumination, or fixtures can be added either to mimic the pattern of the existing practicals or to throw a well-defined shape of light that maintains the low-key, contrasty mood of a night-for-night shot onto the background.

EYE-LEVEL PRACTICALS

Eye-level practicals often provide sufficient illumination in themselves, or they can be boosted to provide enough illumination both to light the background and to separate the subject from the background. For example, if the practical used in the porch-light sequence mentioned earlier is a wall-lantern type, it can be used to create an interesting and realistic pattern of light on the exterior wall (8-12). Remember that the practical is not used as a key light here, so its intensity does not have to match that of the keys. It only adds realism, acts as a motivating source for the key, and produces usable illumination for the exterior wall. For this effect the practical's ordinary household bulb may have to be replaced with a brighter photoflood—a 250-watt ECA or a 500-watt ECT, for example. The boosted practical must have enough intensity to over-expose the background areas as much as two f/stops over the key light in order to create a realistic atmosphere.

When confronted with a night-for-night situation similar to this one, select the wattage of the practical's bulb by taking an incident-light reading of the background about 2' away from the practical. Change wattages as needed or place the practical on a dimmer and vary the voltage until the desired reading is reached. When using this method of lighting backgrounds, remember that the intensity to which the background is lit is influenced by its luminance. If the background is lighter than normal, use the same measuring technique but adjust the wattage of the bulb until it reads only one f/stop over the exposure of the scene. If the background is especially dark, light it to read more than two f/stops over the exposure level. Night-for-night practicals are more noticeable, heightening the lighting effect, when they are filmed against darker backgrounds. This is especially important when the illumination from a background practical needs to be further intensified by adding another off-frame lighting fixture.

ADDING A BACKGROUND LIGHT TO THE PRACTICAL

The filmmaker often finds that the background illumination provided by a practical needs to be supplemented by an off-frame source that lights a larger area than that lit by the boosted practical itself. Again referring to the porch scene, suppose that the practical is of an open design or resembles a bare bulb (8-13). When boosted, it may spread

8-12. A wall-mounted lantern acting as a porch-light practical can create an interesting pattern of illumination on the background.

8-13. An open-design wall-mounted practical can be boosted with a bulb of lower wattage (than that used in the lantern design) to control its spread, while a patterned illumination is produced on the background by directing a focusing spot toward the background.

194

light uncontrollably over the background, ruining the realistic, contrasty effect of the shot. This setup poses a problem. The practical must be seen in the shot and must appear visibly intense but must also be regulated to control the spread of illumination. The easiest way to control the spread of the illumination is to use a "boosted" bulb of lower wattage: its light would not spread as far, preserving the low-key mood. After the intensity of the practical is set, probably to one f/stop above the exposure of the scene near the fixture, the key can be positioned to light the back wall near the practical, and the light can be barndoored or flagged to produce a patterned shape on the exterior wall near the practical. A diagonally streaked light seen just below the practical usually works well (8-13) when adjusted to an f/stop below that of the primary exposure for the shot. The filmmaker should be careful to position the fixture so that the projected beam does not interfere with the actor's movements, unless this is clearly intended—for example, if the shadow of one actor is to fall on the face of another. Be careful also not to spill any light onto the practical itself.

THE KEY LIGHT

In many instances, such as in the street exterior (8-4), the key light serves a dual purpose: it lights both the actor and the background. This can be accomplished only with careful placement of the lights and the camera. High camera angles should be used in the case mentioned above so that the subject is framed against the streaks of light as he moves toward the camera. If this is not possible or desirable, the background will have to be lit.

To light the background, place keys with an extremely long throw out of camera view or hide them behind background objects. As long as the keys light objects such as buildings or cars, there may be no need to maintain directional lighting continuity with that of the rest of the shot, since most outdoor night lighting originates from multiple directions. To illuminate areas of the background seen in the frame, especially those in which the subject is photographed against the background, place the background keys in any position where they will not be seen. Keep the background dark and contrasty: to set the illumination intensity, keep the exposure two f/stops below that of the action area so that a feeling of depth is created. If there are any windows in buildings in the distant background, lighting their interiors will add extra realism to the shot. If possible, their intensity should be one to two f/stops over the main exposure, depending on the effect desired.

THE RIM LIGHT

Rim lighting may be used to add a specular highlight that outlines the back or side of a subject, adding separation between the subject and the background. Rim or back-lights add the finishing touch on a night-for-night shot, for their specular illumination further increases the contrast of the scene. The rim-lit area on the subject is usually the most intensely lit portion of the scene, except perhaps for the area around an eye-level practical. Rim lights are highly specular: long-throw PAR or FAY fixtures and focusing spots with mirror reflectors work well. The fixtures are placed far from the subject and behind the action, just out of the camera frame and fairly close to the lens axis. A typical placement for a rim used in a street exterior is shown in the illustration (8-4). If it were used in the porch scene (8-3), it should be rigged high above the action to backlight the subject from a position that mimics the manner and direction of the practical.

Motivated backlights outline the subject more fully than those that are not motivated. In the street scene there is no motivation for the backlight, so it is directed from a lower angle (from a stand-mounted, long-throw fixture off to the side of the lens axis) and controlled to light only a section of the subject's back. There is only enough light to separate the subject from the background.

It is important to realize that the backlights should not spill appreciable illumination on the front or sides of the subject. If they do, it will be assumed that their highly specular light is coming from another key source, which may prove to be a problem in justification.

Setting the intensity of the backlight is usually done with the aid of a viewing glass. To get an idea of what the correct intensity should look like, try the following method. Replace the hemispherical dome of the incident-light meter with the flat disk. From the subject's position (his back) point the disk directly at the backlight. Have someone adjust the intensity of the light until the reading is approximately one f/stop over the scene's exposure. This method, though approximate, should work, unless the subject is seen against a very bright background. In this case adjust the intensity of the light until it is one f/stop over the exposure of the background. Before shooting place the subject in position and, with the viewing glass, evaluate the effect subjectively.

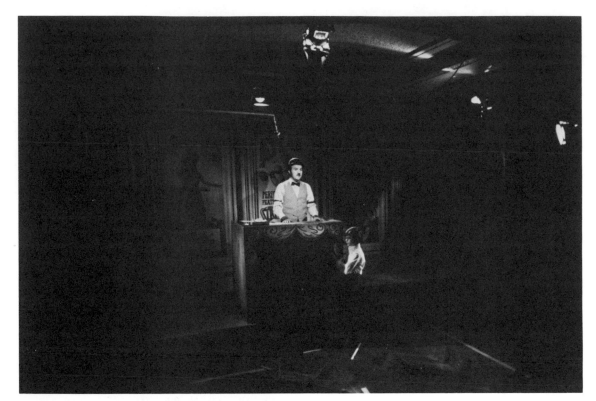

8-14

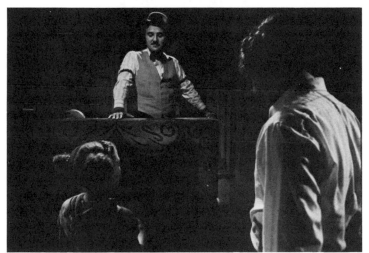

8-15

Long shot/carnival man/night-for-night effect. 8-14. Frontally keyed and intensely backlit, the subject is separated from the background by the large amount of contrast. 8-15. Key light is positioned to strike the actor from a fairly low angle in order to bring out eye detail and to decrease the length of the hat shadow. The exposure ratio between the action area and the background is 8:1. 8-16. Other actors are side-lit with specular sources, mimicking a night-for-night quality. 8-17. From this camera position the side light appears to be a motivating practical. 8-18. Lighting diagram: note that no fill light is used.

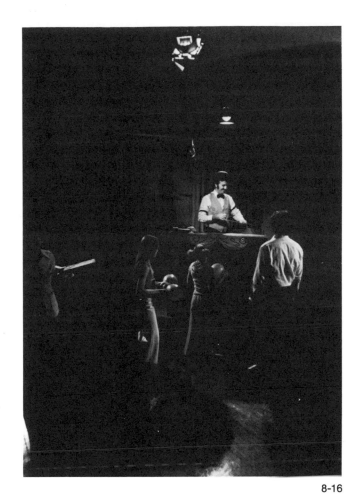

8-16

8-17

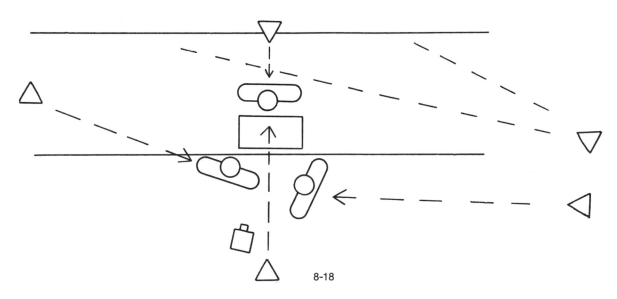

8-18

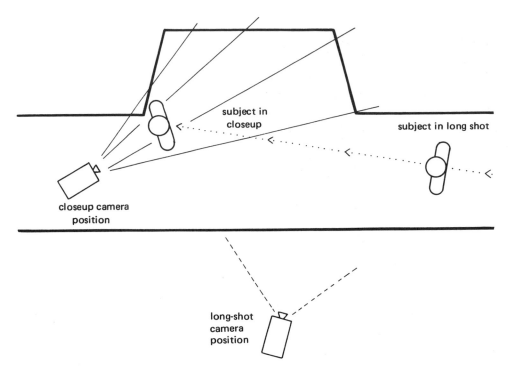

subject in closeup

subject in long shot

closeup camera position

long-shot camera position

8-19. An evenly lit background: filming with no lights.

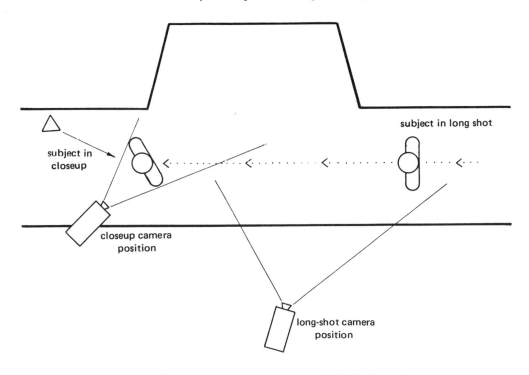

subject in long shot

subject in closeup

closeup camera position

long-shot camera position

8-20. Lighting a subject closeup filmed against an evenly lit background.

EVENLY LIT BACKGROUNDS

Shooting against evenly lit, bright backgrounds such as storefronts poses a new set of problems for night-for-night photography. There is no need to create an illusion of night-for-night: the background itself is of sufficient luminance to provide enough light for an exposure. Although added keys may be used to light portions of the action, their intensity must be adjusted to the luminance of the background, which is predominant in the frame. Rim or backlights are not usually needed: there is no problem with separating the subject from the background. Any lights that are used must match the color temperature of the background illumination. There are many ways to deal with this type of lighting. Consider the following situation. The filmmaker is using 7247 color-negative film, which, with its proper exposure for 125 footcandles, yields an f/stop of f/3.5. The action is being filmed parallel to a storefront: a matching closeup or medium shot of the actor as he stops in front of the store is also being filmed. There are three lighting strategies: to use no lights, to light only the closeup, or to light both long and closer shots.

USING NO LIGHTS

With this method (8-19) the subject will appear as a silhouette in the long shot and will be softly side-lit in the medium shot by the practicals inside the window display. Block the action close to the windows to pick up exposure illumination on the subject or at least have the subject move in a diagonal path so that he ends up in a position close enough to the windows to be lit by the ambient light in the medium shot. The exposure for the shots can be set in one of two ways. In the first the camera is set so that the background windows are overexposed by one f/stop. This will provide the maximum level for the exposure of the subject without affecting the realism of the natural lighting and will maintain continuity of background exposure between cuts. In the second the long shot is exposed with the same overexposure, but the following shot is framed as a closeup instead of as a medium shot, eliminating much of the background from the frame. Overexpose the closeup another f/stop from the long-shot measurement in order to record more facial detail at the expense of a lighting-continuity mismatch between the backgrounds of the shots.

LIGHTING ONLY THE CLOSEUP

With this technique (8-20) the long shot will appear as a silhouette, and, as in the previous method, it is overexposed one f/stop from the window exposure, but the closeup is side-lit with a controllable focusing spot that is color-corrected to the temperature of the illumination present in the windows. It should strike the subject from the direction of the natural source: because it can be mounted on a stand, you have greater freedom in blocking the subject. By using the key the detail will be brought out in the closer shot. To maintain lighting continuity, keep the camera set for the same exposure for both shots but adjust the intensity of the key to *match* the exposure level for which the camera was set in the long shot. This will expose the closeup subject correctly and keep the background one f/stop overexposed.

LIGHTING THE LONG SHOT AND THE CLOSER SHOTS

This technique (8-21, 8-22) is usually the most successful of the three: it offers the filmmaker the most control over the background and the foreground. The filmmaker lights the subject's action from an angle that maintains a low-key, contrasty, night-for-night effect while controlling all the illumination. The key's position should be chosen so as not to spill light on the foreground: in this example narrow or frontally directed keys would work best. The lighting for the matching closer shot may be changed for better modeling as long as the direction from which the closeup is lit is similar to that from which the long shot is lit. The lighting ratio of the closeup should be high: the closeup is usually framed against the lit background, which helps to separate the subject from the exterior. If a fill light is added to lower the lighting ratio, rig the fill on a stand and use a fixture that is softer than the key, but keep the ratio around 4:1 or 6:1 so that the contrast of the night-for-night shot is not destroyed. Keep the camera exposure constant at all times. To record all the detail of the background, set the camera so that the background is correctly exposed and level the intensity of the lighting to match.

To measure the luminous intensity of the store window's interior in each of the above cases, point the incident-light dome of the meter toward the camera from a position inside the window. If this is not possible, either use a spot meter to determine the reading coming from the window or point a domed incident-light meter against the glass toward the lit interior. Assume that there is at least twice as much light inside as that read by the meter: use that as the light reading. It may not be exact, but it is a good way to estimate an exposure when more exact means are not available.

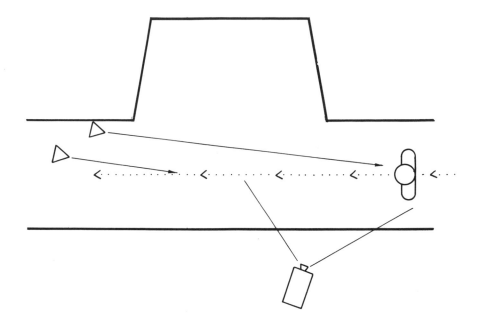

8-21. Lighting a subject long shot filmed against an evenly lit background.

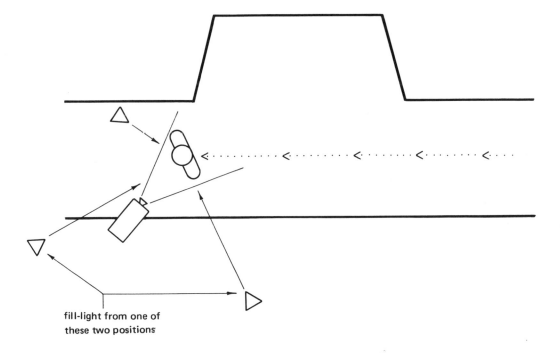

fill-light from one of
these two positions

8-22. Lighting a subject closeup to match a long shot of the same subject.

9. The Basics of Electricity: Power, Potential, and Current

Electrical units are based on the mathematical relationship between three components of energy: power, potential, and current. *Power* is defined in terms of *watts*. Quartz bulbs are rated by wattage, which is generally associated with the strength or brilliance of the illumination produced. Electrical *potential* is defined by a unit called the *volt*. All lighting units and lamps are designed to be operated at a prescribed voltage. *Current* refers to the actual flow of the energy and is measured in units called *amperes*, or *amps*. Electrical current will flow if there is a difference in electrical potential and if there is a conductor to carry the flow of electrons or to resist their movement. A lamp filament in a location fixture resists the flow of electricity. A 1000-watt lamp made to function at 120 volts operates at an electrical potential of 120 volts and uses 1000 watts of power.

Wattage, volts, and amps are related to each other by the following equation: $w = v \times a$. Similarly, $a = w/v$. This mathematical relationship is invaluable to the location filmmaker in calculating the electrical units used, in choosing proper wire sizes based on the total amperage, and in preventing electrical overloads.

MEASUREMENTS
ELECTRICAL UNITS USED

Measurement of the electrical units used by the location filmmaker is the basis for a calculation of the cost of energy consumed. Power companies measure the consumption of this power by wattage, with the charge usually based on the kilowatts per hour used. (A kilowatt equals 1000 watts.) If the total wattage of the lighting units in use is added up and translated into kilowatts, the cost of the electricity consumed may be computed. To do this, multiply the kilowatts by the hours used by the rate per kilowatt hour.

This calculation is helpful in projecting the anticipated expenditure for electrical power. The precise cost of the actual power consumed may be calculated after the shoot, however, using readings from the location's electrical meter. This meter, the property of the power company, is always situated on the location, keeping a record of the kilowatts used by the building. To calculate the cost of the power consumed during the shoot, make a record of the meter reading both before and after filming. Subtract the two figures: the remainder will indicate the total wattage used during the shoot. Multiply this number by the supply company's kilowatt-hour rate to find the cost.

TOTAL AMPERAGE ON A LOCATION

In order to select the proper thickness of wiring to be used on a location, the total amount of current that is to travel through the wire must be known. To calculate the total amperage, add the wattage of all the lighting units that are to be connected to the wire and divide the total wattage by the voltage: the result will indicate the current draw, or amperage, of all the fixtures to be used. (To learn how to choose a safe wire for the amount of current used, see the section below on wire gauges.)

OVERLOAD PREVENTION

The same mathematics used to find the total amperage is used to prevent an electrical overload. An electrical *overload* occurs when the total amperage exceeds the current-carrying capacity of the electrical installation. This is extremely dangerous, as an electrical fire may result. The current-carrying capacity of electrical installations and the distribution of total amperage among subdivisions in the circuits are fully discussed in the section on fuse boxes and circuits.

ALTERNATING AND DIRECT CURRENTS

Two types of current can be described by the way in which they flow through a circuit: alternating and direct.

Normally referred to as *AC*, *alternating current* is the electrical standard for the majority of electrical circuits in homes and industry. It is produced at the supply company by a generator that reverses the polarity of the electrical energy 60 times a second. Each pole reversal is referred to as a *cycle*: 60-cycle AC is the most widely used type of electricity in the United States. The supply companies carefully monitor and control the 60-cycle pulse of the power, for it is very important to maintain operational synchronization of motors. The cycle of the current, however, does not affect the operation of any type of lighting equipment.

Direct current is identified by its single directional flow. Commonly called *DC*, it does not have a cycle and does not change direction. DC current was once fairly popular, but, due to transmission and other problems, AC has almost entirely replaced it. It has, however, become a most valuable portable-power source for location filmmakers in the form of wet-cell and dry-cell batteries.

Wet-cell, or *storage*, *batteries* produce electricity through a chemical reaction between acid and a metal. Often large and heavy, their primary advantage is that, after the energy generated by the chemical reaction is used, it can be re-

versed: the battery can be recharged to produce more electricity. Storage batteries are frequently used as backup power for emergency-lighting systems. Standard location-lighting equipment may be operated on DC as well as AC, but the voltage produced by batteries is notoriously low. For example, a typical auto storage battery produces only 12 volts, and most lighting equipment requires 120 volts. It would thus take ten 12-volt storage batteries connected together to produce enough volts to light the standard location fixture. Wet-cell batteries also tend to be heavy and cumbersome.

Dry-cell batteries, on the other hand, are much smaller and weigh only a fraction of the wet cell's weight. There is no liquid inside them: their potential is instead produced by a reaction between a metal rod and a dry powder. Most are not rechargeable, and the voltage produced is minimal. Recently, however, a new type of battery, called the *nickel-cadmium battery*, has become popular. It is rechargeable and, when connected together in quantity, can produce enough energy to power portable motion-picture lights and cameras.

WIRES

Wires, or *cables*, are the means of transmitting electricity from the source to the load. Wires, cabling, and extensions are generally made up of three separate groups of conductors. The *conductors* promote the flow of current through the wire, with two groups responsible for operating the load—e.g., the lighting fixture—permitting the electricity to flow to and from it and the third acting as a ground. The ground normally carries no electricity, unless something happens that causes it to flow unintentionally from the two conductors. This is called a *short*. Whereas the two power conductors are connected to the load (e.g., the lamp socket), the ground wire is connected to the fixture's housing. In the case of a short the electricity from one of the power conductors may jump to the metal of the fixture's housing or switch. If the ground wire is properly connected, it will permit the electrical short to flow back into the wiring system, where it will do no damage: it will instead blow a fuse at the fuse box or tie-in. If the ground wire is not properly connected to the fixture, if the plug at the end of the cable is not a three-pronged connector, or if the location's electrical system is not grounded, electrical shock becomes a danger.

WIRE GAUGES

Wire *gauge* refers to the thickness of the electrical cable: it is determined by measuring the diameter of the wire and is assigned a numerical rating in accordance with its thickness. Called the *American Wire Gauge*, the numbering system for wires starts at 0000 for the heaviest cable and gradually *increases* as the thickness of the cable *decreases*. For example, the thin lamp-cord wire used for home extension cords and light appliances is usually between 14- and 18-gauge. Heavy-duty extensions may be between 10- and 12-gauge, while battery-jumper cables are commonly 6- or 8-gauge. The gauge rating may be stamped onto the insulation of the wire itself or listed on the package. The gauge rating is sometimes replaced by information listing the load-carrying ability of the cable. A thicker cable can carry greater amounts of current more safely than thinner wire.

The actual gauge of the cable to be used should be chosen by considering the total draw in current that is expected to pass through the cable and the total running length of the wire, which influences the transmission of the voltage through the cable.

If undersized wires are used, electrical and photographic problems will result. Wires will become hot to the touch; there will be a chance of electrical fire within the walls of the location; and the color temperature of the lights may be lowered.

VOLTAGE DROP AND WIRE LENGTH

All wires offer some resistance to the potential that is traveling through them. The shorter the distance between the source and the load, obviously, the better. If the distance between the source of electricity and the load is too great, the internal resistance of the cable to the current flow can prohibit delivery of the full electrical potential of the source. The resistance per unit length, determined by the wire gauge, is called the *voltage drop*. Voltage is affected by wire length. Voltage drop is equal to current times resistance, or, in the form of an equation, $vd = c \times r$. A voltage drop of 2% across a cable is generally considered safe.

To save work in calculating distances and to help in choosing the proper wire gauge for the load to be carried, refer to the chart (9-1). It is used in this way. Determine the maximum amperage that the cable will carry. Match the total amperage to or below the maximum amps allowed. Read over to the left for the matching wire gauge; to the right, for the "safe" distances over which the cable

will carry the chosen current. This chart provides a reasonable assurance that the setup will be electrically safe and, in terms of proper color temperature, photographically safe as well.

If you are interested in calculating the precise voltage drop over a given length of a particular wire gauge, the following gauge/ohms-per-foot chart may be used to determine the resistance factor for the voltage-drop formula (9-2). Simply apply the resistance factor to the voltage-drop formula and multiply by the amperage being drawn and by the total length in feet. Remember that the voltage will effectively drop off both toward and away from the load, so the running feet of the cable should always be doubled for the calculation. For example, the voltage drop over a 12-gauge cable 25' in running length with a 15-amp load would be calculated as follows: $vd = 15$ (amps) \times $0.00162 \times 25 \times 2 = 1.22$ v.

gauge	maximum allowed amps rubber insulation	5	10	15	20	25	35
18	5	35'					
16	7	55'					
14	15	90'	45'	30'			
12	20	140'	70'	50'	37'		
10	25	220'	110'	75'	60'	45'	
8	35	360'	175'	125'	90'	75'	55'
6	45	560'	280'	190'	150'	120'	85'

9-1. Amperages that can be carried safely over various distances by various wire gauges.

gauge	resistance per foot
18	.00651
16	.00410
14	.00257
12	.00162
10	.001018
8	.0006404
6	.000410
4	.000259
2	.000162

9-2. Resistance per unit length of copper at 77° Fahrenheit.

COLOR TEMPERATURE AND VOLTAGE

The bulbs of any lighting unit are designed to produce the designated color temperature only when the correct voltage reaches the bulb, generally from 115 to 120 volts AC. If the lamp receives less voltage, the color temperature will drop, producing an increasingly warmer illumination. When the voltage rises above the prescribed rating for the bulb, lamp life drastically decreases and the color temperature of the illumination that it produces rises. The chart (9-3) indicates the change in degrees Kelvin produced by a lamp as the voltage reaching the bulb changes.

How much voltage drop is compatible with color-balance maintenance? The answer depends more upon the film stock than upon the voltage drop itself. Of course, with black-and-white film there is no problem with color temperature; a total voltage drop that produces a color-temperature shift of more than 150°K may be insufficient for color filming. Remember that the voltage drop must be thought of in terms of the available voltage reaching the lamp. This includes the voltage drop through the connecting cable from the location to the lights and any reduction of incoming voltage to the location itself. The incoming voltage from the power company can vary by as much as ten volts over the course of the day, depending on the time and the season. A voltage drop of 10 volts at the fuse box of the location will cause a 100° drop in color temperature. This uncontrollable fluctuation must be considered in conjunction with the voltage drop of the cables.

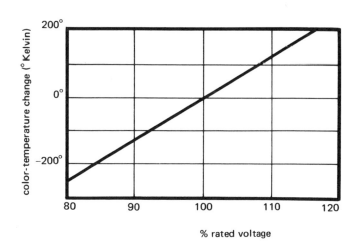

9-3. Color-temperature changes caused by voltage fluctuations. (Reproduced courtesy of GTE Sylvania Lighting Product Group.)

MEASURING VOLTAGE DROP FOR COLOR TEMPERATURE

There are two methods of calculating the voltage drop reaching the lights on the location interior.

1. Measure the incoming voltage supplied to the location at the fuse box or service panel with a voltage meter. Calculate the drop through the cables connecting the fuse box to the lights. Find the ohm resistance for the particular gauge of the connecting cables used and insert it into the voltage-drop formula. Subtract the calculated drop through the cables from the available voltage measured at the fuse box. This difference will indicate the voltage reaching the lights on the set. Compare this "available" voltage to the voltage at which the lights were designed to operate. The difference between the two voltages may be applied to the voltage-drop/degree-Kelvin chart (9-3), and the actual color-temperature shift can be found.

2. A color-temperature meter is faster than the above method. To determine the electrical safety on the set, calculate the voltage drop over the cables. With the lights on the set at working intensity, point the meter toward the key light from the subject's position. The color-temperature meter will indicate the correct color in degrees Kelvin reaching the subject and will suggest possible filtration changes to bring an unacceptable color reading within the color tolerance of the film stock used. By taking readings often any shortages in incoming voltage supply may be detected.

INSULATION

The protective insulated coverings of wires have a lot to do with the current-carrying capabilities of the cables. The *insulation* protects the wire bundles within from electrical shorts as well as from physical damage. In many flexible cords, commonly called *extension cords*, the insulation acts as a barrier to separate each of the two individual bundles from each other as well as a binder to encase the two wires within the single cable.

Five types of insulation are commonly available for flexible cords: *rubber, plastic, neoprene, bound cloth,* and *asbestos.* Which type to use is determined by considering the wire's gauge, the conditions under which it is to be used, and its flexibility. Rubber, plastic, and neoprene are produced in varying thicknesses. Rubber is the most flexible but is rapidly being replaced in thinner cables by cheaper plastic insulation. Neoprene is commonly found in heavy-duty extension cords. Although it is not as pliable

as rubber, it is oil-resistant and provides greater resistance to cracking. Bound cloth is found in what are commonly called heater cables. It is not water- or oil-resistant but is extremely flexible. Asbestos is heat-resistant and is used inside lamp-fixture housings. Although it does not bend easily, it is perfect for special applications in which the wire is to be subjected to intense heat. The varying types of insulation are designated by code letters: the code is stamped on the wire insulation to indicate the type of covering. The chart (9-4) outlines the coding system.

#18	rubber	SP	ordinary lamp extension cords
#16	plastic	SPT	
#10	tough rubber	S	
#12	less tough rubber	SJ	
#14	tough neoprene	SO	thicker coverings
#16	less tough neoprene	SJO	

9-4. National Electrical Codes for insulation.

LETTERING

When choosing cables to be used for a particular location, first consider the current load and the voltage drop. To select the correct wire for the specific conditions, the filmmaker must consider three notations. The first is the AWG, or American Wire Gauge. The second is the set of letters indicating the type of insulation. These two codes are sometimes not printed on the insulation covering but are instead replaced by a third notation that simply indicates the maximum load-carrying properties of the particular wire. A typical covering notation would be 600V, 30 A, which denotes 600 volts and 30 amps. Keep in mind that this type of wire notation indicates only the maximum capacity in voltage and amperage that the wire can safely handle: voltage drop must still be calculated from the AWG listing.

CABLE-WEIGHT CONSIDERATIONS

Although it is always electrically safe to run a minimum amount of current in an oversized cable, the physical weight of such a cable may prove to be a disadvantage for location shooting. Low-gauge cable is not very flexible, difficult to move and work with, and very heavy. For example, 100' of #4 cable may weigh 150 pounds. The

flimmaker should thus select the right cable for the load and conditions. If heavy cabling is unavailable or undesirable, break up the load into several groups: these smaller groups could then use thinner, more flexible, lighter wiring.

RUNNING AND RIGGING THE CABLES

Cables run from an electrical source should be kept together and in sight, not behind or under objects. To prevent possible insulation damage, they should not be stepped on. All cables should be secured to the set. If the wiring must be placed in a well-traveled path, gaffer-tape the bundled cable to the floor (9-5). If the wires and extensions are not secured, anyone tripping over the wires may pull down lighting fixtures, electrical connections, or an entire lighting grid. If a lighting grid is being used, loosely wrap the extensions around the horizontal supports, bundle them together, run them down one of the verticals, and secure them to the floor. If a tie-in with a local fuse or breaker box is not being used, keep the on-off switches for each lamp hanging on the grid accessible.

It is also important to identify every wire. Number each fixture clearly on a piece of white cloth tape or cloth gaffer tape and wrap it around the wire near the switch. Repeat this identifying procedure periodically along the length of the cord until the cable reaches the source. This will avoid wiring mixups, and it will be easier to troubleshoot electrical problems.

9-5. Cables taped to floor.

ELECTRICAL-SAFETY CHECKS

Grasp each of the wires frequently to test for heat on the insulation. If the proper gauge is being used, the insulation should never be warm to the touch. Warm wires may indicate an overload, short, crack in the insulation, or faulty plug or switch. If you do find a warm wire, carefully turn off the lamp on the wire at its switch or cut the circuit at the box. Inspect everything until the cause of the heatup is determined.

PLUGS

Plugs are used whenever a connection needs to be made, except if an electrical tie-in is used to hook directly into the power source. All plugs are rated by the total amperage that they may carry safely but vary greatly in shape, size, type of ground, covering, and safety. Plugs are placed into receptacles called *outlets*, or *sockets*. The plugs are sometimes referred to as the *male connector*; the receptacle, as the *female connector*. Although there are many types of plugs and even more types of specialized junction boxes and connectors, only those most frequently encountered by the location filmmaker will be mentioned here.

HOUSEHOLD PLUGS

Household plugs are made of either rubber or plastic; they are rated at 15 amps. The two-prong type does not offer a ground and is commonly found on thinner-gauge extension cords and at the end of most wires leading from practical lamps. For safety's sake do not use a two-prong plug on a fixture or on an extension cord that is attached to a grounded fixture: three-prong household plugs are available for such purposes.

HEAVY-DUTY HOUSEHOLD PLUGS

Heavy-duty household plugs always have three prongs; they provide an adequate ground and are usually rated at up to 30 amps. They are slightly larger than ordinary plugs and are often covered with plastic, vinyl, or neoprene insulation. These plugs are frequently attached to the permanent cable leading to location-lighting fixtures rated at up to 2000 watts. Some are made with cable clamps that securely fasten the cable to the plug. The clamp prevents damage to the wiring connections within the plug if the fixture cable is unintentionally pulled from the socket.

PIN CONNECTORS

Many location-lighting fixtures and heavy-duty cables are made with *pin-connector* plugs. The pin connector, used in

theatrical and motion-picture lighting for years, is a small, rectangular wooden block designed with two or three conductor-post connections protruding from one side; it can carry large amounts of current safely. When the male connector is slipped into a similarly designed female socket, the connection forms a rectangular, relatively flat wooden block. This connection may be easily prevented from separating accidentally by tying or taping the blocks together. Pin connectors are sturdy and rugged. Their design permits limited abuse such as being stepped on without danger of being crushed or damaged.

STAGE PLUGS

Stage, or *floor*, plugs, another heavy-duty connector frequently found on lighting equipment or cabling, can draw or transmit large amounts of electrical current. They are usually rectangularly shaped and slightly larger than the pin-connector blocks. Unlike pin connectors, stage plugs do not have rigid post conductors but instead are designed to conduct electricity through large, springy, flat conductors attached to either side of the plug. This design makes them very dangerous to all but those who are experienced in handling them. Some floor plugs are not grounded. The matching female receptacles are made in the form of a large distribution box. Each box is designed to accept several stage plugs. Any section of the receptacle not in use is potentially dangerous, especially in small locations in which the cables must be stretched near well-traveled paths.

TWIST-LOCK PLUGS

Twist-lock plugs resemble heavy-duty household plugs at first sight but have three curved metal conductor connectors that securely lock them into their receptacle when twisted a quarter turn. One of the safest and most practical of the newer plug designs, they are replacing pin connectors and other heavy-duty plugs that have traditionally been used for motion-picture cables. They provide grounding for the lighting; the connections will never loosen unless intentionally untwisted. They never have to be taped, and the plug's metal housing can easily withstand repeated abuse.

SINGLE-PIN CONNECTORS

Some of the heaviest three-conductor cables terminate in *single-pin connectors*. A single-pin connector is a rigid metal post surrounded by insulation and attached to one of the three conductors at the end of the cable. Three conductor cables end in three separate single-pin connectors. Each of the pins is identified by a color code to avoid connection faults. They are capable of carrying large current loads safely. Many twist-lock into matching female sockets. The junction cannot be inadvertently pulled apart and is somewhat water-resistant, for the connection is tight.

PLUG AND CONNECTOR SAFETY

Following are a few simple guidelines to ensure the safety of everyone on the set when running electrical cable.

1. Keep all plugs and cable connections in sight but out of the way so that they are not stepped on.

2. Tape or tie together all cable connections that do not have a self-locking design.

3. If dampness is present, seal all connections with a silicone gel and tape the connection to prevent an electrical short.

4. Do not pull a connection apart by the cable.

5. Do not pull apart or make a connection while a lighting fixture is turned on. The electricity may arc, or jump, from the outlet to the plug, causing an electrical short or upset.

6. Do not attempt to make any connections with damp, sweaty, or wet hands. This could cause a short and electrical shock.

PLUG AND CONNECTOR ADAPTERS

Plug and connector *adapters* are devices used to alter the electrical configuration of a connection so that a junction can be made. The most commonly used adapter is the *3:2* type. This rubber or plastic plug has a three-conductor female socket on one end and a two-conductor household plug on the other; a free wire with a screw terminal is also on the male end. The 3:2 adapter is used to insert a three-conductor plug into a standard wall outlet with only two conductors but does not provide a ground for the load. If the two-conductor outlet box is properly wired, the free ground wire attached to the adapter may be screwed to the face plate of the outlet box to achieve a safe ground. If the wire from the 3:2 adapter is not attached, the lighting fixture will still work, but, as it is not grounded, it creates a potential electrical hazard due to a short. The filmmaker should take the time to attach the ground wire of the adapter and should also refrain from breaking off the ground pin of a three-pronged end. It is much better to take the time to get an adapter than to run the risk of an electrical problem.

Another frequently used adapter is the *cube tap.* This is a small rubber or plastic household-plug connector that allows more than one fixture to be plugged into a single socket. The cube tap is commonly a four-sided unit with a male plug on one side and three female sockets on the others. Cube taps are a convenient means of eliminating many extension cords, but care should be taken not to overload the single outlet by drawing more than the maximum current that the outlet box or the cube tap itself is designed to carry. If the cube tap is to be used on the end of an extension cord, check the gauge of the cable to make certain that it can safely handle the increased load.

THE LOCATION'S ELECTRICAL SYSTEM

Before any lighting fixture is connected, the location's existing electrical-supply-and-distribution system must be inspected and understood. Although systems will vary from location to location, theories and methods of operation are basically the same.

THE SUPPLY COMPANY

The power company that provides electrical service to the location is called the *supply company.* It is responsible for making the connection between the power source and the location. This connection is called the *service head.* The type and gauge of wiring that goes into the service head depends upon the projected electrical needs of the location. The location filmmaker may thus have to make allowances for poor electrical systems that were not designed to handle the increased load of all the film equipment brought to the location.

The supply company's responsibility ends with the delivery of a constant supply of electricity at a certain voltage and the billing of the consumer for the electricity used. The power company adheres to the first fairly well (although the supply voltage usually drops during peak-load periods) and never fails to do the second!

The collective term *service entrance* refers to all the electrical connections and hardware that lie between the service head and the actual circuits delivering the power to the various locations within the home or business. Most location service entrances are made up of four components: the service head, the electrical meter, the power main, and the fuse box or service panel.

THE ELECTRICAL METER

The incoming power flows from the service head directly to the *electrical meter*, which monitors and records the amount of electricity consumed. No electricity flows through the meter until it is drawn through by a *load*— i.e., anything using electricity. The amount, drawn by the load, is recorded by the meter: the draw is measured by the spinning of a large, horizontal metal disk inside the meter body. The speed of the spinning disk is an indication of the amount of current being consumed. The disk is connected to four (sometimes six) small pointer dials, which meter the accumulated kilowatts consumed. The electrical meter, usually sealed by the supply company to prevent misuse, should never be tampered with.

THE POWER MAIN

The electricity flows through the meter and into the *power main* (9-6). This is the main switch for all the electricity entering the location. Cutting or throwing the power main off prevents any electricity from passing through. For most small locations this power main will control the entire house or business.

On most locations one of three types of power mains is used. One type is in the form of a large *rocker switch* housed in its own metal shell apart from the rest of the service entrance. To cut the power, simply throw this switch. Written on the face of this type of main is the designated maximum electrical capacity that the system was designed to carry. These specifications must not be extended at any time during filming, even when the electricity being used is connected directly to the service entrance by an electrical tie-in. The second type of power main is a *pullout switch* located inside the fuse box itself. It permits a flow of electricity when the switch is inserted into its socket within the fuse box. To cut the power with a pull-type main, simply pull the entire switch from its socket, removing it from the fuse box. Pullout power mains may or may not have the maximum load written on their face. If they do not, the maximum current that the system was designed to carry safely may be determined by checking the large, cylindrical cartridge fuses attached to the back of the main (9-7). (For a full description of fuses see the next section.) The fuses should be marked with their amperage. If there is more than one fuse, add them together to get the total amperage: this will indicate the safe current-handling capacity of the system. Remember again that the total current to be drawn through the location's electrical system should never exceed the capacity of the power main.

A third type of power main is a *circuit-breaker switch* (or switches), usually located in the main fuse box but

separated from the other fuses or circuit breakers, which distribute the electricity into branches throughout the location. Circuit-breaker mains generally are clearly marked to indicate the total load-carrying capacity of the system.

FUSES AND BREAKERS

The power is protected against electrical overloads and shorts by fuses or circuit breakers. A *fuse* is an electrical safety "switch" made up of a thin strip of conductive material that melts when an overload occurs, breaking the flow of electricity. Fuses are not reusable: after the fuse is "blown," the circuit must be inspected, the cause of the failure remedied, and the fuse replaced.

The fuses protecting the pullout main are usually part of the main itself, located in the back of the housing. When the power main is pulled, the main circuit is broken by removing the main's fuses. Fuses most commonly found in power mains are long, cylindrical types called *cartridge* fuses, which are capable of carrying large amounts of current. Typical cartridges are rated at 50 to 100 amps and are used singly or in groups. Cartridge fuses are covered with an opaque insulation that makes them impossible to inspect for fuse burnout. The fuse must therefore be tested for damage with a circuit tester or meter.

A *circuit breaker* is an electrical safety switch, rated at a particular amperage, that breaks the circuit that it is connected to if the current drawn exceeds the breaker's rating. Pullout mains are generally protected with fuses, whereas the separate rocker-switch types are most commonly safeguarded with breakers. Because of their ease of operation breakers are being used on more and more locations. When the circuit is overloaded, the breaker automatically flips an internal switch in the form of a relay, cutting the power to the circuit. The circuit may be reset by flipping on an external hand lever attached to the face of the circuit breaker. Because the position of this lever visibly indicates whether the circuit is on or off, it provides a fast way of locating an overload.

Separately located power mains may be protected with either cartridge fuses or breakers. If the separate main contains fuses, the rocker switch attached to the power main must be thrown off before any attempt is made to test the fuse for malfunction. If there is no main rocker switch to throw, the cartridge fuses may be safely removed from the main with fuse pullers. Fuse pullers are completely insulated pliers with a specially rounded nose for grasping cartridge fuses. After the fuses are removed from the main, no power will flow through the location,

and the fuses may be tested for their condition. If the system is protected by a circuit breaker that handles a large amount of current, there may be a manual breaker switch inside the power-main box. If it has been overloaded, its external flip switch will be in the off position. To reset the main circuit breaker, first find the cause of the overload and remedy it. Push the rocker switch of the power main, if there is one, to off. Flip the breaker inside the main to off and then over to on. This should restore the electricity.

9-6. An electrical meter and a power main. Attached to the fused side of this main is AWG #2 cable, connected with single-pin connectors. It carries power to a location tie-in.

9-7. Inside the power main are the large, cylindrical cartridge fuses that protect the supply. The neutral wire is always color-coded white.

THE FUSE BOX OR SERVICE PANEL

The electricity from the protected power main flows to the *service panel* or *fuse box*, where it is divided into smaller load-carrying circuits that distribute the power through the location. This distribution at the fuse box is the final step in the service entrance of the location's electrical system. From the fuse box emerge many circuits, each of which usually terminates in a series of electrical outlets.

Circuits

A *circuit* may be defined as any path for electricity that includes its energy source. The fuse box is not the energy source: it merely acts as a distribution point from the source as supplied by the power company through the service head. The total number of circuits that an installation may safely provide depends upon the designated load-carrying ability of the main and upon the amperage of each of the circuits included in the box. For example, a 60-amp main may be divided into four 15-amp circuits. A 100-amp main may be divided into six 15-amp circuits, with 10 amps to spare; five 15-amp circuits plus one 20-amp circuit, with 5 amps to spare; or four 15-amp circuits and two 20-amp circuits. Whatever the circuit distribution, the total amperage used must not exceed that of the power main, and the amperage of the individual circuits must not exceed the load capacity of the wiring leading from the fuse box through the walls into the outlet boxes. (For most houses, apartments, and light industry and business 12-gauge wire is used.) To assure that an overload cannot cause any significant damage to the electrical system, each circuit is protected at the fuse box with a fuse or circuit breaker.

Fuses

Fuses (9-8) are small, conductive wires housed in a glass screw-in mount. They screw directly into sockets built into the face of the fuse box, each of which represents a separate circuit. The fuses are clearly rated in amperage: if the current draw through the circuit exceeds the rating of the fuse, the fuse will break the circuit, stopping the flow. The rest of the circuits will remain intact, provided that they are not overloaded.

The thin conductive wires in each of the fuses can be seen through the clear-glass casing. If the wire melts or separates in any way, the fuse will blow and must be replaced. A break is sometimes not evident, and the fuse must be tested with a meter or self-powered circuit tester.

Although it is best to throw the power main before changing a blown fuse, it may be changed with the power on, provided that you are relatively insulated. (See the section below on safety and electrical shock.) Fuses in the service panel may be exchanged for others with a higher current capacity as long as the main is not overloaded and the internal wiring leading to the wall outlets can handle the increased electrical draw.

Screw-in fuses are available in two types: regular and slo-blow. Regular fuses commonly protect lighting circuits in which the current draw is stable over the period during which the load is applied—i.e., a lighting fixture draws the same amount of current at the moment that it is switched on as it does over the entire length of time that it is on. *Slo-blow* glass fuses are made to tolerate slightly higher current draws so that they will not blow if there is an initial surge of electricity when a fixture is turned on. They are normally used to protect circuits involving heavy-duty motors with capacitor starters, which draw a great deal of current when they are started but stabilize after this initial period. The slo-blow fuse prevents the circuit from breaking during short periods of heavy current draw but still protects the circuit from an excessive or extensive overload.

9-8. A residence service panel with 15- and 20-amp slo-blo fuses. Note the wiring diagram on the door and the well-marked neutral bar. This is a 50-amp service panel; circuits 2, 4, and 5 are in use.

Circuit Breakers

Many newer locations use breakers in the fuse box instead of fuses (9-9). These circuit breakers are exactly the same as those described in the section on power mains except for their power rating and load-carrying capacity. Fuse-box circuit breakers are generally divided into 15-, 20-, and 30-amp circuits. Again, the total amperage of all the circuits must not exceed the capacity of the main. Although broken breakers can easily be spotted and reset when overloaded, they may not be replaced with higher-rated units to increase the capacity of an individual circuit, a luxury afforded by the older fuse systems.

9-9. Interior of a typical 200-amp residential service panel. The power main is protected with two 100-amp circuit breakers. The fused side of the power main is marked "load." The eight 120-volt circuits of the panel are protected by fuses. Three 240-volt circuits are also present: each is protected by a separate cartridge fuse held in place by a black, rectangular pullout breaker. The neutral bar is located at the bottom of the panel.

THE INTERNAL WIRING

The cables of the location's internal wiring are visible at their entrance into the fuse box and the power main. The filmmaker never has to deal with this wiring but should be aware that, especially if the building is old, the internal wiring may be undersized, frayed, or otherwise damaged. Under these conditions it is of utmost importance to make certain that the lighting equipment in use does not overload any of the circuits. If it does, an electrical fire could start inside the walls of the location.

ELECTRICITY FLOW THROUGH THE SERVICE ENTRANCE

Two basic electrical systems are used in most locations: they vary only in the use and location of the power main to the system. In the first the power main is separately housed outside the fuse box. The flow of electricity enters at the service head and passes through the meter and into the power main, where it is fused with breakers or cartridge fuses for protection. The power-main fuses act as a backup safeguard in case the individual service-panel breakers fail or become grossly overloaded. A heavy cable passes out of the main (the *fused* side of the main) and travels a short distance to the fuse box, where the available power is broken up into circuits and distributed through fuses or protective breakers. In the second type of system the power main is incorporated into the housing of the fuse box itself. The electricity enters the service head and meter in the same manner as in the first system, but, instead of going into a separate box for the main, the wiring goes directly from the meter into the fuse box. The electricity travels through the main fuses, out through the fused side of the internal main, and into the fuse-box connections, where it is broken up and distributed.

The actual wiring of the service entrance must be understood only if the existing outlets of the location will not be used but the available power that the location has to offer will be used. This requires *tapping in* to the power at its source (the power main) and is a common procedure to connect to the location's power. The procedure is referred to as making a *tie-in* and will be described in depth later in the chapter.

No matter what the particular service entrance looks like, there is a standard for the wiring and the colors of the wires to be used. For example, in a typical 120/240-volt installation (which is present in most locations) a cable containing three separate conductors, red, black, and white, enters the power main and travels through

the fuses and into the fuse box. The red and black conductors *each* carry an electrical potential of 120 volts. The total voltage actually reaching most locations is the total potential of these two conductors, 240 volts. The white conductor is a ground, or *neutral*, cable. The ground offers zero voltage and thus has an electrical potential of zero. Electricity will flow through a circuit if there is resistance and if there is a difference in potential within the circuit. The neutral ground is used in a 120-volt system to provide the potential difference in order to promote the flow of electricity.

The red 120-volt conductor enters the power main through a fuse and emerges on the fused side of the main. The black follows the same path, usually through another fuse. The white neutral wire is attached to the power-box fixture itself and emerges as a white conductor. It is not fused. All three conductors are usually wrapped into a thick insulated cable that connects the fused side of the power main to the fuse box or service panel. In a typical fuse box the red conductor is attached to one side of half the available circuits, and the black to one side of the others. In this way the incoming power from the main is divided. The white neutral is attached to the remaining terminals on both the red and the black side of the fuse box.

The power company is grounded at the plant through the white ground. The location is grounded through a connection to the cold-water pipe (cold-water pipes always pass into the earth somewhere), and the outlets (and fixtures plugged into them) are grounded via conductors that attach to all the other grounds through connections in the fuse box itself.

All the wiring in the service entrance is done by electricians and should never be tampered with by anyone else. It is, however, beneficial for the filmmaker to understand its basic operation and design so that he or she can assess the electrical capacity of the interior properly prior to the shoot, compare it to the anticipated electrical potential needed for the lighting, and make any alternate arrangements for tapping into the power of the location if the existing circuits and power distribution on the location are insufficient.

As previously mentioned, three wires lead into the usual service entrance. This is called a *single-phase, three-wire* installation and is labeled as such on the service panel itself or on its door. Single-phase service entrances are characterized by the presence of two "hot" wires colored black or red (or another color but never white) and a white neutral wire. These three wires can be seen on the exterior of the location as they enter the service head where the wires from the power company are attached to the building or inside the service panel (fuse box) when the cover is removed. (Note that it may be necessary to remove the cover of the fuse box to observe the three separate wires because in many cases they are wrapped in a protective jacket that at first glance appears to be a single strand of wire.) In a single-phase three-wire system touching one of the probes of a voltmeter (an instrument used to measure voltage discussed later in this chapter) to the red and the other to the black lead should give a reading between 220 and 240 volts. A voltmeter connected to the red and white or to the black and white leads should read close to 120 volts.

When more power is required for commercial and industrial applications, a *three-phase* service panel is often used. With three-phase service there are usually four wires that enter at the service head outside the location. Inside the service panel are three "hot" wires: they are coded black, red, or blue (never white or green). A fourth white wire again acts as a neutral ground. The colored wires are attached to a main or to fuses or breakers, while the neutral wire is attached to a rectangularly shaped metal piece called a *neutral bus bar*. The neutral bar is usually easily identified, for many other smaller-gauge white wires that lead out to the many branch circuits that the panel services are also attached to it. In a four-wire system a voltmeter connected to any two of the three hot wires should give a reading in the 210- to 240-volt range, while a connection between the white neutral wire (or neutral bus bar) and any one of the hot leads should read 120 volts.

If the existing outlets and electrical system of the location are to be used to power the lighting, the most important information that the filmmaker needs is the total amperage rating of the system (listed on the power main or the panel itself or calculated by adding the individual amperage ratings of each of the fuses or circuit breakers) and the panel equipment, either breakers or fuses. (If fuses are used, the filmmaker will need to buy extras for the shoot). If an alternate system of tapping into the service panel is planned, the filmmaker should note the running distance between the service panel and the filming location, the total capacity of the service entrance, and the type of service offered (single-phase or triple-phase). A Polaroid picture of the interior of the panel (with the panel cover removed) is helpful to the person making the tie-in so that he or she can get the

proper parts from the rental or electrical-supply house as well as preview the internal setup of the box, saving time on the day of the shoot.

LIGHTING THE SET

The power required to operate the lighting fixtures will almost always come directly from the location itself. The manner in which the electricity is connected to the lighting units or the lighting units connected to the electricity varies with such factors as the total power available at the location, the amount of power to be consumed, and the time and money required to buy, rent, and set up special systems for tapping the power. The most popular methods for obtaining the power necessary to operate the lights on location sets are to use the existing circuits or to use an electrical tie-in.

AVAILABLE POWER

The use of available power is the most popular method of lighting a small location: it is the easiest, cheapest, and most obvious way to get power to the lights although not always the fastest or the most reliable. It does not require any special hardware, cords, or connections: each lighting unit is simply plugged into the existing outlets of the location. The use of existing circuits is not, however, considered the most professional way to electrify the set. Some electrical systems may not be able to handle the amount of power needed for an intricate lighting pattern: the filmmaker will have to limit his lighting setups. The filmmaker may also have to run many extension cords from electrical outlets far from the actual set, which can become bothersome and dangerous. The use of existing circuits for lighting the set should be considered only if the total current draw of all the lights to be used is relatively low or if there is not enough money or time or expertise to bring power onto the set with other means. If the existing circuits must be used to light the set, follow these suggestions when connecting and rigging the electricity for the shoot.

1. Determine the total current-draw combination of all the fixtures to be used on the set at any one time.

2. Check the capacity of the power main.

3. Check the number of circuits at the fuse box and any special fuses that power electrical units that must remain on, such as burglar alarms, freezers, or heaters.

4. Calculate the current required to operate any set practicals to be used during the shoot.

5. Calculate the current required to operate any safety lamps needed to light other parts of the location that must also remain on during the shoot.

After all the above are considered, it will become apparent whether there is sufficient power to operate the lighting from the existing circuits. If the current is found to be sufficient, connect the lighting in this manner.

1. Divide the circuits to be used at the fuse box and letter them.

2. Select the appropriate amperage for the fuses in each circuit if the system is so equipped.

3. Letter the existing outlets on the location with the same letter that identifies the breaker or fuse in the service panel that controls the power to the outlet. A small piece of tape lettered with a marking pen will speed the identification of overloads and other problems.

4. Rig the lighting fixtures and select an appropriate gauge extension to carry the voltage over the distance between the fixtures and the actual outlets to be used without an appreciable voltage drop.

5. Do not overload any of the individual circuits by attempting to draw more current through the outlets than they are safely designed to carry. For most household circuits this is no more than 15 or 20 amps.

TIE-INS

A *tie-in* refers both to a system and to the components needed to tap the location's electricity at its service panel in order to provide a safe and convenient means for getting electricity to the lighting fixtures. A tie-in provides no more electrical potential than is available at the service panel or through the branch circuits located as outlets throughout the location. The purpose of a tie-in is to centralize the location's available power into a convenient location (usually just outside the room where the shoot is to take place) so that all the lighting fixtures may be controlled and electrified at a common source instead of running many extensions to various outlets on the location.

Components

There are four main components of a typical tie-in: a location service panel, distribution hardware, a feeder cable to the electrical mains, and hardware to attach the feeder cable to the power source.

The location *service panel* is the heart of the tie-in. Its purpose is much the same as that of the service panel that is permanently mounted in the service entrance. It may even be an exact duplicate of the one in the service entrance, except that it is usually mounted on a portable support: it has a fused on/off switch, rated at a capacity no higher than that of the actual power main on the location, and multiple breakers, each wired to an individual circuit. The location panel receives the electricity from the service head through heavy-gauge feeder cables, passes it through a system of protective breakers and safeguards, and distributes it through individual breakers, each representing a circuit that exits the panel or wires to be connected to the extension cords leading to the lights.

Feeder cable is the heavy-gauge wiring used to transmit the electricity from the power source (the location's actual service-entrance panel) to the location panel. To select the proper feeder cable, the distance between the tie-in panel and the service entrance and the total amperage that the wire is to carry must be known. Select the wire gauge that can carry the maximum load to be drawn the necessary distance without an appreciable drop in voltage at the tie-in panel. The cables are usually supplied in 25' lengths and are connected together with twist-lock single-pin connectors both to each other (when multiple lengths are used) and to the tie-in panel itself. Each cable should be color-coded with colored tape to avoid mixups in connections. The number of cables needed depends on the load to be carried and the type of service, either single-phase or three-phase, at the service entrance. In a single-phase three-wire setup three separate conductors are usually needed to connect the location tie-in to the service entrance, while in a three-phase system four conductors are required.

Hardware must be used to attach the ends of the feeder cable leading from the tie-in panel to the power main. With either system the number of conductors needed indicates the number of connections that need to be made. The separate conductors may, however, be contained within a large, insulated jacket-wrapped cable to reduce the actual number of wires that are needed to connect the power to the tie-in. Whether single- or triple-phase wiring is present at the service head, the tie-in service panel that you rent will be wired to distribute the electricity properly into the usable 120-volt single-phase power that is needed to operate the lights. The actual connection to the power source is generally made either with large alligator-type clamps that clip onto the proper connections or with lugs or screws that securely bolt to the proper points (9-10, 9-11). The latter are considered to be the safer of the two attachments, as they are more permanent and less likely to cause any electrical shorts or other complications that might occur if the clip-on hardware connectors slip off. The alligator clamps, which resemble large automobile jumper cables, may be safely connected to the supply without switching off the power main if this is done with extreme caution by someone completely familiar with electrical safety factors. Attaching the lug or screw-type hardware connection without cutting the power main can prove to be extremely dangerous. Both the alligator clips and the lug nuts are usually attached to a short piece of heavy wire ending in a twist-lock pin connector that matches those on the ends of the feeder cable.

The distribution of the electricity actually takes place within the tie-in service panel itself, but, after the electricity has been broken down to individual circuits by the panel, a selection of components is needed to connect each of these circuits to the cords that lead to the lights themselves. Materials used for this purpose may be referred to as the *distribution hardware*. The proper selection of distribution hardware can only be made after the type of plugs on the end of the lamp fixtures and the type of plugs or connections that are needed to connect all the wiring to the tie-in service panel are known. For example, if the light-fixture cords end in a three-prong household plug and the wires exiting the service panel on the distribution-circuit side are female twist-lock connectors, the filmmaker will need distribution hardware in the form of a male twist lock (to connect to the panel) attached to a cable of appropriate length and gauge and ending in a regular female three-prong receptacle. Since most lightweight location-lighting fixtures terminate in a regular household three-prong plug, many filmmakers use tie-in service panels with ordinary outlet boxes (usually *quad* boxes, with four outlets, or *duplex*, with two) attached to the panel: this eliminates the need for any special distribution hardware to attach the common extension cable. In selecting distribution hardware the most important question is how to attach the fixture cords to the service panel.

Selecting the Right Tie-in

Tie-ins are rented as component pieces from film-supply or electrical-supply houses. Below is a checklist of information needed to select the right parts for the job.

1. The phase rating (single- or three-phase) of the service entrance.

2. The total current-carrying capacity of the service entrance and the location.

3. The existence of a power-main switch.

4. The total amperage of any loads (lights, refrigerators, heaters) that must remain on during the shooting. (The tie-in does not disconnect the available location's circuitry but merely "taps" into it.) This amount must be subtracted from the total load-carrying capacity of the service entrance: this current plus the current to be used

9-10. A tie-in at the location's service panel. The white neutral feeder cable from the tie-in service panel is attached to the neutral bar with an alligator-type clip. Note the white markings along the length of the neutral wire. The two heavy white bands are wrapped around single-pin connectors: one side is male, the other female. This junction enables the feeder cable to be used with adapters other than the alligator clips shown here.

9-11. The tie-in service panel located just outside the interior being rigged. Before any electrical connections are made, this jumble of wiring must be straightened out. The output plugs on this panel are female three-pin connectors. To connect each of the 12 panel circuits to the location's fixtures, male three-pin connectors carry the power to three auxiliary circuit panels, which in turn lead to the household-type outlet box to which the lights may be plugged.

by the tie-in must not exceed the rating of the service entrance (9-12).

5. The exact location for the connection of the feeder cable to the mains. This will help determine the type of hardware to use for the connection. (Again, a Polaroid photo will help.)

6. The position of the tie-in panel in terms of the location.

7. The distance in running feet between the service entrance and the tie-in panel.

8. The expected load for the lighting in amps. (The gauge of the feeder cable and the length of wire will be needed here.)

9. The type of plug on the end of each of the fixtures to be used.

10. The running distance between the fixtures and the tie-in panel on the location.

11. The type of hardware, plugs, or means in which the distributed power (circuits) exits the tie-in panel.

9-12. Portable step-down transformer. In this industrial-filming situation the available power is 600 volts. A tie-in made at the location service panel enables the power to be carried to this transformer, which is located on location. The movable transformer steps the 600 volts down to 120 volts, which are distributed into a duplex outlet box into which the lighting equipment can be plugged.

Connecting the Tie-in

The location of the tie-in panel should be chosen first: set up in a position close to the room being filmed, out of the way as far as pedestrian traffic is concerned, and able to remain in place until all the interior shooting is completed. Remember to consider the location at which the cables for each of the fixtures used to light the set will exit the room to reach the tie-in. It is best if all the cables from the lights come together in a bundle and leave the room from a position that will not interfere with any of the camera angles.

As the lights are being roughed in, attach the feeder cable to the tie-in panel, making sure to follow the color coding of the wires. Make sure that each connection is secure: if in doubt, tape the wires together after the connection is made. Run the feeder down the predetermined and measured path to the service entrance, leaving enough slack at the service end of the cables to tape or tie the cabling to a sturdy insulated support so that, if you accidentally pull on the cables, the wiring will not be disconnected from the service-entrance connections. Remove the service-panel front.

A *certified electrician* should take over from here. The exact points chosen to make the connection will vary from installation to installation. Points for each of the "hot" wires will probably be located on the *fused* side of the main. To find these points, the electrician will follow each of the hot wires (colored red, black, or blue) as they enter the service panel and pass through the power-main switch or main fuse and then select a point on a surface somewhere between where they exit the main and where they disappear into the panel to be distributed into the circuits. It is at such a point that the colored feeder cables will be attached. With a single-phase installation there will be two colored cables to attach; with a three-phase system, three colored "hot" wires. In a single-phase installation each of the colored wires exiting the main fuses or breakers will be secured to power one side of the circuits available in the tie-in service-entrance panel. In a three-phase system each of the three colored wires exiting the main will be connected to provide power to each of three separate tie-in circuit divisions. With either single- or three-phase systems the connection of the white neutral feeder is easily sighted, as it is often attached directly to the neutral bus bar. After the tie-in to the power source has been installed, the filmmaker can connect the fixtures to the tie-in panel at the location interior, balancing the load by dividing the total to be drawn by the lights equally among

the circuits exiting the location service panel.

As the roughing-in procedure for the lighting is taking place on the set, the filmmaker should place a numbered tag or tape on each fixture in a place that won't be affected by the heat from the fixture. The numbered tag identifies the lamp: if the same number is taped to the wire running to the fixture, the tie-in panel, and the circuit breaker that controls the light, troubleshooting malfunctions becomes extremely easy. Remember to leave the line on/off switches for each fixture in the on position: they can be turned on and off directly from the tie-in panel itself simply by throwing the breaker (or unscrewing the fuse) that controls the circuit.

After all the wiring and connecting hardware has been positioned and the lights connected to the tie-in panel, the filmmaker should not throw the power main on the tie-in panel until each of the breakers on the box has been switched off individually. If this is not done and the main on the tie-in is used to turn on all the location lights at once, the fuse of the main might blow or the main breaker might be "popped," and all the electricity to the location would be cut. Always switch on the circuit breakers of the tie-in one at a time; to switch them off, turn them off one at a time and then switch off the main breaker at the tie-in panel. After completing the above procedures the film-maker is now ready to power the set and trim the lights.

SAFETY PROCEDURES

Working with electricity is a serious matter: the more you know about correct operational procedures, the mechanics of choosing the right equipment for the job, and safety principles to follow in order to avoid electrical hazards, the more accident-free your shoot will be. At first you should be overly cautious about using and connecting electricity. Check and recheck everything that you do *before you do it.* If you are not sure about something, find someone who knows the correct procedure.

There are two factors that should always be observed when working with electricity: use *one hand* whenever possible to make or break any electrical connection and *insulate yourself.* The one-hand rule is important because your body is a good conductor of electricity. If you accidentally touch a live wire with your bare hand, the electricity will flow through your arm, torso, legs, and feet to the ground. This, of course, is dangerous, but it is much safer than if you use two hands. If you touch a live connection with both hands, the electricity will most likely flow across your chest before it reaches the ground, increasing the chances of electrocution because this path includes your heart. *Be careful when working with electricity.*

Insulating yourself is a good way to avoid some of the hazards of shock and electrocution. Remember that *rubber* and *wood* are good *insulators,* while *metal, water, damp surfaces,* and *sweaty bodies* are good *conductors.* Insulate yourself when making major electrical connections by wearing heavy rubber gloves, keeping your hands dry, wearing rubber-soled shoes or boots, and standing on a piece of dry wood when making tie-ins. Always use tools that have special insulated handles. Don't attempt to make connections in damp or watery areas.

What should you do if you see someone being shocked or electrocuted? Think fast, then act. If there is water on the floor or visible loose wires, avoid them or you may also get shocked. Cut off the power. If this can't be done, very carefully try to get the person out of the area with a piece of wood, a broom, or a rubber hose. Once the victim is safe, use artificial respiration and treat for shock and burns while someone else calls for medical assistance.

The filmmaker should also be prepared in case of an electrical fire. An electrical fire can occur if there is an overload or short in the wiring: the filmmaker should always have a fire extinguisher handy. The best type for electrical fires is a dry-chemical B-C fire extinguisher.

THE ELECTRICIAN'S TOOLBOX

Following is a list of handy items for dealing with electricity on the set:

tapemeasure (wind-up 50' cloth measure)
regular $\frac{1}{4}$" slotted-blade screwdriver with insulated handle
electrician's screwdriver
Phillips screwdriver
scissors
wire cutter and stripper
crimping tool
pocket knife
pliers with insulated handle
long-nose pliers with insulated handle
fuse puller
flashlight with spare batteries
small screwdriver sets, regular, slotted, and Phillips
one-handed neon circuit tester
volt/ohm/milliamp meter (called a VOM)
hacksaw
soldering iron with solder and wire
cloth gloves (for handling hot bulbs)
heavy-duty electrician's rubber gloves (for insulation)

vise-grip locking pliers
vinyl electrical tape
three-prong-to-two-prong converters
cube taps
screw solderless terminals
crimp solderless terminals
bright-colored grease pencils
acrylic markers
extra cartridge power-main-line fuses
extra assortment of glass fuses

Two of the electrical tools on the list need a further explanation: the volt/ohm/milliamp meter and the neon circuit tester.

THE VOLT/OHM/MILLIAMP METER

The *volt/ohm/milliamp meter* (VOM) is a device capable of measuring AC and DC voltages, resistance in ohms, and milliamps. Most meters have a multipurpose scale calibrated in varying degrees, a deflection needle that travels across the scale to indicate the measurement, a small battery for power, and a rotary switch to select the type of measurement desired and the range or sensitivity to which the measurement is made.

To take a measurement, select the proper scale and type of reading to be taken with the rotary switch and touch the tip of each of the measuring probes attached to the meter to the points at which the reading is desired. For example, if you want to check the location service-entrance panel for voltage, set the rotary switch of the meter to AC volts, select the range on the meter (0 to 250 for our example), and touch one of the probes to the neutral bar of the panel and the other to either of the live red or black wires at the point at which it is connected to a screw lug after it exits the power main but before it disappears into the distribution circuits of the panel. The readings should indicate the voltage present at these points—120 v, for example. The meter can also be used to check for a voltage drop over the length of a long extension cord. Simply slip each of the probes into one of the slotted openings at the end of the cord's female household socket. A drop in voltage over the length of wire will show up as a low voltage reading on the meter's scale.

Another use of the VOM is to check the voltage of dry-cell batteries used to power the camera or recorder. The meter should be set for DC volts, and an appropriate scale that includes the maximum voltage of the battery chosen. For example, if the battery is a common D cell, its maximum voltage when fresh is 1.5 volts. Set the meter for a DC-volt scale of 0 to 3 volts. DC, unlike AC, has *polarity*, or a negative and a positive side. The red wire of the meter probe is connected to the positive value, and the black to the negative. Touch the probes to the correct ends of the battery and read the voltage from the scale.

Another common use for the VOM is to check fuses for malfunction. Since it is often difficult to determine by sight whether or not a fuse is defective, a VOM set to read resistance may act as a continuity tester to indicate quickly whether or not a fuse has blown. To do this, set the meter for ohms and the lowest resistance scale possible (e.g., 0 to 150 ohms). Touch the two ends of the meter's probe together. The needle should deflect fully, indicating that there is no, or zero, resistance between the probes. This tells you that the meter is working properly. Remove the suspected faulty fuse from the panel. Every fuse has two contact points: in a cartridge they are at either end of the fuse; in a screw-in glass fuse both are on the same end—one is the metal ring around the base, and the other is the metal nipple in the center of the base. Touch a probe to each of the contacts simultaneously: if the fuse is good, the needle will deflect fully, indicating zero resistance. If the fuse is bad, the needle will not deflect at all.

THE NEON CIRCUIT TESTER

The VOM is used to indicate exact voltages; the one-handed neon circuit tester is used only to indicate the presence of electricity in a wire, connection, or plug. This tester looks like a small, insulated, clear-plastic screwdriver. It is usually used to indicate whether the power at an outlet on the set is on or off when rigging the wiring or troubleshooting a fixture that is not working due to a lack of power. To use it, place the screwdriver tip of the tester into one and then the other of the slotted holes of a female household socket. If electricity is present, the neon lamp encased in the handle will glow when inserted into one of the holes. If it doesn't, continue to trace the wire back to the next electrical junction to locate the problem.

ALTERNATIVE POWER SOURCES

There are three common methods of obtaining alternate electrical power: generators, automobile alternators, and auto batteries.

GENERATORS

Gasoline- or diesel-powered *generators* are the most efficient and productive tools for providing large amounts of

electricity for a location. Generators create their own electricity and are usually mounted on trucks. Renting a generator truck to provide power for a location is expensive. Special generators are needed for filming purposes: they must be muffled in some way so as not to interfere with sound recording. Such specially designed units require an operator, a truck driver (if it is a union job), and heavy cabling to feed the power into the location. Small, portable generators can be rented from building-supply houses. They are moved either by hand or on small hand trucks, run on gasoline, and very noisy. Typical units produce 3000 to 4000 watts, which is suitable for movie lighting. Remember, however, that if you plan to place the noisy generator far away from the set, long, heavy, large-gauge cable will be needed to feed the power into the set in order to avoid a voltage drop.

ALTERNATORS

If a small amount of electricity is needed—i.e., 2000 to 3000 watts—an automobile *alternator* may provide enough power if the engine is running. Kits can be bought inexpensively from auto-supply stores that will provide this tie-in to the auto alternator. Installing the kit to your auto alternator will not harm the car or the alternator, but not all makes and models of cars are adaptable to such use, particularly those in which the alternator and the voltage regulator are integral parts of each other. The best bet before buying a kit is to check with the nearest car dealer's service department. Some supply houses sell DC-to-AC converter kits that plug into the cigarette lighter. Avoid them: they produce only a few hundred watts of usable AC.

CAR BATTERIES

Generators and alternator tie-ins permit regular lighting fixtures with standard 120-volt bulbs to be used. If the filmmaker can get away with a minimum of light, he may be able to use 12-volt lights and run them directly from an auto *battery* in an emergency or to save money. For example, suppose that a moving car is being filmed from the interior both in daylight and in night-for-night shots. To get fill light into the car for the day shoot and enough key light onto the face of the driver for the night shoot, simply attach two battery jumper cables to the car battery and buy enough thin wire (18-gauge lamp cord) to run two pieces from the car battery to the car. Strip off 2" and 3" from one end, wrap the wires around the free ends of the jumper cables, and insulate the connections with elec-

trical tape. Secure the wires so that they do not flop around and interfere with the engine. Buy an ordinary auto high-beam headlight at an auto-supply house. Attach (preferably with solder) each of the two ends of the wires from the car battery to the contacts on the back of the headlight. Mount the lamp under the dash pointing toward the driver or cover the ceiling of the cab with tin foil and bounce the light onto his face from the back seat or another floor area. Correct the color temperature of the illumination (it is probably as low as 2600°K or 2800°K) by filtering the light with a blue gel. Adjust the intensity of the illumination falling on the face of the driver in the daylight shot to about one-half f/stop under the camera exposure, which should be set for the level of natural illumination seen through the windows of the moving car. When the car driver is seen against lighted storefronts in the night shot, measure the correct exposure for the storefront exterior and set the camera aperture one f/stop over the indicated amount. Adjust the inside car key light to an intensity equal to the exposure at which the camera aperture is set. The driver will be properly exposed, and the exterior storefronts will appear naturally bright.

Depending upon the intensity of the natural-lighting conditions, it is necessary at times to directly light the actor flatly and/or from the camera position. If this is the case, diffuse the illumination to reduce sharp, hard shadow production in order to help mask the positioning of the lamp.

Index